INSTITUTE FOR STUDIES
ON LATIN AMERICAN ART

The publisher and the University of California Press Foundation
gratefully acknowledge the generous support of the Institute for
Studies on Latin American Art (ISLAA) in making this book, and
the entire Studies on Latin American Art series, possible.

Forming
Abstraction

This series is supported by a gift from the Institute for Studies on Latin American Art (ISLAA).

Studies on Latin American Art

ALEXANDER ALBERRO, SERIES EDITOR

Forming Abstraction

Art and Institutions in Postwar Brazil

Adele Nelson

 UNIVERSITY OF CALIFORNIA PRESS

Publication of this book has been aided by the President's Office of the University of Texas at Austin.

University of California Press
Oakland, California

© 2022 by Adele Nelson

Illustration on p. viii: Installation view of the second São Paulo Bienal (detail), 1953–1954, Fundação Bienal de São Paulo/Arquivo Histórico Wanda Svevo. Illustrations on pp. xvi, 46, 132, and 208: Hélio Oiticica, *Três tempos (quadro 1)* (details), 1956 (see fig. 90). Illustrations on pp. 14, 88, 172, and 254: Geraldo de Barros, *Fotoforma* (details), 1952 (see fig. 19). Illustrations on pp. 268 and 334: Exhibition layout of the first Bienal de São Paulo (details), 1951, Fundação Bienal de São Paulo/Arquivo Histórico Wanda Svevo.

Cataloging-in-Publication Data is on file at the Library of Congress.

ISBN 978-0-520-37984-8 (cloth : alk. paper)
ISBN 978-0-520-38520-7 (ebook)

Printed in China

30 29 28 27 26 25 24 23 22 21
10 9 8 7 6 5 4 3 2 1

To my family

Contents

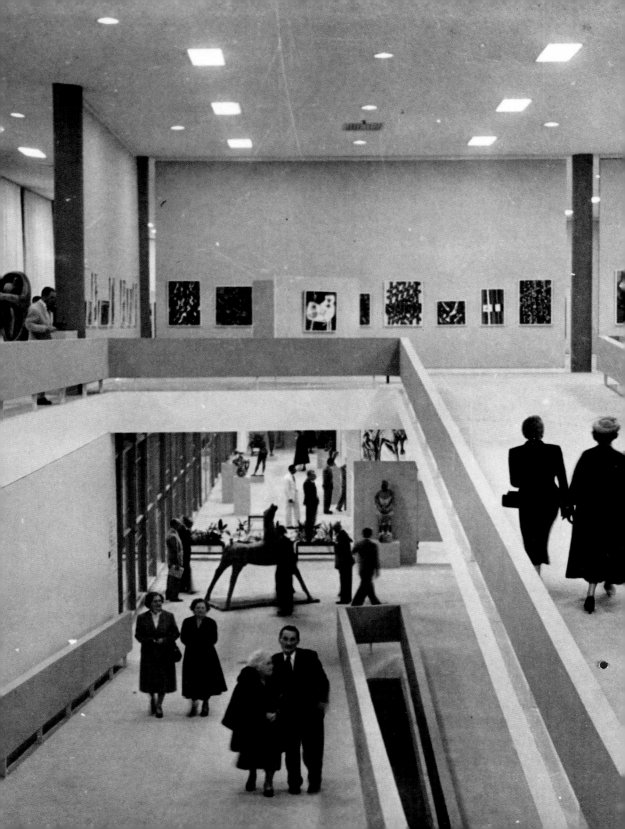

Acknowledgments

Many people contributed to this book, and I deeply appreciate all the individuals and institutions that have enabled my work on it. My students, from teaching at New York University, City College of New York, and Southern Methodist University while still in graduate school, to my prior appointment at Temple University and my current institution, the University of Texas at Austin, have made the work on this study rewarding and enriched its contents immeasurably.

This project would not have been possible without the support of the families of artists and critics who provided indispensable access to documents and artworks and shared insights. I give my profound gratitude to Fabiana and Lenora de Barros and Michel Favre; Alessandra Clark, Fabiane Moraes, and Sonia Menezes; Analívia Cordeiro; Paula Pape and Pedro Pape Fontes; César Oiticica and Ariane Figueiredo; Vera Pedrosa; Heraldo, Leila, Yves, and Katherine Serpa; as well as to Judith Lauand and Elissa Khoury and the late Almir Mavignier and Alexandre Wollner. I also thank Aluísio Carvão Jr.; Adriana and Mônica Charoux;

Antonio, Pedro, and Thiago Maluf; Delmar and Sigmar Mavignier; and Valter Sacilotto, as well as Mira Haar, Peter Fejér, André Victor Flexor, João Candido Portinari, Heitor dos Prazeres, Selma Sevá, Tobias Visconti, and the cultural support of the Instituto Alfredo Volpi de Arte Moderna.

This book has benefited from the research excellence of numerous Brazilian institutions. First among them is the Arquivo Histórico Wanda Svevo, Fundação Bienal de São Paulo, where Ana Paula Marques and Marcele Souto Yakabi, as well as Adriana Villela, Dalton Delfini Maziero, Natália Leoni, and Wagner Pereira de Andrade provided exceptional research assistance and good cheer over many years. I am similarly indebted to Elizabeth Catoia Varela, Aline Siqueira, and Cláudio Barbosa at Pesquisa e Documentação, Museu de Arte Moderna do Rio de Janeiro (MAM Rio); Ivani Di Grazia Costa, Adriana Villela, Romeu Loreto, and Bárbara Bernardes, Centro de Pesquisa, Museu de Arte de São Paulo Assis Chateaubriand; Léia Cassoni and Maria Rossi, Biblioteca Paulo Mendes de Almeida, Museu de Arte Moderna de São Paulo; Maria Fernanda Nogueira and Vera Faillace, Biblioteca Nacional; Silvana Karpinscki, Arquivo, Museu de Arte Contemporânea da Universidade de São Paulo (MAC USP); Marilucia Bottallo and Vinícius Marangon, Instituto de Arte Contemporânea; and Virginia Albertini and Joanna Balabram, Instituto Moreira Salles. Recent digitization and preservation projects at Brazilian archives and libraries have contributed to this study, including the groundbreaking digital *hemeroteca* (periodical library) at the Biblioteca Nacional. I also thank Charlotte Sturm and Amy Fitch, Rockefeller Archive Center; Véronique Borgeaud and Didier Schulmann, Bibliothèque Kandinsky, Musée national d'art moderne; Rachel Chatalbash, Solomon R. Guggenheim Museum Archives; Michela Campagnolo, Marica Gallina, and Elena Cazzaro, Archivio Storico delle Arti Contemporanee, Fondazione La Biennale di Venezia. The help of librarians, archivists, and researchers at the Museum of Fine Arts, Houston (MFAH), Museum of Modern Art, New York (MoMA), New York Public Library, New York University (NYU), Temple University, and the University of Texas at Austin has been key, and I thank especially Ana Marie Cox, Michelle Elligott, Maria Gaztambide, Linda Gill, Milan Hughston, Michelle Harvey, Jill Luedke, Ryan Lynch, Beatriz Olivetti, and Jennifer Tobias.

The study of artworks in conservation labs, storage, and study rooms and the expertise of conservators, curators, and registrars have been fundamental to this project. In Brazil, I thank profoundly Ana Gonçalves Magalhães and Fernando Piola, MAC USP; Angélica Pimenta and Luis Guilherme Vergara, Museu de Arte Contemporânea de Niterói; Luiz Camillo Osorio, Frederico Coelho, Veronica Cavalcante, and Marcela Motta, MAM

Rio; Regina Teixeira de Barros, Pinacoteca do Estado de São Paulo. I returned repeatedly to several US collections, occasionally with graduate students, and owe gratitude to: Katherine Alcauskas, Karl Buchberg, Kathy Curry, Lee Ann Daffner, Paul Galloway, Scott Gerson, Krista Lough, Sarah Meister, David Moreno, Emily Talbot, and, especially, Erika Mosier at MoMA; Mari Carmen Ramírez, Michael Wellen, Rachel Mohl, Arden Decker, and Del Zogg at MFAH; and Gabriel Pérez-Barreiro, Ileen Kohn, Skye Monson, and John Robinette at the Colección Patricia Phelps de Cisneros. The Cordeiro, Oiticica, and Pape families afforded me precious access to works in their collections over extended periods. The Barros family and Pascale Pahud made possible my study of Barros's photographs at the Musée de L'Elysée. During the Cordeiro and Pape exhibitions at Paço Imperial and the Metropolitan Museum of Art, Lucia de Oliveira, at the former, and Iria Candela, Allison Barone, Marina Ruiz Molina, and Michele Wijegoonaratna, at the latter, allowed my examination of works on non-public days with the kind permission of the artists' families and the assistance, in the latter case, of António Leal. I also thank the following collectors, collection managers, and gallerists: Ricardo and Susana Steinbruch: Vivian Bernfeld; Fernanda Feitosa and Heitor Martins: Ana Barros; Andrea and José Olympio Pereira: Sophia Whately; Fabio Faisal and Tera Queiroz; Luciana Brito; Galerie Lelong: Dede Young, Liz Bower; Cristin Tierney.

I had the enormous good fortune as an undergraduate of studying Portuguese and Brazilian Studies with Marguerite Itamar Harrison, Luiz Valente, and Nelson Vieira at Brown University. Edward Sullivan, at the Institute of Fine Arts, NYU, guided my graduate study with exceptional generosity. Edward, Robert Storr, Jonathan Brown, Robert Lubar, and Linda Nochlin modeled not only art historical inquiry and the craft of writing, but also character and collegiality. Andrea Giunta, as a visiting scholar at the IFA, and Thomas Crow, near the end of my graduate study, helped me shape the questions I pose of institutions. Working in the Department of Painting and Sculpture at MoMA afforded me an apprenticeship with Anne Umland in object and archival research that importantly shaped this project. Since my first dissertation research trips to Brazil, I have benefited greatly from the guidance of Aracy Amaral, Ana Maria Belluzzo, Tadeu Chiarelli, Paulo Herkenhoff, Luiz Camillo Osorio, and during a postdoctoral fellowship supported by CAPES and Fulbright at the Universidade Federal do Rio de Janeiro, the advisement of Glória Ferreira and Paulo Venancio Filho. In New York, before and during graduate school, I was transformed intellectually and personally by a supportive, dynamic world of professionals dedicated to the art of Latin America. These debts run too deep to enumerate, but I cannot fail to mention Isabella Hutchinson, Anna Indych-López, and Lynda Klich.

At the University of Texas, I have the privilege of participating in the rich scholarly communities of the Department of Art and Art History, Center for Latin American Visual Studies (CLAVIS), Lozano Long Institute of Latin American Studies, Blanton Museum of Art, and Visual Arts Center, and thank particularly Florencia Bazzano, Holly Borham, Eddie Chambers, Vanessa Davidson, George Flaherty, Seth Garfield, Rosario Granados, Julia Guernsey, Linda Henderson, Fernando Lara, Janice Leoshko, Lorraine Leu, Stephennie Mulder, Samantha Pinto, Ann Reynolds, Sonia Roncador, Jeff Chipps Smith, and MacKenzie Stevens. At Temple University, I thank my former colleagues and friends Rob Blackson, Betsy Bolman, Tracy Cooper, Philip Glahn, Therese Dolan, Marcia Hall, Pepón Osorio, Jerry Silk, Hester Stinnett, and Ashley West.

The development of this project has benefited from opportunities to present parts of it publicly, and I especially thank those who provided early publication and speaking opportunities, namely Alexander Alberro, Karen Benezra, Janis Bergman-Carton, Gwen Farrelly, Ariel Jiménez, Jay Levenson, Mary Kate O'Hare, Gabriel Pérez-Barreiro, Luis Pérez-Oramas, Katy Siegel, Sven Spieker, and Lynn Zelevansky. A working group of interdisciplinary thinkers, meeting biannually since 2013, sustained me and expanded my thinking as I wrote this book: Natalia Brizuela, Mary Coffey, Sergio Delgado Moya, Claire Fox, Esther Gabara, Adriana Michele Campos Johnson, China Medel, Fernando Rosenberg, Roberto Tejada, Camilo Trumper, and Alejandra Uslenghi. Beyond those named above, this book has been enriched by conversations with scholars and artists in and out of Brazil, including Francisco Alambert, Mónica Amor, Adrian Anagnost, Ana Cândida de Avelar, João Bandeira, Karen Bearor, Dorota Biczel, Kaira Cabañas, Claudia Calirman, Roberto Conduru, Vivian Crockett, Heloisa Espada, Briony Fer, María Amalia García, Aleca Le Blanc, Abigail Lapin Dardashti, Jac Leirner, Anneka Lenssen, Ethel Leon, Ana Gonçalves Magalhães, Cara Manes, Camila Maroja, Sérgio Martins, Rosana Paulino, Bruno Pinheiro, Rachel Price, Mari Carmen Ramírez, Irene Small, Gillian Sneed, Megan Sullivan, Regina Teixeira de Barros, Elena Shtromberg, Lilian Tone, Elizabeth Catoia Varela, Barbara Weinstein, and Edith Wolfe. I also give my heartfelt thanks to Beverly Adams, Anna Arabindan-Kesson, Rhys Conlon, Aglaíze Damasceno, Jennifer Josten, and Paulina Pobocha for their friendship and intellectual dialogue.

Periods of research and writing were supported by a Fulbright US Scholar Postdoctoral Research Award in Humanities and Social Sciences, Brazil, an NEH Summer Stipend, and fellowships and awards from the Rockefeller Archive Center, the Institute of Fine Arts, Temple University, and the University of Texas at Austin. (Any views, findings, conclusions, or recommendations expressed in this publication do not necessarily reflect

those of the National Endowment for the Humanities.) Image reproductions and permissions were supported by a subvention grant from the President's Office of the University of Texas at Austin, as well as a Sherry Smith Endowment Grant and Jeanette and Ferris Nassour Faculty Fellowship in Art History at the University of Texas. My chair, Susan Rather, and Dean Doug Dempster supported a course reduction at a critical juncture.

At the University of California Press, I thank Archna Patel, for her excellent stewardship, and Nadine Little, for her early interest in my project. I am very grateful to Alexander Alberro for his inclusion of my book in the Studies on Latin American Art series, and his incisive, generous guidance early in my career. I also warmly thank Catherine Osborne and Do Mi Stauber for their detailed copyediting and index work, and Lia Tjandra, Jessica Moll, Angela Chen, and Teresa Iafolla for the expert design, production, and marketing of the book.

I am greatly indebted to the richly productive critical insights of Mary Coffey and Mari Carmen Ramírez at the early peer review stage, and to Vera Beatriz Siqueira and an anonymous reader of the full manuscript. I thank Libby Hruska for her excellent, sensitive feedback on drafts of this manuscript, and Regina Teixeira de Barros for her precise and superb insights on complex translations from the Portuguese. For research assistance at various stages of the book project, I thank Maeve Coudrelle, Julia Detchon, María Emilia Fernández, Sasha Goldman, Tie Jojima, Rachel Remick, Jennifer Sales, William Schwaller, Lilia Taboada, Talita Trizoli, and especially Martha Scott Burton for her stellar shepherding of the image and permission process and assistance as I prepared the final manuscript. Anna Katherine Brodbeck, Aliza Edelman, Geaninne Gutiérrez-Guimarães, and Katia Mindlin Leite Barbosa made generous introductions and, in several cases, crucial facilitation of image permissions. Sarah Meister, Dana Ostrander, Jon Evans, and Liz Donato offered above-and-beyond help with elusive images. At the University of Texas, I also warmly thank José Barroso, Michelle Harper, and Jill Velez for their administrative assistance.

To the community who have helped Scott and me care for our children, especially the exceptional staff at the UT Child Development Center, Sophia Gibson, Jen Danforth, Katherine Brookman, and Dakota Walker, as well as my in-laws, mom and dad, sisters, and nieces, our profound thanks—my work would not have been possible without you. The book's completion occurred during the COVID-19 crisis. I cannot begin to express my gratitude to many noted above who so generously gave their time and expertise—from research and image permission requests to critical and editorial feedback—particularly those in New York at the start of the pandemic and in Brazil as it unfolded.

My father lived in São Paulo for a year and half when he was in his twenties, working for an accounting firm. It was the albums of Brazilian music he kept; the warm glow of his memories of time as a young person far from small-town Texas; and above all my enormous affection for him that propelled me to first study Portuguese and study abroad in Rio as an undergraduate. My mom, an artist by training, took my sisters and me regularly to the art museums in our hometown, and encouraged a love of art and travel. My aunt, for whom I am named, would burst into song at mention of my work: "Brazil, where hearts were entertaining June." My husband Scott has supported me with a patience and love I can never repay, particularly as we welcomed to the world the wonderful Arthur and Evelyn. He was a fellow traveler on the long life of this project, helping me understand the architectural spaces I analyze and putting his career on hold and caring for our children. My deepest thanks, and my heart, to my dear friends Aubrey, Jenny, Eric, and Claudia, and to Scott, Arthur, Evelyn, and the Campbell, Diaz Mathé, Ellis, Gibson, Hart, Lipscomb, and Nelson families, especially my beloved father and aunt, with whom I wish I could share this book.

Introduction

The spectacle of Getúlio Vargas, former dictator turned democratically elected president, presiding over the awards ceremony at the second Bienal de São Paulo (São Paulo Bienal) in December 1953 illustrates the vertiginous shifts in the relationship between modern art and the state over the course of the mid-twentieth century in Brazil (fig. 1). During his fifteen-year rule from 1930 to 1945, inclusive of the quasi-fascist Estado Novo (New State) dictatorship from 1937 to 1945, Vargas vastly expanded the federal government's role in culture: creating the Ministério da Educação e Saúde (Ministry of Education and Health, MES) and giving particular attention to preservation of the nation's colonial patrimony, on one hand, and promoting Brazilian modern architecture, on the other. Living modern artists, with the notable exception of social realist Cândido Portinari, received limited state patronage. Following World War II, including a second, democratic Vargas administration from 1951 to 1954, the federal government dedicated substantial resources to modern art, notably at the São Paulo Bienal, Brazil's most ambitious bid for relevance in the

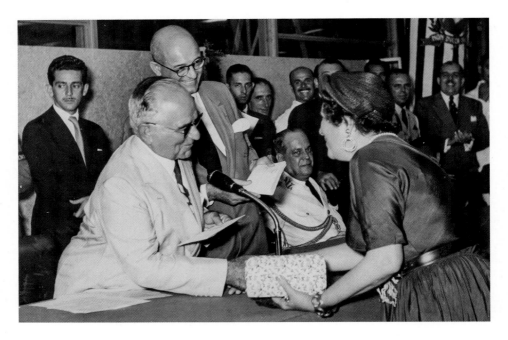

FIGURE 1. Getúlio Vargas giving an award to Maria Martins at the second São Paulo Bienal. 1953. Francisco Matarazzo Sobrinho is behind Vargas. Fundação Bienal de São Paulo/Arquivo Histórico Wanda Svevo.

international cultural arena. The federal government endorsed the Bienal's stated project of enrichment and internationalization of the local artistic scene, including the adoption of nonobjective abstraction by Brazilian artists. From the inception of the Bienal, Vargas supported the event: he paved the path for foreign cooperation via letters to Brazilian ambassadors abroad, served as the honorary president of the event, and dispatched both his wife and the minister of education and culture to the inauguration of the first Bienal in 1951. The pro-Vargas newspaper *Última Hora* declared the exhibition "America's greatest artistic event."[1]

The stagecraft of the reinvention of the former autocrat as benevolent avant-garde art patron was most pointed at the second Bienal. There Vargas was in the presence of not only a world-famous symbol of resistance to totalitarianism, Pablo Picasso's *Guernica* (1937), on display at the event, and multinational presentations of abstract art that would have been marginalized under his prior administration, but also individuals he had once censored and sometimes jailed. To cite the most striking example, critic and political

activist Mário Pedrosa, who had endured years of persecution, periodic imprisonment, and eventual self-exile from Brazil during the Estado Novo, was among the organizers. Also present to receive an award, and embodying the rewriting of a formerly repressive regime as a culturally progressive one, was artist Maria Martins. She served as an unofficial emissary for the Bienal and was wife of Brazilian ambassador Carlos Martins, who had been the representative of the Estado Novo regime in the United States.

This book attempts to reconstruct the complex climate in which abstraction emerged in postwar Brazil in the cities of Rio de Janeiro and São Paulo. I argue that abstract art developed out of a dynamic interplay of local and international conditions, forms, and discourses in an artistic milieu that was defined, on one hand, by elite deployment of soft power to establish a host of new modern art entities and, on the other, reciprocal and at times contested relationships between artists and the new art institutions. The role of Latin American abstraction in the art and politics of the Cold War is often misunderstood as a depoliticized formal enterprise or as a neocolonial product. The case of Brazil reveals the inadequacy of shopworn narratives that rely on binaries of national and international, political and apolitical, left and right. In the chapters that follow, I analyze the interaction between emerging nonobjective abstract artists, the Concrete-oriented abstract artistic groups Grupo Ruptura (Rupture Group) and Grupo Frente (Front Group), new modern art institutions, and a vibrant art press, and I ask what politics informed the reception of abstract art and whose interests were served by these artists' proposals and production.[2] The answers to these inquiries changed substantially from the late 1930s to the mid-1950s as modern art institutions, initially envisioned as antiauthoritarian beacons by opposition intellectuals in a dictatorial context, ultimately functioned as private, decidedly elite entities backed by substantial public monies.

During the autocratic and democratic stages of the Vargas era from 1930 to 1954, the ideals of electoral democracy—equal rights and representative governance—were codified, albeit incompletely. Brodwyn Fischer and James Holston examine what Holston calls the "disjunction" between idealized political citizenship and inequitable, unjust, and violent civil citizenship.[3] Fischer notes the universality of the democracy inscribed into mid-century Brazilian law (with the notable exception of disenfranchisement of illiterates, but without race-based discrimination and with reforms to gender discrimination, including women's suffrage in 1932), writing that "legal inequality thus has to be sought not in the letter of Brazil's laws but instead in the assumptions that underlay them, and in the processes that enforced them."[4] Holston describes Brazilian citizenship as emphasizing social differences and legitimating inequalities, and sees the marking for exclusion of

illiterates, who represented half of the populace at mid-century, as exemplary.[5] (The literacy requirement was not eliminated until 1985.)

Barbara Weinstein examines how the consolidation of the myth of Brazil as a racial democracy, purportedly without racial prejudice, at mid-century coexisted with earlier racist theories of progress through whitening and the assertion of the economic and cultural exceptionalism of São Paulo to allow the expression of an association between whiteness and civilization through regional terms.[6] She argues that "racialized images of modernity and progress have deeply informed discriminatory policies and practices."[7] Denise Ferreira da Silva theorizes the extricable linkage of race and gender in the Brazilian national subject bracketed by "the whitening thesis" and racial democracy, noting that both narratives are dependent on miscegenation and "the appropriation of the non-European (colonized or enslaved) female subject" by the European.[8]

This book contributes to the disentanglement of the ideals and realities of democracy and scrutinizes the representation of Brazilian citizenship. Its protagonists—art patrons, artists, and writers—were, with few exceptions, the privileged, educated and largely white although from a range of class, ethnic, and regional identities, and were not subjected to disenfranchisement or violence by the state. They were, however, subjects and agents of reimaginings of the individual and society following World War II as Brazil experienced a return to democracy and an expansion of the urban middle class. As the following chapters reveal, abstract artists, in collaboration and conflict with the new art entities, consolidated group artistic identities. The figure of the abstract artist was celebrated by all but the orthodox left and right as nonconformists who modeled engaged civil participation. Emergent white-collar middle-class men like Geraldo de Barros and affluent women like Lygia Clark were touted as public thinkers, though not without tensions. Critics, for example, struggled with how to assimilate femininity and motherhood with Clark's identity as an artist, and sexist depictions of women as vapid consumers of art proliferated. Nontraditional and self-taught artists, some Afro-descendent, were also elevated—demonstrations, in the artistic realm, of the social and intellectual inclusion Pedrosa advocated, in which creativity was a larger inheritance shared by all and, in the political realm, of racial democracy. But the production of nonprofessional artists was also cordoned off and seen as a subsidiary to abstraction, and deployed to paper over racial inequalities. Abstract artists ultimately became skeptical of their celebration and sought to differentiate their project from state developmentalism.

A photograph of a storefront display from 1955, showing mannequins and works of art displayed on easels, captures the newfound embrace of abstract art in Brazil (fig. 2).[9] The

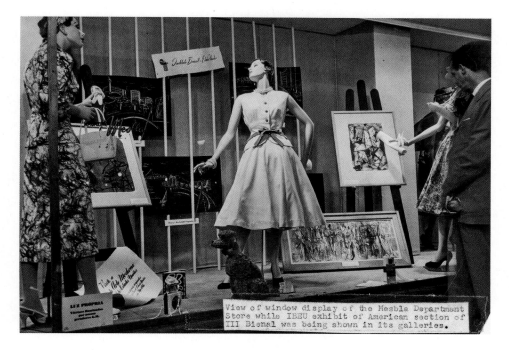

Within the image: View of window display of the Mesbla Department Store while IBEU exhibit of American section of III Bienal was being shown in its galleries.

FIGURE 2. Display at the department store Mesbla promoting an exhibition of US art, Rio de Janeiro, 1955. International Council and International Program Records, I.B.124. The Museum of Modern Art Archives, New York. Digital Image © The Museum of Modern Art/Licensed by SCALA/Art Resource, NY.

display advertised a traveling exhibition of art from the United States, previously shown at the third Bienal. Organized by the Instituto Brasil-Estados Unidos (Brazil–United States Institute), the exhibition was held at the high-end department store Mesbla, located in an Art Deco building in downtown Rio, then the nation's capital. What at first seems like a straightforward scene is in fact layered with classed, gendered, and racialized discourses that organized the reception of abstract art in Brazil. The connection between wealth, whiteness, and the consumption of abstract art is made clear: smartly dressed white female mannequins, donning pearls and gloves, pose as both art admirers and as objects of admiration themselves. A fair-skinned male viewer, in suit and tie, cropped and in shadow at the right edge, takes in the scene, perhaps contemplating the artworks, perhaps assessing the clothing, perfume, and jewelry for sale, perhaps consuming the elegant stand-ins for women. The abstract paintings and prints are presented not as controversial works of art, but as the height of good taste.

Such a banal presentation of abstraction in the mid-1950s followed a decade of intense institutional and artistic change defined by the interaction between emergent abstract artists, critics, and newly formed modern art entities, and by robust transnational and interdisciplinary dialogues. The confluence of art, shopping, and tourism, set in the context of cultural diplomacy in the Mesbla display, also makes tangible the sometimes hard-to-see entanglements of art exhibitions, what historian Tony Bennett termed the exhibitionary complex.[10] This describes how the museum constitutes part of a network of diverse enterprises, the department store among them, by which objects are organized for public reception and, in turn, by which the public becomes "both the subjects and the objects of knowledge."[11] Like Bennett, Donald Preziosi views museums from the late-eighteenth to the mid-nineteenth century in Western Europe (and subsequently in the United States) not only as sites of the development and transmission of new disciplines and discursive formations—art history and aesthetics among them—but also as privileged instruments for transformed conceptions of citizenship and the spread of Eurocentrism.[12]

Absent from these accounts, however, are the art institutions of postcolonial nations, whose claim on Western history is subject to contestation as "underdeveloped" states targeted for interference from hegemonic countries.[13] Yet the immediate post–World War II period in Brazil offers a singular case in which new art institutions—and their exhibition of abstract art in particular—served as loci for the articulation of individual and societal identities in a newly democratic nation at the initiation of the Cold War. Following World War II, industrialists and media magnates established a triad of modern art museums in the Southeastern cities of Rio and São Paulo, the country's dominant political and economic centers: the Museu de Arte de São Paulo (São Paulo Museum of Art, or MASP; now Museu de Arte de São Paulo Assis Chateaubriand); Museu de Arte Moderna do Rio de Janeiro (Museum of Modern Art of Rio de Janeiro, MAM Rio); and Museu de Arte Moderna de São Paulo (Museum of Modern Art of São Paulo, MAM-SP). These business leaders sought to transform their cities into international artistic centers, most visibly via the São Paulo Bienal (1951–present), the third exhibition of its type established worldwide and arguably the most important artistic entity in Latin America.[14] The institutions undertook their projects to revamp the domestic art scene in concert with the professionalization and expansion of art criticism: columns focusing on the visual arts proliferated in mainstream, wide-circulation newspapers and magazines, and new art, architecture, and design magazines and professional associations were established. The creation of these journalistic and exhibitionary enterprises was facilitated by the expanded wealth of

the Southeast, including a postwar building boom in São Paulo and the continued consolidation of the federal administration of cultural policy in Rio initiated at mid-century by Vargas.

A central premise of this book is that Brazilian modern art institutions were not transplanted copies of Euro-American art institutions. Rather, these multiauthored adaptations were advanced by artists, intellectuals, and elites of a country that had long been marginalized who decided to promote new narratives for their postcolonial nation. Brazilian actors strategically adapted the structures and approaches of the Museum of Modern Art (MoMA) in New York, the Venice Biennale, the Bauhaus, and other less-recognized interlocutors to create institutions that were both derivative and original. Cultural theorist Silviano Santiago has called for a reclaiming of "the possible originality of a derivative product," a perspective that invites the discernment of subversive or decolonizing acts among colonized and colonizing ones.[15] Such an approach has the merit of not wishing away the dependent condition of Brazil, a country whose aspirations for global economic and political power—encapsulated in the phrase "the land of the future" in 1941 by Austrian émigré Stefan Zweig—have often been thwarted or deferred.[16] It also focuses attention on the inextricable nature of colonial and neocolonial relationships: in the case of the entities examined here, between Brazil and the United States and Europe, and between the country's privileged and marginalized groups. Indeed, we cannot understand the art history promulgated by Euro-American hegemonic centers without contending with the elaborate exchange between Europe, the United States, and Latin America, where abstraction, modernism, and museums played a central role in questions of the social function of art.

In their respective studies of Pan-Americanism and regional identity in São Paulo, Claire Fox and Barbara Weinstein emphasize the complexity of the construction and expression of discursive positions.[17] Divergent objectives oriented the leadership within the postwar Brazilian art institutions—from the patrons, both private and governmental, and the art professionals who conceptualized and realized the undertakings, to the artists who served as advisors, laborers, subjects, and polemicists. The entities analyzed in this book, the Bienal in particular, are too often treated in a one-dimensional manner, as heroes or villains, pillars of Brazilian vanguardism or neo-imperialist shills. The classifications of art—whether stylistically as abstract or figurative; geographically as of Brazil, Latin America, Euro-America, or the world; or as created by professional and nonprofessional artists—proffered to viewers of exhibitions at the new museums and Bienal did not derive from univocal, one-directional, consistent positions on the part of the organizers.

This book similarly argues for the dynamic interplay of local traditions and circumstances with international modernist forms and discourses in postwar artistic production and theory. Beginning in the late 1940s, artists in Rio and São Paulo adopted nonobjective abstract practices that they came to define as Concrete art. The term was initially coined and promoted by European artists Theo van Doesburg and Max Bill to define art devoid of any reference to the natural world, composed of geometric forms, and focused on mathematical relationships and rhythms. In the early 1950s, Brazilian artists founded Grupo Ruptura and Grupo Frente, mounted group exhibitions, and issued programmatic texts. I highlight how these artists' individual and collective production extended across the fields of painting, sculpture, printmaking, design, art criticism, exhibition practice, and pedagogy, and cast new light on both their aesthetic and social proposals, including extended study of the art theories of Pedrosa and Waldemar Cordeiro. Like other art historians, I resist the facile centering of Bill as the progenitor of Brazilian Concretism and the persistent characterization of *carioca* and *paulista* artistic sensibilities as opposites. Kaira Cabañas, Luiz Camillo Osorio, and Mari Carmen Ramírez have demonstrated the pivotal role played by the art of psychiatric patients, Alexander Calder, and color study, respectively, mapping new relationships between artists and thinkers of Rio and São Paulo.[18] María Amalia García has provided fine-grained analysis of the inter-American networks by which Bill was known to Brazilian artists.[19] Building on this scholarship, I bring to light new dialogues and divergences among the artists and groups. Among these are the centrality of the notion of *forma* (form) and intermedial experimentation to emergent nonobjective abstraction in both cities, and how study of figures like Paul Klee and Sophie Taeuber-Arp in addition to the valorization of the art of nonartists distinguished Brazilian Concretism from its expressions elsewhere. I highlight the shared concern with social responsibility among artists and thinkers and the roles of gender, class, and race in the presentation and reception of abstraction, and establish how the museums' new art schools significantly shaped the understanding of artists as citizens and producers.

The São Paulo Bienal is understood as the first of a so-called second wave of biennials staged in the global south.[20] The sustained success of a biennial in a developing nation in attracting foreign participation contributed to the creation of other events, but the narrative of São Paulo as the earliest global biennial glosses over fundamental differences between the postwar event and those that would follow in subsequent decades. My analysis grapples with how to understand the trumpeting of Euro-American history with the assertion that space be made for Brazilian art in the canon. I argue that the challenges to

Eurocentricism undertaken by Brazilian producers and agents must be understood through in-depth consideration of the theories and debates of the time.[21]

Prior to the groundswell of literature on biennials and international attention to Brazilian art over the last several decades, it was Brazilian thinkers who turned scholarly attention to the São Paulo Bienal, the country's modern art museums, and the postwar history of art in Brazil. The question "why abstraction?"—and its expanded form: "what caused the shift from the dominance of social realism before World War II to the ascendancy of geometric abstraction thereafter?"—motivated this foundational art historical scholarship in the 1970s.[22] At its root, the pursuit of a cause for the emergence of nonobjective abstraction seeks to defend against claims that Brazilian and Latin American postwar abstraction was a latter-day, derivative replaying of the innovations of the European historical avant-garde of the teens and twenties. Alfred H. Barr, Jr., founding director of MoMA, infamously implied as much in his dismissal of works by Brazilian artists in 1957 as "Bauhaus exercises."[23] Building on recent scholarship by Brazilian art specialists in and outside Brazil, my study rejects the conception of Brazilian abstraction as derivative. However, it extends that assertion beyond celebrated works of the late 1950s and 1960s by well-known artists such as Clark, Hélio Oiticica, and Lygia Pape to include the early activities of Barros, Aluísio Carvão, Cordeiro, Abraham Palatnik, Luiz Sacilotto, and Ivan Serpa, among others. My approach to the artists' production also sets it against the backdrop of the complex Brazilian artistic and cultural milieu of the period, accounting for the multiple actors and their specific agendas. A larger aim of this book is to provide a corrective to the prevailing understanding of the immediate postwar period as being a mere incubator for Neoconcretism—the movement, founded in 1959, that has received more attention than any other of Brazil's contributions to contemporary art.

The book begins in the late 1930s, when a modern art museum was first proposed as a democratic ideal in then-autocratic Brazil, and zeroes in on the mid-1940s as the idea of the museum was debated by art critics, patrons, and public officials in the midst of redemocratization. It concludes in 1956–57, with the Exposição nacional de arte concreta (National Exhibition of Concrete Art), a culminating event in the history of Brazilian Concretism realized as the country was constructing a new federal capital in its geographic center from scratch. The narrative arc of the book is threefold: it traces the founding of modern art museums, art schools, and the São Paulo Bienal beginning in the late 1940s; explores the emergence of abstract art and theory in concert with the exhibition strategies of the artistic groups; and examines the aims, effects, and reception of the early Bienal and the new museums and art schools. In order to do this I have synthesized

archival research from Brazilian, European, and US repositories—published and unpublished writings and correspondence of artists and critics of the time, and architectural, photographic, and textual documentation of exhibition planning and installation design—with close consideration of the materials and techniques of works of art. The book charts the art and institutions of postwar Brazil in order to revise our understanding of the role of abstraction not only in the politics of Brazil's return to democracy, but also in the larger Cold War.

The first chapter looks at the strategic decision by the leadership of MAM-SP, soon after the museum's opening in 1949, to abandon the model of a traditional museum for that of a biennial in order to successfully realize international exhibitions. I also argue that the contentious art-critical discussion of abstraction in the late 1940s, centered on MAM-SP and its inaugural exhibition of abstract art, must be understood in light of both local and international conditions. In the former case, art professionals who were aligned with the museum felt an urgency to support artistic expression following the censorship and lack of support for modern art during the Estado Novo dictatorship. In the latter case, art institutions in New York and Paris that influenced the museum's founders, namely MoMA and the Museum of Non-Objective Painting (now the Solomon R. Guggenheim Museum) in New York, and the Salon des réalités nouvelles (Salon of New Realities) in Paris, promoted a history of avant-garde art predicated on abstraction and excluding social realism.

Notions of *forma* (form) crucially oriented early theorizations of nonobjective abstraction as well as underpinned the first definitions of Concretism by Brazilian artists. In the second chapter I consider the complexity, and unanticipated sources, of early Brazilian Concrete art. Pedrosa's theories of visual perception and modernism loomed large, as did Cordeiro's art criticism. In the first solo exhibitions of nonobjective abstract works in the country, Barros, Almir Mavignier, and Serpa included the word *forma* in their titles, utilizing the multivalent term to highlight the perceptual work underway in the production and reception of their works in language keyed to both local and international audiences. A focus on Barros's production, and his generative dialogue with both Pedrosa and Cordeiro, reveals how *forma* also signaled a bridging across and merging of media.

The scholarly consensus is that at the first Bienal, in 1951, we see the mechanics of how emerging Brazilian abstraction came to embody an internationalist vision for new art. But robbing the spotlight from the national figuration of prior decades and focusing on the Bienal as a catalyst for the postwar abstract turn in the country, while it makes for

good dramatic framing, is a simplification. As the third chapter establishes, the leaders and cultural brokers of the first Bienal had a multitude of often conflicting agendas and several distinct historical narratives were displayed at the event. Concurrent artistic and critical debates, including a war of words between leaders of MAM-SP and MASP about which entity "authentically" represented Brazil and the creation of new art schools at both museums, belie the notion that the new modern art institutions abandoned constructions of national culture. By examining anew the objectives, installation, and reception of the first Bienal, as well as displayed works—facilitated by previously unstudied color photography and film footage—this chapter reveals the nonmimetic ways in which the region, nation, and world functioned as complementary rather than oppositional terms, complicating the interpretation of early Brazilian abstract and Concrete art as negating the national in favor of the international and universal.

Grupo Ruptura's exhibition in São Paulo in 1952 and the Exposição nacional de arte abstrata (National Exhibition of Abstract Art) in Petrópolis, outside of Rio, in 1953 offered the first group exhibitions of Concrete-oriented abstraction in the country. With a close look at these presentations and auxiliary events, the fourth chapter offers a revised reading of the intellectual and political nexus of ideas defining Brazilian Concretism and considers the production of an array of artists, including Carvão, Clark, Cordeiro, Samson Flexor, Maurício Nogueira Lima, Palatnik, Pape, Sacilotto, and Anatol Wladyslaw. It argues that the stakes of the inaugural exhibitions included the consolidation of collective artistic identities enmeshed with leftist political commitments and institutional critique. Cordeiro's theorization of the collective life of the artist framed art critical and artistic discourse and informed the institutional gambits deployed by artistic groups. Scrutiny of the press coverage of the exhibitions and of Clark's self-fashioning offers insights into the gendered ways in which the producers and consumers of abstract art were imagined in relationship to the public sphere.

The fifth chapter views the second Bienal (1953–54) as a key incubator and model for the redefinition of modernism that abstract artists and aligned critics in Brazil were undertaking. This second iteration—the most ambitious and historically significant of the early Bienals—was a veritable temporary museum of modern art where the displays of historical modernism rivaled and in many cases surpassed those at the postwar Venice Biennale. Pedrosa, who directed the European contributions, significantly shaped the story of art that was told, enacting key parts of his theory of modernism on the walls in São Paulo. Through its installation design and displays of recent geometric abstract art by artists of the Americas, the second Bienal also visualized a Pan-Americanism that

positioned Brazil as a hemispheric leader alongside the United States. The articulation of international identities in the exhibition both dovetailed and conflicted with the expression of national stories. Exploration of organizational priorities, the design and installation of the galleries, and reception of the second Bienal reveals the multiauthored narratives crafted by the organizers of the Bienal in Oscar Niemeyer's open-plan buildings and, importantly, the geographic and racial erasures that underpinned that cohesion.

The Rio-based Grupo Frente, which exhibited predominantly abstract art from 1954 to 1956, positioned the artist as model citizen. The sixth chapter looks at the group's influence in the social debates and electoral mobilization of the turbulent period of the mid-1950s, which saw the suicide of one president (Vargas) and the election of another (Juscelino Kubitschek) challenged by coup attempts. The group consolidated Pedrosa's and Serpa's challenges to a style-based definition of art, and Pedrosa explicitly situated Grupo Frente's resistance to a uniform stylistic identity as a challenge to what he saw as the conformist character of Brazilian political participation. Grupo Frente envisioned the artist as ethical, nonideological citizen, beliefs that were articulated most effectively around, on one hand, Serpa and his students at MAM Rio, Oiticica among them; and, on the other, the three female members of the group, Clark, Elisa Martins da Silveira, and Pape. Although the majority of its artists practiced Concretism, the production of the participating artists was heterogeneous. The identification of Martins, one of the group's figurative artists, as "primitive" functioned as a racialized description applied to Afro-descendant and white artists who portrayed Afro-Brazilian and popular culture. This chapter reveals how Grupo Frente's rhetoric of inclusivity integrated vernacular culture into modern art circles, but in a subsidiary role to abstraction.

I conclude by examining the Exposição nacional de arte concreta, held in São Paulo in 1956 and Rio in 1957, long recognized as a moment of unity among Brazil's Concrete artists and poets that soon fractured into discord along geographic lines. Separate from the consequences this future rupture would have, the exhibition is significant in its own right. Through a focused analysis of the well-documented installation in São Paulo, its accompanying texts, and contemporaneous, parallel debates about pedagogy and architecture, I argue that the stakes of the display and its reception were not limited to aesthetic and theoretical disagreements about Concretism. The artist- and poet-organizers elected to exclude applied design from the exhibition and instead highlighted the relationship between visual art and poetry, insisting on the sensitive and sensorial components of perception and the arts.

Turnabout Is Fair Play

Institutional Gambits at the Museum of Modern Art and Bienal in São Paulo

The ground shifted for artistic practice in Brazil following 1945, the year that brought both the end of World War II, in which Brazil fought on the side of the Allies, and the coup d'état that reestablished democracy and deposed Getúlio Vargas. Between 1947 and 1952, a host of private institutions for the collection, exhibition, and teaching of modern art were founded. These included an encyclopedic museum with in-depth attention to modern art, design, and architecture in São Paulo, the Museu de Arte de São Paulo (MASP); museums of modern art and art and design schools in Rio and São Paulo, the Museu de Arte Moderna do Rio de Janeiro (MAM Rio) and Museu de Arte Moderna de São Paulo (MAM-SP); the art schools at MAM Rio and MAM-SP; and the Instituto de Arte Contemporânea (Institute of Contemporary Art, IAC) at MASP. It also included the São Paulo Bienal. The institutions, seemingly straightforward replications by tropical newcomers of names, administrative structures, exhibition programs, and curricula of known quantities, contain a more complex tale. The Brazilian institutions are exemplary of how elites

15

in a postcolonial nation responded to the risks of being pawns of cultural diplomacy and soft power during the Cold War by harnessing that power themselves and strategically adapting the structures and approaches of US and European entities.

In this chapter, I examine the institutional strategies of the museum of modern art in São Paulo and its creation of the São Paulo Bienal, for the first time drawing together analysis of archival materials in Brazilian, European, and U.S. repositories.[1] In the catalogue of the first São Paulo Bienal, in 1951, artistic director Lourival Gomes Machado wrote, "In this introduction it is better to leave aside the history and merely underscore that the greater objectives of the museum, at this moment of its existence, demand the establishment of the I Bienal de São Paulo."[2] "The museum" was the newly established MAM-SP, which had opened its doors just two and a half years before. The question is, why was the Bienal necessary? Why did MAM-SP's leaders decide to change course and effectively turn the institution into a staging ground for the organization of this new showcase for art? The overhaul of MAM-SP was not the mere caprice of its founder and president, Francisco "Ciccillo" Matarazzo Sobrinho, as is often suggested in primary and secondary accounts.[3] Nor, as art historian Caroline Jones indicates, can MAM-SP and the Bienal be spoken about as a single entity, a hybrid of the Museum of Modern Art, New York (MoMA) and the Venice Biennale.[4] The leaders of the museum reevaluated political situations at home and abroad and adopted a different tactic. Rather than leave the history aside, as Machado suggested, it is imperative to trace the conversations, debates, and events that led to the radical decision to trade the model of a museum, constituted by a permanent collection, for that of a biennial, dedicated to temporary displays.

DEBATING A MUSEUM OF MODERN ART, IN AND OUT OF DICTATORSHIP

The debates regarding the creation of a museum of modern art for São Paulo took place over a decade of tremendous political change in Brazil, and the meaning of the museum changed from its first mention in 1938 to its inauguration in 1949. Conceived as a democratic, anti-authoritarian beacon by opposition intellectuals in a dictatorial context, the entity ultimately founded was a private, decidedly elite museum. Housed initially in corporate headquarters, it garnered early and significant support from the Brazilian government at all levels, including the federal government under Vargas, as well as from US and European institutions and individuals. In the late 1930s and early 1940s, São Paulo art critics—notably Sérgio Milliet and Luís Martins, both of whom opposed the Estado Novo dictatorship—published the first articles about the need for a museum to support modern

art. Sustained public and private debates about the museum and its structure continued as the dictatorship ended and during the early years of the return to democracy, a transition that extended over several years after the military removed Vargas from office in May 1945 (direct elections at the municipal levels were not phased in until 1953). Unsurprisingly, given the genesis of the idea of the museum as a bulwark against authoritarianism, the issue of the state's role in the proposed institution and the place of modern art in democratic society more broadly was discussed extensively.

During the course of Vargas's fifteen-year rule, modern art received state patronage most visibly in the form of the artworks commissioned for new building projects, such as Cândido Portinari's interior and exterior murals for the Palácio Gustavo Capanema in Rio.[5] Portinari—as a result of his success abroad, including his painting *Café* (Coffee) winning an honorable mention at the Carnegie International in 1935, and his embrace by government circles—became the paradigmatic artist of the 1930s and early 1940s, and his monumental portrayals of workers stood in for modern art for the Brazilian public during the Estado Novo dictatorship (fig. 3). However, Portinari's heroic figuration, which drew on Mexican Muralism and Pablo Picasso's classicizing paintings of the 1920s, did not represent the full range of Brazilian art in the first half of the twentieth century, which was characterized by a heterogeneous mixture of European avant-garde styles and cross-pollination between the arts. Art critics writing during and immediately following the dictatorship conveyed frustration at the continued neglect of modern artists other than Portinari and demanded support come from some quarter.

A privately organized exhibition in São Paulo in 1939, the III Salão de maio (III May Salon), sought to challenge the stultification of modern art and free expression under Vargas and shine a light on the regime's repressive tactics toward workers and political dissidents by employing stylistic inclusivity and rhetorically linking artistic and societal freedom. The salon cast a wide net to include Brazil's avant-garde artists of the 1910s and 1920s, including Lasar Segall, and young artists working in a figurative idiom aligned with Portinari, such as Clóvis Graciano, alongside Brazilian and foreign established and emerging abstract artists and architects, among them Josef Albers and Bernard Rudofsky. The salon's principal organizer, Brazilian artist, architect, and activist Flávio de Carvalho, hardly concealed his opposition to the dictatorship in the epigraph and manifesto in the de facto exhibition catalogue, the first (and only) issue of *RASM: Revista Anual do Salão do Maio* (RASM: Annual Magazine of the May Salon). Carvalho quoted US President Franklin D. Roosevelt's radio address on the occasion of the inauguration of MoMA's new building in New York, in 1939: "Only where men are free can the arts flourish and the

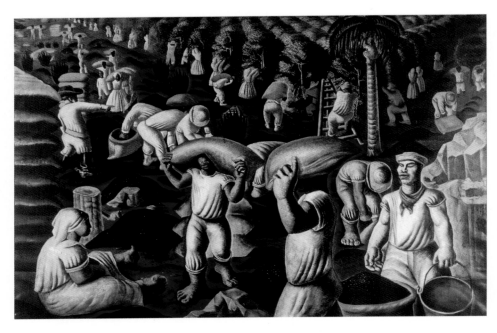

FIGURE 3. Cândido Portinari. *Café*. 1935. Oil on canvas, 51 × 77 in. (130 × 195.5 cm). Museu Nacional de Belas Artes, Rio de Janeiro. © 2020 Artists Rights Society (ARS), New York/AUTVIS, São Paulo.

civilization of national culture reach full flower."[6] The manifesto, authored by Carvalho, explained the objectives of the salon in language laden with references to political revolution and oppression. For example, Carvalho wrote that the event sought nothing less than to provide an artistic haven for "those who have . . . battered out their existence against the surrounding prison walls."[7]

Neither Carvalho's quotation of Roosevelt's assertion that democracy is a necessary condition of artistic freedom, without any comment or elaboration, nor the manifesto, were deemed sufficiently provocative to be censored by the government press bureau, the Departamento de Imprensa e Propaganda (Department of Press and Propaganda, DIP). The transcript of Roosevelt's 1939 address also appeared in the Brazilian mainstream press where, in the context of the US Good Neighbor Policy, World War II, and Roosevelt's cultivation of a relationship with Vargas, the text could be interpreted as enlightened words by an allied statesman against the repressive cultural policies of the Axis. Carvalho exploited this—how could DIP censor Roosevelt's words in one context and not another?—and thereby, with the censor's approval, denounced domestic curtailment of

artistic expression and cut to the ideological contradiction of Brazil's participation, under a quasi-fascist dictatorial rule, in World War II on the side of the Allies. Voices in the art world continued to invoke Roosevelt's connection of democracy with artistic freedom. In an article titled "Arte moderna e Estado Novo" (Modern Art and Estado Novo) that functioned as an artistic call to arms, Martins emphasized what he saw as the implications of Roosevelt's principle: not only was democracy a precondition for artistic freedom, but artistic freedom was essential for democracy to flourish.[8]

It is in this context of competing claims to modern art by the state and artists that the first public discussions of a modern art museum for São Paulo occurred. The museum's advocates proposed that the institution be funded and run by the city government. On July 22, 1938, Milliet issued the inaugural call for a municipal museum dedicated to collecting and exhibiting modern art in São Paulo.[9] He had been working for the São Paulo Department of Culture for several years, where he participated in an expansion of the city's support for culture. He wrote that the municipal Department of Culture was considering organizing a modern art museum to permanently register the current generation of Brazilian artists and provide stable and consistent support for modern artists, an effort he hoped would not be abandoned.[10] Without the museum, Milliet argued that artists and the art-viewing public would be left dependent on privately organized and sporadic exhibitions, such as the Salão de maio. In the early 1940s, on the occasion of the announcement that the estate of the late businessman Armando Álvares Penteado intended to establish a fine art museum in São Paulo, Martins criticized São Paulo's deficient support of living artists. He wrote that it should not be surprising that the city continued to be dependent on a private initiative to fulfill "an elemental and urgent necessity" that the municipal government had neglected.[11] He found existing institutions lacking, from São Paulo's "obscure and very secretive Pinacoteca [do Estado (State Collection)], where half a dozen works of dubious value vegetate melancholically," to Rio's Museu Nacional de Belas Artes (National Museum of Fine Arts), "whose major riches are constituted by works of secondary importance and some copies."[12] He was particularly critical of these institutions' absence of attention, with rare exceptions, to the acquisition of modern works of art, both local and foreign.

Neither the municipal modern art museum nor the museum of fine arts discussed by Milliet and Martins in the late 1930s and early 1940s came to fruition. When Milliet was named the director of the Biblioteca Municipal (Municipal Library) in 1943, he implemented a program to support local modern artists: the Seção de Arte (Art Section). The Seção de Arte acquired and displayed works by Brazilian modern artists, built an art

library, and organized didactic exhibitions utilizing its collection of photographic reproductions of works of art by nineteenth- and twentieth-century European artists. Martins greeted Milliet's first installation, in 1944, of photographic copies of European works in the entrance of the library's new building in the central São Paulo neighborhood of Consolação with unqualified praise. Given the "sad precariousness" of São Paulo museums, he lauded Milliet and the Biblioteca Municipal for filling the gap.[13] Art historian Annateresa Fabris has interpreted the Seção de Arte as "an embryo of the desired modern art museum," and it was indeed the first institution in Brazil to focus on the acquisition and display of works by modern Brazilian artists.[14]

The Seção de Arte was officially inaugurated on January 25, 1945, on the anniversary of the founding of the city of São Paulo and during the I Congresso Brasileiro de Escritores (First Brazilian Congress of Writers), the occasion of one of the first public criticisms of the Estado Novo dictatorship and its censorship policy.[15] The convergence of the inauguration of the Seção de Arte and direct resistance to the dictatorship was a convergence of Milliet's own politics: Milliet was the coordinator of the writers' congress and a member of the political opposition calling for a return to democracy.[16] Martins was also a participant in the congress.[17] More broadly, the coincidence of the two events highlights the political stakes of the fight for a modern art museum: namely, in seeking public support for modern art and a museum, Milliet, Martins, and others saw themselves as bringing democratic institutions to their nation. The writers' congress issued a manifesto that called for "complete freedom of speech" and demanded the establishment of democratic elections.[18] Historian Thomas Skidmore argues that the fact that the censorship agency, DIP, allowed this protest to be publicized in the press indicated to the Brazilian populace that the dictator was loosening his grip on power and intended to follow through on his vague promises of a return to democracy.[19] And, indeed, the following month, press censorship was abolished.

Although the Seção de Arte supported local modern artists, it did not satisfy Milliet's or Martins's desire for a more ambitious institution dedicated to the promotion of modern art, as evidenced by their renewed calls for a museum in 1946.[20] As before, both continued to envision a municipal museum. The political situation, however, had transformed since their earlier statements: Brazil now had a free press, a democratically elected federal government, and a new constitution was being authored.[21] Broad references to the imperatives of democratic, open societies fell away and instead, both critics mounted a targeted, likely coordinated effort to direct the disparate efforts by various São Paulo entities. A pair of unsigned commentaries in the daily newspapers where Milliet and Martins

served respectively as art critics, *O Estado de São Paulo* and *Diário de São Paulo,* set off a wide-ranging public debate regarding the museum.[22] The sharp and sweeping criticisms of both private and public figures took on authority as the opinion of the papers. One cajoled the various private groups discussing a modern art institution to collaborate on a single museum project, writing: "Maybe this museum has not been created yet, less by the fault of the public authorities than because of the lack of a collective effort—of the artists, critics, art students—in a grand campaign that 'demands' of these public authorities a museum of modern art."[23] The other editorial voiced the doubt that the city government could be convinced to support a new museum when it was unable to adequately support the existing municipal museums.[24]

From then on, as art historian Regina Teixeira de Barros has demonstrated, Martins's articles sparked a sustained and heated discussion that drew in the city's mayor, Abrahão Ribeiro, and established artists and writers.[25] Martins issued an open letter to Ribeiro demanding that the museum be founded.[26] The mayor responded stating his opposition to the effort, and individuals on both sides of the cause proceeded to publish blistering statements over the next six weeks.[27] Modernist artists and poets, including Oswald de Andrade, Emiliano Di Cavalcanti, Anita Malfatti, and Menotti del Picchia, as well as critic Ciro Mendes, published remarks in support of the museum.[28] Writer José Bento Monteiro Lobato was Ribeiro's ally in the debate, and a subtext of this fight for institutional support of vanguard art was Monteiro Lobato's polemics against modern art of the 1910s and '20s.[29] The passage of time had done nothing to lessen his disdain: he declared that the proposed institution, despite being called a museum, would function essentially as city-supported storage for unsellable works of art.[30] As the debate illustrated, modern art had yet to be widely accepted as worthy of public support. The mayor wrote that he considered modern art to be a deformation, saying that a museum of modern art would be a "museu monstro" (monster museum) and concluding: "For this, I do not have money."[31] This would prove the final word: there was to be no municipal modern art museum.

A NEIGHBORLY GIFT TO THE FUTURE MUSEUM OF MODERN ART

In mid-November of 1946, Nelson A. Rockefeller arrived to fanfare in Brazil, first visiting Rio and then proceeding to São Paulo. As the former head of the Office of Inter-American Affairs (OIAA), a United States agency dedicated to promoting economic and cultural cooperation in the Americas, and former US Assistant Secretary of State, as well as a renowned businessman with a prominent surname and president of MoMA,

Rockefeller enjoyed a celebrity status in Brazil and was awarded the nation's highest civilian honor for foreigners, the Ordem Nacional do Cruzeiro do Sul (National Order of the Southern Cross), during his trip. Rockefeller came to Brazil to announce that the country would be the first site of his new venture, the American International Association for Economic and Social Development, a philanthropy funded by private enterprise to improve social welfare in developing nations.[32] Rockefeller envisioned this organization as the continuation of the work of the shuttered OIAA, as well as the basis for its possible renewal.[33] He went so far as to think—inaccurately—that he would be able to secure federal funding for the program.[34] As was understood by senior US diplomats following the war and stated definitively by President Harry Truman at the Inter-American Conference held in Petrópolis outside of Rio in 1947, there was to be no Marshall Plan or large-scale government-funded economic recovery for Latin America.[35]

As it was in the economic arena, so it was in artistic matters. Rockefeller spearheaded private initiatives to take the place of wartime governmental programs. He announced in a press conference early in his two-week stay that he had planned some unspecified cultural exchange for his trip.[36] Carleton Sprague Smith, chief of the music division at the New York Public Library and former US cultural attaché in São Paulo, accompanied him and was designated a consultant to MoMA. On this trip, Rockefeller drew on the insights and relationships that Sprague Smith had developed in the art world in Brazil since the early 1940s, as well as the relationships René d'Harnoncourt, then MoMA's vice president in charge of foreign activities, established during his visit to Brazil as part of a three-month membership campaign in Latin America in late 1944 and early 1945. Both men had worked for Rockefeller at OIAA during the war and collaborated on MoMA's inroads into the Brazilian art scene in their respective government posts. Sprague Smith had witnessed firsthand the heated public debate surrounding a modern art museum in São Paulo in 1946 and forged relationships with key figures, including Milliet and businessman Carlos Pinto Alves.[37]

Rockefeller brought with him fourteen works of art that he intended to donate to "museums in São Paulo and Rio de Janeiro," which he presented to the future museums of modern art of Rio and São Paulo at a meeting on November 22, 1946, at the Biblioteca Municipal in São Paulo.[38] Art historians have suggested that Milliet organized this meeting of those interested in creating a modern art museum separate from Rockefeller's visit and that Rockefeller's inclusion was fortuitous.[39] But it is equally likely that Milliet organized the meeting at Sprague Smith's suggestion to provide an occasion for Rockefeller to donate the works and to participate in the discussion of the modern art museum. With the exception of two works on paper by Fernand Léger already in Rockefeller's possession,

MoMA curators Alfred H. Barr, Jr., and Dorothy Miller purchased the works from New York galleries according to Rockefeller's guidance to select works by young US artists and by European artists working in the United States.[40] Art historian Serge Guilbaut interprets Rockefeller's criteria as an attempt to underscore the creativity of the US art scene.[41] Given the immediate postwar context and Brazil's very recent return to democracy, Rockefeller's intention may also have been in the spirit of Roosevelt's 1939 remarks that democracy was a necessary condition for the flourishing of the arts.[42] Of the works by European refugee artists, George Grosz's watercolor *Bestiality Marches On* of 1933 most directly addresses the war. But, as a group, the works by the European and US artists—Alexander Calder, Marc Chagall, Jacob Lawrence, André Masson, and Yves Tanguy among them—vary widely in tone and style, and the dates of the works are not limited to the events of World War II. Aside from creating publicity for the modern art museum initiative, the meeting to receive Rockefeller's gift occasioned pivotal collaboration among São Paulo arts professionals and patrons, specifically the formation of a committee to study the creation of a modern art museum in São Paulo.[43]

Rockefeller made clear—likely in person during his visit, but unequivocally in the correspondence Sprague Smith subsequently sent to figures in Brazil—that he intended the works to be given to private institutions and hoped to foster museums in Rio and São Paulo modeled on MoMA. Days after the November 1946 meeting, Sprague Smith requested that the works given by Rockefeller be stored at the Instituto de Arquitetos do Brasil (Institute of Architects of Brazil, IAB), rather than the Biblioteca Municipal, because the former was a private institution.[44] In addition to requesting the removal of the works from Milliet's institution, Sprague Smith also excluded Milliet from his follow-up letter to the committee members.[45] Though the motivations for Milliet's exclusion are unrecorded, it is likely his past advocacy for a municipal modern art museum and his position at a public institution contributed.

If there were disagreements about whether the museum should be public or private, however, they too went unrecorded. In fact, after Rockefeller's visit, the press almost entirely ignored the museum project for a year and a half. In place of public discourse, extensive and dynamic private conversations about the structure and mission of the museum occurred, in person and in the form of letters and telegrams, between the figures who emerged as the key players in founding the museum. There is, however, one, exception to the silence in the press: Milliet's call for the revitalization of the Salão de maio in 1947, in which he wrote, "The absence of museums of modern art impedes permanent and indispensable observation of what is being produced. We cannot compare, weigh, and

ponder in order to judge. The Salão de maio would be a test of our progress in the fine arts."[46] Milliet's choice to advocate for the salon, rather than continue his decade-long advocacy for a modern art museum, reflected the fact that he had been sidelined in the conversations that would lead to the museum's foundations. (He was subsequently reintegrated and was among the founding leadership of MAM-SP when it was officially established in 1948.) His article also appeared just a few weeks after the inaugural exhibition of MASP, yet it is absent from his assessment of the São Paulo art scene. Milliet thus tacitly aired his doubts about MASP's ability to survey current artistic trends.

Milliet's change of tactics speaks to the fluidity with which he and others affiliated with MAM-SP approached the type of artistic institution that could fulfill their larger objective to transform the local art scene, including their openness to ultimately ephemeral artistic events. For Milliet, support of local vanguard artists of all stylistic persuasions was paramount. While the foundation of a modern art museum in São Paulo was itself a coveted goal, the willingness of the idea's very originator to set it aside would prove a prescient one.

TRANSATLANTIC AND HEMISPHERIC NEGOTIATIONS

In 1947 Matarazzo became the primary protagonist in the creation of the modern art museum in São Paulo. According to his wife, Yolanda Penteado, Matarazzo and some close associates, including Pinto Alves, had begun discussing the possibility of an institution dedicated to modern art and cultivating promises of support from local and state authorities in the mid-1940s.[47] He and Penteado spent close to a year in Europe, from late 1946 to late 1947, during which time they visited Rome, Paris, Milan, and Davos, as a honeymoon and to receive treatment for Matarazzo's lung condition. During this sojourn, Matarazzo formulated a series of ideas for a modern art institution in São Paulo, all of which were unambiguously private initiatives. He maintained frequent correspondence with Pinto Alves and met with art critics, dealers, and artists who informed his vision of the museum and its initial activities. Over the course of his European stay, and after his return to São Paulo in October 1947, Matarazzo considered various institutional models, amplifying his original vision of a showcase for his own collection to that of an ambitious museum modeled on international institutions.[48]

Matarazzo's letters to Pinto Alves early in 1947 were peppered with questions that indicate he was not fully informed of the recent happenings in his native city, including the substance of the meeting with Rockefeller in November 1946, and Pinto Alves was

slowly bringing him up to speed.[49] At the same time, Matarazzo instructed Pinto Alves to pursue founding a gallery to display the works he was purchasing in Europe.[50] In May 1947, the Galeria de Arte Moderna de São Paulo (Gallery of Modern Art of São Paulo) was legally registered, though it never came into existence.[51] A gallery dedicated to an individual collector was of course not what Rockefeller or Sprague Smith had in mind, or for that matter Milliet and others in São Paulo. Sprague Smith bluntly communicated as much in a lengthy letter to Pinto Alves on July 23, 1947.[52] Although MoMA supported the initiative, Sprague Smith wrote that he and his colleagues at MoMA felt that the name, Galeria de Arte Moderna, was not "sufficiently descriptive" and were concerned about the dominance of one family among the founders of the institution. He not only listed the individuals they hoped to see involved, but also noted that for MoMA to work with a Brazilian institution, it must reflect a broader perspective. He encouraged Pinto Alves to focus on finding and training personnel, rather than constructing a building or acquiring works. He concluded his letter with a statement that could be read as an ultimatum: if the various private and public museum initiatives, meaning the Galeria de Arte Moderna, MASP, and the Álvares Penteado estate, could not come to an understanding and establish distinct responsibilities, it would be difficult for any of them to work with US museums.

By July 2, 1947—before Sprague Smith's misgivings arrived to Pinto Alves—Matarazzo had soured on the name Galeria de Arte Moderna, favoring instead Museu de Arte Moderna or Museu de Arte Contemporânea, and, more crucially, had expanded his idea of the institution he hoped to found.[53] Rather than primarily a repository for his collection, Matarazzo envisioned an institution that would inform the public about the history of modern art through loan exhibitions and a comprehensive collection. Although a more complete understanding of Rockefeller's intentions from Pinto Alves's letters may have influenced this change of opinion, Matarazzo's conversations with art critics, artists, and dealers in Paris and Davos certainly informed his more ambitious plan. In Paris in the winter of 1947, Matarazzo was introduced to the Belgian art critic Léon Degand, who would later become the first director of MAM-SP, by Italian artist Alberto Magnelli.[54] At the time of their meeting Degand was the art critic for *Les Lettres Françaises,* a journal aligned with the Parti communiste français (French Communist Party, PCF), and was a known partisan for abstract art. Degand advised Matarazzo on the history of modern art and the formation of a comprehensive collection for the museum. In a thirty-page text Degand authored for Matarazzo, he provided an introduction to the history of modern art, beginning with Impressionism and followed by summary descriptions of key movements, in which he indicated the principal artists and works that would form an ideal

collection.[55] In the spring and summer of 1947, Magnelli, Paris-based Brazilian artist Cícero Dias, and German-born New York dealer Karl Nierendorf joined Matarazzo in Davos to discuss the museum and propose an exhibition dedicated to abstract art as the museum's inaugural event.[56] Nierendorf, whose New York gallery received key patronage from Hilla Rebay, curator of the Solomon R. Guggenheim Foundation and director of the Museum of Non-Objective Painting (later the Solomon R. Guggenheim Museum), offered suggestions regarding the museum's administration and proposed that its objectives combine exhibiting and collecting works by important living artists with fostering innovation among young artists.[57]

In addition to Pinto Alves, Matarazzo also corresponded about the museum with architect Rino Levi, a member of the committee formed at the November 1946 meeting with Rockefeller in São Paulo. During a trip to New York in summer 1947 with a group of architects from IAB, Levi met with Sprague Smith, received a copy of MoMA's bylaws, and became an intermediary, along with Pinto Alves, between Matarazzo and MoMA.[58] Upon Matarazzo's return to São Paulo in October 1947, he met with Levi and Pinto Alves to discuss the direction of the museum. Levi proposed a broader institution than had previously been discussed—the Instituto de Arte Moderna (Institute of Modern Art)—that would include applied and fine arts.[59] Levi's proposed institution, previously overlooked in histories of MAM-SP, was a cultural center devoted to the fostering of all modern artistic activities, not a museum with a permanent collection.[60] This proposal, made following Levi's visit to the United States and shared with MoMA, belies the persistent suggestion by historians that after Sprague Smith criticized the structure of the Galeria de Arte Moderna, Matarazzo, Pinto Alves, and the others involved in the museum project elected to model their institution on MoMA in order to secure that institution's cooperation. Where Levi's ideas mirrored MoMA's suggestions were his assertions that "the greatest possible number of groups" be included in the institution's formation and that the utmost importance would be placed on finding knowledgeable art professionals to lead it.[61]

Like the Galeria de Arte Moderna before it, the Instituto de Arte Moderna never came to pass. Instead, in January 1948, the Fundação de Arte Moderna (Foundation of Modern Art) was established.[62] The founders were expanded to include the figures Sprague Smith suggested. A sixteen-member Conselho de Administração (Administrative Council or Board of Trustees) with a four-member Diretoria Executiva (Executive Board) replaced the Galeria de Arte Moderna's sole president in perpetuity and its insular circle of leaders. Historians have argued that this new administrative structure was modeled on that outlined in MoMA's bylaws.[63] However, it is important not to overstate the degree to which

Matarazzo, Pinto Alves, and Levi incorporated MoMA's structure.[64] Although they adopted the notion of officers and a board of trustees, they did so in a limited manner in comparison to MoMA.[65] Moreover, officers and boards of trustees were common in US cultural institutions and by no means specific to MoMA. In fact, the two-part organization of the Fundação de Arte Moderna, where the foundation was the basis for a museum, was closer in concept to the Solomon R. Guggenheim Foundation and the Museum of Non-Objective Painting. If the far-from-complete adaptation of MoMA's bylaws concerned d'Harnoncourt, Rockefeller, and Sprague Smith, it went unmentioned in writing when they congratulated Matarazzo and his collaborators on the more inclusive spectrum of founders and advocated for the hire of a qualified artistic director.[66]

The statutes also did not clearly establish the relationship between the Fundação de Arte Moderna and the hoped-for modern art museum. The museum does not appear until the fifth statute, and even then with some ambiguity: "to maintain or help in the maintenance of museums and galleries of modern art."[67] Although correspondence by Matarazzo, Pinto Alves, and Levi evidence that they viewed the Fundação de Arte Moderna as a means of establishing MAM-SP, the establishment of the foundation in advance of the museum cannot be dismissed, as Levi asserted to Sprague Smith, as merely a necessity of Brazilian law.[68] Critic Paulo Mendes de Almeida persuasively argues that the Fundação de Arte Moderna was not a precursor supplanted by MAM-SP.[69] Unlike the earlier concepts of the Galeria de Arte Moderna and Instituto de Arte Moderna, the foundation and museum were intended to exist concurrently, with the museum's patrimony reverting to the foundation in the event of dissolution, a structure Matarazzo would exploit later.

MAM-SP was officially established six months after the foundation, on July 15, 1948.[70] In contrast to the laundry list of objectives put forth in the Fundação de Arte Moderna statutes, the MAM-SP statutes identify only two: "to acquire, conserve, exhibit, and transmit into posterity works of modern art," and "to incentivize artistic taste in the fields of visual art, music, literature, and art in general."[71] The administrative structure of MAM-SP expanded on that of the Fundação de Arte Moderna, keeping intact the sixteen-member Conselho de Administração, enlarging the Diretoria Executiva to six rather than four officers, and adding a Diretoria Artística (Artistic Directorship) composed of one or more paid or unpaid directors. The statutes no longer called for the president to serve for life; instead the post would be elected to three-year terms, changes that more closely followed MoMA's bylaws.

Despite the balance called for in the museum's statutes between collecting and exhibiting, in practice from its foundation in 1948 through the early 1960s, the acquisition of

works for the permanent collection was not prioritized. In its first fifteen years of exis-
tence, virtually the only prominent acquisition MAM-SP made—beyond works acquired
through prizes at the Bienal and Rockefeller's donation—was a gift of more than five
hundred drawings by Di Cavalcanti. Instead, an unclear line existed between Matarazzo's
and Penteado's personal collection and the museum's collection. As became evident when
Matarazzo orchestrated the dissolution of the museum, in 1963, the donation of his and
his wife's collection to MAM-SP was temporary. In 1962–63 he gave their and the muse-
um's collections to the Universidade de São Paulo, which created the Museu de Arte
Contemporânea da Universidade de São Paulo (Museum of Contemporary Art of the
University of São Paulo, MAC USP) to house these works.[72]

The conflation of the collection of Matarazzo and Penteado and that of MAM-SP,
initiated in the early discussions of the Galeria de Arte Moderna, was consolidated over
the course of the late 1940s. Early in 1948, the museum represented the couple's works as
belonging to the future museum in both private correspondence and public announce-
ments.[73] Milliet's account of a viewing, at Penteado's residence in São Paulo, of the works
that Matarazzo and Penteado had purchased in Europe perpetuated the understanding
that the collection, which included works by Georges Braque, Giorgio de Chirico, Henri
Matisse, and Amedeo Modigliani from the 1910s–1930s, would be donated to the soon-to-
be-founded museum.[74] After the museum's foundation in July 1948 and before it inaugu-
rated its galleries in the Diários Associados building in March 1949, it occupied a tempo-
rary space at the Metalúrgica Matarazzo in the industrial neighborhood of Brás. In that
temporary space, the works from the couple's private collection were once again pre-
sented as belonging to the museum, expanded to include works by Brazilian artists. These
displays occasioned Almeida's memorable description: the "so-called 'Collection of the
Museu de Arte Moderna de São Paulo.'"[75]

From the early days of the museum's founding, figures at MAM-SP tried to convince
Matarazzo to prioritize collection acquisitions. This included Degand, who arrived in
São Paulo from France in July 1948, coincidentally the same day that MAM-SP was offi-
cially registered.[76] He planned to stay for three months to mount the museum's inaugural
exhibition, oversee the organization of the exhibition's catalogue, and give a series of
lectures, but within a week he was named the museum's first director and made respon-
sible for the museum's artistic direction.[77] Sometime during his first two months in
Brazil, Degand created a document referred to as the "programa" (program) of the
museum, which was distributed in early September 1948 to the Brazilian press and shared
with institutions that MAM-SP hoped to collaborate with, including MoMA.[78] The final,

distributed version restated the statutes of MAM-SP with some elaboration, detailed that the collection of the museum would span from 1900 to the present, and contained a laundry list of the exhibitions the museum planned to organize. In contrast, the draft version that Degand submitted to Matarazzo emphasized the permanent collection over special exhibitions.[79] Given the museum's limited financial means, Degand recommended focusing the collection on recent artists, evoking the Musée de Grenoble as a model. He also advocated for a permanent gallery displaying works from the collection, an initiative he considered central to museum's educational mission. Degand's suggestions in the draft program were not implemented, and the balance indicated in the museum's statutes between the collection and exhibitions was not upheld. Instead, Matarazzo and his staff focused their time and resources on the organization of exhibitions.

EXHIBITIONS AS FOCUS

After a year and half of planning, the exhibition *Do figurativismo ao abstracionismo* (From Figuration to Abstraction) opened on March 8, 1949, at the recently inaugurated home of MAM-SP, the renovated third floor of the Diários Associados building in downtown São Paulo.[80] Like the museum project itself, the exhibition should be considered an agent of the postwar expansion of the art-historical study of twentieth-century art. As various scholars have noted, Barr, in his exhibitions at MoMA; Christian Zervos, in his Picasso catalogue raisonné project; and, after the war, the Venice Biennale and Documenta, pioneered the application of the methods of art history to the display and study of modern art.[81] The São Paulo abstract exhibition is also an early example of this trend after World War II, as is the second São Paulo Bienal (1953–54), analyzed in a subsequent chapter.

In his study of the exhibition, Guilbaut has illuminated the political and aesthetic debates of postwar Paris and focused on the motivation of Degand, including viewing Degand, Matarazzo, and Rockefeller as allied in contesting the influence of Communism in Brazil while narrating what Guilbaut argues was a contest between European and US figures for influence on the postwar art scene in Brazil.[82] My account illuminates the motivations and strategies of the Brazilian actors, demonstrating the financial and geopolitical stakes of the exhibition for the leadership of MAM-SP and the specificities of the debates surrounding abstraction in Brazil. It also brings to light new research about the organization of the exhibition, including the unrealized New York component and the modification of the exhibition from conception in Paris and Davos in 1947 to

installation in São Paulo in 1949. Matarazzo, and his European and US advisors on the project, attempted to marshal Matarazzo's personal wealth, and the country's postwar economic might, to autonomously mount an internationally visible cultural event. The exhibition was initially organized outside the orbit of MoMA, and Guilbaut has asserted that the leadership at MoMA viewed the exhibition as outmaneuvering their interests.[83] The archival record suggests that figures at MoMA would have preferred that MAM-SP mount a show organized by MoMA and were frustrated at not being kept informed about logistics, but also documents support for the exhibition. In internal correspondence, Rockefeller dismissed Matarazzo's suggestion that MoMA might exhibit *Do figurativismo ao abstracionismo* even while Sprague Smith relayed to MAM-SP what he described as the shared enthusiasm among himself, d'Harnoncourt, and Rockefeller for the "excellent" and timely project.[84] MoMA agreed to lend to the exhibition and continued, inaccurately, to list the loans in reports as evidence of its activities in Latin America.[85] Moreover, my analysis reveals that the exhibition, as envisioned and as realized, was less an endorsement of geometric abstraction than has been proposed by Guilbaut and others.[86]

The idea of a major exhibition devoted to abstract art coincided with the founding of the museum itself. Matarazzo considered the Salon des réalités nouvelles (Salon of New Realities) as the model for the exhibition, though his health prevented him from traveling from Davos to Paris to view the 1947 iteration in person.[87] In proposing abstraction as a focus and suggesting the salon as model, Matarazzo's advisors—Degand, Dias, Magnelli, and Nierendorf—elected the artistic mode closest to their interests, and a project with which both Magnelli and Nierendorf were involved. The earliest recorded mention of the exhibition was in correspondence between Matarazzo, Levi, and Pinto Alves in August and September of 1947.[88] Matarazzo wrote to Pinto Alves, "With Mr. Nierendorf in New York, we are organizing, in the name of the future museum of modern art of S. Paulo, a colossal exhibition of abstract art of all countries, from its origin until our times. It will be a 'replica' of the accomplished exhibition in Paris, though more selected."[89]

Although Matarazzo may have been unaware, his advisors certainly knew that the salon proposed a different account of the history, and future, of modern art than MoMA, and Nierendorf expressed to Rebay that he viewed MoMA as a rival for his influence with Matarazzo.[90] A diagram that appears in the catalogue of the third salon in 1948 announced—to artists, art critics, and knowledgeable art viewers—its target: Barr's well-known diagram of 1936 that traced the relationships between modern artistic movements and that illustrated the cover of the catalogue of *Cubism and Abstract Art* (figs. 4–5). The salon's organizers disagreed with the history recounted in Barr's diagram and at MoMA,

namely the privileging of Cubism rather than Impressionism, but his and MoMA's low esteem for current geometric abstraction also prompted this counter-model. While Barr's diagram suggests equality between geometric and non-geometric abstraction, his catalogue essay summarily dismissed geometric abstraction as "in the decline" and reserved particular criticism for Jean Hélion and César Domela, vice president of and regular exhibitor in the salon, respectively.[91] In response to Barr's corporate-style flowchart, the inverted Réalités nouvelles diagram juxtaposes artistic movements, artistic institutions, exhibitions, and organizations against a backdrop of variegated diagonal lines that suggest surging expansion rather than orderly influence. The salon reigns over this field of ascending abstraction and is positioned—along with its predecessor, the 1930s artistic group dedicated to the promotion and exhibition of abstract art, Abstraction-Création (Abstraction-Creation)—as the defender of not only abstract art, but also a predominantly French and Russian history of art rooted in Impressionism.

The salon's defense of abstract art, including the figure ultimately appointed to oversee the São Paulo exhibition, had another more proximate enemy: the embrace of Socialist Realism and condemnation of abstraction by the PCF in 1947. Degand, as a defender of abstract art employed by a Communist publication, found himself in an increasingly precarious professional position in Paris. As Guilbaut has persuasively established, Degand's engagement with Matarazzo and the museum project for São Paulo was influenced by the loss of his position as the critic at *Les Lettres Françaises* by August 1947.[92] Matarazzo's correspondence reflected no concern for the vitriolic French debate between realism and abstraction, though he was opposed to Communism and its organization of labor. Nonetheless Degand, Dias, Magnelli, and Nierendorf had real stakes in this fight. On one side, the PCF demanded socially engaged realist art and decried abstract art as merely, and inexcusably, art for art's sake. On the other side, organizers of the Salon des réalités nouvelles eschewed overt discussions of societal responsibilities in favor of references to the aesthetic revolution and the construction of an ever more international survey of current abstract art. As Guilbaut has suggested vis-à-vis Degand, and as is documented in Nierendorf's correspondence with Rebay, all four of Matarazzo's early interlocutors—Degand, Dias, Magnelli, and Nierendorf—likely desired to bring abstract works to Brazil in hopes of influencing local artists and contributing to abstraction's global reach.[93] Matarazzo, for his part, calculated accurately that an exhibition dedicated to abstraction would make an immediate name for his museum in the local context.[94]

With Nierendorf's sudden death in New York on October 25, 1947, the plans for the inaugural exhibition at MAM-SP were temporarily thrown into doubt. Dias informed

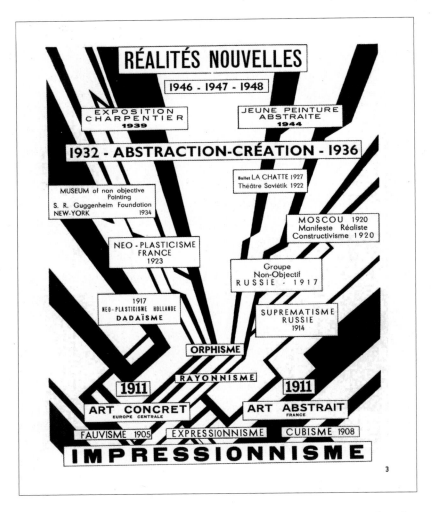

RÉALITÉS NOUVELLES

1946 - 1947 - 1948

EXPOSITION CHARPENTIER **1939**

JEUNE PEINTURE ABSTRAITE **1944**

1932 - ABSTRACTION-CRÉATION - 1936

Ballet LA CHATTE 1927
Théâtre Soviétik 1922

MUSEUM of non objective Painting
S. R. Guggenheim Foundation
NEW-YORK 1934

MOSCOU 1920
Manifeste Réaliste
Constructivisme 1920

NEO - PLASTICISME
FRANCE
1923

Groupe
Non-Objectif
RUSSIE - 1917

1917
NEO - PLASTICISME HOLLANDE
DADAÏSME

SUPREMATISME
RUSSIE
1914

ORPHISME

RAYONNISME

1911

1911

ART CONCRET
EUROPE CENTRALE

ART ABSTRAIT
FRANCE

FAUVISME 1905

EXPRESSIONNISME

CUBISME 1908

IMPRESSIONNISME

3

FIGURE 4. Diagram in *Réalités Nouvelles,* no. 2 (1948): 3. Courtesy of Getty Research Institute, Los Angeles (84-S646).

Matarazzo of the dealer's death and noted that he, Degand, and Magnelli, who would soon name themselves the Paris Committee, were already preparing a report for Matarazzo's consideration on how the exhibition might be salvaged.[95] In subsequent correspondence, the committee proposed that together Degand and René Drouin, a Parisian gallery owner who had shown both Dias and Magnelli in 1947 and who had established

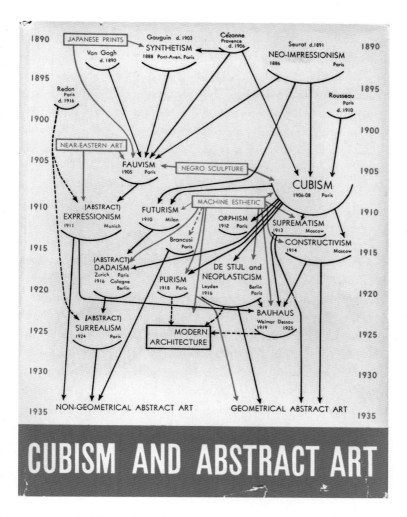

FIGURE 5. Alfred H. Barr, Jr. *Cubism and Abstract Art*. 1936. Offset, printed in color; 10 ⅛ × 7 ¼ in. (25.7 × 19.7 cm). The Museum of Modern Art Library, New York. Digital Image © The Museum of Modern Art/Licensed by SCALA/Art Resource, NY.

connections in New York, would substitute for the late Nierendorf.[96] Matarazzo agreed to this new arrangement in early December 1947.[97] By late January 1948, Drouin was in São Paulo to meet with Matarazzo and sign a contract for the show's organization, a contract that designated Drouin, rather than Degand, the exhibition's general director.[98] Drouin departed São Paulo for New York, where he arranged for his business partner Leo

Castelli, in collaboration with Marcel Duchamp and Sidney Janis, to select US works from New York galleries and collections.[99] Drouin and the Paris Committee quickly came into conflict about the leadership and focus of the exhibition, disputes the committee and Degand won, but Drouin's integration into the project would prove central to the lessons Matarazzo and the leadership of MAM-SP drew from the exhibition.

The proposed focus of *Do figurativismo ao abstracionismo* evolved from 1947 to 1948. The original conception of the exhibition that Matarazzo touted from Europe to his São Paulo collaborators was a systematic survey of current international abstract art.[100] The Paris Committee's report of late November 1947 instead narrated a vast historical exhibition documenting the development of abstraction, from the mid-nineteenth century to the present, focused primarily on artists working in France and the United States, with sections focused on the evolution of painting from Cézanne until abstraction; the pioneers of abstract painting, including Jean Arp and Vasily Kandinsky; and works by young nonfigurative painters of the School of Paris and the United States.[101] The revised exhibition plan Degand shared with Matarazzo on May 22, 1948, took into account the practical difficulty of securing loans of nineteenth-century works within the exhibition's budget.[102] It focused instead on art of the last forty years and proposed transhistorical groupings to demonstrate the difference between the broad category of abstraction and nonobjective abstraction. The historical section, revised to be composed of color reproductions rather than original works, was to be followed by a section dedicated to artists whose works take nature as a point of departure, including Arp, Paul Klee, and Joan Miró, as well as younger artists. The final section included nonobjective abstract works by both historical figures, such as Kazimir Malevich and Piet Mondrian, and younger artists.

There are several noteworthy elements of the proposals by the Paris Committee and Degand. First is the degree to which this was an exhibition for importation into Brazil. Though initiated and supported by a Brazilian individual in the name of a Brazilian institution for a Brazilian audience, the planned exhibition did not include Brazilian artists with only one exception: the Paris-based Dias. Second, Degand and others from the Paris Committee explained to Matarazzo the need to limit their selections to artists active in Paris and the United States (by which they meant New York) due to inadequate time and resources. But, as Degand's comments to an interviewer about the exhibition upon his arrival in Brazil indicate, the choice was not merely practical: the exhibition was intended to serve as "a type of trampoline" for São Paulo to establish a targeted exchange with the artistic centers of New York and Paris.[103] Degand sought to realize an exhibition of US and European art, disregarding local production and art histories, that would resonate as

a major event in New York and Paris, and serve as an education, and catalyst, for the assumed-to-be retrograde artistic milieu in Brazil.

Degand's revised conception of the show of May 1948 guided the selection of works in Paris and New York. While Degand favored nonobjective abstraction and great effort was expended in both cities to assemble historically significant examples of the idiom, the practices of nonobjective abstraction documented in the envisioned checklists were by no means exclusively geometric abstraction. In fact, gestural abstraction was prominent among the young practitioners in both the Paris and New York selections. In Paris, Degand assembled paintings and sculptures by Arp, Sonia and Robert Delaunay, Julio González, Kandinsky, Frank Kupka, Fernand Léger, Francis Picabia, and Sophie Taeuber-Arp, including several from the 1910s and 1920s, along with recent works by Hans Hartung, Pierre Soulages, Geer van Velde, and Victor Vasarely. Castelli, Duchamp, and Janis selected an array of works by US artists working in geometric and gestural abstraction, including Burgoyne Diller and Fritz Glarner, as well as Willem de Kooning, Arshile Gorky, Robert Motherwell, Jackson Pollock, and Mark Rothko, and also works by historical figures, including Alexander Calder, Naum Gabo, Klee, El Lissitzky, Miró, Malevich, Mondrian, Kurt Schwitters, and Theo van Doesburg.[104] The New York advisors also supplemented their checklist with an unsolicited group of works by what they called "American pioneers," including Arthur Dove, Man Ray, Georgia O'Keeffe, and Joseph Stella, and thereby sought to counter the predominance of European early-twentieth-century works with an assertion of US innovation.[105]

True to Matarazzo's boasts to Rockefeller, an exhibition that brought together the proposed works from New York and Paris would have been an impressive achievement for a newly founded museum in a developing nation.[106] The majority of the artists would have been displayed for the first time in Brazil, and the envisioned organization would have studied different approaches to abstraction in an innovative transhistorical and transnational manner, albeit one that excluded Brazilian artistic production and staged a formal and conceptual dialogue between hegemonic artistic centers. The selection included historically significant examples of nonobjective abstraction, such as Robert Delaunay's *Circular Forms* (1912–1913) and Kandinsky's *Black Accompaniment* (1924), lent by the artists' respective widows, and Lissitzky's *Proun GK* (c. 1922–1923), lent by MoMA, and Mondrian's *Composition with Yellow, Blue, and Red* (1937–1942), now in the Tate collection, as well as Taeuber-Arp's *Rising, Falling, Flying* (1934) (fig. 6). Similarly, the smaller number of historical works by artists who referenced the real world would have brought European artists, like Miró and González, into dialogue with O'Keeffe and Stella. Moreover, the

FIGURE 6. Sophie Taeuber-Arp. *Rising, Falling, Flying*. 1934. Oil on canvas, 39 ¼ × 28 ⅞ in. (99.8 × 73.3 cm). Kunstmuseum Basel. © 2020 Stiftung Arp e.V., Berlin/Rolandswerth/Artists Rights Society (ARS), New York. Digital Image © DeA Picture Library/Art Resource, NY.

exhibition would have allowed for the thinking across recent abstract practices of artists in New York and Paris, with juxtapositions of paintings by Jean Bazaine and Gorky, in the referential section, and Hartung and Rothko, in the nonobjective section.

When the exhibition eventually opened in March 1949, however, it was limited to ninety-five paintings and sculptures: the eighty works Degand selected in Paris, with the addition of fifteen works from São Paulo collections. Likely as a result of the impending bankruptcy of Drouin's gallery, a financial disagreement unexpectedly erupted between Castelli, Drouin, and Matarazzo in October of 1948, and the New York selection of works was never shipped to Brazil.[107] Just a few days before the works were scheduled to depart New York for São Paulo on October 8, 1948, Castelli submitted an invoice to Matarazzo's representative stating that Drouin had only covered under half of the total expenses for the New York portion of the show and requesting payment of the difference from Matarazzo.[108] Citing the January 29, 1948, contract in which Drouin agreed to organize the exhibition for an agreed-upon total amount, which Matarazzo had already paid, Matarazzo refused to pay Castelli and the shipment was suspended.[109]

As Degand wrote in letters and in an unpublished chronicle of his time in Brazil, he viewed the exhibition as "amputated" without the works from New York, and lamented the absence of the historical works of European modernism.[110] The realized exhibition maintained elements of Degand's proposed installation, with works from different decades and stylistic approaches juxtaposed, and works by an individual artist spread out through the exhibition (fig. 7).[111] For example, on a long, prominent wall in the largest gallery at MAM-SP, Degand displayed large- and medium-format paintings by Kandinsky, Taeuber-Arp, van Velde, and Jacques Villon in a chronologically, geographically, and stylistically diverse grouping that juxtaposed geometric and gestural works. But the overarching organization Degand proposed in May 1948 was abandoned: gone were sections dedicated to different approaches to abstraction as well as the didactic display of historical reproductions. Instead the scale of the works, and practical concerns for display of the sculpture, contributed to works' placement. For example, in the small gallery, González's *Head* (1935) was placed near Taeuber-Arp's *Planes, Bars and Undulating Lines* (1942), works that would not have been in proximity in Degand's May 1948 exhibition proposal.

Possibly in the context of the absence of the New York component of the exhibition, Degand included two artists working in Brazil, Waldemar Cordeiro and Samson Flexor, in addition to his already planned inclusion of Dias. Despite their belated addition to the checklist, Degand did not sequester the Brazilian works, and Cordeiro's *Composição*

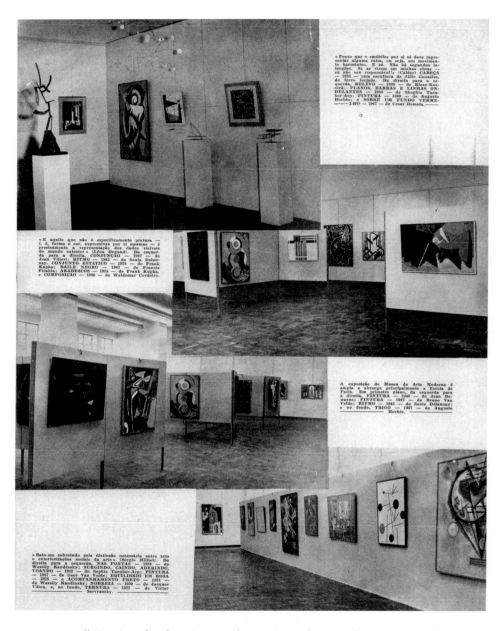

FIGURE 7. Installation view of *Do figurativismo ao abstracionismo* at the Museu de Arte Moderna de São Paulo. 1949. Reproduced in *Jornal das Artes*, no. 3 (1949): 56. Biblioteca Paulo Mendes de Almeida, Museu de Arte Moderna de São Paulo.

FIGURE 8. Waldemar Cordeiro. *Composição*. 1948. Oil on canvas, 27 ⅜ × 38 ¾ in. (69.5 × 98.5 cm). Cordeiro Family Collection. © Analívia Cordeiro. Image courtesy Luciana Brito Galeria. Photo: Edouard Fraipont.

(Composition) of 1948, a Cubist-informed representation of sculptural forms, was prominently displayed in the large gallery, in proximity to works by Sonia Delaunay, Kupka, and Villon (fig. 8). Critics closely weighed the merits and shortcomings of the three works by Brazilian artists, among the first by local artists to be theorized at the time of their creation as abstract works. Cordeiro, who had issued a series of polemical texts on abstraction in the months before the exhibition opened, was criticized for his technical abilities and the persistence of representation in his works.[112] While critics were more positive about the contributions of Dias and Flexor and noted their vivid palettes, the larger critical reception tended to view the former, native-born artist as engaged in serious study of tropical vegetation and light and to accuse the latter émigré of exoticization.[113]

Beyond myriad logistical adaptations, Degand's realization of the exhibition also responded to the debate of abstraction among artists and art critics in Brazil's cosmopolitan centers, which bore similarities to the Parisian debates in which Degand had

participated, but also distinct differences. Sometime in the months following Matarazzo's cancellation of the New York shipment, Degand substituted the longstanding descriptive title of the exhibition, *As tendências atuais da plástica de não-figuração* (Current Nonfigurative Tendencies in Art), with the more polemical *Do figurativismo ao abstracionismo*, suggesting that the evolution of modern art moves inextricably from figuration to abstraction. That argument was already implicit in Degand's conception of the exhibition and in his public remarks and published texts while in Brazil, which deemed referential abstraction essentially figuration and nonobjective abstraction the true abstraction, but the change of title represented a rhetorical doubling-down prompted by the art critical discussion in Brazil.[114] In her groundbreaking account of the debate of abstraction and realism of the late 1940s, art historian Aracy Amaral underscores the increasingly partisan character of the artistic scene after 1945 and argues that the debate centered on the questions of the roles of art and artist in a newly established democratic society.[115] The answers varied with the diverse political positions that emerged post-dictatorship, when the solidarity among artists and art critics of the left during the Estado Novo dictatorship fractured. Milliet, Martins, and Pedrosa, all involved in the founding of the Partido Socialista Brasileiro (Brazilian Socialist Party), argued for artistic experimentation and stylistic openness, with Pedrosa in particular supporting abstraction. The artists and critics aligned with Partido Comunista Brasileiro (Brazilian Communist Party, PCB), including prominent modernist artists Di Cavalcanti and Portinari, advocated for a socially engaged art, calls that became particularly fervent after the party was declared illegal and blocked from electoral participation in 1947.

Despite the fractions among leftist art critics, Degand had few public defenders and provided, for pro-realism Brazilian actors, an effective foil for the rejection of abstraction as a neocolonial import. Di Cavalcanti, for example, deemed Degand an apologist for abstraction.[116] For Brazilian critics of all persuasions, Degand, and his formalism, seems to have provided an impetus to articulate the specific stakes of the debate of abstraction in the Brazilian milieu. Tellingly, a roundtable discussion Di Cavalcanti convened in 1948 focused on the artist's role in society, whereas a panel Degand subsequently staged at MAM-SP highlighted stylistic allegiance and was titled "A favor ou contra o abstracionismo?" (For or against abstraction?). In his texts and public talks, Degand reiterated formalist definitions of abstraction and figuration and sought to model how to appreciate abstract art by, for example, comparing it to music. Texts by Brazilian critics, inclusive of pro-abstraction writers such as Pedrosa, grappled with how modern art and psychology reflect human experience.[117]

Given the centrality of the abstract art exhibition to Matarazzo's vision of the museum as a whole, not to mention the significant money and time he dedicated to its organization, including the weekly correspondence he maintained with Castelli from July to September 1948, the failure to achieve the scope and historical depth he hoped for in the marquee exhibition did not sit well. Reviewers did not pull their punches: one asserted that the exhibition did not fulfill its stated aims and was incomprehensible because of the absence of the works from New York, and many encouraged visitors to also view the didactic exhibition on the history of abstract art at MASP to compensate for the truncated display.[118] Matarazzo and Degand wrote letters to all concerned—lenders, artists, Duchamp, and Janis—airing their grievances against Drouin.[119] The preface to the exhibition catalogue cast this failure in a different light: "Within the parameters that were designated, our exhibition is far from as complete as could be hoped for in normal times. The current difficulties prevailing in international relations and transport were the reasons why we had to limit ourselves principally to the School of Paris."[120] Matarazzo and Degand placed the blame squarely at the feet of Drouin in private correspondence, and yet in public blamed the situation on the postwar political and economic situation. Though there were clearly other factors that truncated the exhibition, the expense and difficulty of obtaining import licenses did impede its timely and affordable realization. Going forward, Matarazzo would emphasize the cost of insurance and shipment as key obstacles and would couch MAM-SP's activities in the context and the rhetoric of international relations. Furthermore, the failure to successfully mount a—in Matarazzo's words—"colossal" international exhibition led Matarazzo and those aligned with MAM-SP to reconsider the museum model as a whole.[121]

REEVALUATING THE MUSEUM MODEL

Following the failure to receive the New York portion of the inaugural exhibition, leaders at MAM-SP held internal discussions about whether they could realize the type of international exhibitions Matarazzo desired with the museum's current organization. One result of this questioning was the ramping up of the museum's effort to secure public support, whether from city, state, federal, or foreign governments, for its exhibition program. Degand and Matarazzo contacted Brazilian governmental authorities, cultural attachés at foreign embassies in São Paulo, and cultural ministers in Europe to solicit financial support and collaboration on exhibitions of each given nation's artistic patrimony.[122] As Matarazzo stated bluntly to the US cultural attaché in 1949, he had reached

the conclusion that without governmental support from Brazil and other countries it would be impossible for his new institution to realize a program of international exhibitions.[123] In each case, the foreign authorities politely declined to subsidize the shows and encouraged the museum to assume the costs and organize a larger South American tour for future proposals.[124] The sole exception was the French government's extension of the tour of the exhibition *De Manet à nos jours* (From Manet to The Present Day) to include MAM-SP in November 1949 after it was shown in Buenos Aires and Rio and before it traveled to Lima, Santiago, and Montevideo.[125] But MAM-SP's success in securing this exhibition confirmed the responses from the various foreign authorities: the need for a larger regional audience. As Milliet recounted from his conversations with French authorities, the French government viewed the Brazilian venues as an afterthought to their primary interest in sending the exhibition to Argentina, which, in Milliet's opinion, possessed a more sophisticated diplomatic corps.[126] By late 1949 Degand's successor as artistic director, São Paulo art critic Lourival Gomes Machado, declined a number of foreign shows proposed to the museum by governmental and private organizations, explaining that the museum lacked the funds to realize the projects.[127] For example, in April 1949 Matarazzo reluctantly declined an exhibition of highlights from MoMA's collection because of its high cost.[128] Like Matarazzo, Rockefeller also saw governmental support as crucial to successful cultural exchange, but he too received a negative response from the US Secretary of State when he inquired about the possibility of public funding for sending an exhibition of paintings to Brazil.[129]

In light of the financial situation of MAM-SP, Milliet suggested the museum focus on its collection rather than an internationally oriented exhibition program. In May and June of 1949, Milliet traveled to Paris to attend the second International Congress of Art Critics. While there he pursued several matters on the museum's behalf, including trying to confirm possible exhibitions the museum had discussed with artists and galleries in Europe. Milliet sent regular updates to Matarazzo, and in his first letter paused from recounting the details of his meetings to write the following:

> Frankly I will explain how the atmosphere in Paris appears to me. (This is also the opinion of Cícero [Dias].) I feel that we are on an incorrect and costly path. The museum cannot have, and will not ever have, a sufficient number of large international exhibitions. They cost an arm and a leg and the organizers are not interested in Brazil, a bad market for the official modern painting of the day here and in the United States. This tremendous obstacle should in my opinion orient us toward other more Brazilian and more didactic realizations, as well as to apply the same money to

acquire good works in order to amplify our collection. Why don't we follow the program of the work of the Kunstmuseum Basel, for example, instead of staying with the model of New York, which exceeds our possibilities?[130]

Milliet appealed to Matarazzo to embrace a targeted modern acquisition and exhibition program, like art historian Georg Schmidt was realizing with modest funds at Basel, over that of MoMA, an argument that echoed Degand's suggestions in his draft program of the year before. Milliet was not advocating the abandonment of the private nature of the museum, as was made clear in his scathing criticism of the Brazilian government's inept cultural exchange program in his letters to Matarazzo, but rather that the museum envision itself more as a local, as opposed to an international, institution.[131] Although Matarazzo did not heed Milliet's suggestions, his appraisal of the dismal chances for the type of major exhibitions Matarazzo envisioned did not go unheard.

In 1950 Matarazzo took three decisive steps to raise the profile of the museum and increase its ability to organize important exhibitions of international art and attract governmental support. First, on January 13, 1950, the museum announced that it was organizing a biennial exhibition, which would be given the name Bienal do Museu de Arte Moderna de São Paulo, and occur the following year.[132] Second, the museum accepted the invitation by the Brazilian government to organize the first Brazilian representation to the Venice Biennale in June–October 1950. Third, on October 19, 1950, Matarazzo and Rockefeller signed an agreement of cooperation between MAM-SP and MoMA in New York.[133] The agreement was announced publicly in mid-November 1950 in coordinated press releases by both institutions. Matarazzo and the leaders of MAM-SP saw these three initiatives as interconnected.[134] They believed that only by raising the international visibility of the museum and its activities could the institution successfully secure local and foreign support. In the same sentence, a report shared the news that the federal government had entrusted the museum to organize the Brazilian representation to the Venice Biennale and that the state government had awarded the museum public funding, in the form of a generous annual grant for five years.[135] Rockefeller, too, viewed the joint agreement between MAM-SP and MoMA as a way to secure public support for both institutions.[136] In the wake of the signed agreement, Matarazzo and Rockefeller wrote to Brazilian President Eurico Dutra and US Secretary of State Dean Acheson, respectively, sharing the news of the agreement and reiterating their requests for public support.[137]

At the first Bienal in 1951, MAM-SP was able to secure nineteen foreign representatives, and at the second, in 1953–54, thirty-two. Foreign governments and cultural entities

funded delegations to the Bienal when they had been unwilling to subsidize sending shows to the museum. The museum had heeded the advice of the foreign cultural attachés and ministers: by hosting a biennial, the museum provided a large regional and international audience. But it was also more difficult for foreign government to decline to participate in a biennial, which was officially a national event. The Bienal was presided over by three honorary presidents: the president of the nation, the governor of the state of São Paulo, and the mayor of the city of São Paulo. While Brazil may not have been an attractive art market, it was an attractive economic market for US and European exports and was becoming a significant economic force abroad.

Another element of the strategic acumen of the Bienal was the securing of contributions from private individuals and enterprises in Brazil. Prior to the founding of the Bienal, Matarazzo underwrote the costs of the museum, with the exception of the small contribution of membership fees—a decision leaders at MAM-SP at one point cast as a pillar of the museum's accessibility to broad publics.[138] While Chateaubriand, the president of MASP, was aggressively procuring donations from many of São Paulo's wealthy, there is no record that MAM-SP solicited support for acquisitions. This changed with the Bienal. Matarazzo appealed to his fellow industrialists and members of the São Paulo elite to sponsor the various prizes at the Bienal, to which, of course, their names were given. As a result, the prize list reads like a social directory, and private entities funded the acquisition of works of art for the museum's collection.

If the Bienal provided a successful means for the acquisition of a permanent collection and of special exhibitions, it also entailed a loss of control on the museum's part. The foreign institutions selected their representations. A jury of international and national art critics and curators awarded the prizes. The acquisition of works by the international artists featured at the early biennials, including, for example, Klee, Mondrian, and Picasso, was beyond the monetary means of the museum and the prize sponsors, and so the overriding focus continued to be placed on bringing temporary displays of international art to Brazil.

In the first Bienal catalogue Machado provided a new and audacious formulation of the museum's and the Bienal's objectives: "By definition the Bienal should fulfill two principal goals: to place modern art of Brazil not simply in proximity, but in active contact with the art of the rest of the world; at the same time it seeks to conquer for São Paulo the position of international artistic center."[139] Matarazzo and the museum's leaders had had these goals from the museum's inception, but found it impossible to achieve them through the structure of a museum. After unsuccessful attempts to attract and finance

exhibitions from abroad and to secure public funding and support, MAM-SP changed the rules. In the Bienal, the museum's leaders found a model that obliged the crucial players to come to the table. In so doing they also increased the exposure of the museum to the fluctuations of economic markets and geopolitics. It should be noted that Machado was not enthusiastic about abandoning the museum model, and that something significant was lost in the museum's transformation into an organizer of a biennial—namely the ideal of a permanent collection of international and Brazilian modern art on public display in São Paulo.[140] Though the biennials provided the "active contact" Machado posited as the high-minded goal of the institution, they provided this contact periodically, not permanently.

Forma

The Mutability of Form in Early Abstract Art and Theory

In a few short years following the establishment of the new museums in Rio and São Paulo and the centering of abstraction in their early programming, emergent abstract artists in Brazil's cosmopolitan centers adopted the term *forma* (form) for articulating the stakes of their practices to local and international audiences.[1] This chapter argues that notions of form crucially oriented early theorizations of nonobjective abstraction and underpinned the first definitions of Concretism by Brazilian artists. I consider the complexity, and unanticipated sources, of early Brazilian Concrete art and the dynamic interplay of local traditions and circumstances with international modernist forms and discourses. Mário Pedrosa's theories of visual perception and radically inclusive definition of modernism loomed large, as did Waldemar Cordeiro's art criticism. A focus on the multimedia production of São Paulo artist Geraldo de Barros, and his generative dialogue with both Pedrosa and Cordeiro, reveals how *forma* signaled not only the perceptual work of making and seeing nonobjective abstraction, but also a merging of media.

The noun *forma* was on the tips of the tongues of abstraction-inclined artists and critics in Brazil's cosmopolitan centers in the early 1950s. Barros, Almir Mavignier, and Ivan Serpa foregrounded the term in the first solo exhibitions of nonobjective abstract works in the country, adopting the titles *Fotoforma* and *Formas*. Barros and Cordeiro settled upon composites of form and object—*Objeto-forma* (1952) and *Forma-objeto* (1952–53), respectively—when titling major works. *Forma* became a prominent term in art, design, and commercial realms over the course of the decade, employed as the name of an arts magazine and furniture store, where its meanings eclipsed formalism, heralding up-to-date taste.[2] Internationally, form also functioned as a synonym for good design, as in Swiss artist and designer Max Bill's 1952 publication *Form: A Balance Sheet of Mid-Twentieth Century Trends in Design*.[3] The book was a compendium of examples of mid-century design and art, modeled on the 1949 traveling exhibition *Die Gute Form* (Good Design), and presented Bill's interests as formalist, evolutionary, and qualitative. He defined form "as the attempt to make inert matter embody perfect suitability for a given purpose in such a way that the fusion achieves beauty."[4] In Brazil, the term also indicated a cross-genre outlook, as in the *Vitrine das formas* (Vitrine of Forms) didactic display in 1950 at the Museu de Arte de São Paulo (MASP), where a transhistorical and nonhierarchical consideration of functional and artistic objects was staged.[5]

Pedrosa's writing on Gestalt theory was part of an international proliferation of consideration of visual perception at mid-century, and form served as a highly visible and manifestly interdisciplinary term in these considerations. The 1951 exhibition *Growth and Form* at the Institute of Contemporary Art, London (ICA London)—as well as its companion publication and symposium *Aspects of Form*—for example, sought, as Herbert Read put it, to stage a "rapprochement" between visual art and natural science made possible by Gestalt theory and "the revelation that perception itself is essentially a pattern-selecting and pattern-making function."[6] In his early writing, Cordeiro also articulated a theory of form in which abstract art nonmimetically manifests social and political realities, an important framework for early nonobjective abstraction in São Paulo. This constellation of ideas and projects transformed "form" into a multivalent term at mid-century, one emergent abstract artists utilized to express the formal, historiographic, medial, expressive, social, and political meanings of their practices to local and international audiences.

MÁRIO PEDROSA'S INCLUSIVE CONCEPTION OF MODERNISM AND FORM

Pedrosa was a key advocate and interpreter of Brazilian artists' abstract turn. Pedrosa brought to his analysis of postwar abstraction the belief that art must engage society. He

refused to cede the mantle of socially engaged art to realism and criticized historical and contemporary expressionist practices, arguing that figures like Alexander Calder and Paul Klee, rather than Pablo Picasso, provided models for the creation of socially transformative art. Pedrosa also articulated a broad, inclusive conception of modernism wherein expression and creativity are not the domain solely of artists, but part of a larger cultural and, to Pedrosa's mind, spiritual inheritance shared by all.

Pedrosa published his first two books of art criticism and art history in 1949 and 1952. Titled *Arte, necessidade vital* (*The Vital Need for Art*) and *Panorama da pintura moderna* (*Panorama of Modern Painting*), respectively, the two volumes establish the essential if seemingly contradictory poles of the critic's thinking about modern art: namely the assertion of the universality of creativity and an evolutionary, European-centered understanding of the development of avant-garde art.[7] Simultaneously transhistorical and teleological, Eurocentric and transnational, formalist and Marxist, Pedrosa proposed a redefinition of modernism that intertwines the significance of nonobjective abstraction with the recognition of the art of outsiders. *Arte, necessidade vital* is a collection of essays from 1933 to 1948 that draws its title from Pedrosa's lecture in 1947 at an exhibition of art by mentally ill patients under the care of Nise da Silveira at the Centro Psiquiátrico Nacional Pedro II in Rio, often referred to by the neighborhood in which it is located, Engenho de Dentro. Here Almir Mavignier helped establish an art studio, which drew active interest and participation from local abstract artists and Pedrosa. In the lecture, Pedrosa stated that the dual origins of modern art in the late nineteenth and early twentieth centuries are widely understood to be the rejection of Renaissance illusionism and the awareness of so-called primitive art, and he dedicated his remarks to analyzing primitive art's significance for modernism. For Pedrosa, encountering the art of ancient and contemporary peoples of the Americas, Africa, and Oceania sparked not only formal innovation but also a historical, geographical, and epistemological reorientation. He saw modern artists' recognition of what he described as a "resemblance" between the art of primitives, children, and untrained artists and the reconceptualization of the human mind as possessing an unconscious—thanks to the fields of psychoanalysis and psychology—as the foundation for a new understanding of creativity as inherent in all humans.[8]

Pedrosa's *Panorama da pintura moderna,* part of the *Cadernos de cultura* (Culture Notebooks) series of books commissioned from prominent Brazilian thinkers and dedicated to the arts, is recognized as a significant text in his oeuvre and in the historiography of Brazilian art. Nonetheless, the book has been little studied.[9] The seeming conventionality of Pedrosa's text—both in its adoption of art historian Heinrich Wölfflin's notion of

enduring stylistic binaries and in its similarity in content and approach to the accounts of modernism put forward by Daniel-Henry Kahnweiler, Alfred H. Barr, Jr., and others in the 1920s and 1930s—has perhaps deterred a finer-grain analysis. In the book, Pedrosa proposed a teleological account of modern art in which Impressionism and Cubism beget a succession of artistic movements that can be distilled into two opposing trajectories, which Pedrosa described as expressionist and constructive. According to the critic, past and present artists participating in the former privileged emotive color, while artists in the latter employed structured space in their respective challenges to naturalism. Within this evolutionary scenario, however, he took a significant detour. His interest lay not in the direct descendants of the expressionist and constructive lines—the Picasso–Jackson Pollock lineage proffered in US postwar criticism, for example, or the strict adherence to the ideas of Piet Mondrian on the part of interwar and postwar artists—but in the outliers. Among the historical figures he considered, Pedrosa singled out Klee for particular praise, seeing Klee's allusions to the world, or "reminiscences of the real," as the key to the artist's protean work, an approach he contrasts to what he views as Mondrian's doctrinaire and hyper-formal practice.[10] He also asserted that the most engaging new artists reinvented the constructive legacy of Mondrian, or "open again the door closed by the Dutch master," by investigating time and light, thereby integrating the real into art in a non-illusionistic and, to his mind, socially engaged manner.[11]

Over the course of these texts and others in the late 1940s and early 1950s, Pedrosa interpreted the genesis of modernism as a formal revolution accompanied by an equally crucial conceptual reorientation wherein art and creativity are viewed as "universal acquisitions" rather than the exclusive domain of artists.[12] For Pedrosa, the emergence and significance of abstraction, which he viewed as the leading edge of modernism, cannot be separated from this larger epistemological shift in which "the enchanted world of forms" is accessible to all of humanity.[13] Both of these paradigms required an expanded notion of art denuded of Renaissance illusionism and without the artist's elevation above society. Pedrosa thereby recasts a linear, European story centered on artists and intellectuals as a global one that insists on a larger conception of creativity.

In contrast to the limited study of Pedrosa's history of modern art, his writing on Gestalt theory has recently received insightful analysis, as has the criticism of poet and critic Ferreira Gullar, Pedrosa's younger colleague in arms in defense of abstraction.[14] Mavignier, for one, retrospectively drew a straight line between his early practice of abstraction, as well as that of Abraham Palatnik and Serpa, and their study of Pedrosa's analysis of visual perception.[15] Pedrosa produced the eighty-page text "Da natureza

afetiva da forma na obra de arte" ("On the Affective Nature of Form in the Work of Art") in February 1949. It was not published until 1979, but it circulated among his circle of artists and thinkers in Rio and São Paulo.[16] Pedrosa, along with other theorists of visual perception, understood art as the ideal realm for comprehending the dynamics of perception.[17] For the Brazilian critic, experimental avant-garde art tested and expanded our experiences of space, time, light, and color via new media.[18] Art historian Kaira Cabañas observes that in the text Pedrosa wrestles with the questions of how an artwork is perceived and how we make sense of it.[19] In order to answer these queries, he departed from rational, formal Gestalt theory to focus on articulating a theory of physiognomic perception. As Cabañas explains, "Where the formal gestalt focuses on the organizational patterns of perception, physiognomic perception hinges on an understanding of perception attuned to expression."[20] Understanding the expressive, emotive, or, as Pedrosa preferred, affective properties of perception—rather than only the interaction of form and structure—was key to Pedrosa's theory, as was the assertion that the expression at stake was not self-expression. Pedrosa's approach, while drawing on, analyzing, and maintaining a dialogue with international debates of visual perception, differed markedly in another way. The ICA London exhibition and publication *Growth and Form* and *Aspects of Form* took up mainstream Gestalt theory and aimed to demonstrate a shared intellectual inquiry in science and art. Pedrosa, in contrast, was interested in asserting continuity and parity between work that has traditionally been understood to be art and marginalized past and present visual practices: the art of mental health patients, children, and so-called primitive artists. Form was the shared source and dictionary for the making and reading of these equal examples of creativity.

WALDEMAR CORDEIRO, ALMIR MAVIGNIER, AND FORMS THAT ARE NOT FORMS

The theorization of form in mid-century artistic circles in Rio and São Paulo was not limited to Pedrosa. Cordeiro also emphasized the notion of form in his art writing in daily São Paulo newspapers and magazines, including his first two programmatic texts dedicated to abstraction, from 1949, titled "Abstracionismo" ("Abstraction") and "Ainda o abstracionismo" ("Abstraction Continued, or Still More Abstraction").[21] In these texts Cordeiro called for an abstract art focused on formal relationships. He criticized figuration and the notion of expressing emotions in art. He argued that "only by objectivizing and depersonalizing form can one make it a matter of reflection, making the work

comprehensible."[22] Art historian Mónica Amor interprets this passage as an early instance of Cordeiro rejecting intuition and emotion in favor of information and understanding and "advancing the notion of a legible art."[23] Cordeiro's subsequent writing, however, did not banish emotion from his conception of abstraction, and the vision of form he articulated hewed to a more wandering path between representation and abstraction, expression and objectivity, than his 1949 rhetoric might suggest.

Cordeiro's early theory of abstraction writ large was not steeped in Gestalt theory. While he acknowledged Bill's interest in Gestalt, as well as topology and relativity—and these are subjects in the new scientific knowledge that he would argue oriented Grupo Ruptura practice in the 1952 manifesto—Gestalt was not a sustained subject of inquiry in his early writing.[24] His notebooks and copious reviews of the late 1940s and early 1950s are instead historiographic in profile, like a large portion of Pedrosa's contemporaneous art criticism. Cordeiro sought to position the new art of young Brazilian artists in relationship to particular trajectories within European modernism and to steep himself in modern art histories, as exemplified by his transcription and translation of Michel Seuphor's 1949 *Abstract Art: Its Origins, Its First Masters*.[25] Components of his early writing are also characterized by a hit-you-over-the-head integration of Marxist terminology. In "Abstracionismo," Cordeiro repeatedly called for a dialectical understanding of new art, arguing that abstraction represents a "resolute qualitative leap" within the struggle of opposing artistic trends.[26] As scholar Givaldo Medeiros has identified, Cordeiro also quoted an extended explanation of dialectics from Josef Stalin's 1938 text *Dialectical and Historical Materialism*.[27] In an unpublished text of c. 1948–49, Cordeiro articulated how abstraction was, to his mind, vitally "connected to the material life of our society, never disconnected from real life."[28]

Both champions of abstraction, Cordeiro and Pedrosa diverged in the roles they played in the art world. While Pedrosa was the subject of vociferous criticism by the orthodox Communist press in the 1940s and 1950s, emerging abstract artists, a generation his junior, revered him as a theorist, supporter of abstraction, and often hands-on mentor, as well as influential curator and cultural broker with an international reach. Pedrosa was also a trained lawyer from an affluent background, with both European university training and unimpeachable leftist political bona fides, as a well-known political activist throughout his lifetime. He was a Communist, a Trotskyite, and ultimately a socialist; underwent multiple periods of imprisonment and political exile during the Estado Novo dictatorship of Getúlio Vargas (1937–45) and, later, the military dictatorship (1964–85); and served in official capacities within political organizations. Nevertheless, his artistic

and political activities operated in separate realms. For example, Pedrosa founded and directed the socialist newspaper *Vanguarda Socialista* (*Socialist Vanguard*) in the mid-to-late 1940s, while his art criticism appeared in mainstream daily newspapers, books, and exhibition catalogues. Cordeiro, Italian-born, a national of both Brazil and Italy, attended a prestigious secondary school in Rome and studied at the Accademia di Belle Arti di Roma as a teenager. He was not a member of the Partido Comunista Brasileiro (Brazilian Communist Party, PCB), though he participated occasionally in its initiatives. In contrast to Pedrosa, Cordeiro's political activities were more ad hoc and confined to the realm of culture, but his art criticism overflowed with political discourses. Cordeiro, like Pedrosa, held a megaphone as a regular contributor to a daily newspaper with a wide circulation.[29] As a practicing artist, contemporary to the majority of the artists he wrote about, and a bomb-thrower in art world debates, Cordeiro's role in the São Paulo art world provoked both dissent and collaboration and he was sometimes seen as imposing his views on others.[30]

Pedrosa's and Cordeiro's respective assessments of Mavignier's solo exhibition held at the Museu de Arte Moderna de São Paulo (MAM-SP) in August 1951, among the earliest exhibitions of nonobjective abstract art in the country, reveal crucial differences in their theories of form. In the texts he authored to accompany the exhibition, Pedrosa described the young artist's works as "pure formal research," arguing that current thinking on visual perception, especially the relationships of color and form to psychology, provided an important theoretical toolkit for experimental artists like Mavignier.[31] Pedrosa connected Mavignier's painting practice to his role as an art teacher at the Engenho de Dentro, writing that the young artist learned there that "art is not a profession, but an internal necessity."[32] The critic drilled down on the affective facets of the *Forma* paintings, describing the yellows as "violent and surprising" (fig. 9).[33] As Cabañas writes, Pedrosa's approach to Gestalt theory was focused on how one perceives phenomenon emotively or expressively: "Such tertiary properties of object perception—that an object of perception be perceived in its dynamism as gay, melancholic, or pensive, rather than through primary and secondary properties such as form and color—are central to its analysis."[34] And it is those tertiary qualities that Pedrosa argues Mavignier makes palpable to viewers.

Cordeiro was baffled by such an erudite thinker as Pedrosa advocating for Mavignier.[35] He argued Mavignier's paintings were poorly-executed post-Cubist exercises polluted by self-expression and therefore, to his mind, unintelligible and muddled. He did not directly address Pedrosa's view of the paintings as studies of perception.[36] Cordeiro's dismissal of Mavignier rested in part on a critique of his sources in European modernism,

FIGURE 9. Almir Mavignier. *Formas n. 2.* 1950. Oil on canvas, 25 ⁵⁄₁₆ × 21 ¼ in. (64.3 × 54 cm). Collection of Pinacoteca do Estado de São Paulo. Transferred by Divisão de Defesa do Patrimônio Cultural e Paisagístico, 1979. Courtesy Atelier Mavignier. Photo: Isabella Matheus.

namely the tonal variation of Pierre Bonnard and Giorgio Morandi and the biomorphism of Joan Miró, references Cordeiro considered passé. He also did not accept the distinction Pedrosa asserted between affective and expressive and read the works not as studies of perception but as a continuation of Expressionism, an orientation Cordeiro and many emerging geometric abstract artists saw themselves as having shaken off by the early 1950s. The title of Cordeiro's review of the exhibition, "Forms That Are Not Forms," speaks not only to the function of the term "form" as a watchword in emerging abstractionist circles, but also to the divergent thinking underway among allied artists and thinkers. Cordeiro accused Mavignier of disingenuously masking his retrograde practice

with theoretical terminology, a condition he argued was widespread in the ascent of wishy-washy "abstractionism" in Brazil.[37] Cordeiro's insistence that the notion of form be tethered to intelligibility and legibility echoed his earlier critique of Expressionism as "forms that cannot be known."[38]

Later in 1951, Cordeiro most fully defined his own conception of form, employing the neologism *"forma-ideia"* (form-idea) to describe the goal of nonobjective art. Specifically, when writing about a painting by Luiz Sacilotto, he wrote:

> This is an abstract picture. The artist does not need to draw his impressions directly from a landscape; rather, he drew the content (impressions) from his own concrete life experience. His impressions formed within the 'neo-plasticist' artistic conception, which is expressed by the movement of colored planes that act jointly or in opposition. Here the research is conscious and, by developing the geometric theme, achieves the 'form-idea,' which is the synthesis of scientific concepts and justified intuitions.[39]

The scientific concepts at stake for Cordeiro are the color and compositional theories of artists like Mondrian synthesized with what he vaguely described as "justified intuitions." The lived experience, and intuition, that Cordeiro considered paramount—as detailed in a series of rosy profiles on Sacilotto, Alfredo Volpi, and other artists—was that of the working-class and emerging middle-class skilled laborers and artisans of the expanding metropolis.[40] Cordeiro singled out Sacilotto's training and employment as a letterer, hand-painting the minute letters and numbers on the tabulating cards for the Hollerith system, a progenitor of the IBM punch card. Sacilotto's mastery of this system, and that of architectural drafting, allowed the artist to create "analogies and relations with things and peoples."[41] Rather than Expressionism or realism, Sacilotto was crafting a nonobjective abstraction that drew, nonmimetically, on the urban modern experience and technical systems, creating "an easily read art" accessible to all audiences.[42] *Forma-ideia* denotes the ideal achieved when an artist activates nonobjective abstraction, grounded in color and compositional theory of the European constructive avant-garde, with lived systems of urban modernity.

Cordeiro aligned his theory of *forma-ideia* with Bill's anti-illusionism, mentioning Concrete art and its suitability to the contemporary moment at the conclusion of the text. But the theory of form put forward by Cordeiro differed from Bill's in both its terms and in the place assigned to the social realm. Bill wrote extensively about the notion of form, and for Cordeiro, who was not in Pedrosa's immediate circle, Bill, along with the Italian

artistic group Forma, were among the sources and foils for his own theorization of form.[43] In 1951, Bill's first text to be translated into Portuguese, "Beauty from Function and as Function," originally written in 1948, accompanied his exhibition at MASP.[44] In the text, amid his call for educational reforms oriented toward training industrial designers, Bill asserted a reorientation of our understanding of the role of beauty in artistic and design processes. While acknowledging the responsibility of the designer to "make useful, ethical products," he argued that it is beauty, which he describes as the "more universal need to give things form," that motivates all artistic and design processes, not "social responsibility."[45] Cordeiro tried on Bill's privileging of beauty, characterizing abstract and Concrete art as "beauty invented by man for man."[46] But his objection to idealism prevented him from investing in beauty as a category, and his notion of *forma-ideia,* in contrast, was interested in the enmeshment of creative processes in economic, social, and quotidian experience.

In one sense Cordeiro's and Pedrosa's conceptions of form were opposites: for Cordeiro form was the exclusive domain of cutting-edge abstraction and tied to urban modernity and new technologies, while for Pedrosa form was the universal means of perception underlying all human experience of the world. For Pedrosa, it was vanguard artists' encounter with alterity, in the form of so-called primitive art for the historical avant-garde and the art of children and mental health patients for the neo-avant-garde in Brazil, that underpinned a reconception of form and human experience. But both Pedrosa and Cordeiro believed art must engage society, and they shared an interest in articulating a non-idealist conception of abstraction as nonmimetically embedded in the world.

If Pedrosa and Cordeiro differed starkly in their assessments of Mavignier, the two critics converged in their admiration for Barros. Pedrosa described Barros as "the most fertile researcher of his generation."[47] In an extended, unpublished text on Barros, likely from early 1951, Pedrosa argued for the singular path of Barros's turn to abstraction oriented not by modernist dictums, but by his own vision and expression, including via his training in photography.[48] Through Barros's diligent experimentation with the camera—the "objective machine"—and its possibilities, "errors," and "deficiencies," Pedrosa asserts that Barros was liberated from naturalism.[49] Cordeiro and Barros had been friends since the late 1940s, and Cordeiro praised Barros's seriousness and talent to others in private correspondence.[50] In his review of the 1951 *Fotoforma: Geraldo de Barros* exhibition at MASP, Cordeiro declared that Barros represented a definitive break in Brazilian art, closing one chapter and opening another (fig. 10).[51] Barros's experimentation with media and

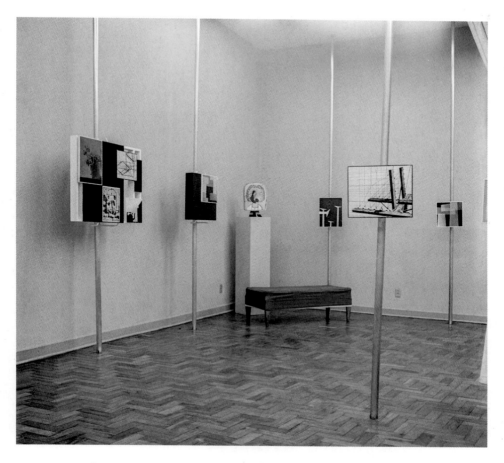

FIGURE 10. Installation view of *Fotoforma: Geraldo de Barros* at the Museu de Arte de São Paulo. 1951. Geraldo de Barros/Acervo Instituto Moreira Salles.

"denaturalization" of mimesis created what Cordeiro described as "new and utterly inventive relations" and new formal interplays.[52] While Cordeiro read the artist's experimental photographs as a rejection of straight realism, he also evidenced more inclusive criteria for vanguard abstraction than his earlier writing suggested, lauding Barros's "othering" of representation. Cordeiro wrote, "Geraldo saw new horizons and turned his attention to those forms that spoke most revealingly of human potential."[53] Cordeiro's definition of form, while distinct from Pedrosa's affective form and radically inclusive conception of modernism, did not cleave abstraction from lived experience.

As the convergence of Pedrosa's and Cordeiro's esteem suggests, Barros's production defies and expands past and current understandings of Brazilian postwar abstraction. Barros, who had moved to São Paulo as a young child from the interior of the state and was from a family consisting of both long-standing Brazilians of Portuguese descent and recent Italian immigrants, was in some respects prototypical of the expanding urban middle class. He earned a degree in economics and worked as a white-collar employee of Banco do Brasil in São Paulo, a job that allowed him to travel regularly to Rio and to take up painting, photography, and printmaking as a young adult. Though he maintained his day job, art became his focus, and by his late twenties he received a solo exhibition at MASP and support from the French government for extended artistic study in Europe. Moreover, Barros traversed the geographic, genre, and stylistic divisions of his day, giving the lie to any facile division of São Paulo and Rio abstract idioms and complicating a painting-centered account of abstraction. From the late 1940s through the early 1950s, Barros created a body of work that encompassed experimental photography, a multitude of printmaking techniques, painting, and graphic design in representational and abstract modes. Prominent exhibitions and prizes, the *Fotoforma* show among them, established Barros as one of the most visible and discussed young artists of the early 1950s.

Barros participated in several distinct artistic circles in São Paulo and Rio, as well as, during a year abroad in Paris, in a community of French, Brazilian, and US artists and intellectuals. In São Paulo he joined expressionist artistic circles prior to nonobjective abstract ones and was involved with the Foto Cine Clube Bandeirante (Bandeirante Photo Cinema Club, FCCB), an amateur photography and film club that held regular salons. Barros was an active collaborator with both São Paulo's new museums and the Bienal—helping to install and photograph exhibitions, taking printmaking classes, and establishing, with Thomas Farkas, a photography lab at MASP—and a vocal critic of those same institutions. Via travel to Rio, he joined the discussions of abstraction, Gestalt theory, and the nature of creativity led by Pedrosa with artists Mavignier, Serpa, and Palatnik. His community in Paris and during his European travels included French artist François Morellet and Mavignier and extended to mathematician Carlos Benjamin de Lyra, physicist Jorge Leal Ferreira, political theorist Cláudio Abramo, film theorist Paulo Emílio Salles Gomes, and cultural administrator José Simeão Leal.[54]

The challenge of how to make sense of Barros's multimedia and far-ranging early practice is not a new one. Critics saw him as dropping one medium to pick up another.[55] As

early as 1953, Barros felt it necessary to counter critics who suggested "I leap irrationally from one thing to another."[56] Barros's exhibition practice reinforced the sense of profound heterodoxy in his production. He sequestered works of different media into separate exhibitions, dedicating his aforementioned first solo exhibition to photography (MASP, January 1951), subsequently organizing a solo exhibition of multimedia drawings and prints (MAM-SP, August 1952), and lastly foregrounding his industrial paint-on-compressed-board paintings from late 1952 on, beginning with the Grupo Ruptura exhibition (MAM-SP, December 1952). Barros also participated in larger exhibitions with works of various media, exhibiting paintings, photographs, and prints at the Bienal; government-sponsored municipal and national salons; local and international photographic salons; and exhibitions of Brazilian art sent abroad, including the Venice Biennale, as well as winning graphic design commissions for event posters. Beyond the diversity of materials used, the bodies of work featured in the various exhibitions oscillated between figuration and abstraction. The *Fotoforma* exhibition in 1951, for example, included straight realist photography alongside highly abstract works and works that experimentally combined drawn and photographed representation with nonrepresentational components, a mix embodied in the panels he composed of photographs, black rectangles, and voids (fig. 10). Barros's works featured in the exhibitions six months apart in 1952 also contrasted sharply: the multimedia, small-scale, Klee-inspired works on paper combine realism and abstraction, while the paintings featured at the Grupo Ruptura exhibition were emphatically nonobjective.

Building on the insightful scholarship of Heloisa Espada, Annateresa Fabris, and others along with newly available archival materials, it is possible to revise our understanding of the emergence of Brazilian Concretism via Barros's multimedia production.[57] Espada and Fabris argue that Barros's dual engagement with Klee and Pedrosa are key to understanding his early practice, and Espada asserts the primacy of photography to the artist's imagination across media and throughout his career.[58] Rather than seeking a coherent through line, I argue that Barros tacked between different orientations in the late 1940s and early 1950s: Klee and Pedrosa among them, but also the ideas of Cordeiro and those Barros encountered during his year abroad.

In August 1952 Barros staged a solo exhibition at MAM-SP composed of approximately thirty to forty prints and drawings of 1950–51, including works he created during his yearlong stay in Europe from February 1951 to January 1952.[59] His works on paper encompass a wide range of media—carbon paper, color monotype, etching, aquatint, lithography, gouache, and hybrids thereof—and are often composed of childlike scenes, where his

washy brushstrokes do not mind their contours and scenes are schematically rendered. The titles are emphatically multilingual, with French, English, and Italian appearing among the Portuguese phrases. In his works on paper, Barros oscillated between different historical registers, from the modern city to the walls of prehistoric caves, to conjure human, animal, and natural realms—from the playground and theater stage to lakes, ships, and "oceanography" populated by nocturnal birds, sleeping animals, happy hunters, and combatants. Taken as a whole, the works delineate an imaginative realm keyed to Klee's practice in format, technique, and subject matter. The series *Cenas da batalha lacustre* (Lakeside Battle Scenes) of 1950 is representative of this diversity and study of Klee (fig. 11).[60] Barros utilized multiple techniques and degrees of abstraction, from experimental color monotypes populated by armed stick figures, evoking children's scratched crayon drawings, to the more traditional printmaking techniques of drypoint employed to render non-illusionistic forms. In *Cena da batalha* (Battle Scene), Barros adopted the intimate scale and schematic, pictographic vocabulary of Klee's compositions, right down to the practice of captioning works in a hieroglyphic-like script, though Barros rendered the script fully nonsensical (fig. 12).

Barros left no doubt of his desired connection to Klee at the exhibition by including Portuguese translations of passages from Klee's diaries, written in Bern in April and June 1902, in the accompanying exhibition pamphlet. One passage was on creating "small but original deeds," and the other one of Klee's best-known statements: "I want to be as though newborn, knowing nothing absolutely about Europe; ignoring poets and fashions, to be almost primitive."[61] Barros aligned himself with the creative anti-dogmatism of Klee and provided a lens to view his own works of seemingly modest means as drawing from a wellspring of sincere experimentation.

Pedrosa encouraged Barros's attention to Klee—likely in their Rio meetings and in his letters to Barros prompting him to visit Bern and Basel, both cities with museums with major Klee holdings.[62] That being said, Klee was by no means the exclusive domain of Pedrosa; he was widely celebrated among transatlantic writers. Moreover, Klee was at the front of the minds of art professionals and patrons at the new Brazilian art institutions: for the initial programming of MAM-SP, Matarazzo had unsuccessfully sought to display his work, and in 1951 MASP announced an ultimately unrealized retrospective.[63]

Wolfgang Pfeiffer, director of MAM-SP, and reviewers reinforced the relationship between Barros and Klee in their commentary on the exhibition, often detailed appraisals congratulating Barros's genuine, fertile creativity and noting his humility.[64] Sérgio

FIGURE 11. Geraldo de Barros. *Cenas da batalha lacustre*. 1950. Color monotype on paper, sheet: 11 ¼ × 9 ¼ in. (29.8 × 24.8 cm); image: 10 ½ × 8 ½ in. (26.7 × 21.6 cm). MAC USP Collection. Gift of the Museu de Arte Moderna de São Paulo. © Lenora and Fabiana de Barros.

FIGURE 12. Geraldo de Barros. *Cena da batalha.* 1950. Drypoint on paper, sheet: 7 9/16 × 10 9/16 in. (19.2 × 26.8 cm); image: 4 3/4 × 7 3/8 in. (12.1 × 18.7 cm). MAC USP Collection. Gift of the artist. © Lenora and Fabiana de Barros.

Milliet interpreted Barros's transparency about the influence of Klee as laudable modesty in a young artist and goes about detecting signs of Barros's "personal invention" within the works.[65] Reviewers noted that other artists, including Mondrian, Sophie Taeuber-Arp, and Maria Helena Vieira da Silva, also mediated Barros's practice.[66] It was nonetheless Klee's influence that was most strongly felt, allowing the diversity of figurative and nonfigurative languages and small-scale, experimental materiality to hang together.

The pamphlet's graphic design suggests something more complex may be afoot in the artist's apparent deference to European modernism and Klee's renown. On the outer fold of the pamphlet, Barros rendered the white background of one of his Lakeside Battle Scenes in a flat, vivid red. Barros positioned himself as a new primitive in the discourse surrounding the exhibition, not only in the homage to Klee, but in his singling out of Italian "primitives" for particular praise in accounts of his year abroad.[67] The graphic design, however, undercut the innocence of such posturing, creating a slightly ominous overlay for the artist's formal and historiographic play.

FIGURE 13. Geraldo de Barros. *City to Conquer.* 1951. Lithograph, 7 9/16 × 8 13/16 in. (19.2 × 22.4 cm). Collection of Fabiana de Barros. © Lenora and Fabiana de Barros.

A related operation, in which bellicosity and good humor coexist, can be found in the creative process surrounding the English-language-titled lithograph *City to Conquer.* Created in Paris in 1951, the lithograph renders a densely built fortified city in schematic, geometric forms (fig. 13). Interestingly, the city on which the young artist trained his ambition to mark a place in the art world is not the modern city. Barros depicted that city in other works of 1951 as idealized though unpeopled spaces bustling with plants and structures. In *City to Conquer,* on the other hand, the depicted metropolis is dense, walled, and capped by towers, built over centuries and prepared for combat. It is Carcassonne, a medieval fortified city on the French-Spanish border that Barros visited multiple times during his year abroad.[68] He created a number of photographs of the city, zeroing in on its

FIGURE 14. Geraldo de Barros. Poster for the Fourth Centennial of the City of São Paulo. 1954. Screenprint, 41 ¼ × 29 ¼ in. (104.8 × 74.3 cm). The Museum of Fine Arts, Houston, The Adolpho Leirner Collection of Brazilian Constructive Art, museum purchase funded by the Caroline Wiess Law Foundation, 2005.980. © Lenora and Fabiana de Barros.

palimpsestic qualities, capturing more than one register of time. It is also Siena depicted by Ambrogio Lorenzetti in *City by the Sea* (c. 1340) as a compact city of multiple towers contained within high walls, and the paintings of other late medieval and early Renaissance painters, such as those at the Basilica of Saint Francis of Assisi, which Barros praised in the highest terms.[69] It is also Paris, and particularly the visual art world of the immediate postwar moment, which artists from the Americas visited with both awe and ego. Barros described the French capital as "the ex-city of barricades . . . fighting to survive," in competition with other art centers, such as Switzerland.[70] The lithograph, then, is a shape-shifting composite of these and other European urban environments, and evidence of the host of non-avant-garde visual practices paramount to his thinking while abroad.[71]

Upon his return to Brazil in January 1952, Barros transformed this amalgamated European city into a revealing depiction of São Paulo in the award-winning design for the poster of the IV Centenário (IV Centennial) celebration of the city of São Paulo (fig. 14).[72] Towering above the pointed medieval towers and pitched roofs reminiscent of those seen in *City to Conquer* are rectilinear skyscrapers topped with radio towers; city walls become single, thick lines stretching out from the central cluster of buildings, suggesting train tracks, roadways, and unlimited growth. Barros's riffing on late medieval, rudimentary perspectival drawing in *City to Conquer* gives way in the poster to flattened, de Stijl-inflected compositional organization, where black orthogonal lines serve as an armature activated by occasional red-filled triangular and trapezoidal planes. The poster envisions São Paulo as a surging urban site, both historical and modern, with the palimpsestic qualities of a European site like Carcassonne. This suggestion of a long built history glosses over São Paulo's actual development, which only began late in the nineteenth century—its prior existence was as a decidedly nonurban colonial outpost—a reimagining appropriate to the mythology associated with the celebration of its four hundred years.

The transpositions Barros engaged in the print and poster, and the analogies he drew between the ancient and the modern, the playful and the violent, skilled and unskilled, in his works on paper as a whole, were grounded in Pedrosa's study of Gestalt theory. However, Barros was not interested in distilling certain perceptual dynamics and making visible the irreducibility of form, but in traversing temporal and stylistic registers to create works dense with mutability. Barros retrospectively dated his in-depth engagement with Gestalt theory to the time of his departure for his year in Europe—"When I left Brazil, the critic Mário Pedrosa cleared up some doubts I had about the creation of the space and the psychology of Gestalt"—an assertion supported in Barros's correspondence from Europe with Pedrosa and others.[73] Barros's letters with Pedrosa during his year

abroad included joking references to past and ongoing Gestalt get-togethers in Rio, the fourth dimension, and a "gestaltian hug," as well as a humorous framing of the accident aboard the Recife-Dakar leg of his air travel to Paris in February 1951, where Barros's belongings took a "privileged direction" when they were sucked out a broken window.[74]

A lengthy letter he composed in September 1951 to his close friend Joana Cunha Bueno, with whom he had studied painting in the late 1940s in São Paulo, is particularly reveal-ing of the focus of Barros's consideration of form. In it he noted that on several occasions—in Paris, during his visit to the exhibition *Growth and Form* at the ICA London, and elsewhere—he encountered "comrades" also interested in "the same problems."[75] Barros's seven-page letter detailed his impressions of the museums he visited and works of art he saw at the mid-point of his year abroad, following frequent travel outside of Paris, to Austria, Germany, Spain, England, Scotland, the Netherlands, and Belgium, and immediately before his most extended sojourn, a month-long trek across Italy.[76] Barros described J.M.W. Turner's work, which he saw during his two brief stays in London, in more depth than any other art or architectural object, and expressed fascination with his manipulation of form. Barros's textual description of multihued, almost stained works on paper by Turner not only provides an on-the-nose description of the material qualities of Barros's own works on paper, but also importantly supplements his public references to Klee and clarifies the nature of his engagement with Gestalt theory. He wrote, "It is very difficult to describe these works but imagine a sheet of watercolor paper covered with beautiful colors and some little marks in black and a title like *Shipwrecked Ship* or the same thing and the title *COLOR* or *Marine Monster* or another thing altogether."[77] The same form could become a naval disaster, abstraction, and fantastical creature guided by the English artist's suggestive titling that conjured sometimes whimsical and sometimes weighty subjects. He continued to Cunha Bueno, "And this in 1840 or 1850. (Turner is authentic and confirms important conclusions about Gestalt and other researches)."[78] What Turner's production verified for Barros was Pedrosa's insistence not to confuse the assigning of meaning to a given form with the act of visual perception. Instead Pedrosa sought, as philosopher Otília Arantes explains, to disentangle perception "from all mechanical and cultural association."[79] As Pedrosa wrote, "Nothing is more mistaken than to suppose that perception is the fruit of intellectual activity."[80] For Barros, Turner's work attested that the comprehension of form is universal and primary and entails per-ception, not recognition. His work also appears to have affirmed the Brazilian artist's aim to operate on and traverse the border between abstraction and realism.

A review of Barros's 1952 exhibition by José Geraldo Vieira contended with the very question of what is being depicted and how the viewer decodes the materially and stylistically hybrid artworks that resist any easy reduction.[81] After dismissing Barros's titles as "occasional labels," Vieira evoked a panoply of tools and systems of visualization and meaning-making—lenses, telescopes, microscopes, cryptography—that a viewer might be inclined to reach for to understand the strange scenes that verge on "photospheric deliriums."[82] Are these massive or microscopic universes? He concluded that such tools are unnecessary, as Barros's works "have nothing to do with galaxies" and, when the artist turned away from photography, he turned away from reality.[83] Instead Vieira proposed that the closest analogy to Barros's works are damaged historical documents. This description of Barros's multimedia prints as containers of knowledge acted upon by time and resistant to decoding matches the artist's own transformation of his prints into red-dyed specters in the 1952 exhibition pamphlet and 1954 poster. Multiplicity and mutability of meaning oriented Barros's Gestaltian theory in the early 1950s.

In an interview with Louis Wiznitzer that appeared in a Rio newspaper in August 1952, soon after his exhibition of works on paper opened at MAM-SP, Barros proposed a vision of the artist distinct from the Klee-inspired unprepossessing newborn finding truth in the margins and minutiae of lived experience.[84] Barros instead adopted a combative tone and envisioned the abstract artist/photographer as countering conventional techniques and styles to create a new viewing experience. He provided a lengthy definition of abstraction, writing:

> For me to abstract means, in photography as in painting, to create abstract forms, to create signs, a language in which reality no longer figures. I am, in some form, obligated to photograph something, transforming it subsequently, at my will, following the elements, equilibriums, rhythms to make a plastic composition, in which the subject is entirely forgotten, absorbed.[85]

His discussion encompassed both photography and painting, but it was when explaining how abstraction functions in his photography that Barros employed psychologically charged words to argue that the abstract photographer must willfully undermine the medium itself. The viewing experience he conjured is forced amnesia.

The transformation and erasure of mimetic representation potently describes the visual activity driving the construction of a host of Barros's photographs, many featured in his 1951 exhibition, and continued in his subsequent photographic production. In

FIGURE 15. Geraldo de Barros. *Fotoforma.* c. 1950. Gelatin silver print, 15⁵/₁₆ × 11½ in. (38.9 × 29.2 cm). Fernanda Feitosa and Heitor Martins Collection. Geraldo de Barros/Acervo Instituto Moreira Salles.

particular, the technique of rotating the Rolleiflex camera to create multiple exposures on a single negative allowed Barros to create composite, abstracted works of the ceilings, windows, and chairs. In a series of photographs featuring compositions of overlapping translucent bands, Barros erased any suggestion of representation (fig. 15). As Espada's analysis of their creation reveals, what appear to be cut-out geometric forms are in fact shafts of light projecting from backlit doors and windows that Barros photographed at

FIGURE 16. Geraldo de Barros. *Forma*. 1951. Monotype on paper, 10 ⅝ × 8 ³⁄₁₆ in. (27 × 20.8 cm). MAC USP Collection. Gift of the artist. © Lenora and Fabiana de Barros.

different angles.[86] The interior of a built environment with door jambs or window frames is faintly perceptible in the dark gray backgrounds of some and entirely "absorbed," to borrow Barros's phrase, in the black background of others.

In his printed and photographic practice before, during, and immediately after his year abroad, Barros walked a nonlinear itinerary between abstraction and realism. He proposed a host of modernist myths to frame his practice—artist as ethnographer, conqueror, and constructor—and in diverse ways visualized the fungible nature of form. In a monotype print created in Paris, titled *Forma,* Barros rendered a constellation of intersecting bars and lines, potentially a conventional mid-century abstraction, but the picture plane is besmirched with smudged black marks, evoking finger and handprints and ink splatter (fig. 16). Rather than distilling form, Barros multiplied forms, and the resultant clusters read as though they have been created under the pressure of his cohering of disparate media and idioms. The work exemplifies the labor of the Brazilian trajectory for abstraction, not derivative of European modernism, but rather immersed in a dynamic exchange of local and international forms and discourses.

DEFINING CONCRETISM AS THE OBJECT-FORM

Beginning in 1952–53, Barros's photographic and painting practices bridged the ideas of Bill, Cordeiro, and Pedrosa to formulate an innovative, non-derivative Concretism. Barros dated to 1953 his in-depth engagement with Bill's ideas, grappling with both the imperative for photographers to create new forms fully divorced from representation and the proposal to develop a composition via a rigorous, predetermined system. Barros's reception of those ideas, however, was framed by Bill's agnostic rhetoric at the time, focused on the primacy of form in Concrete art; Pedrosa's affective theory of visual perception; and Cordeiro's call for the nonobjective activation of lived systems of urban modernity. This cohering of distinct orientations is particularly noteworthy as Barros was among the Brazilian artists with the most privileged access to Bill.[87] Far from narrowly following Bill's program, Barros grounded his production in the material processes of artistic creation and visual perception and in an examination of the mediating role of technology. Through close analysis of works, reconstruction of exhibitions, and newly available archival sources, I revise the existing dating of Barros's most experimental photographs, including his computer punch card photograms, to 1952–1953.[88] I also recover the original titles of his first paintings composed of industrial materials and refine their dating. (Subsequent chapters examine the exhibitions themselves, namely the Grupo Ruptura exhibition in

1952 and the second São Paulo Bienal in 1953–54, and Barros's participation in artistic activism.) These findings reveal that Barros created these bodies of work—his most experimental photographs and his inaugural Concrete paintings—in tandem and demonstrate the centrality of the notion of *forma* to the articulation of a Brazilian Concrete art.

Two primary documents from 1953, one only recently available to researchers, provide vivid accounts of Barros's thinking about his effort to reorient his practice from abstraction toward Concretism. The first is an interview with Walter Zanini, then a young art critic and painter, in March 1953 in a Rio daily newspaper.[89] The second is a letter Barros sent to Pedrosa, likely on June 12, 1953, following Bill's visit to his studio earlier that month.[90] Barros offered both descriptions of a new series of photograms and of the relationships he saw between the different facets of his production.

To Zanini, Barros defended against criticism that he jumped between styles and media. He explained that in between his *Fotoforma* exhibition (1951) and the Grupo Ruptura exhibition (1952), "there is a 'continuity' that was not exhibited. There are the photographic works. When I left Klee, I fell into Concrete painting via experiences with abstract photography."[91] Barros also stated that after his return from Europe, he transformed his photographic practice from abstraction to Concretism, abandoning the camera, which he viewed as a compromise with the figure, to produce photograms, a camera-less, modernist photographic process. Barros distinguished between abstract and Concrete photography as follows: "If we succeed in focusing on some particularities that no one knows what they are, we are in the phase of abstract photography. When we organize forms in space, we are in the field of Concrete photography."[92] Whereas abstract photography obscures representation, Concrete photography elides it.

While Barros mentioned Bill along with a host of other artists in the conversation with Zanini, several months later Barros indicated to Pedrosa that Bill's ideas had become pivotal to both his painting and photographic practice, and provided a more extended description of what he saw as the mechanism at play in the photogram. In a letter to Pedrosa, Barros described Bill's recent visit to his studio in São Paulo, and thanked Pedrosa for encouraging Bill to visit him.[93] Barros recounted that he had started a new series of what he identifies as photograms, where he could play "with the *measurement of time* in relationship to the *intensity of light*."[94] He continued, "I think with the principles that Bill discovered, it will be possible to realize something solid."[95] Barros did not enumerate Bill's principles to Pedrosa, but in a subsequent text he quotes Bill, stating that photography "only achieves artistic creation through a photogram, and only when the artist creates and organizes his or her own shapes."[96] The latter requirement nuances

Barros's broad definition of Concrete photography to be the organization of forms in space, with the privileging of the photogram and the argument that a photographer must create a new vocabulary of forms.

Subsequent to his dialogues with Zanini and Pedrosa, Barros created and exhibited photographs that demonstrate subtle and radical changes in his technical and theoretical processes from his earlier works, and the following year, in 1954, he would exhibit photograms. I propose that these are the photographs, along with his computer punch card photograms, that he described to Zanini and Pedrosa as a hinge between his so-called "Klee works" and his Concrete paintings, and as measuring time in relationship to the intensity of light. At the second Bienal (December 1953–February 1954), Barros helped assemble the photographic room, a selection added at the last minute and composed of works by members of the FCCB. Barros himself displayed *Fotoforma n. 12*, composed of multiple exposures made with his Rolleiflex camera of the ceiling of the Estação da Luz train station. He had previously exhibited a photograph of this subject at his 1951 MASP exhibition, but *Fotoforma n. 12* and related works such as *Fotoforma n. 13* exhibited in the mid-1950s were less concerned with creating dense, refracting spaces (fig. 17).[97] These *Fotoformas* instead entailed the overlay of two views where the orthogonal lines in the whiter, overexposed gridded layer match the lines in the darker layer. The works signal an interest in erasure, with the white layer veiling the more recognizable ceiling, creating sparse, inconstant images, where geometric forms can be read as nonobjective.

At the 13th Salon of Art Photography in São Paulo, which opened in November 1954, Barros exhibited three photographs that set aside heterodox realism and the technique of multiple exposures (fig. 18). In the works—a work printed from cut negatives, a photogram, and a likely photogram—Barros employed highly experimental technical processes to realize works that, as Bill called for, involved the artist organizing forms of his own creation. Yet even as Barros undercut the camera, his new works emphasized their material origins as photographs. In one photogram, Barros assembled what appears to be the raw, nonactivated material of photographic printing—unprocessed film or cellulose acetate perhaps, with visible parallel scratched lines—cut into circles of various scale that abut and overlap as he placed the forms onto light-sensitive paper (fig. 19). Barros sliced up and reassembled a representational medium into geometric compositions that call to mind—via denotation and connotation—technological systems.

Barros's most sustained engagement with the photogram is the series he created using computer punch cards, a group of five works which, to the best of my knowledge, were not exhibited in the 1950s (fig. 20).[98] Barros re-presented a novel technology in a manner

FIGURE 17. Geraldo de Barros. *Fotoforma n. 13*. 1949–1950. Gelatin silver print, 11 ⁷⁄₁₆ × 15 ⅜ in. (29 × 39 cm). Museu de Arte de São Paulo Assis Chateaubriand. Comodato MASP Foto Cine Clube Bandeirante. Photo: Eduardo Ortega. Geraldo de Barros/Acervo Instituto Moreira Salles.

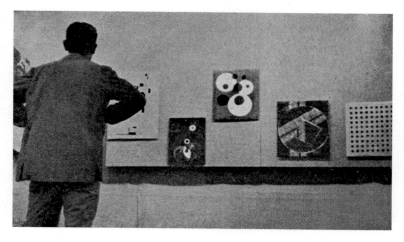

FIGURE 18. Installation view of photographs by Geraldo de Barros (right) at the 13ª Salão internacional de arte fotográfica de São Paulo, Galeria Prestes Maia. 1954. Reproduced in *Boletim Foto-Cine* 8, no. 93 (October–December 1954): 15.

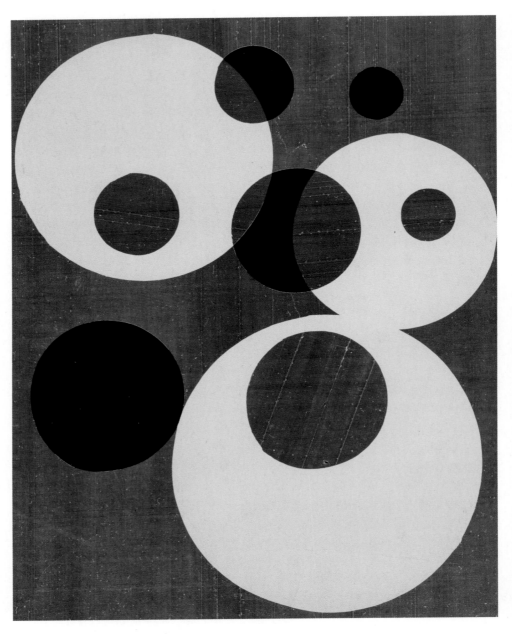

FIGURE 19. Geraldo de Barros. *Fotoforma*. 1952. Gelatin silver print, 15 5/16 × 11 1/2 in. (38.9 × 29.2 cm). Susana and Ricardo Steinbruch Collection. © Fabiana de Barros. Photo: Edouard Fraipont.

FIGURE 20. Geraldo de Barros. *Fotoforma.* 1952–1953. Gelatin silver print, 11 ¹³/₁₆ × 15 ⅛ in. (30 × 38.4 cm). The Museum of Modern Art, New York. Acquired through the generosity of John and Lisa Pritzker. © Fabiana de Barros. Digital Image © The Museum of Modern Art/Licensed by SCALA/Art Resource, NY.

that evokes its intended use—lines of code program a computer to generate reams of calculations—and materially registers his use of the technology itself as the medium. Yet the works are profoundly nonmimetic: the code here is nonsensical to a computer and grounded instead in the compositional dictums of De Stijl. The photograms fulfill Bill's criteria for Concrete photography, but the ideas Cordeiro articulated as *forma-ideia* also inform them. Specifically, Cordeiro argued artists should seek just this kind of nonrepresentational centering of the new economies of São Paulo. Part of the punch card works' hold on our imagination is their evasion of pure nonobjectivity to engage an emergent, highly visible technology and visual culture. Here, in contrast to the works shown at the 13th Salon, the technology itself—the punch card—is the matrix, and thus the works can be said to eclipse denotation and connotation to directly imprint the real.

In the punch card series, Barros experimented with a one-to-one relationship between object and form with varying degrees of legibility. Some of the works could be read as broadly referencing informational and imaging technology, but the larger and more intricate compositions home in on the specific nomenclature of the computer punch card and employ repetition, reorientation, and enlargement. For example, in the work now in the collection of MoMA, Barros repeatedly revealed the specific source material, arranging, at different orientations and scales, four identical sets of perforations, with little paper fibers and irregularities visible as white intrusions into the gray rectangles, to create distinct gray tonalities as they overlap.

To Pedrosa, Barros described the photograms not in terms of signification or systems of representation, but of material and conceptual cohesion: "the *measurement of time* in relationship to the *intensity of light.*" In the stripped-down vocabulary of geometric forms, each shift in tone and scale can be understood materially—the amount of time an element was exposed by light. Form is both material and conceptual, legibly merged and uniting the chain of terms in Barros's and Cordeiro's lexicon, form-idea-object. However, Barros also signaled that something more might be afoot in his process. He both directly printed the punch card, but also likely used internegatives printed on transparent sheets.[99] For example, in the MoMA photogram, the contours of the forms remain consistently crisp, rather than the hazy edges one would expect if the punch card had been held at different heights. Put differently, the technical production was mediated not only by material and durational conditions, light and time, but also by duplicative photographic processes, resulting in a multiplication and mutation of forms. Between matrixes and artwork, Barros, and early Brazilian Concrete artists more broadly, identified a hugely generative feedback loop between form, idea, and object.

In Barros's Concrete paintings of 1952–53, unlike the computer punch card photograms, there is no referent, readily legible or not, to a specific technology. Nor are there representations of the built environment of São Paulo that provide the raw material of many of Barros's photographs or the heterogenous aquatic, nocturnal, and urban realms depicted in his multimedia prints. However, Barros's choice of materials—industrial paint on compressed wood, the latter a domestically produced construction material—tether the works to urbanity and modernity. The scale of the paintings, generally around twenty-five inches square or close-to-square, is large in comparison to the small format of his works on paper. The diverse marks of the prints, drawings, and scratched negative photographs are replaced with uniformly and flatly applied paint, ruler-sharp geometric forms, and centered compositions that fill the entire picture plane. The paintings

nevertheless largely adopt the black, white, and gray palette of his photographs, with some inclusions of cream and blue. They also engage in many of the same operations of repetition and inversions of orientation and scale as the artist had explored in hundreds of photographs.

Barros's Concrete paintings evidence both attention to and distance from Bill's production. In his June 1953 letter to Pedrosa, Barros interpreted his Concrete painting as evolving from a more intuitive practice to one oriented by Bill's ideas.[100] Barros signaled that he sought a new development in his work, but he also presented the change as a deepening rather than rupture of his practice. To wit, he did not write to Pedrosa: I am rejecting your ideas and following Bill's going forward. It seems likely that Barros responded to the generative procedures Concretism offered, which art historian Alexander Alberro explains: "Bill's Concrete art program entails developing and transforming an abstract idea or scheme, a preordering matrix, into a variety of dramatically different forms."[101] Barros's reception of that program, however, was framed by the specific intellectual interests of his Brazilian milieu.

Spanning late 1952 through 1953 and likely predating Bill's June 1953 studio visit, Barros created a series of paintings and drawings that provide insight into what he described to Pedrosa as an intuitive approach to formal variation. At the Grupo Ruptura exhibition, Barros displayed a square medium-format painting made in 1952 where white diamonds of equal proportions and diminishing scales are delineated by the contours of a series of black geometric forms (fig. 21).[102] It is a work, which today bears the title *Função diagonal* (Diagonal Function), that remained at the front of Barros's mind following its creation: he provided the title *Objeto-forma (Desenvolvimento de um quadrado)* (Object-Form [Development of a Square]) for the work to Zanini in March 1953 and it is possible it is the black, square painting Barros referred to in his letter to Pedrosa in June 1953. He also executed several related drawings and another near-identical painting, the design of which he proposed for a large-scale metal panel for a new building in downtown São Paulo.[103]

His subsequent paintings activated a diverse vocabulary of geometric forms and compositions in the investigation of Gestalt formal relations. Following the Ruptura exhibition, Barros foregrounded his Concrete painting practice in exhibitions, most notably submitting solely paintings to the second Bienal in 1953–54 despite having received a prize for his prints at the first Bienal. Newly available photographic collections at the archive of the Bienal allow the identification of an installation view of paintings by Barros as at the second Bienal, an image that had been previously been dated to 1952 and categorized by

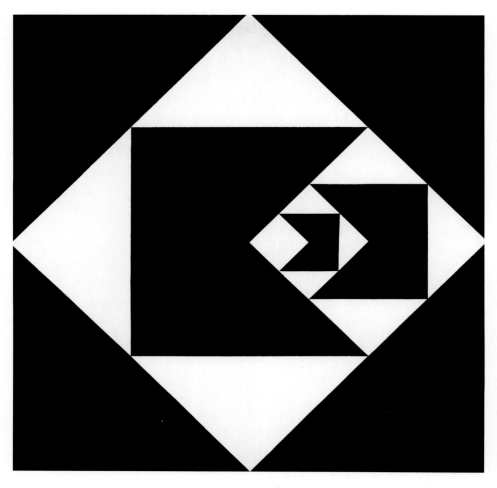

FIGURE 21. Geraldo de Barros. *Função diagonal*. 1952. Lacquer on wood, 24 ¼ × 24 ¼ × ½ in. (62.9 × 62.9 × 1.3 cm). The Museum of Modern Art, New York. Gift of Patricia Phelps de Cisneros through the Latin American and Caribbean Fund. © Lenora and Fabiana de Barros. Photo: Carlos Germán Rojas.

scholars as either his solo show or the Grupo Ruptura show (fig. 22).[104] The identification of this installation view not only shifts the dates of these paintings to 1953, rather than 1952, but also reveals the original titles Barros gave the works, the serial title *Forma-objeto*. The original titles mirrored those used by Barros and Cordeiro in other exhibitions— *Objeto-forma* (Barros, 1952), *Forma-objeto* (Cordeiro, 1952; Barros, 1953), *Objeto plástico*

FIGURE 22. Installation view of paintings by Geraldo de Barros at the second Bienal de São Paulo. 1953–1954. Pictured: Geraldo and Electra de Barros. Arquivo Geraldo de Barros. © Lenora and Fabiana de Barros.

(Barros, 1952), and *Ideia-objeto* (Cordeiro 1953)—and affirmed the two artists' intellectual exchange.[105] The identification of the installation view also opens the possibility that Barros completed the paintings shown at the second Bienal following Bill's visit to his studio in June 1953.[106] The titles that appeared in the second Bienal catalogue, which have remained (with small alternations) with the works, are gregarious in comparison, detailing colors and geometric shapes and characterizing the type of perceptual encounter staged in the works: *Descontinuidade* (Discontinuity), *Tensão formal* (Formal Tension), *Conjunção harmônica de dois grupos de triângulos* (Harmonious Conjugation of Two Groups of Triangles), and *Movimento contra movimento em branco e azul* (Movement Counter Movement in White and Blue). These revised titles with their didactic, procedural tone and emphasis on complex perceptual interchange via geometry were decidedly more Bill-esque, and it is likely Barros changed them in the wake of Bill's visit.[107]

FIGURE 23. Geraldo de Barros. *Movimento contra movimento.* 1953. Enamel on Kelmite, 23 ⅝ × 23 ⅝ in. (60 × 60 cm). Private collection, Miami, FL. © Lenora and Fabiana de Barros.

In *Movimento contra movimento,* Barros examines the progressive variation and alteration of a geometric form represented as a centrifugal unfurling of forms, which were repeated compositional motifs in Bill's work (fig. 23). Barros assembles an emphatically centered composition, aligning the middle points of the chevron forms precisely along the horizontal axis of the composition and delineating a black diamond at the center that oscillates between reading as figure or ground. Art historian Irene Small has identified

differences between Brazilian Concretism and Bill's production. She has noted how Cordeiro, in contrast to Bill, was less interested in mapping the individual permutations of a given geometrical operation and instead "condensed the serial method onto a single canvas" to reach a "stable asymmetry."[108] Her description illuminates Barros's *Movimento contra movimento,* where the chevrons create a rhythmic pulsating that feels uncontrolled and tittering yet also contained within the contours of the outer square. Small further emphasizes that the result of this "cumulative progression" is the visual idea, or visible idea, as Cordeiro began titling his works in 1955, and that Brazilian Concretism, like its European counterpart, conceived of the work of art as "a transparent and transferable vehicle of visual information."[109]

Cordeiro's and Barros's notions of form-idea and form-object/object-form, I propose, open a new window into understanding the genesis of Brazilian Concretism. We are seeing forms, stripped of representation, transform, but in the early 1950s the two artists did not view art as information made perfectly visible and legible. Instead they sought to create artworks, conceived as physical objects, that disrupted habits of seeing and experiencing the world. Barros's 1952–53 paintings as a whole hold our attention because of their affective qualities. In *Movimento contra movimento,* the unfurling chevrons stretch, bulge, and ping against each other in a manner that nonmimetically calls to mind actual things acting in space and our sensorial experiences of such events—from concentric water ripples to the limited visibility of entering a tunnel.

IVAN SERPA: COMPRESSING FORMS AND TECHNOLOGIES OLD AND NEW

Looking solely at the painting production of Brazilian Concrete artists, it is tempting to interpret their abandonment of oil on canvas and embrace of industrially produced materials and a strictly geometric vocabulary as technophilia. Such a view occludes the intermedia experimentation crucial to the emergence of abstract idioms among Brazilian artists and the debates of art's relationship to society among artists and aligned thinkers. Like Barros, Serpa's early work—encompassing painting and experimental collages in his case—involved a sustained intermediality, and he highlighted the diversity of his practice in solo and group exhibitions. Like the computer punch card photograms created by Barros, Serpa's most materially experimental series draws on the technology he accessed at his day job, in his case as an employee in rare book conservation at the Biblioteca Nacional (National Library), that allowed him to create collages using heating, pressing, and layering of tissue paper.[110] In the works on paper, as well as his contemporaneous

FIGURE 24. Ivan Serpa. *Formas*. 1951. Oil on canvas, 38 ¼₆ × 51 ¼ in. (97 × 130.2 cm). MAC USP Collection. Gift of the Museu de Arte Moderna de São Paulo.

paintings on the domestically produced compressed board Eucatex, Serpa heightened the surface qualities of the works in ways that complicate notions of genre and media and suggest a skepticism toward the promises of modernity.

Serpa was perhaps the most visible Brazilian practitioner of geometric abstraction in the early 1950s, receiving coverage in national and international press, a fact attributable to his receipt of a prize at the first Bienal; his position as a respected educator; and Pedrosa's advocacy. Serpa had solo exhibitions showcasing both his painting and collage nonobjective abstract production, notably in 1951 at Instituto Brasil-Estados Unidos (IBEU) in Rio and in 1954 at the Pan American Union in Washington, DC, and he exhibited repeatedly at the São Paulo Bienal and Venice Biennale.[111] Serpa displayed nonobjective paintings, oil on canvas works titled *Formas,* at the first Bienal, where the largest received the national young painter prize (fig. 24). In this and other *Formas* paintings from c. 1951–53, Serpa's

arrangement of multihued forms on intersecting diagonal axes recall Sophie Taeuber-Arp's paintings of the 1930s and 1940s.[112] Serpa had seen two of Taeuber-Arp's paintings at the presentation of works from *Do figurativismo ao abstracionismo* in Rio in early 1949, namely *Rising, Falling, Flying* (1934) and *Planes, Bars and Undulating Lines* (1942), and a larger selection at the first Bienal in 1951, including *Triangles, Point-to-Point, Rectangle, Squares, Bar* (1931) (figs. 6, 38).[113] In some *Formas* paintings, Serpa adopted Taeuber-Arp's vibrant palette and diminutive scale of forms relative to the picture plane, creating a rhythmic perceptual tension. In the painting awarded at the first Bienal, he also experimented with monumentalizing geometric forms rendered in muted tones. His pale blue ground reads less as a neutral backdrop and more as an irregular polygon abutting the white form that fills the lower left corner of the canvas and merges with the circle painted in the identical tone of white. The translucency of the blue and thin gaps between each form make the warm tan of the unprimed canvas visible and palpable. Serpa thereby created a field of large, almost unwieldy geometric building blocks, leading the composition to suggest potential action rather than an interconnected, active network.

Serpa's works of the subsequent years translated the vocabulary of curved and rectilinear geometric forms into increasingly heterodox materials. By 1952 he was experimenting with the shiny readymade colors of industrial paints, including Ripolin, an enamel paint formulated for industrial applications. He was the first among Rio-based artists to do so and worked contemporaneously with Barros and other São Paulo artists in the adoption of industrial materials. Serpa proselytized the medium to fellow artists in Rio and a broader public, via remarks to the press, as a uniquely durable and stable material that allowed for the creation of uniform surfaces.[114] Distinct from his first experimentations, in 1953 he created a series of small- to medium-format paintings where he worked against the typical qualities of automotive paint (fig. 25). With a ruling pen, Serpa created precise patterns of elongated chevrons and triangles on uniform grounds. The paint appears matte and thin, calling to mind the qualities of gouache, and the palette consists of yellows, ochers, browns, grays, blacks, brick reds, and blue-greens. Instead of sheen, vibrancy, and high-key contrast, Serpa's *Rítmos resultantes* (Resultant Rhythms) and *Faixas ritmadas* (Rhythmic Strips) offer decidedly earthbound, chromatic studies. In the painting now in the collection of the Museum of Fine Arts, Houston, Serpa painted on the rough side of Eucatex, and the gridded mesh texture produces a subtle geometric matrix that permeates the viewer's experience of the work and intersects with the vertically oriented pattern of elongated chevrons. The paint surface, which extends to the edges, appears to saturate the board and creates the sense of an integrated object. Calling

FIGURE 25. Ivan Serpa. *Faixas ritmadas*. 1953. Industrial paint on hardboard, 48 ¼ × 35 ⅛ in. (122.6 × 89.9 cm). The Museum of Fine Arts, Houston, The Adolpho Leirner Collection of Brazilian Constructive Art, museum purchase funded by the Caroline Wiess Law Accessions Endowment Fund, 2005.473.

FIGURE 26. Ivan Serpa. *Abstrato II*. 1953. Cut-and-pasted paper on colored paper, 29 × 21 in. (73.7 × 53.3 cm). The Museum of Modern Art, New York. Latin American and Caribbean Fund. Digital Image © The Museum of Modern Art/Licensed by SCALA/Art Resource, NY.

to mind the warp and weft of a textile, Serpa's paintings, made with twentieth-century materials and methods, embed geometric abstraction in a long, non-fine art history.

In 1953 Serpa also began his series of tissue-paper collages, which he would continue until 1955 and would ultimately number around one hundred, utilizing and experimenting with the techniques for book repair and preservation. Serpa exhibited these works extensively in 1954 and 1955 in Brazil and abroad, though the collages are little known today and the colored dye-based papers in them have faded. Serpa adapted a host of preservation techniques and broadly pointed to his working process with the serial title *Collage a compressão* (Compression Collage).[115] Serpa used tissue paper cured with adhesive that is heat sensitive and adhered by applying heat with pressure.[116] He often placed a sheet of tissue the size of the support over the entire composition, creating a "facing"—a conservation technique. He also integrated insect-damaged cream and white papers as collage elements alongside new, colored dye-based papers. In the collages Serpa created multilayered containers that both employ and allude to paper conservation techniques, often in excess and to corrosive and contingent effects.

In an early collage, Serpa created a composition proximate to Taeuber-Arp, composed of a vocabulary of circles, trapezoids, rectangles, and irregular polygons set at diagonals and oblique angles to one another (fig. 26). He created subtle color shifts via the physical overlap of tissue, insect-damaged paper, and thin multi-toned papers—layers that alter the vitality of color and crispness of the forms. Pedrosa argued for the recognition of Serpa's collages as innovations in the modernist treatment of color as a physical, luminous thing.[117] Pedrosa proposed that in the collages Serpa allowed for a viewer to experience both "pure physical color" and "color-light."[118] He wrote:

> The colors are truly liberated and take on variations more characteristic of spatial appearance: They change from pure tone, of optimum saturation, to the most exquisite gradations, sometimes preserving the resistant specific quality of the surface of color-objects, sometimes featuring translucencies, full of the resonances that deepen filmic, spectral colors (disconnected from any idea of the flat surface).[119]

Pedrosa was fascinated by the low-fi means—cut, damaged, and adhered papers—by which Serpa achieved a cinematic experience of color and conveyed color's physicality—"color-objects."[120]

New technologies deployed to sustain old technologies, and old technologies laying bare new ones. This is manifestly the case in Serpa's collages, but Barros's photograms also document the intersection of technologies of different vintages. In one of his photograms,

Barros composes his camera-less creation with the very materials of standard printed photography (fig. 19). In the computer punch card photograms, Barros registers the afterlife of early-twentieth-century avant-garde proposals in the design of an emergent technology (fig. 20). In both artists' productions what is "restored" is not some hallowed artifact, but the leftovers of the artist's studio and darkroom and the bureaucrat's office—the used, malfunctioning, and discarded punch card and the cut-up detritus of artistic creation. Moreover, Serpa's collages and Barros's photograms are works where the constituent parts are interconnected. Forms are disassembled and reassembled but kept in parts. Barros and Serpa thereby make the forming of form visible, but the experience is one of fragmentation, multiplicity, and mutability, not resolution.

The intermedial innovations in the early production of Barros and Serpa studied here, like those of Palatnik illuminated by the scholarship of Luiz Camillo Osorio, were a crucial nexus for the development of Brazilian Concretism.[121] Their practices demonstrate the interdisciplinary, socially charged nature of the nonobjective abstraction fostered by Pedrosa and Cordeiro, and how artists strategically navigated local and international discourses of formalism and modernism. As is examined in the following chapters, during and following the first Bienal, the acumen and alliances that early abstract artists honed in positioning their own production would be applied to collective actions, including the creation of Concrete-oriented abstract art group exhibitions and extending to a last-minute display of photography at the second Bienal that Barros helped organize.

National Culture and Abstraction at the First São Paulo Bienal

In June of 1951, a mere three months before the inauguration of the first São Paulo Bienal, photographs began appearing in local newspapers depicting the start of demolition at the terrace of Trianon, the hilltop site where the event was to be held, and today occupied by the Lina Bo Bardi–designed home of the Museu de Arte de São Paulo (MASP). The terrace and its multilevel Beaux Arts structure, containing pavilions, a restaurant, and a ballroom, had been created during the coffee boom of the late nineteenth and early twentieth centuries as part of the development of an exclusive residential subdivision along the Avenida Paulista. Beginning in the 1930s, the Avenida Paulista was transformed into a center of high-end commerce as part of the industrial development of the city orchestrated by national and local authorities. Nineteenth-century buildings were replaced with high-rise modern buildings to house the industrial and commercial interests that would soon dominate São Paulo's economy.[1]

The partial destruction of a prominent Beaux Arts building and its replacement with a modernist shed—each symbolic of the

elite wealth of their respective eras in Brazil and the consistent public investment in spaces meant for the affluent—encapsulated the enmeshed class and political stakes at play in the organization and reception of the Bienal. The mayor of São Paulo had ordered the existing structure at Trianon demolished as part of the area's redevelopment as a commercial district, and gave the site temporarily over to the Museu de Arte Moderna de São Paulo (MAM-SP) for staging the Bienal, with public money contributing to fund the construction of the building and its operation. MAM-SP commissioned a temporary modernist building designed by local architect Luís Saia with the collaboration of Eduardo Kneese de Mello (fig. 27).[2] The destruction and construction at Trianon, where one Europeanized vision of Brazilian grandeur was supplanted by another, shoddily and hastily realized, tempers the Bienal's own fanfare as a novel enterprise, recreating the Venice Biennale in the tropics. Brazil's elite had long looked to Europe as cultural standard-bearer and, in cultural production, privileged what film historian Robert Stam has called "Euro Brazil."[3]

The first Bienal has often been seen as a key catalyst of the emergence of Brazilian abstraction and its interpretation as an embodiment of an internationalist vision for new art, successfully robbing the spotlight from the national figuration of prior decades. While it makes for good dramatic framing to describe the Bienal as a partisan for abstraction and handmaiden for the abstract turn in Brazilian art, such a narrative neglects the generative environment constructed by Mário Pedrosa, Waldemar Cordeiro, and the new museums prior to the Bienal, as well as the flourishing of a novel practice of nonobjective abstraction oriented by theories of form by Geraldo de Barros and Ivan Serpa, examined in the prior chapter. Moreover, the understanding of the Bienal as an actor with a univocal aesthetic program obscures the manifold iterations of history on display and the often conflicting agendas held by the event's leaders and cultural brokers. There were many authors of the first Bienal. Beyond those with leadership titles—Francisco "Ciccillo" Matarazzo Sobrinho (president), Sérgio Milliet (first secretary), Lourival Gomes Machado (artistic director), and Arturo Profili (public relations director)—there were three separate visual art juries with markedly different aesthetic and ideological profiles; the commissioners of the individual foreign representations; local artists and designers who worked as preparators, installed the exhibitions, and designed the building, catalogue, and poster; and further individuals outside of MAM-SP who served as informal advisers and advocates.

Artistic and critical debates around the first Bienal, including a war of words between leaders of MAM-SP and MASP about which entity "authentically" represented Brazil

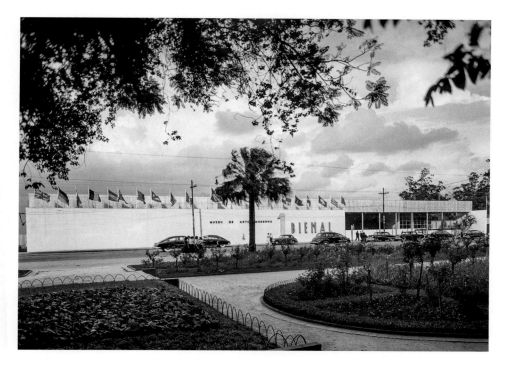

FIGURE 27. Luís Saia's and Eduardo Kneese de Mello's temporary building for the first São Paulo Bienal. 1951. Photo: Hans Gunter Flieg/Acervo Instituto Moreira Salles.

and the creation of new art schools at both museums, also belie the notion that the new modern art institutions abandoned constructions of and claims to national culture. The first Bienal attempted to consolidate a national history of modern art centered on a masculinist, moderated vision of social realism epitomized by the recent production of Cândido Portinari. That effort met criticism from local artists and critics as well as a resounding rebuke by the prize jury composed of local and foreign critics. As this chapter demonstrates, emerging Brazilian abstraction was foregrounded at the first Bienal in a more tenuous manner than has been acknowledged. The failure of the story centered on Portinari—and the prizes and special mentions awarded to Barros, Max Bill, Alberto Magnelli, Antonio Maluf, Abraham Palatnik, Serpa, and Sophie Taeuber-Arp—all contributed to the presentation of Brazilian abstraction as in innovative dialogue with international art. However, the character and mechanisms of that visibility, including the fragmented installation, gendered reception, and anxiety about artists' superficial

adoption of abstraction, affirm the limits and fissures in the celebration of abstract art at the event. The reception of abstraction at the Bienal was not the coronation of a small number of young practitioners of geometric abstraction and their European artistic interlocutors. Rather, it grappled with abstract experimentation by a multigenerational cohort of figurative artists and what abstraction meant for expressions of national and regional identities. Put simply, regionalism and nationalism, in addition to internationalism, underpinned the discourse around abstraction at the first Bienal.

Art historian Andrea Giunta has asserted that in Latin America following World War II internationalism "served as an ideologem for the legitimization of artistic expression in opposition to the national character."[4] Giunta builds on Perry Anderson's insights that following World War II, in what Anderson characterizes as "one of the great watersheds of the twentieth century," the meaning of internationalism was transformed from a term claimed by the left to one associated with Western capitalism and the postwar ascendance of the US hegemony.[5] And, indeed, a number of leftist cultural critics in Brazil saw the Bienal as the prime example of just such a postwar reinscription of internationalism: a fine art exhibition founded by the industrial elite, drawing huge sums from the government and sustained by underwriting from foreign capital, with lucrative prizes on the offer and artworks for sale to boot. The postwar Partido Comunista Brasileiro (PCB) presented itself as a defender of national culture, where nationalism was defined as anti-imperialism in opposition to a capitalist cosmopolitanism. However, recent historical, cultural, and sociological studies of mid-century Brazil scrutinize the universalizing and internationalizing discourses generated by São Paulo elite to highlight the enmeshment of their internationalism with regional and national identities. Historian Barbara Weinstein argues in her study of São Paulo regionalism that region and nation do not function as antitheses. She writes that the self-image of the region of São Paulo, constructed in the twentieth century to naturalize progress, is "an indispensable site from which to imagine the nation."[6] At the Bienal, São Paulo, via visual art, was imagined as the center of not just the nation's gambit for international stature, but also the Brazilian national project.

A BIENNIAL BORN IN PROTEST

"The Bienal Is Against Brazilian Artists."[7] So read the title of architect João Batista Vilanova Artigas's impassioned denouncement of the Bienal as a neo-imperialist sham serving the United States and capitalist interests. Artigas's article appeared in PCB's

cultural magazine *Fundamentos: Revista de Cultura Moderna* (Fundamentals: Magazine of Modern Culture) in December 1951, the month the biennial closed, and represented the crescendo of a furor against the Bienal initiated by critics and artists of all political and stylistic persuasions almost two years earlier.[8] Historians have viewed the "confrontation" with the Bienal, as art historian Aracy Amaral has put it, as a continuation of the debate between realism and abstraction of the late 1940s.[9] However, the Bienal changed the stakes for the discussion of art in Brazil, creating new alliances that eclipsed the battle lines drawn in the prior decade. Remarkably, given the realism-abstraction acrimony, critics from conflicting ideological and stylistic positions rallied around the shared perception that MAM-SP was marginalizing the role of the artist in the institution's decision-making in favor of an insular, patron-centered enterprise.

The early 1950s witnessed the transformation of the recently inaugurated MAM-SP from one voice among many to a uniquely authoritative voice. Through its international projects, including the announcement of the São Paulo Bienal (January 1950); organization of the Brazilian representation to the Venice Biennale (April–June 1950); signing of a cooperation agreement with the Museum of Modern Art, New York (October–November 1950); and its success in securing public and private funds and land, the museum threatened to overshadow all other entities. While Artigas's condemnation of the Bienal was not adopted by all critics of the events, the issue of national culture, and who gets to speak for Brazilian art, pervaded the reception of the Bienal. Put differently, the debates of the early 1950s were animated not only by the view that the new museums, and particularly MAM-SP's organization of the Bienal, represented potential threats to artist-driven organization of the visual art field, but also by a heated negotiation among artists, critics, and leaders of the institutions about who should be the authors of and audiences for visual art. Building on Amaral's foundational scholarship, especially her study of social commitments in Brazilian mid-century art, I suggest that the Bienal debates also revolved around questions of art and art history by whom and for whom.[10]

The genesis of the public agitation about the artist's role, or lack thereof, at MAM-SP can be traced to a year and a half before the Bienal opened its doors, namely to the protests around the museum's process of selecting the artists who composed the first Brazilian representation to the twenty-fifth Venice Biennale in 1950.[11] The initial stakes of this discussion were twofold: reforming the selection process of the first Brazilian representation to a premier international art event, and influencing the yet-to-be-established regulations of the first São Paulo Bienal. Before the public announcement of the Venice selection jury in local newspapers, artists and critics had organized a meeting to discuss their

grievances that the jury had been chosen without outside input.[12] The meeting was held at the Clube dos Artistas e Amigos da Arte (Club of Artists and Friends of Art, often referred to as the Clube dos Artistas or simply as the "Clubinho," or "Little Club"), an organization established in the mid-1940s that sponsored exhibitions and served as a gathering place and collective advocate for artists in the city. Several individuals, such as Rino Levi and Sérgio Milliet, played leadership roles in the establishment of both the Clubinho and MAM-SP. Given that close relationship, the setting for the protest underscored the widespread concern about MAM-SP's emerging policies.

How to understand MAM-SP and the Bienal in a longer national artistic landscape was up for grabs among artists and critics. Paulo Mendes de Almeida, a collaborator with MAM-SP since the early 1950s and its eventual director, distilled a narrative of continuity in his influential—and São Paulo-centered—compilation of essays on Brazilian modern art and institutions in the first half of the twentieth century.[13] Almeida saw modern artists, artistic organizations, and modern art museums as partners in a refusal of conservative aesthetic production, and cast the first Bienal as the culmination of what Mário de Andrade described as the "fight for the modernization of the Brazilian arts."[14] Art critics writing for the Communist press viewed the relationships between these entities markedly differently. Ibiapaba Martins argued that the Semana de Arte Moderna of 1922 and the Bienal should both be seen as initiatives of and for the elite of Brazil, the former agricultural and the latter industrial. The patrons of the Bienal and the new museums promoted abstraction and formalism to distract artists, and the public, from the problems of the people and, therefore, the new art institutions were against progressive artists and culture. In contrast, he privileged artistic groups of the 1930s and 1940s, Grupo Santa Helena principal among them, that were driven by working class, self-taught artists and dissented from the elite system.[15]

The statement published after the Clubinho meeting about Venice establishes that the protestors' unifying contention was procedural. Signed by thirty-six individuals and dated April 11, 1950, the statement voiced opposition to the process by which the jury had been chosen and proposed alternate jurors.[16] Positions critical of MAM-SP and abstraction without doubt informed the protest: Virginia Artigas, social realist artist and frequent illustrator for *Fundamentos,* led the effort, and Ibiapaba Martins was proposed as a member for the jury; the four members of the jury closest to MAM-SP were singled out as unacceptable. However, the larger dynamic was of a cross-section of artists of different generations and diverse stylistic approaches collectively arguing that MAM-SP had improperly excluded artists from voting to select jury members. The signatories included

pioneer modernist Anita Malfatti; a large number of figurative artists who participated in the Grupo Santa Helena and Família Artística Paulista (Paulista Artistic Family) in the 1930s and 1940s; and abstract artists Barros, Lothar Charoux, Cordeiro, Kazmer Fejér, Luiz Sacilotto, and Anatol Wladyslaw (all the founding members of Grupo Ruptura save Leopold Haar).

The protest, though covered in the press, did not prompt MAM-SP to alter the jury's composition nor its autonomy in selecting the artworks sent to Venice. Individuals, however, did act: one juror, Quirino da Silva, resigned and artist Aldo Bonadei, among the protestors, publicized his declining an invitation to exhibit because of the exclusion of artists from the organizational process.[17] Moreover, the quality of the ultimately realized representation—composed of twelve artists of varying generations, the majority in figurative and figure-inflected idioms, from the famous Portinari to the young and unknown Milton Dacosta—received sharp criticism from local press outlets. Reviews compared the exhibition unfavorably to the Mexican representation at Venice, featuring that nation's best-known artists, José Clemente Orozco, Diego Rivera, David Alfaro Siqueiros, and Rufino Tamayo, and argued the Brazilian representation contained too few of the consecrated modernists of the teens and twenties and too many young artists, resulting in an incoherent account of the country's artistic scene.[18]

The public debate soon eclipsed arguments about procedure and qualitative evaluations to become a war of words centered on who had the authority to author a representation of the national artistic scene on a grand stage—at the Venice Biennale, and the São Paulo Bienal to come—and who could be considered a Brazilian artist. In its first issue, a new São Paulo magazine, *Habitat: Revista das Artes no Brasil* (Habitat: Brazilian Arts Magazine), created a dust-up thanks to its dim view of the first Brazilian representation to Venice. The magazine, an enterprise of Habitat Editora Ltda. backed by publicist Rodolfo Klein, was directed by Lina Bo Bardi, MASP's gallery and exhibition designer (and, later, architect of its new building inaugurated in 1969).[19] *Habitat* counted on collaboration from Bo Bardi's husband, MASP director Pietro Maria Bardi, and MASP founder Assis Chateaubriand, and in its early years, it frequently lauded MASP's accomplishments and criticized the rival museum in town, MAM-SP, serving as an unofficial MASP publication where readers understood the opinions to be those of the Bardis. An anonymously written short critique in the "Crônicas" (Chronicles) section at the back of the magazine did not mince words, deeming the organization of the Brazilian representation for the Venice Biennale incompetent. In particular it chastised the absence of Lasar Segall, and leveled the accusation that the jury was "watched" by individuals unqualified

in the realm of visual art and seeking only glory—a thinly veiled critique of MAM-SP founder Matarazzo.[20] In the face of this withering appraisal and an article by Bardi in a local Italian-language periodical, Matarazzo asked members of the selection jury to publicly refute what he perceived as inaccuracies, and MAM-SP issued a press release contesting the *Habitat* criticism.[21]

Several answered Matarazzo's call, including Antonio Bento, art critic for the daily Rio newspaper *Diário Carioca,* and Tomás Santa Rosa, set and book designer, visual artist, and critic. In his article, Bento refuted the *Habitat* critique point by point, including noting that Segall's absence was by the artist's own choice: he was invited and declined the invitation for pragmatic, not polemical, reasons.[22] Santa Rosa went further, attributing the absence of Segall and a key painting by Portinari to MASP's interference and criticizing Bardi as an ambitious arriviste who has behaved unethically in the wake of not having been selected himself to organize the representation.[23] Santa Rosa also noted that artists in Rio and São Paulo, led by Cordeiro and Quirino Campofiorito, had campaigned with the jury for young artists to be included in the representation rather than a selection limited to the consecrated figures like Portinari and Segall. He cast Bardi as a high-handed, condescending interloper, who did not appreciate how "things" are in Brazil, a turn of language he repeated in the text and denoting an understanding of the cultures, histories, and habits of the country.[24]

Bardi's response to this admittedly personal indictment is nevertheless remarkable: in an open letter to Santa Rosa in the second issue of *Habitat,* he asserted that MASP, the museum he directed, not MAM-SP, was "the 'authentically Brazilian' museum."[25] He buttressed this claim by enumerating MASP's acquisitions of Brazilian artworks, its dedicated gallery for exhibitions of young Brazilian artists, and its educational programs. On the covers and pages of *Habitat,* the mantle of Brazilianness was claimed visually with images of popular art, vernacular design, and art of untrained artists, which the magazine described collectively as the "real Brazilian art" (figs. 28–29).[26] In the inaugural covers, photographs, arranged on a grid, identify the nodes of the modern and Brazilian as defined by *Habitat* and MASP, streamlined in the second issue to a distilled map juxtaposing vernacular craft, modernist architecture, and a nonobjective drawing by Bill on an orange-red ground. (Eliminated between the two covers was a representation of MASP's European masterpiece collection, the venture to which the museum dedicated the most resources in its early history.) In *Habitat,* the Bardis' claim that MASP represented Brazil was made explicitly via their commitment to the visual culture of non-white Brazilians,

whether Northeastern and indigenous artisans or predominantly Afro-Brazilian so-called primitive, untrained painters.[27]

Matarazzo's name does not appear in either Santa Rosa's or Bardi's text, but the question of who has the authority to represent Brazilian modern and contemporary art and culture pervades the protests of the first representation at Venice: an artist and intellectual such as Santa Rosa, who emigrated from the Northeast and was active in both Rio and São Paulo artist-run organizations and was also a founding figure in the Teatro Experimental do Negro (Black Experimental Theater)? Artists, in the case of the Clubinho protestors of multiple generations and heritages, Italian, Portuguese, and Japanese among them, including recent immigrants and first-generation descents, all active in local artist-run organizations and exhibitions? Foreign, locally based experts like Bardi and Bo Bardi who emigrated from Italy to Brazil in 1946? Immigrant and immigrant-descendant patrons such as Matarazzo, a Brazilian-born, Italian-Brazilian industrialist educated in Italy and Belgium who spoke accented Portuguese? Old money patrons like Matarazzo's wife, Yolanda Penteado, heir of the Southeastern Brazilian coffee landholding elite?

The exchanges between artists and art critics underpinned by the question of who possesses the authority to represent Brazilian art and culture challenge our understanding of elite conceptions of national identity at mid-century. Sociologist Maria Arminda do Nascimento Arruda, in her study of the debates around culture in the mid-twentieth century São Paulo, argues that in the 1950s the presence of Italian, Portuguese, Spanish, Japanese, German, Syrian, Lebanese, and other immigrants in the metropolis took center stage, with many first-generation descendants reaching "the top of the social scale in multiple activities."[28] In this context, the Bardis were not exceptions; foreign-born experts were leading and lending cachet to other cultural enterprises. Similarly, to Arruda Matarazzo was an emblematic figure who transformed his wealth into social recognition.[29] Arruda concludes, citing historian and folklorist Ernani Silva Bruno, that the traditional São Paulo elite, the so-called *quatrocentões* (literally the "big four hundred year-ers"), considered the Italian-descended counts and countesses as equals, a judgment they did not extend to the larger Italian-Brazilian populace.[30]

However, the Bardi/Santa Rosa exchange, and the larger scrutiny of the Brazilian representation to the Venice Biennale, demonstrate that the incorporation of elite Italian-Brazilians was not without friction. At the very least the ethnicity of even economically and culturally powerful European-immigrant and immigrant-descendant figures was subject to scrutiny, and these challenges were issued by individuals from a diversity of

FIGURES 28–29. Covers of *Habitat: Revista das Artes no Brasil* (October–December 1950 and January–March 1951). © Instituto Bardi/Casa de Vidro + Edouardo Ortega.

regional backgrounds. As Arruda notes, the visibility of a subset of Italian immigrants occurred in the context of an influx of internal migrants from the Northeast and Minas Gerais to the city and state of São Paulo, beginning in the 1940s.[31] Bento and Santa Rosa, who moved from the Northeast—Paraíba and Pernambuco, respectively—to Rio, were products of internal migration, albeit as participants in middle class mobility. (They, along with Pedrosa, minister of education Ernesto Simões Filho, and director of the

documentation service of the ministry of education José Simeão Leal, are also examples of the prominence of cultural figures from a range of geographic backgrounds in Brazil's cosmopolitan centers of Rio and São Paulo.) The questioning, and defense, of MAM-SP's authority to represent the nation then was issued by intellectuals and artists who themselves were engaged in altering Rio and São Paulo identities to encompass other regional identities.

In his studies of non-European immigration to Brazil, historian Jeffery Lesser fruitfully distinguishes between consolidated discourses of the nation and the negotiation of national identity by and in relation to immigrants, writing:

While a relatively coherent elite discourse asserting ethnicity as treasonous was intended to constrain and coerce new residents into accepting a Europeanized and homogenous national identity, this should not be confused with the actual ways in which it was perceived at either the elite or popular level. Indeed, immigrants and their descendants developed sophisticated and successful ways of becoming Brazilian by altering the notion of nation as proposed by those in dominant positions.[32]

While Lesser is reflecting in particular on the experience of Jewish, Japanese, and other non-European immigrants to Brazil, his insights point to the distance between prescription and policy, on one hand, and day-to-day experience and practice, on the other. The Bardis and Matarazzo were elite, and their cultured Italian heritage reinforced a Europeanized vision of Brazil. But the Bardis' and Matarazzo's claims to Brazil and their ability to represent Brazilianness were actively questioned by their contemporaries and they, and the institutions they led, were engaged in a strategic adaption of national identity.

In the face of the uproar that greeted MAM-SP's organization of the Brazilian representation for the Venice Biennale in 1950, the museum's leaders reformed the jury selection process for the first São Paulo Bienal. Three of the jury members were selected by artists voting, with the final juror selected by MAM-SP. The votes were tallied publicly in the auditorium of MAM-SP by representatives of the very groups that criticized the Venice selection, including the Clube dos Artistas.[33] This process yielded a markedly different jury than for Venice in 1950: halved in size, there was not a pro-abstraction critic among them, and artists, two of them realists, outnumbered the critics three to one.[34]

If MAM-SP conceded to artist input on the selection jury for the Seção geral (general section) of the first Bienal, it avoided external input in its invitations for a special exhibition of *Artistas brasileiros convidados* (invited Brazilian artists). The internal deliberations of MAM-SP leadership nevertheless reflected the impact of the past controversy. Correspondence between Machado and Milliet shows that they weighed the best approach to the special exhibition, considering the options of inviting "everybody," as at the 1950 Venice Biennale; limiting the selection to two artists; or not staging a special exhibition.[35] MAM-SP ultimately invited a smaller number of artists than it had to Venice. The majority were recognized leaders of Brazilian modernism, including Segall, on whose behalf the museum had been pilloried after not displaying him in Venice.

Neither the reform to the general section selection process nor the selection of artists for the special exhibition quelled the criticism of the Bienal from the orthodox left and

right, both of which accused the Bienal, and the state and federal governments, of domineering practices. (In advance of the event's inauguration, mainstream publications, by contrast, tended to share the information MAM-SP distributed in regular press releases in a positive tone.) Academic artists affiliated with the conservative Associação Paulista de Belas-Artes (São Paulo Fine Arts Association) submitted a formal protest to the governor of the state of São Paulo, criticizing the ceding of public land to an event they argued promoted "anti-Christian, anti-Latin and anti-Brazilian" artistic practices.[36] Artigas pointedly described the Bienal and its methods as fascist, and equated the Bienal with the use of such exhibitions by authoritarian regimes, namely Benito Mussolini's intervention in the Venice Biennale during his rule and Francisco Franco's recent inauguration of the Bienal Hispanoamericana de Arte (Hispanic-American Art Biennial) in Madrid.[37]

Communist-aligned periodicals, including the magazine *Fundamentos* and daily newspapers *Voz Operária* (Worker's Voice) and *Hoje* (Today), undertook a sustained, blistering critique, viewing the Bienal and abstraction as inextricable from US economic interests and as fronts in the Cold War, born of an anti-Communist, neo-imperialist assault on Brazil by the United States and industrialist Nelson A. Rockefeller. As discussed in the first chapter, after World War II, Rockefeller promoted the International Business Economic Corporation (IBEC), his for-profit international development venture, in the country and collaborated with the modern art museums in Rio and São Paulo as president of MoMA. *Fundamentos* denounced the Bienal as an attempt by local and foreign economic elites to control the course of Brazilian artistic production, and focused on the role of foreign players, particularly Rockefeller, declaring the Bienal a "cosmopolitan impostor."[38] As sociologist Rita Alves Oliveira has recognized, militant labor activists portrayed the Bienal as a corrupt enterprise of greedy local and US elites with turns of language like "Ciccillo-Rockefeller" and "Bienal of IBEC," and the reproduction of a photograph of Penteado and Rockefeller dancing together with the headline "The Bienal Partners Dance."[39] Thus Oliveira argues that the radical press utilized the first Bienal to symbolize "a new stage in capitalist development, in which the internationalization of capital was beginning to emerge led by the United States."[40] All three periodicals judged that "honest artists" creating "progressive art" should not participate in the Bienal and that abstraction was a form of decadent bourgeois art intended to negate the life of the people.[41] *Fundamentos* also singled out Pedrosa, and a cartoon illustration showed Pedrosa pleasing fat-cat patrons by showing artworks depicting the Bienal as a cannon shooting down Pablo Picasso's peace dove (fig. 30).[42]

FIGURE 30. Dan. Illustration in *Fundamentos: Revista de Cultura Moderna* 4, no. 22 (September 1951): 12. Benson Latin American Collection, LLILAS Benson Latin American Studies and Collections, The University of Texas at Austin.

While Getúlio Vargas's name appears in the critiques of the Bienal in the Communist press—noting his role as honorary president and seeing the event as serving foreign and domestic economic monopolies—he was generally cast as a bit player. The starring roles were reserved for Matarazzo, Penteado, Rockefeller, and occasionally Pedrosa. This is a fascinating decision on the part of Communist-aligned magazines and newspapers, perhaps attributable to Oliveira's insight about the effective symbolism of the foreign imperialist, aided by the local rich, as a harbinger for larger economic change afoot. However, the juxtaposition in an issue of *Fundamentos* of an extended analysis by J.E. Fernandes of Vargas's whitewashing of the cultural policy of his administrations, past and present, with a critique by Pedreira of the Bienal under the shared banner of "defense of culture," suggests the debate on national culture and the Bienal was intertwined with a critique of the federal government.[43] Both the Bienal and Vargas are declared impostors by *Fundamentos,* one in the guise of the cosmopolitan and the other as a demagogue.

In November 1951, the Clube dos Artistas was yet again the site of a debate. The Communist-aligned press had successfully transformed the protest against the Bienal in the mainstream press from a discussion centered on artists' inclusion in the deliberative processes and which institutions and individuals had the right to create national representations to one inclusive of concerns about neo-imperialism and authoritarianism. The meeting at the club, with Matarazzo in the audience, was advertised as a roundtable discussion to consider the differences and commonalities between abstract and figurative art

latter—underscored that the presentation of Brazilian culture at the Bienal was from a regional position, that of São Paulo, which they saw as having a unique claim to leadership in modern art. In the first Bienal catalogue Machado provided an audacious formulation of the Bienal's objectives: "By definition the Bienal should fulfill two principal goals: to place modern art of Brazil not simply in proximity to, but in active contact with the art of the rest of the world; at the same time it seeks to conquer for São Paulo the position of international artistic center."[67] Simões Filho's remarks at the inauguration of the first Bienal echo this yoking, in particular of the national and regional, asserting that São Paulo is "the natural center of Brazilian modernism" and that modern art reflects the "Brazilian industrial transformation."[68] His hope for the Bienal was that it serve as a point of departure and inspiration for Brazilian artists. The discourse of freedom of expression that framed the earliest discussions of a museum of modern art in São Paulo fell away, and in its place left a rhetoric struck through with boosterism of São Paulo and positioning modern art as a barometer of Brazil's economic development and geopolitical status.

A negotiation site for narrating the national, and its relationships to region and world, was the effort to define a national art history in the special exhibition of invited Brazilian artists composed of works by painters Emiliano Di Cavalcanti, Portinari, and Segall, sculptors Victor Brecheret, Bruno Giorgi, and Maria Martins, and printmakers Lívio Abramo and Oswaldo Goeldi.[69] Machado pointed to the significance of these presentations, stating in the catalogue that the Bienal aimed to create a definitive account of Brazilian modern art history and influence the future trajectory of national artistic practice.[70] Art historian Tadeu Chiarelli has persuasively argued that the special exhibitions at the early Bienals need to be understood as part of a larger project by Brazilian art institutions in the 1940s and 1950s to legitimize and consolidate a history of Brazilian modernism.[71] During that period, institutions promoted a select roster of artists, including solo exhibitions of Tarsila do Amaral, Di Cavalcanti, Malfatti, Portinari, and Segall, and MAM-SP produced a series of well-illustrated monographs.[72] At the Bienal, however, prominent women artists and the more heterodox aspects of Brazilian modernism were excluded, and in its place a masculinist and moderated vision of social realism prevailed.

The federal government, via MES, collaborated with the activities of the new modern art museums in the consolidation of a national cultural history and integration of those national stories with international narratives. The *Cadernos de cultura* (Culture Notebooks), a series of books commissioned by Simeão Leal from prominent Brazilian thinkers, had a European orientation, with the covers illustrated by a classical vase. The visual arts

volumes, modestly illustrated, slim publications, took the form of episodic essays and historical, evolutionary narratives, including Pedrosa's 1952 *Panorama da pintura moderna*.[73]

This history-writing was happening in plain view, as Cordeiro noted in his review of MAM-SP's 1950 Amaral exhibition:

> For those of us who are not interested in judging the interpretation of the principle of self-determination in national art by the anthropophagic or Pau-Brasil movements, nor in spinning a fable about the 'anything goes' exhibition that was the Modern Art Week of 1922, and much less in getting ourselves mixed up in personal causes—which are, however, being elevated repeatedly to the public forum—for us, we repeat, it is more useful to focus on the aesthetic aspects. . . . And we do this without losing sight of what our young artists are creating today.[74]

Cordeiro offered close scrutiny of the works, attuned to the concerns of current artists, as an alternative way to interpret and interact with the emerging national canon of modern art, and avoid what he saw as a hopelessly compromised, partisan construction of a national art history.

With the notable exception of MAM-SP's 1949 exhibition *Do figurativismo ao abstracionismo,* discussed in the first chapter, the museums' exhibitions and publications of the late 1940s and early 1950s were aimed at domestic audiences. In the first Bienal special exhibition, Milliet and Machado sought to establish an equal relationship between Brazilian and Euro-American art histories for an international audience. This project entailed, to their minds, presenting a cohesive picture of Brazilian art in line with foreign expectations and existing knowledge. Milliet's reflections on MAM-SP's early activities underscored the museum's desire to provide a historical account that sorted out the "anarchy" that prevailed during the first half of the twentieth century.[75] This comment is telling, as the selection made for special exhibition avoided the stylistic and ideological heterodoxy of Brazilian modernism of the 1910s, 1920s, and 1930s, setting aside not only consecrated modernists Amaral and Malfatti, but also Flávio de Carvalho and Cícero Dias, the latter two having been shown in Venice in 1950. Machado also understood the need to define a national art history in order to assert an international stature for Brazilian art. In his introduction to the biennial catalogue, Machado described the thinking behind the selection of artists for the special exhibition as follows: "The choice, which was studied by the Executive Board of the Museu de Arte Moderna, aimed to select a handful of Brazilian artists whose names and whose works have, in some way, attracted the attention of foreign critics."[76] But Machado's assertion that the presentation of Brazilian

modernism put forth at the first Bienal was calibrated to the existing international appraisal of local artists deserves scrutiny.

Much of Brazilian modernism was sidelined in the special exhibition display, and Machado's criteria were applied with a short memory—Amaral was among the best-known Brazilian artists internationally—as well as subjectively. It is a reach to make the case that Brecheret, Giorgi, or Goeldi were internationally known figures. It is true that at mid-century Portinari was the most well-known Brazilian artist abroad, where he epitomized the Pan-American ideal of artist as a cultural worker uniting people, and where his Communist commitments were ignored. It is possible organizers conceived the assembled painting display, in particular, to be in sync with foreigners expecting to encounter in Latin America a social realism inspired by Mexican muralism and proffering a critical representation of reality.[77] The Brazilian special exhibition likely followed the widely praised model of foregrounding select great artists in the Mexican representation to the Venice Biennale in 1950. Organizers perhaps also sought to avoid anticipated claims of the belatedness or derivation of Latin American artists' employments of Cubism, Expressionism, and Surrealism. (A reviewer writing for *Time* saw Di Cavalcanti as "a smaller replica of his idol, Diego Rivera," simultaneously indicating that foreign critics did seek to assimilate Brazilian art with their existing knowledge of Mexican muralism—and that narratives of derivation are difficult to evade.[78])

In aggregate, the special exhibition of the first Bienal adopted a heroized representation of the nation, foregrounding the acknowledged masters of social realism in the painting display; the vernacular connections of the woodcut medium, with works by Goeldi and Abramo; and cultural stereotypes in Brecheret's and Giorgi's sculptures. Brecheret's biomorphic sculpture *Índio e a suassuapara* (Indian and the Fallow Deer) of 1951 was among the most reproduced representations of the nation from the special exhibition, rendered in miniature as a prize statue for the event (fig. 33). Rather than a social painting dedicated to current realities, Brecheret merged human and animal into a biomorphic mass, and proffered the trope of the indigenous as analogous to nature, a compliant participant and backdrop to the colonial and national projects. Such an image was far from the radical edges of art of the early twentieth century, and instead offered a romanticized image of the national past in an abstracted style that at least one critic accused the artist of cynically adopting to suit the tastes of the patrons of the Bienal.[79]

With the sole exception of Maria Martins, the selection was exclusively male, excluding the two most prominent women modern artists, Malfatti and Amaral, as well as Carvalho, an artist who challenged heteronormative sexuality. Malfatti's expressionist

FIGURE 33. Victor Brecheret. *Índio e a suassuapara.* 1951. Bronze, 31 ¼ × 40 ⅛ × 18 ¼ in. (79.5 × 101.8 × 47.6 cm). MAC USP Collection. Gift of the Museu de Arte Moderna de São Paulo.

paintings had infamously been greeted in the 1910s with misogynistic dismissal as the products of a hysteric, but the art writing about Malfatti and Amaral at mid-century argued for their foundational positions in the history of Brazilian modernism. However, that same discourse was dismissive of their recent works, which were viewed as recycling their early production or descending into genre painting, appraisals reflective of unequal professional possibilities for women artists.[80] In the opening days of the Bienal, Malfatti staged a retort and asserted her primacy in the history of Brazilian modernism, giving a lecture titled "The Arrival of Modern Art to Brazil."[81] That the lecture was held at the Pinacoteca do Estado de São Paulo, the long-standing collector of local art which the founders of MAM-SP and MASP had usurped in resources and limelight, adds to the critical edge of Malfatti's gesture. In Martins's densely installed exhibition seventeen sculptures overflowed from a bay measuring 8 × 4 meters (approximately 26 × 13 feet) (fig. 34).

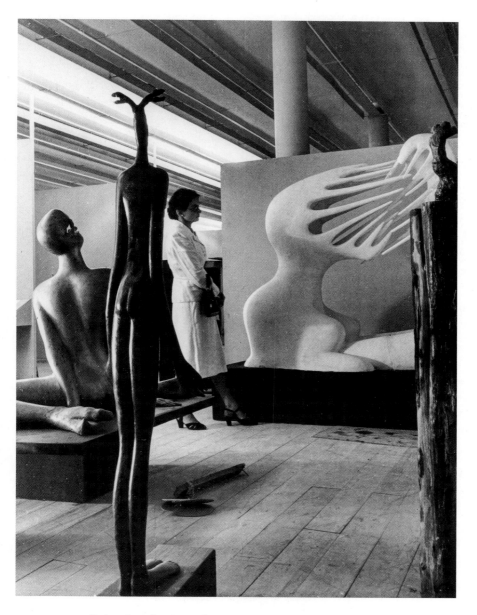

FIGURE 34. Installation view of sculptures by Maria Martins at the first São Paulo Bienal. 1951. Fundação Bienal de São Paulo/Arquivo Histórico Wanda Svevo. Photo: Peter Scheier/Acervo Instituto Moreira Salles.

Large-scale, menacing representations of naked female bodies confronted visitors, an abrupt interruption of the normatively masculine vision of Brazilian modern art elsewhere in the special exhibition.

Portinari's display of works encapsulated the perils of the gambit to narrate a national art history as a moderated form of social realism in which, as Pedrosa wrote regarding Segall's display, "social tragedy stopped being a real preoccupation to become a theme."[82] Portinari assembled his recognized masterworks, *Retirantes* (Drought Refugees), *Enterro na rede* (Burial in a Hammock), and *Criança morta* (Dead Child), all from 1944, alongside commissioned religious and history paintings, including the *Primeira missa no Brasil* (First Mass in Brazil) of 1948. He also displayed several early 1950s medium-format paintings, dwarfed by the surrounding works, depicting a figure known as the *cangaceiro,* a renowned outlaw in the Northeast in the late nineteenth and early twentieth century who formed bands and violently confronted landowners and the government alike (fig. 35). Portinari debuted the new series in the context of the severe drought centered in the Northeastern state of Ceará that stretched from 1951 to 1953. His 1944 works responded to a prior drought, in 1942, and employed multifigure, monumental compositions, a grisaille palette, and expressionist facture to render harrowing, affective scenes of desperation. The *Cangaceiro* series, by contrast, were formatted as portraits that humanized the outlaws, going so far in some paintings as to include a white lamb or horse nurtured gently by the bandit. Devoid of context aside from regional dress and weapons, Portinari re-presented the anti-hero with little criticality. Filmmaker Glauber Rocha's criticism of Victor Lima Barreto's 1953 film *O Cangaceiro* can be applied to Portinari's paintings: Rocha describes the film as relying on easy psychological archetypes rather than analyzing the devastating social and economic conditions the *cangaceiro* revolted against.[83] By the 1950s, as art historian Annateresa Fabris has established, critics disapproved of Portinari's tacking between styles and cast doubt on his claim to social criticism, deeming his recent work artificial and theatrical.[84] In the context of the Bienal, the portrayal of the Northeastern subject as outlaw served as a counterpart to the image of São Paulo as a place of progress and modernity.[85]

The installation of the Bienal placed the invited Brazilian artists on the ground floor alongside the representations from the nations considered in Brazil to be international artistic and cultural leaders, including Britain, France, Italy, and the United States, using this positioning to assert the parity implicit in a biennial project by a developing nation.[86] While the invited artists were afforded privileged placement, the prize jury—presided over by Machado and composed of eight international critics and curators, René d'Harnoncourt, Jacques Lassaigne, and Jorge Romero Brest among them, as well as Brazilians Milliet and

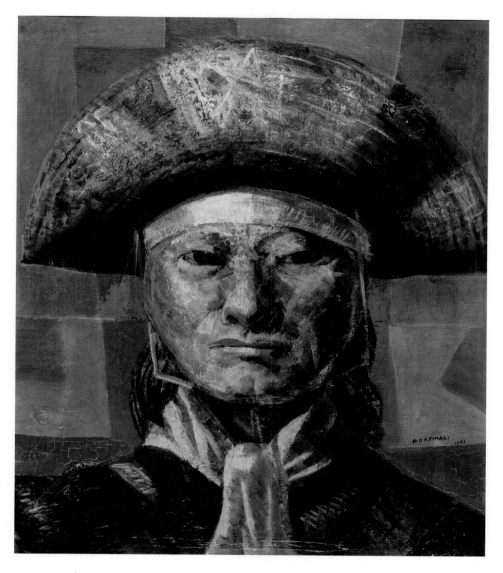

FIGURE 35. Cândido Portinari. *Cangaceiro*. 1951. Oil on canvas, 21 ¼ × 17 ¾ in. (54 × 45 cm). Private collection. © 2020 Artists Rights Society (ARS), New York/AUTVIS, São Paulo.

Santa Rosa—delivered a far from resounding endorsement of the national art history pictured at the first Bienal. The possibility of excluding invited artists from the prizes was briefly discussed in the press prior to the Bienal, but it became neither the policy nor the practice.[87] Brecheret and Goeldi received the top national prizes in their mediums—the official domestic sculpture and printmaking prizes, respectively—and Giorgi received the largest of the sculpture acquisition prizes for a domestic artist. But none of the invited painters received an official or acquisition prize. (Brazilian modern painting was not excluded: Amaral's important 1924 painting *E.F.C.B.*, hung amid the cacophony of the general section, received an acquisition prize.) If we understand the special exhibitions of Brazilian artists to be an attempt to consolidate a national art history and to establish an equal relationship between Brazilian and European and US art histories, the decision by the prize jury to deny the ostensibly most celebrated Brazilian painters laurels suggests a failure of those objectives.

Curator Ariel Jiménez has asserted, regarding the Venezuelan postwar context, that it is paramount not to disregard the desire among Latin American artists and critics for international legitimization and the establishment of "historic synchrony" with European modernism.[88] Copious press commentary on the painting prize substantiates the premium placed on international acceptance of the equality of Latin American and European modernism that Jiménez notes. Critics ranged in their reaction to the shutout from indignation at perceived slights and condensation by foreign jurors to widespread rumination on the uneven quality of the Brazilian works on display. Both Bento and Pedrosa were troubled by what they saw as the capitulation of the Brazilian jurors to the inclinations of the foreign jurors.[89] Underpinning the various responses was a debate about what artistic idiom and which artists genuinely represented Brazilian visual art innovation. As various critics recounted, for the top national painting prize the prize jury considered Di Cavalcanti, Portinari, and Segall, as well as the Afro-Brazilian samba musician and self-taught artist Heitor dos Prazeres and emerging artist Maria Leontina, before selecting a still life by Danilo Di Prete, a relatively unknown artist who had immigrated to Brazil from Italy five years earlier.[90] Unsurprisingly, the choice of Di Prete caused controversy.[91] Bento, who had denounced as nativist earlier criticism of foreign-born Brazilian artists as unsuitable to represent Brazilian art, nevertheless viewed the choice of "that Italian painter" as a dismissal by foreign critics of the originality of Brazilian modernism.[92]

With official and acquisition prizes to Prazeres, Leontina, and Di Prete, the jury avoided social realist painting, opting instead for smaller-scale still lifes and genre scenes, and offered a vision for Brazilian painting made by more diverse practitioners than the

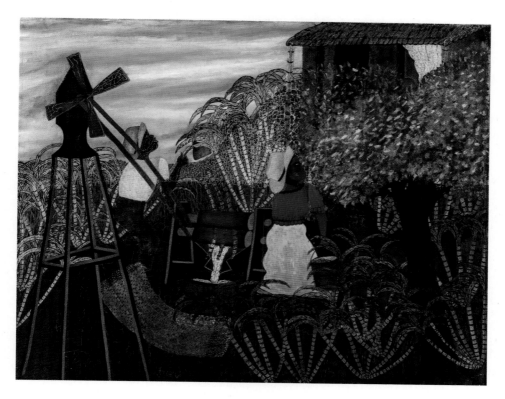

FIGURE 36. Heitor dos Prazeres. *Moenda*. 1951. Oil on canvas, 25 9/16 × 31 15/16 in. (65 × 81.1 cm). MAC USP Collection. Gift of the Museu de Arte Moderna de São Paulo. Patrimônio Família Heitor dos Prazeres.

Bienal organizers featured in the special exhibition. In *Moenda* (Sugarcane Mill), Prazeres depicted two Afro-Brazilian figures amid a sugarcane crop, mill, and building, both standing still, looking upward toward the empty veranda of the building (fig. 36). Rather than history painting, Prazeres's framing is up-close and quotidian. In an inversion of the hierarchies that paralleled the prize jury's favoring of the minor over the monumental, Pedrosa doubted the potential of sculpture and painting as the mediums for an authentic national art, describing Brecheret as a potter making big figurines and Portinari as a painter of superficial anecdotes.[93] Instead, Pedrosa put forward Goeldi and his woodcuts as the best guideposts for national art going forward in terms that echoed the praise for Prazeres as producing a "legitimate expression" of Brazilian existence.[94] Pedrosa argued that by avoiding any concern with being "modern," Goeldi's work

"defines an atmosphere that is ours, and current."[95] While essentialized, the valorization of Prazeres and Goeldi by critics seems alert to the potential perils of a heroized national art history and of a biennial project that presented Brazilian artists as merely inserting local flavor into imported Euro-American modern art formulas.

That being said, much attention by art critics and politicians to Prazeres was self-serving. With the prize to Prazeres, foreign members of the Bienal prize jury arguably found in Brazilian art the racialized other they sought, and not the avant-garde fellow traveler Machado asserted.[96] The Vargas administration quickly instrumentalized Prazeres's prize at the first Bienal to evidence its purported advocacy for those marginalized because of race and class in Brazilian society. In a series of articles on the artist and musician, *Última Hora,* the Vargas-funded newspaper which pioneered populist journalism targeted at the lower-middle and working class, deemed Prazeres "one of the true assets of Brazilian painting."[97] The federal government was cast as a just patron, including accounts of personal meetings of Prazeres with President Vargas and Education Minister Simões Filho, and their commitment to elevate Prazeres's status as a public employee given his achievement.[98]

ABSTRACTION'S AUDIENCES AND AUTHORS

No art object has been more closely associated with the emergence of Concretism in Brazil and the role played by the Bienal in its rise than Bill's sculpture *Tripartite Unity* of 1948–49 (fig. 37). The work stands some three feet high and consists of a composite, three-part Möbius strip realized in stainless steel. In the context of Bill's retrospective at MASP in March–April 1951, *Tripartite Unity* was one of some seventy works in mediums ranging from painting and sculpture to drawing, printmaking, photography, and graphic design. As art historian María Amalia García has noted, there was little coverage of Bill's exhibition by the Brazilian press.[99] It was not until half a year later when *Tripartite Unity* was displayed, with the permission of the artist, in the general section of the first Bienal and received the international sculpture prize that Bill became a subject of widespread discussion by Brazilian art critics.[100]

Deemed a masterwork by its purchasers at MAM-SP and, in the aftermath of the Bienal, by a growing number of local artists, the work came stand for the connection to the history of the European historical avant-garde and the international relevance sought by Brazilian artists, thinkers, and patrons.[101] Art historian Beverly Adams has argued that the whole of the Brazilian Concrete art movement—and Bill's sculpture in

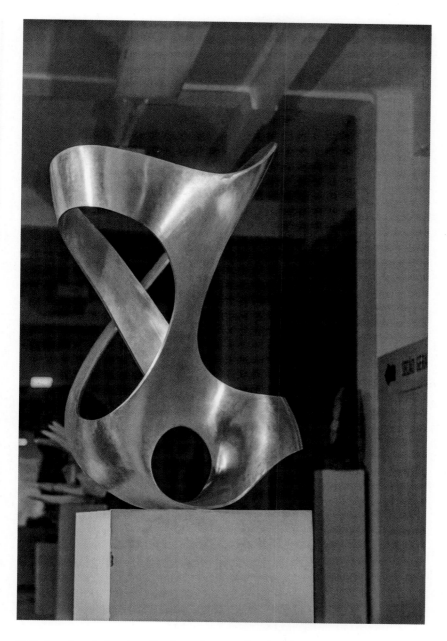

FIGURE 37. Installation view of sculpture by Max Bill at the first Bienal de São Paulo. 1951. Fundação Bienal de São Paulo/Arquivo Histórico Wanda Svevo.

particular—succeeded in part because they were well suited aesthetically and conceptually to the country's push for large-scale economic development at the time.[102] Bill wrote that it was the task of contemporary artists to tackle the axioms of mathematics and physics in order to create "new symbols" that revealed, in his view, the fundamental and universal concepts organizing human existence.[103] The slick, crisp geometric forms of *Tripartite Unity* functioned in Brazil's cosmopolitan centers at mid-century as an emblem, embodying the desire for an image of a thoroughly modern nation-state. (The symbolic potency of Bill's sculpture was confirmed by Oscar Niemeyer's emulation of it in monumental scale for the fourth centennial celebration of the city of São Paulo in 1954, a work analyzed in the fifth chapter.) The visibility that the first Bienal granted to emerging Brazilian abstraction was predicated on its resonance with the practices of international artists, none more so than Bill. However, the character of that visibility and the mechanisms by which a relationship between Euro-American abstraction and disparate domestic abstract practices were made legible warrants close examination. As analysis of the installation of abstract works, Brazilian and otherwise, in the galleries at Trianon and the gendered reception of abstract art in the press reveals, both the practice of early Brazilian abstraction and its reception were enmeshed in considerations of region, nation, and world.

While the design of the catalogue, poster, and building were directly or indirectly controlled by the leadership of MAM-SP, and foregrounded modern design, the selection of works for the general section was not controlled by MAM-SP and figuration featured prominently. The selection jury, which counted adamantly pro-realism artists and critics Campofiorito and Clóvis Graciano among its four members, did not exclude abstraction, accepting a number of the abstract works submitted. Numerically, however, figuration predominated in the general section, partially reflecting the character of the works submitted, but also as a result of choices by the jury. Each artist was able to submit a maximum of three works, and a larger portion of realist or quasifigurative artists' submissions were integrated into the exhibition on average, with three works shown by not only consecrated figures like Amaral, Roberto Burle Marx, Alberto da Veiga Guignard, and Malfatti; established so-called primitive artists Djanira da Motta e Silva, Prazeres, and José Antonio da Silva; and figures active in the 1930s and 1940s São Paulo and Rio artistic scenes like José Pancetti and Alfredo Volpi, but also lesser-known social realist and genre scene painters. In contrast, the jury mostly accepted only one or two of the works submitted by emerging abstract artists, and famously rejected Palatnik's experimental kinetic light work (ultimately included in the exhibition as the result of Pedrosa's advocacy).

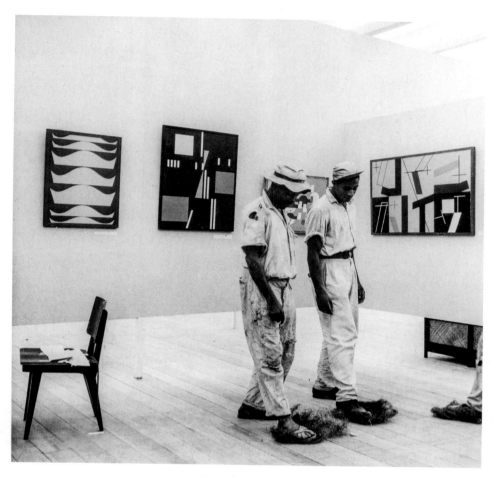

FIGURE 38. Janitorial staff members in Sophie Taeuber-Arp's display at the first São Paulo Bienal. 1951. Fundação Bienal de São Paulo/Arquivo Histórico Wanda Svevo. Photo: Peter Scheier/Acervo Instituto Moreira Salles.

Antonio Bandeira and Serpa were the sole abstract artists whose entire submission was accepted by the selection jury.

If not numerically predominant, the abstract works in the general section neverthe-less attracted substantial press and critical commentary. The poster prize to Maluf, national young painting prize to Serpa, a print prize to Barros, and honorable mention to Palatnik, along with prizes to Bill, Magnelli, and Taeuber-Arp, afforded the idiom

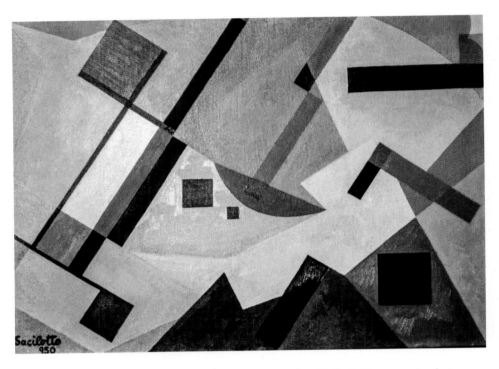

FIGURE 39. Object view of Luiz Sacilotto's *Pintura I*, 1951, at the first São Paulo Bienal. 1951. Fundação
Bienal de São Paulo/Arquivo Histórico Wanda Svevo. Image courtesy Valter Sacilotto.

visibility. Machado's installation and the composition of the Swiss representation made
emerging geometric abstraction intelligible. Machado installed Bill's *Tripartite Unity* at
the entrance to the basement, which displayed the general section (composed of works by
Brazilian and non-Brazilian artists submitted and selected by the selection jury) as well
as the foreign representations not featured on the ground floor, the architecture exhibi-
tion, and the small theater and music exhibitions. Nonobjective abstraction literally
served as the threshold as visitors transitioned from the first floor to the more densely
installed basement galleries.[104] Heinz Keller, curator of Kunstverein Winterthur, also
elected to focus the Swiss representation exclusively on nonfigurative art, and fore-
grounded Taeuber-Arp as the progenitor of geometric art practiced by Bill, Leo Leuppi,
and Richard Paul Lohse, the latter two of whom were included in the representation and
all were discussed in Keller's catalogue essay.[105] Taeuber-Arp's mini-retrospective of eight
paintings, likely installed by Machado, functioned as a space of formal legibility in the

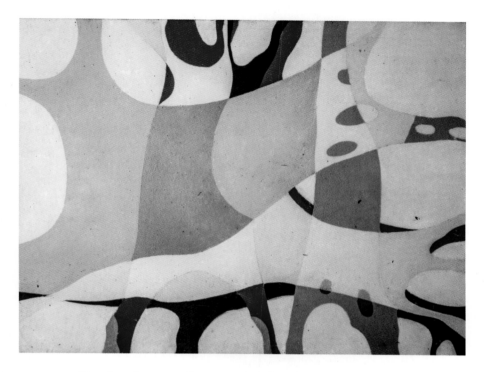

FIGURE 40. Object view of Kazmer Fejér's *Composição,* n.d., at the first São Paulo Bienal. 1951. Fundação Bienal de São Paulo/Arquivo Histórico Wanda Svevo.

midst of a large, stylistically heterogeneous, and labyrinthine two-floor exhibition (fig. 38).[106] Bill's work a floor below amplified the coherent presence of Swiss Concrete art at the event. Rather than being marginalized by its exclusion from the Swiss national representations on the ground floor, Bill's sculpture was presented in its installation at the Bienal as a crucial frame, through which a visitor could understand and evaluate the recent, predominantly Brazilian, art displayed in its wake.

In the general section, at least in several instances, Machado installed nonobjective abstract works close together, juxtaposing, for example, paintings by Sacilotto and Fejér as well as those of Mavignier and Ramiro Martins, a Rio-based abstract artist (figs. 39–40).[107] Moreover, among the works by emerging abstract artists, paintings by Cordeiro and Serpa grew from study of artists also on display, Bill and Taeuber-Arp respectively, and thereby tangibly visualized the local dialogue and historic synchrony with international art (fig. 41). García has shown that the works Cordeiro exhibited at the first Bienal resulted from

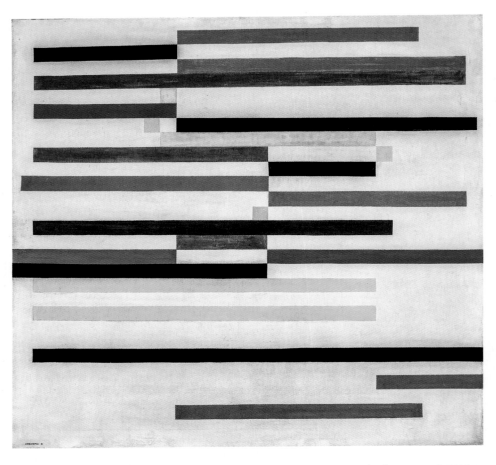

FIGURE 41. Waldemar Cordeiro. *Movimento.* 1951. Tempera on canvas, 35 ½ × 37 ⅛ in. (90.2 × 95 cm). MAC USP Collection. Purchase MAC USP. © Analívia Cordeiro.

thinking through paintings by Bill, which Cordeiro likely saw exhibited in Bill's 1951 retrospective at MASP.[108] As discussed in chapter 2, Serpa's series *Formas,* including his prize-winning painting of 1951, emerged from sustained study of Taeuber-Arp (see fig. 24).

That being said, it is important to note the diverse practices among emerging Brazilian abstract artists. Visitors to the first Bienal were confronted with titles that suggested an engagement with visual perception, mathematics, and movement—*Blue and Purple in First Movement, Equation of Developments, Double Space,* and *Movement*—as well as the

watchword of emergent abstract debates, *Form,* but also with titles that broadly sought to clear away representation, such as *Composition, Abstraction,* and *Painting,* which had been used by Brazilian artists since the late 1940s. The former titles announced the moves by Cordeiro, Maluf, Palatnik, and Serpa away from a Cubist-based abstraction to a nonobjective abstraction composed of geometric forms and engaged with visual perception. In contrast, Charoux and Wladyslaw displayed kaleidoscopic compositions organized by Cubist faceting and scaffolds in which the artists stripped still lifes and interior scenes down to bare-bones geometric forms. To different effect, Bandeira used roughly hewn Cubist grids to organize his loose brushwork and fragments of realism. Sacilotto also relied on an illusionist genre, specifically landscape, but, rather than Cubist devices, his *Pintura I* (Painting I) of 1950 brings together several nonobjective abstract styles (fig. 39). The colorful scene calls to mind elements of geometric compositions by Kandinsky, Paul Klee, Taeuber-Arp, and Xul Solar, with opaque and translucent geometric forms that seem to be airborne. Into this dynamic, Sacilotto inserted an overtly De Stijl passage at the left of the composition, in which black orthogonals delineate flat, rectilinear areas of red, white, black, and gray. Fejér and Palatnik, who would become prominent experimental sculptors in subsequent years, displayed works with vastly different materials—an oil painting in Fejér's case and a kinetic light work in Palatnik's—that signaled a shared interest in dynamic chromatic and material transformation (fig. 40).[109] Diaphanous forms undulate, appear, and disappear before the viewer's eyes. The side-by-side juxtaposition of Sacilotto's painting, staging an apprenticeship to European modernism, with Fejér's microscopic study of morphology encapsulates the range of abstract practices.

Amid the overwhelming experience of viewing 1,854 artworks from twenty countries—more if we include the architecture, theater, and music sections—between the two crowded floors (a viewing experience up to that point only distantly approximated by the national and municipal salons) and the diversity of emerging Brazilian abstraction, is it possible to imagine a visitor perceiving and being convinced by an internationalist vision of local abstraction? Armed with the catalogue, knowledge that Bill, Palatnik, Serpa, and Taeuber-Arp received prizes and mentions, press coverage on the importance of the Swiss representation; commentary by Romero Brest trumpeting Bill as a modern-day master on par with Michelangelo for a new generation of abstract artists; and Pedrosa's declaration that Bill, Taeuber-Arp, and Palatnik were the future of art, would a visitor have walked between the Swiss exhibition and the general section and noted resonances?[110] Between Taeuber-Arp's paintings and those of Serpa and Sacilotto? Between Lohse's and Cordeiro's paintings, both composed of colored bands on monochrome

grounds? Between Leuppi's and Fejér's biomorphic abstractions? Can we imagine the legibility of an international context for emerging Brazilian abstraction being extended to less coherent components of the exhibition, such as paintings by František Kupka or those of prize-winner Magnelli, both in the French representation? Would Joaquín Torres-García's presence in the Uruguayan representation and potential affinities with Brazilian abstraction have been reinforced by abstract works by Torres-García's younger countrymen Julio Alpuy and José Pedro Costigliolo in the general section? In other words, is it possible to imagine a visitor constructing an understanding of Brazilian abstraction as one node of an international network? And could one suspend that story alongside the many, seemingly contradictory accounts of the national artistic scene proffered in the press, such as those of intergenerational stylistic and ideological strife and of the superiority of the country's printmaking to its painting and sculpture?

Perhaps not, or at the very least not by a wide cross-section of visitors. What is not in doubt, however, is that emerging abstract artists—catalogue and press coverage in hand and conversations with thinkers like Pedrosa and Romero Brest, both in person and on the page, in mind—sought out both connections and distinctions between their own theory and practice and that of Euro-American artists. Indeed, Machado viewed local artists as the primary focus of the Bienal project, and made possible, likely both wittingly and unwittingly, the itineraries between international and national abstract artworks, bridged by Bill, whereby artists enacted the "active contact" he envisioned between Brazil and the world. Matarazzo, for his part, worked to concretize this relationship in the collection of MAM-SP through the acquisitions he funded from the Bienal, including purchase of Lohse's painting and Bill's sculpture and financial support for the acquisition prize awarded to Taeuber-Arp.[111]

In a lengthy article about the first Bienal, *Habitat*'s reviewer—possibly the Bardis writing under the pseudonym Serafim—argued that Brazilian abstract artists, "that swarm of pseudo-geometrizers," were no different from academic artists who followed a fashionable style in order to secure buyers.[112] The concern about a facile adoption of abstraction by local artists was widespread among critics. For example, Milliet wrote: "I am not against abstraction, as I am not against any contemporary school, but it should not be the attitude of our painters to explore a formula. But to seek to experiment with authenticity."[113] Similarly, poet Murilo Mendes wrote, "I think the path of some young artists is very dangerous, confusing abstraction with geometrization."[114] The emerging practice of nonobjective abstraction, codified by the awarding of the national young painter prize to

Serpa, was on the mind of these critics. But the small number of works in this idiom, even loosely defined, relative to the larger general section display—fewer than thirty among 397 paintings, sculptures, and prints—suggests this anxiety about pseudo-geometrizing clones had a broader trigger. Some issued explicit swipes at Giorgi and Brecheret for what was perceived as their craven adoption of abstraction in recent works.[115] Critics were also likely jarred by the more abstracted and geometrized recent works by members of Grupo Santa Helena and Grupo Seibi, such as Mario Zanini, Bonadei, Shigeto Tanaka, Flavio-Shiró, and Volpi, whose muted portraits, landscapes, and seascapes and rural scenes had been mainstays of São Paulo salons since the 1930s.

Transformation of accepted, uncontroversial depictions of national and regional distinctiveness, deemed to be created with authenticity, into an abstract vision attuned to the shifting tastes of foreign and domestic audiences, alarmed commentators. The mixture of regionalism and nationalism with what critics perceived as an opportunistic internationalist gloss threatened the ongoing construction of a national art history, in which the 1930s and 1940s had been cast as a period of autonomous socially oriented painting. In other words, the emerging story of national art production could account for a young artist's internationalist break in the early 1950s, but not for the detour of older artists whose practices were considered nationally and regionally grounded. A feature depicting actress Maria Fernanda, daughter of prominent poet Cecília Meireles, posed among paintings in Santa Rosa's studio in 1952 in the new mass-market lifestyle magazine *Manchete* exemplified art writers' fear of losing control of the conversation surrounding the country's visual arts story (fig. 42). Santa Rosa, among the authors of the first Bienal as designer of the abstract catalogue cover and member of the selection and prize juries, was considered one of the regionally diverse constellation of followers of Portinari in his social realist painting practice of the 1940s, and a pioneer of Afro-Brazilian expression via his set design and theater work.[116] In the early 1950s he began making abstract paintings that leapt from works oriented by the Russian and Dutch historical avant-gardes to calligraphic large-scale works at home with Euro-American mid-century gestural abstraction. The *Manchete* article declared that abstract art had made obsolete any method for interpretation: "It does not matter what others think because this is true Art."[117] An announcement of the death of the nascent field of art criticism in a popular magazine, and the use of signifiers of national and regional identity—earthen jugs—as just one accoutrement among others of worldly sophistication—books, easels, paints, young beauties—confirms the worst fears of art critics for *Habitat, Fundamentos,* and beyond

FIGURE 42. Salomão Scliar. Photograph of the studio of Tomás Santa Rosa. 1952. Reproduced in *Manchete*, no. 22, September 20, 1952: 21.

about the implications of abstraction for local art-making, as well as illustrating the degree to which imaginings of the region, nation, and world were intertwined in the reception of abstraction.

Accompanying the *Habitat* review of the first Bienal was an illustration of an advertisement for a US-made industrial oven, torn from a local newspaper and modified to read, "It is already possible to install an ultra-modern abstraction!" (fig. 43).[118] By substituting the word *abstração* (abstraction) for *panificação* (bakery), the illustration equates the artistic style with a brand-new, imported commercial good and compares local

FIGURE 43. Illustration in *Habitat: Revista das Artes no Brasil,* no. 5 (October–December 1951): 7.
Art & Architecture Collection, The New York Public Library. © Instituto Bardi/Casa de Vidro.

abstract artists to consumers of the latest foreign products. Instead of being elevated to a
new aesthetic language that would allow Brazilian artists to contribute as equals to the
international art scene, abstraction is situated alongside a mundane loaf of bread and
machines that will surely be surpassed by newer models next year. At its crux, *Habitat*'s
critique sought to reveal what the Bardis and others inside and outside the magazine's
orbit saw as the false promise of the Bienal model, which was predicated on the undis-
criminating importation of foreign art, the facile adoption of trends by local artists, and
the elision of local traditions and histories.

The *Habitat* reviewer chastised elite visitors for flocking to the Bienal despite their lack of real interest in art, as well as the Bienal organizers for failing to provide visitors with enough information about what they were seeing, commenting that the exhibition was tantamount to inviting the public to see the art market.[119] In an extended diatribe prefaced by criticism of the placement of Bill's sculpture in the basement, the author characterized the public for the Bienal as know-nothing rich women seeking social prestige:

> The splendid steel was located by the organizers of the Bienal in that sort of basement, underground, as an expression of the placid artistic commercialism of the dilettante ladies of São Paulo, the wealthy and beautiful dames who could not be absent, exposing themselves in the basement of an international exhibition. (Art is not something for social ambition or snobbery; it is something serious, profoundly serious; the feminine worldliness should have been marginal, as excessive worldliness ended up confusing international art with the matchboxes of a démodé nightclub. . . .)[120]

Issued from a progressive art magazine aligned with a museum also patronized by the São Paulo elite, sexism was deployed to distinguish the presumed high-mindedness of MASP's patrons from an intolerable mixture of commercialism, dilettantism, and femininity purportedly encouraged by the Bienal.

Habitat was accurate in its identification of the Bienal's audience as privileged. An entrance fee of 10 cruzeiros ($5.25 in today's dollars) limited the exhibition's accessibility, and the event opened with the vague promise of the future establishment of a day or two a week without admissions charges.[121] On the closing night of the Bienal, under a headline that 100,000 people had visited, Matarazzo singled out a smaller number—that of the 50,000 who paid the entrance fee—as an indication of the shapeshifting function of the visual art event, making clear the premium placed on the paying public as the intended audience for the event.[122] The working classes, including the recent influx of internal migrants, many Afro-descendant, from the Northeast and Minas Gerais to São Paulo, who served as the laborers in the expanding industrial and service sectors, were not the intended audience of the event.[123] This included the janitorial staff pictured in documentation of the exhibition (see fig. 38).

Newsreel footage of the event seems to confirm the worst fears of Communist intellectuals that the Bienal sought to promote art that marginalized the lives and rights of working class and poor people: an overloaded truck, cars, and a black woman dressed in the uniform of a domestic worker pass by the façade of the Trianon building, and

moments later a smiling Darcy Vargas, accompanied by an entourage, ascends the stairs where she is greeted by Penteado, each dressed in smart suits and hats.[124] The men, including Matarazzo, also in suits, largely remain at the margins while the first lady, Penteado, and other elite white women dutifully look at the prize-winning works. A variation on the "Ciccillo-Rockefeller" yoking that the militant left press had put forward, here the women of the Brazilian elite are represented as consumers of art that has been announced as modern. That Penteado was in fact a behind-the-scenes author of the event, having traveled widely to secure the participation of foreign governments, was unacknowledged in this visualization of the habits of elite art viewing.

In the reception of the Bienal, gender was utilized as code to distinguish the serious from the unserious, as well as the producer from the consumer. Furthermore, abstraction in particular unleased anxiety expressed in gendered terms about the expanding postwar audiences for art in Rio and São Paulo. The masculinist construction of national painting in the image of Portinari at the Bienal fell flat, but the image of the vapid but savvy Europeanized elite woman consuming novel, geometricized art succeeded and would be deployed again and again in the coming years. As I examine in the subsequent chapter, women abstract artists navigated these treacherous gendered expectations and, as at the first Bienal, the construction of national and regional stories was intertwined with the assertion of international dialogues in the first Concrete-oriented abstract art group exhibitions in the country.

Collective, Concrete Abstractions

Grupo Ruptura and the National Exhibition
of Abstract Art

During a three-month period in 1952 and 1953, abstract artists in Rio and São Paulo and their environs mounted the first group exhibitions of Concrete-oriented geometric abstraction in the country: the exhibition of Grupo Ruptura in São Paulo in December 1952 and the Exposição nacional de arte abstrata (National Exhibition of Abstract Art) in Petrópolis, outside of Rio, in February 1953. Close study of these presentations, auxiliary events and texts, press coverage, and the production of the growing ranks of abstract artists reveals the expanded intellectual and political nexus of ideas defining Brazilian Concretism. Following the reshaping of the Brazilian cultural sphere by patrons and art professionals at the newly formed art institutions, none more so than the Bienal, these exhibitions were gambits, driven by artists and critics, for a transformed collective life of artists in the country. By describing their work as a national artistic practice in the exhibitions and related events, abstract and Concrete artists sought not only visibility but also an elevated status for their collectives.

The exhibitions importantly expanded the early practice and theory of abstract art. In the Ruptura manifesto and its subsequent defense, Cordeiro radicalized his theory of abstraction, asserting a social role for Concrete art. As in his earlier articulation of *forma-ideia* (form-idea), Cordeiro proposed that the contribution of abstract art resides in its derivation from rigorous and timely concepts. But if, in Cordeiro's pre-Ruptura theory of abstraction, the social realm entered via artists' nonmimetic engagement with modern technologies, with Grupo Ruptura the social comes via claiming the historical and spiritual import of art conceived as a form of knowledge. The reception of the Exposição nacional de arte abstrata and its organization by Rio-area artists demonstrate the reconfiguration of the abstract artistic scene in the federal capital, built on the community formed around Mário Pedrosa in the late 1940s, but with Ivan Serpa emerging as a leader. Pedrosa remained a key interlocutor and his study of perception and form stimulated the abstract production of local artists. Serpa, at odds with Pedrosa's concern about the doctrinaire tendencies in Concretism, nonetheless successfully promoted a nonobjective abstract praxis largely free from subjective expression, grounded in close study of mathematics and industrial materials.

The stakes of these inaugural Concrete art displays went beyond conceptual positions on abstraction to extend to the consolidation of group artistic identities enmeshed with institutional critique and broadly leftist political commitments. Cordeiro's theorization of the role of the artist in society loomed large and framed art critical and artistic discourse beyond São Paulo. Alexander Alberro and María Amalia García also foreground Cordeiro's institutional critique in their discussions of Grupo Ruptura, arguing that Cordeiro was oriented by the ideas of Italian philosopher Antonio Gramsci.[1] Drawing on a large body of Cordeiro's writing, including previously unanalyzed writings for the São Paulo newspaper *Folha da Manhã* and scripts for public talks, I instead examine Cordeiro's integration of the ideas of German aesthetic theorist Konrad Fiedler.[2] Cordeiro's use of Fiedler, highlighted by art historian Ana Maria Belluzzo, has long been acknowledged by scholars, but I situate Cordeiro's engagement with the German thinker and resurfacing of a Marxist understanding of history in his sporadic participation in activities of the Partido Comunista Brasileiro (PCB) and intellectual dialogue with fellow Grupo Ruptura members.[3]

In a 1952 essay titled "The Return of the Artist to Collective Life," Cordeiro declared that innovation in the country's abstract painting "could, if properly approached, reorganize human visuality, endowing it with vital and extremely useful energies for ideological progress."[4] With examples from the Italian Renaissance, he narrates how collaboration between groundbreaking artists enabled gains that exceeded aesthetics to engender societal

change. Cordeiro further argues that such a renovation of artistic practice relied on the activities of robust institutions, which he suggests were making possible a flourishing of the art scene in Brazil on a scale comparable to the Italian Renaissance.[5] For Cordeiro, the ideological progress and collectivity he referenced were those of Communism. While Cordeiro's specific political commitments were not widely shared among the artists of Grupo Ruptura or the Exposição nacional de arte abstrata, his tethering of abstract art and artistic activism to societal change in Brazil were consonant with the often nebulously articulated view of many postwar abstract artists that their work and exhibitions represented a transformation reaching to social structures.

As for the institutions contributing to the postwar effusion of visual art in Brazil, Cordeiro, like all but extreme anti-abstraction critics, credited the new private art entities: the Bienal, Museu de Arte de São Paulo (MASP), Museu de Arte Moderna do Rio de Janeiro (MAM Rio), and Museu de Arte Moderna de São Paulo (MAM-SP). But Cordeiro insisted on the crucial role of artist-run organizations and on the responsibility of all art institutions to support artists.[6] Cordeiro also viewed those same new private institutions as adversaries, none more so than the Bienal, which he described as a "threat" that functioned as "an authoritarian, patron organization" with "artistocratic" tendencies in contradiction to its receipt of public subsidies.[7] The broader community of nonobjective abstract artists in Rio and São Paulo, not without contradictions, were both laudatory and critical of local art institutions. They did not narrowly parrot either the pro-capitalist articulation of international art (which the Bienal was accused of doing by the Communist press) or the anti-imperialist nationalism of the orthodox left.

The exhibitions were supported by the museums of modern art in Rio and São Paulo, but also involved artist-run associations and salons and contested the hegemony of the new private art institutions. Grupo Ruptura held its exhibition at MAM-SP, organizer of the Bienal, despite sustained criticism of both institutions by members of the group. MAM Rio, scrutinized by the press for its receipt of federal funding, but largely praised by artists and art critics, extended patronage to the Exposição nacional de arte abstrata. While both events undoubtedly depended on this support, the events were not limited to the ecosystem of the museums of modern art. Grupo Ruptura amplified its notoriety and membership via a coordinated display at the II Salão paulista de arte moderna (II Paulista Salon of Modern Art) in 1952, and the Exposição nacional de arte abstrata was conceived and executed by the leadership of an artist-run fine art association in Petrópolis. The Salão paulista de arte moderna (Paulista Salon of Modern Art) in São Paulo, inaugurated in 1951, and the Salão nacional de arte moderna (National Salon of Modern Art) in Rio,

announced in 1951 with its first iteration in 1952, were created, thanks to artist advocacy, as spaces reserved for non-academic styles. The modern art salons, as well as the first Bienal and exhibitions of Brazilian art at the modern art museums, enabled abstract artists, previously marginalized at official salons, to view their works as part of panoramas predicated on national and regional identities.

Cordeiro's institutional analysis did not focus on another institution key to the postwar artistic scene: the discursive space of periodicals, most notably the arts coverage in daily newspapers in Rio and São Paulo and new art and design periodicals. Both MASP and MAM Rio counted aligned periodicals as steadfast publicists and champions: in the first case, the *Diários Associados* national network of daily newspapers, owned by the founding patron of MASP, Assis Chateaubriand, as well as *Habitat: Revista das Artes no Brasil,* led by Lina Bo Bardi, a MASP staff member, which functioned as an unofficial MASP publication; and in the second case, *Correio da Manhã,* owned by Paulo Bittencourt, who was the husband of Niomar Moniz Sodré, president of MAM Rio, and a monthly bulletin published by the museum. As an industrialist whose family did not own press outlets, Matarazzo, and MAM-SP and the Bienal, did not have similar partnerships. The federal government's support of the Bienal no doubt contributed to fawning coverage in *Última Hora,* the populist newspaper with both Rio and São Paulo editions funded indirectly by, and firmly in the corner of, the Getúlio Vargas administration. MAM-SP and the Bienal, nevertheless, received overwhelmingly positive coverage in the mainstream press, with the notable exceptions of the MASP-aligned publications and the Communist and militant left press. Analysis of the representation of the inaugural Concrete art exhibitions in a range of press outlets makes perceptible the interconnection of the Petrópolis exhibition, in particular, with national political debates and the disjuncture between the social responsibility Cordeiro asserted for Concretism and the significances claimed by and assigned to the practice at the exhibitions. Furthermore, the role of the mainstream press in the emergence of Lygia Clark as a leading abstract artist in the early 1950s and her self-fashioning shed light on the gendered ways in which the producers and consumers of abstract art were imagined in relationship to the public sphere.

GRUPO RUPTURA'S EXHIBITION STRATEGY

On December 9, 1952, the *Exposição do Grupo Ruptura* (Grupo Ruptura Exhibition) opened at MAM-SP (fig. 44).[8] Composed of seven white men, all but two émigrés to Brazil from southern and central Europe, the group included established and emerging

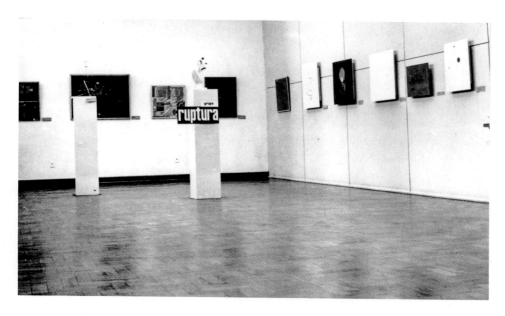

FIGURE 44. Installation view of the *Exposição do Grupo Ruptura* at the Museu de Arte Moderna de São Paulo. 1952. Reproduced in Ana Maria Belluzzo, ed., *Waldemar Cordeiro: uma aventura da razão* (São Paulo: Museu de Arte Contemporânea da Universidade de São Paulo, 1986).

abstract artists and designers Geraldo de Barros, Lothar Charoux, Cordeiro, Kazmer Fejér, Leopold Haar, Luiz Sacilotto, and Anatol Wladyslaw. The artists were from two generations—their ages ranged from late twenties to early forties—and had diverse fine arts, applied art, and technical trainings, including engineering, drafting, printmaking, and photography. Native-born Barros and Sacilotto came from contrasting locales in the state of São Paulo. Barros was the child of an Italian immigrant and a descendant of an old Brazilian family with Portuguese heritage, and spent his early childhood in the agricultural interior before his family moved to the city. Sacilotto was the son of Italian immigrants and came from the industrial ABC region immediately south of the city of São Paulo, where he continued to live. Cordeiro was born in Italy to a Brazilian father and Italian mother, and the remaining four artists emigrated to Brazil from Austria (Charoux), Hungary (Fejér), and Poland (Haar and Wladyslaw). A checklist for the exhibition is not extant, and curators Rejane Cintrão and Ana Paula Nascimento, in their 2002 in-depth study of the exhibition, conclude that most likely it never existed, and the artists themselves curated the exhibition without contributions from MAM-SP staff.[9]

The press commentary on the exhibition focused on the manifesto to the exclusion of discussion of works, with the most detailed comments being generic praise for works by Barros and Cordeiro and noting the presence of different orientations and skill levels among the artists. Before examining the manifesto in the next section, I offer a detailed reconstruction of the installation and works displayed to argue that the inaugural exhibition both occluded and foregrounded the diversity of Grupo Ruptura's practice. Furthermore, examination of a coordinated display orchestrated by the group at a salon reveals the members' focus on cultivating artist-led initiatives as an activist counterweight to the power of private art institutions.

The artists installed the Grupo Ruptura exhibition in a manner that conveyed cohesion, while the exhibition's contents evidenced shared but by no means uniform interests. It was realized in the so-called *pequena sala* (small room) of the museum, which MAM-SP utilized for exhibitions of Brazilian artists. The double-height, irregular space adjacent to the reception and bar areas incorporated a stairway to the mezzanine and occupied over 50 square meters (164 square feet).[10] When visitors entered the gallery to view the Grupo Ruptura exhibition, they encountered a panorama of around twenty-five to thirty similarly scaled, medium-format geometric abstract paintings hung at an identical height.[11] Wladyslaw's and Cordeiro's paintings occupied the walls straight ahead and to the right, respectively, with pedestals for sculptures by Haar placed in the middle of the space, one with a sign reading "grupo ruptura" affixed (fig. 44). The wall on a visitor's left, twice the length of the right-hand wall and interrupted by three large rectangular columns projecting from the wall and creating bays, contained paintings by Charoux, Barros, Sacilotto, and possibly Fejér, displayed monographically.[12]

As a visitor entered the gallery, the first works she would have seen up close were by Sacilotto and Barros, among the most emphatically nonobjective abstract works on display. Barros's *Objeto-forma (Desenvolvimento de um quadrado)* (Object-Form [Development of a Square]), currently titled *Diagonal Function,* and Sacilotto's *Articulação complementária* (Complementary Articulation), both from 1952, were centered in their respective bays (figs. 21, 45). Barros and Sacilotto utilized industrial paint on compressed wood to create crisp, graphic compositions on black grounds with forms set in contrasting white, in Barros's case, and primary and secondary colors, black, white, and gray, in Sacilotto's case. Both artists analyze perception to different effects. Barros's stripped-down composition engages the viewer's eye in tense, perceptual flips between the figure and ground. With his title, Sacilotto signaled his attention to complementary color afterimages: how staring at a color and then a white surface provokes an afterimage of the color's opposite

FIGURE 45. Luiz Sacilotto. *Articulação complementária.* 1952. Enamel on plywood, 21 ¼ × 30 ¹¹⁄₁₆ in. (54 × 78 cm). Private collection. Image courtesy of Valter Sacilotto.

or complement. Yet he blunted the activation of afterimages with his uniform black ground, and instead visualized the bursts of optical activity, creating a unified, flickering field.

The placement of works by Sacilotto and Barros at the outset of the exhibition suggests the group's desire to project a shared language of sparse, geometric compositions that create novel optical experiences. Dissimilarities emerged, however, in the exhibition as a whole. Charoux, for example, showed works composed of hand-drawn curved forms alongside ruler-sharp, rectilinear forms, and Wladyslaw displayed paintings with wide tonal color variations.[13] Haar's contributions, no longer extant, appear to be whimsical, small-format sculptures composed of geometric, multimedia shapes welded or adhered together, suspended in a balancing act. In the mid- and late 1950s Fejér created sculptures of glass, Plexiglas, and wood, but it is probable he displayed paintings at the Grupo Ruptura exhibition, possibly biomorphic abstractions as he had at the first Bienal (see fig. 40), though his works are not identifiable in the known installation views.

The juxtaposition of the paintings by Cordeiro and Wladyslaw, occupying the primary sight line as visitors approached and entered the space, underscored the diverse geometric abstract practices in the exhibition. Cordeiro exhibited paintings composed of precisely and flatly painted geometric forms on uniform grounds. Rather than placing frames on his paintings, Cordeiro mounted all but one of his works onto wooden box constructions that projected the paintings out from the wall.[14] Conservator Pia Gottschaller has noted that Brazilian Concrete artists—Grupo Ruptura artists the first adaptors among them—used this display method "to impart a more object-like depth and make the works appear to hover in space."[15] In *Desenvolvimento ótico da espiral de Arquimedes* (Optical Development of the Spiral of Archimedes) of 1952, the sense of spatial hovering provided by his display technique is matched by the interwoven, overlapping, and spiraling compositions placed in the center of a uniformly painted ground of warm white (fig. 46). Cordeiro selected a geometric form that plots points moving over time, in keeping with the group's interest in space-time and movement. He used a ruling pen and industrial paint on a compressed-wood support to create almost etched lines crisply delineating concentric circles. He then heightened the oscillating effect and suggestion of space by interjecting a flatly painted yellow circle and red band, which punctuate the contours of the sequences of lines. In contrast, an oil on canvas painting by Wladyslaw stands out in the installation views because of its light and variegated palette, likely the combinations of pastel pinks, oranges, yellows, and blues found in his paintings from 1952, such as *Composição* (Composition) (fig. 47). Just a year before Cordeiro had sharply criticized what he considered Wladyslaw's unoriginal post-Cubist abstractions.[16] Cordeiro was therefore not blind to the contrast their adjacent displays afforded, and would again orchestrate just such a combination of disparate geometric abstract practices, on a magnified scale, in an event that followed on the heels of the inaugural exhibition.

The Grupo Ruptura exhibition itself was on view for less than two weeks.[17] The group's visibility, and self-presentation, was amplified not only by press coverage of the jury selection for the II Salão paulista de arte moderna, but also with the salon's inauguration on December 23, 1952, a publicized coordinated display of geometric abstract works by Grupo Ruptura and other artists.[18] In the short time between the two exhibitions, the ranks of abstract and Concrete artists could be seen multiplying: paintings by five Grupo Ruptura members (Barros, Charoux, Cordeiro, Sacilotto, and Wladyslaw) were displayed alongside paintings by artists trained at the Instituto de Arte Contemporânea (IAC) at MASP—Maurício Nogueira Lima and Alexandre Wollner—and by Samson Flexor and his

FIGURE 46. Waldemar Cordeiro. *Desenvolvimento ótico da espiral de Arquimedes.* 1952. Enamel on compressed wood panel, 27 15/16 × 23 13/16 in. (71 × 60.5 cm). Cordeiro Family Collection. © Analívia Cordeiro. Image courtesy Luciana Brito Galeria. Photo: Edouard Fraipont.

FIGURE 47. Anatol Wladyslaw. *Composição*. 1952. Oil on canvas, 21 ½ × 21 ¼ in. (54.7 × 55.2 cm). MAC USP Collection. Gift of the Museu de Arte Moderna de São Paulo.

students Jacques Douchez and Leopoldo Raimo.[19] Initially the salon's selection jury had included Barros, Cordeiro, Flexor, Quirino da Silva, and Alfredo Volpi, all practitioners of abstraction save Silva. Silva protested that Flexor and Volpi could not serve as they were naturalized Brazilian citizens, and the jury was altered to be less abstract in orientation.[20] Despite this change, the selection jury included numerous abstract works. As a member of both the selection and prize juries, Cordeiro, aided by Barros on the selection

within the group and Cordeiro's political and intellectual activities reveals the formulation of a transformed proposal for Concrete art's relationship to reality and the social realm.

In Cordeiro's papers there is a curious juxtaposition of a clipping of an article by Cordeiro with his signed, stamped, and coffee-stained delegate card for the Continental Congress for Culture (CCC), organized by Pablo Neruda in Santiago, Chile (fig. 50).[32] Both date to first half of 1953: Cordeiro's article "Ruptura" was published on January 11, 1953, in the highbrow Sunday supplement *Pensamento e Arte* (Thought and Art) of the oldest daily newspaper in São Paulo, *Correio Paulistano*.[33] From April 26 to May 2, 1953, along with architect João Batista Vilanova Artigas and poet Décio Pignatari and financed by the PCB, Cordeiro attended the Congress, which historian Patrick Iber has described as both one of the most important Latin American gatherings of the Soviet-backed Peace Movement and "a last gasp of cultural Stalinism."[34] This haphazard assemblage of evidence of political work with a product of intellectual labor—adhered to a backing page with scotch tape, the clipping abutting the faded red card—may be accidental. The confluence nonetheless provokes a series of questions: what was the relationship between Cordeiro's political commitments and the exhibition strategy, artistic theory, and practice of Grupo Ruptura—for him, for fellow group members, and as perceived by their contemporaries? Via what interpretative paths did Cordeiro connect abstract and Concrete art with the social realm? Despite Cordeiro's well-earned reputation as a polemical defender of abstract art, did he seek to articulate an understanding of abstraction that would be intelligible and perhaps even attractive to his political allies and pro-realist aesthetic rivals?

Cordeiro's political activities were ad hoc and focused on the realm of culture. He was not a member of the PCB, though he was described by Augusto de Campos as having the party's respect, and he participated occasionally in its initiatives.[35] Following his polemical salvos on abstraction in the late 1940s, Cordeiro had soft-pedaled the discussion of dialectics in favor of his advocacy for artist-run organizations and for artists' input into decision-making at the new modern art museums, on one hand, and analysis of abstract art and artists, on the other. Put differently, Cordeiro had adopted a twofold strategy: he articulated an institutional argument, highlighting the crucial role of artist-run organizations—the Salão paulista de arte moderna among them—amid a bevy of new private art entities, and called for local and federal governments and art institutions to support artists economically through acquisitions and other initiatives.[36] Concurrently, through reviews of exhibitions by emerging artists and profiles of artists, he modeled an

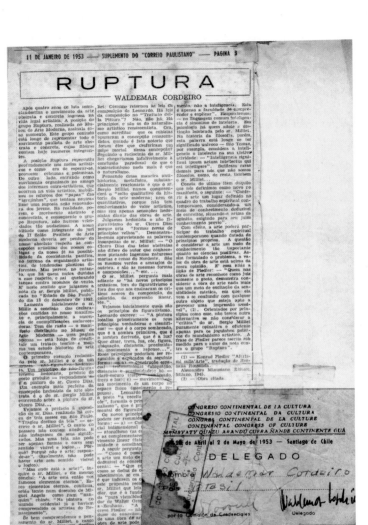

FIGURE 50. Waldemar Cordeiro. "Ruptura." *Correio Paulistano,* January 11, 1953, Suplemento, 3. Lower right: Waldemar Cordeiro's delegate card for the Continental Congress for Culture, Santiago, 1953. Cordeiro Family Collection. Image courtesy Luciana Brito Galeria. © Analívia Cordeiro.

analysis of abstraction and shined attention on the lives of artists, whom he described unfailingly as hard-working, self-made contributors to society. However, in the Ruptura manifesto, its defense, and, particularly, a series of talks in 1953 and 1954 that followed Cordeiro's attendance at the CCC, Cordeiro radicalized his art writing and insisted on the social import of Concrete art.

During the Grupo Ruptura exhibition in December 1952 the artists distributed their collectively signed manifesto (fig. 51).[37] The manifesto was subsequently quoted in its entirety in several São Paulo newspapers, making its contents accessible to a broader public than the exhibition itself.[38] The scholarly consensus is that Cordeiro was the document's primary author; he was an established polemicist and the sole member of the group who also worked as an art critic and regularly published texts. While it is likely that Cordeiro had the largest role in the manifesto's authorship, recently uncovered notes in the archives of Barros as well as an annotated draft of the manifesto suggest that dialogue among at least some of the group's members informed and surrounded the manifesto.[39] The term "rupture" does not appear in the notes in the Barros archive, but the notes share content with the manifesto, most notably the enumeration of the same fundamental values of visual art—space-time, movement, and matter—and attention to the distinction from Renaissance naturalism (fig. 52). The notes, however, do *not* temper the artists' affiliation to Concretism nor their view of Concrete art as the leading edge of contemporary art. In contrast, the exhibition invitation describes Grupo Ruptura as an "abstractionist group," and the manifesto calls for a future national exhibition of abstract and Concrete art. Based on the notes, we can speculate that the collective discussion in the group was more historiographic and pedagogical in orientation than political and—through diagrams, lists, and what may be doodles or heuristics—sought to articulate a model of historical change, conceptual differences between Renaissance naturalism, Cubism, and Concrete art, and the relationship between theory and practice. The removal of a line riffing on the Communist Manifesto in the annotated draft of the manifesto—"from the ruins a new conception of art emerges"—suggests that other members of Grupo Ruptura decided to omit an explicit allusion to Marxism likely proposed by Cordeiro.[40]

In the Ruptura manifesto and subsequent texts and talks, Cordeiro resurfaced his dialectical understanding of the history of art and expanded his aesthetic theory, drawing on the thinking of Fiedler. The title the group adopted, Rupture, and a series of statements in the manifesto—"there is no more continuity! / why? / it was a crisis / it was a renovation"—singled out graphically by their justification and larger, bolded font, made clear the artists' nonlinear, nonprogressive, disruptive understanding of the history.[41] The

ruptura

charroux — cordeiro — de barros — fejer — haar — sacilotto — wladyslaw

a arte antiga foi grande, quando foi inteligente.
contudo, a nossa inteligência não pode ser a de Leonardo.
a história deu um salto qualitativo:

não há mais continuidade!

• os que criam formas novas de princípios velhos.

então nós distinguimos

• os que criam formas novas de princípios novos.

por que?

o naturalismo científico da renascença — o método para representar o mundo exterior (três dimensões) sôbre um plano (duas dimensões) – esgotou a sua tarefa histórica.

foi a crise foi a renovação

hoje o novo pode ser diferenciado precisamente do velho. nós rompemos com o velho por isto afirmamos:

é o velho

• tôdas as variedades e hibridações do naturalismo;

• a mera negação do naturalismo, isto é, o naturalismo "errado" das crianças, dos loucos, dos "primitivos" dos expressionistas, dos surrealistas, etc. . . . ;

• o não-figurativismo hedonista, produto do gôsto gratuito, que busca a mera excitação do prazer ou do desprazer.

é o novo

• as expressões baseadas nos novos princípios artísticos;

• tôdas as experiências que tendem à renovação dos valores essenciais da arte visual (espaço-tempo, movimento, e matéria);

• a intuição artística dotada de princípios claros e inteligentes e de grandes possibilidades de desenvolvimento prático;

• conferir à arte um lugar definido no quadro do trabalho espiritual contemporâneo, considerando-a um meio de conhecimento deduzível de conceitos, situando-a acima da opinião, exigindo para o seu juízo conhecimento prévio.

arte moderna não é ignorância, nós somos contra a ignorância.

FIGURE 51. Geraldo de Barros, Lothar Charoux, Waldemar Cordeiro, Kazmer Fejér, Leopold Haar, Luiz Sacilotto, and Anatol Wladyslaw. Manifesto Ruptura. 1952. Offset lithograph, 12 $^{15}/_{16}$ × 8 $^{5}/_{8}$ in. (32.9 × 21.9 cm). The Museum of Fine Arts, Houston, The Adolpho Leirner Collection of Brazilian Constructive Art, museum purchase funded by the Caroline Wiess Law Accessions Endowment Fund, 2007.16 © Analívia Cordeiro © Lenora and Fabiana de Barros. Image courtesy Valter Sacilotto.

FIGURE 52. Notes by Grupo Ruptura members. c. 1952. Arquivo Geraldo de Barros. © Lenora and Fabiana de Barros.

disagreement about whether the history of art represented a continuous linear progression or, as the Ruptura manifesto stated, was defined by qualitative leaps and ruptures, was a long-standing one between Cordeiro and Sérgio Milliet. Milliet, in addition to his founding roles in São Paulo's modern art institutions, was an esteemed public intellectual and an art and literary critic for the most prestigious newspaper in São Paulo, *O Estado de São Paulo.* Beginning in 1950, Cordeiro had targeted Milliet, almost thirty years his senior, describing Milliet's art criticism as idealist, metaphysical, and prone to defaulting to notions like allegory that Cordeiro considered inappropriate to understanding contemporary art.[42] In December 1952, in a review of the Grupo Ruptura exhibition while it remained on view, Milliet finally took Cordeiro's bait and, in a departure from the typically courteous tone of his art writing, pilloried the manifesto for its claim that abstraction represented a break from Renaissance illusionism.[43] Cordeiro's response appeared a month later, after the holidays and while the II Salão paulista de arte moderna was open to the public, and was calculated for maximum effect to amplify the status of abstraction, Grupo Ruptura, and Cordeiro himself, and to most effectively counter Milliet and what Cordeiro perceived as the old guard. In the lengthy article Cordeiro repeatedly footnoted Fiedler, a little-discussed nineteenth-century thinker. He placed the text not in his wide-circulation former home newspaper, *Folha da Manhã,* but in the cultivated *Correio Paulistano* Sunday supplement, where it appeared with considerations of continental philosophy and European, US, and domestic art and culture.[44]

The January 1953 article expanded Cordeiro's critique of Milliet's "anti-historic, metaphysical, substantially reactionary" understanding of modern history to differentiate their respective theories of visual art.[45] In so doing, Cordeiro revealed that Fiedler's writing underpinned the Ruptura manifesto, including Fiedler's foundational assertion that the importance of visual art was not in its aesthetic contribution but as a form of thought. Several pillars of "the new" enumerated in the manifesto also drew on Fiedler, namely that art is derived from principles and art is a means of knowledge deduced from concepts and above mere opinion, as well as the larger ambition to recognize art's place in what the manifesto describes as "the scope of contemporary spiritual work."[46] Moreover, the statement on the verso of the manifesto, "The work of art does not contain an idea, it is itself an idea," is an unattributed quotation from Fiedler.[47] In his 1953 article, Cordeiro quotes Fiedler dismissing both beauty and taste as appropriate criteria with which to understand art, including the passage: "Beauty is not deducible from concepts, but the value of the work of art is. The work of art can displease and be equally valuable."[48] As in his earlier articulation of *forma-ideia* and rejection of Max Bill's

centering of beauty, Cordeiro insists that the contribution of abstract art resides not in its appeal to aesthetic pleasure, but in its derivation from rigorous and timely concepts. But the gambit of the Ruptura manifesto and Cordeiro's subsequent article are broader, claiming for Concrete art the historical and spiritual import of art conceived as a form of knowledge.

In early 1954, Cordeiro gave several talks on Concrete art that expanded his engagement with Fiedler and Marxism.[49] The context was a six-week course on modern and contemporary art for the Curso internacional de férias-pró arte (Pró Arte International Holiday Course) that he taught between Teresópolis and São Paulo from early January to late February 1954, including holding some of the class meetings in the galleries of the second Bienal.[50] Fiedler remained a mainstay in Cordeiro's remarks, but Cordeiro also responded to the conception of modernism Pedrosa developed in his writing of the 1940s and 1950s, analyzed in chapter 2, and in his organization of the European special exhibitions at the second Bienal, examined in the next chapter. Pedrosa's *Panorama da pintura moderna* (1952) proposes a teleological account of modern art in which Impressionism and Cubism launched two opposing trajectories, which Pedrosa describes as expressionist and constructive. Cordeiro articulated a broadly similar account of modern art history, although he tweaked Pedrosa's terminology and emphasized the dialectical nature of art history. Rather than expressive and constructive tendencies, he proposed that the "two fundamental and opposing tendencies" in modern art are the art of expression, on one hand, and the art of creation or art as a form of knowledge, on the other.[51] He pointed to works and exhibitions at the second Bienal to illustrate the differing approaches, including specific paintings by James Ensor, Edvard Munch, and others, and compared Cubism and Futurism as proposals. His interpretation of these opposing trajectories is struck through with Marxist thought. He asserted that expressive art limited itself to quantitative changes and remained in the feudal phase. On the other hand, art understood as a form of knowledge allows for "qualitative leaps."[52]

Bill was entirely absent from these discussions, though Cordeiro's critique of the most prominent promoter of Concretism in the Americas, Argentine critic Jorge Romero Brest, whom he described as an idealist employing the outmoded tools of aesthetics, indicate that Cordeiro sought to supplant both as the primary spokesperson for Concrete art.[53] Instead Cordeiro privileged the European historical avant-garde of the teens and twenties, citing Theo van Doesburg as the term's originator, and integrating an analysis of Suprematism, Neo-plasticism, and Constructivism with a discussion of philosophy. Fiedler, employed previously as a bludgeon against Milliet, was identified in these lectures

as the founder of the concept of pure visibility and functioned as the model of a non-idealist, non-formalist, materialist conception of art. The German thinker insisted that art is not a secondary form of cognition, but an independent and unique form of knowledge, grounded in its own methods, equal to science and philosophy, and with a singular purchase on reality. For Cordeiro, the privileging of visibility as an ultimate manifestation of reality was revolutionary, and he argued only nonobjective abstract works that negated both naturalism and Expressionism—that is, Concrete art—could forge a transformative, radical form of communication with viewers. Rephrasing Fiedler's statement quoted in the Ruptura manifesto that art does not contain an idea, but is an idea in and of itself, Cordeiro stated, "Art does not express a reality, it *is* a reality in itself."[54] As he mapped in a diagram among the scripts for his late 1953 and early 1954 talks, Concrete geometry is understood not only as image, phenomenon, and perception—the lens we tend to apply to Brazilian Concretism—but also as a relation which is dialectical and real, a "direct construction."[55] Cordeiro also placed *forma* among the terms explicating the type of relation Concrete art achieves, furthering his view, first articulated as *forma-ideia,* that form is tied to the social realm.

Grupo Ruptura is absent from Cordeiro's late 1953 and early 1954 lectures, and instead Concrete art was the category he defined and defended. While it has become common to date Grupo Ruptura's existence from 1952 to the late 1950s and to say that Hermelindo Fiaminghi and Judith Lauand joined the group, "Grupo Ruptura" quickly disappeared from news reporting after 1953 as the group did not mount another stand-alone collective exhibition. Press notices in 1954 regarding Barros, Cordeirio, and Nogueira Lima vaguely refer to "their" and "his" group, in some instances pointing to Grupo Ruptura or its broader Concrete art successor, and in others not.[56] Concretism supplanted Grupo Ruptura as the named shared identity, as is evident not just in Cordeiro's rhetoric, but in the collective exhibitions and artists' statements of the mid-1950s to the early 1960s.[57] The significance of the primacy afforded to Concrete art is at least twofold. First, it tells us that Grupo Ruptura's imagined coherence and longevity is a historiographic invention. And the retrospective re-naming of a broader cohort of São Paulo-based Concrete artists as Grupo Ruptura masks dynamic interpersonal relations and a radicalization of the theory of abstraction from the early 1950s to the mid-1950s.

Returning to the accident/incident of the archive with which I began this section: in the scripts for one of his 1953–54 talks, Cordeiro mentions Milliet only to dismiss him as the prototypical idealist critic in the national context followed by a parenthetical note to "read the clipping."[58] So, if we imagine ourselves among the students in Cordeiro's course

or perhaps the accrued public audience as the teacher and students moved through the Bienal galleries, on at least one occasion, Cordeiro pulled out his copy of his January 1953 "Ruptura" article and read from it (fig. 50). Did he slot his delegate card from the CCC alongside the clipping before such an occasion? While analysis of political theory and commentary on art institutions are absent from his series of remarks in 1953–54, the red card reminds us of the political commitments informing his refusal to rarefy the aesthetic tenets of Concretism and to insist on the relations of art to history and society. Cordeiro asserted that "the new art" was not the mystified product of a divine process, but "is merely a powerful instrument of knowledge that conquers reality as visibility, objectively contributing to collective progress."[59]

GENDERED ENVISIONING OF THE CONSUMERS AND PRODUCERS OF ABSTRACT ART

An item in *Folha da Manhã* in December 1952 dedicated to the Grupo Ruptura exhibition utilizes the image of the vapid female consumer of abstract art previously articulated in the reception of the first Bienal. Titled "Abstracionismo? Figurativismo ou arte concreta? Elegância em todo o caso . . . ," (Abstraction? Figuration or Concrete Art? Elegance in Every Case . . .) and found in the paper's *Vida Social e Doméstica* (Social and Domestic Life) section, the article recounts the reaction of five young society belles to the abstract art exhibition (fig. 53).[60] After recording a bit of banter in which the women proclaimed their incomprehension of the group's manifesto, as well as the paintings themselves, the reporter concluded, "One cannot say they understood much, well But the objective of *Vida Social* focused them: a beautiful show of perfectly figurative art in the midst of the harmonized, colorful charades of the 'Rupture' group."[61] Photographs of each of the women showed them posed in the exhibition space, contemplating the art and looking into the camera while standing next to a work or two. The captions provide details about their outfits, although not about the paintings, and try to capture the women's thoughts: "Maria Helena Cintra is undecided: Do I like it? Do I not like it?"[62] The women are cast as naive and their supposed ignorance is played for laughs, and not, as had been the case of the review of the first Bienal in *Habitat* discussed in the prior chapter, the grounds for a diatribe about the lack of seriousness among the privileged classes in Brazil. While uncertain about the merits of the displayed art, the extended photographic record of the young women's attendance of the Grupo Ruptura exhibition, in a section of the paper aimed at wealthy women, demonstrates the cachet that abstract art held among the elite.[63]

ntre dois quadros de Valdemar Cordeiro, Neli Penteado exibe "Praia de Pernambuco"; blusão de "albene" branco, "slacks" de lonita preta

Alik Kostakis exibe "Dominguin" — Saia de "faile" vermelho plissado e blusa de gorgorão branco e aplicações de "guipure"

Maria Helena Gurgel passeia "Guarujá" diante da mostra "Ruptura"

Maria Helena Cintra está indecisa: — gosto? não gosto?

Planos, volumes, cores... arte moderna... Cecilia Camargo Coimbra está dentro do mural ou do lado de fora?

ABSTRACIONISMO?

Figurativismo ou arte concreta! Elegancia em todo o caso...

PREPARA-SE O DESFILE DO DIA 22 NO CLUBINHO

As garotas estavam no "atelier" de Maria Amalia Camargo Alik Kostakis ensaiando para a grande parada de elegancia de 22 deste, no Clubinho. E falavam de uma porção de coisas, enquanto a "premiére" deixava olhos criticos à queda das saias, no feitio das blusas.

— Você já passou muitas entradas?

— Eu? Todas! Todo o mundo quer assistir à peça de Pola Rezende e ao desfile de modelos.

— Vocês já viram a exposição do grupo "Ruptura" no Museu de Arte Moderna?

— Não. Você viu? O que vem a ser isso?

E Maria Helena Gurgel tirou um papelucho e leu:

tão... Mas a objetiva da Vida Social focalizou-as: bela mostra de arte perfeitamente figurativista em meio às harmoniosas charadas coloridas do grupo "Ruptura".

R U P T U R A

charroux — cordeiro — de barros — fejer — haar — sacilotto — wladyslaw

a arte antiga foi grande, quando foi inteligente.

contudo, a nossa inteligencia não pode ser a de Leonardo.

a historia deu um salto qualitativo:

Não há mais continuidade!

os que criam formas novas de principios velhos.

então nós distinguimos

os que criam formas novas de principios novos.

Por que?

metodo para representar o mundo exterior (três dimensões) sobre um plano (duas dimensões) — esgotou a sua tarefa historica.

Foi a crise

hoje o novo pode ser diferenciado precisamente do velho; nós rompemos com o velho por isto afirmamos:

É o velho

• tôdas as variedades e hibridações do naturalismo;

• a mera negação do naturalismo. isto é, o naturalismo "errado" das crianças, dos loucos, dos "primitivos" dos expressionistas, dos surrealistas, etc. ...;

• o não-figurativismo hedonista, produto do gosto gratuito, as expressões baseadas nos novos principios artisticos;

• todas as experiencias que tendem à renovação dos valores essenciais da arte visual (espaço-tempo, movimento e materia);

• a intuição artistica dotada de principios claros e inteligentes e de grandes possibilidades de desenvolvimento pratico;

• conferir à arte um lugar definido no quadro do trabalho espiritual contemporaneo, considerando-se um meio de conhecimento dedutivel de conceitos, situando-a acima da opinião, exigindo para o seu juizo conhecimento previo. arte moderna não é ignorancia, nós somos contra a ignorancia."

Finda a leitura, as lindas jovens se entreolharam.

— Você entendeu?

— Patavina!

E como não entendessem fo-

ram espiar "in loco" os trabalhos de Charroux, Cordeiro, de Barros, Feger, Haar, Sacilotto, Wladyslaw. Não se pode dizer que hajam entendido mais, en-

FIGURE 53. Photographs of the Grupo Ruptura exhibition and a concurrent tapestry exhibition at the Museu de Arte Moderna de São Paulo, 1952. Reproduced in *Folha da Manhã*, December 14, 1952, 17. Folhapress.

Coincident with the sexist casting of the audience for abstraction, a markedly different image of the producer of abstract art circulated: the hardworking male striver. Also during the run of the Grupo Ruptura exhibition, a photograph of four members of the group—Charoux, Cordeiro, Fejér, and Wladyslaw—in suits and ties, standing before a painting by Emiliano Di Cavalcanti, appeared in *Última Hora.*[64] Under a headline that clashed with the photographic image of fraternity, "Ruptura: brigam os artistas" (Rupture: The artists fight), critic Ibiapaba Martins recounted the public dispute about the make-up of the jury of the II Salão paulista de arte moderna. Of a piece with the presentation in the media of the heteronormative European-descendant masculine artists engaged in debate at public events and bars, the Grupo Ruptura members are portrayed as public thinkers, even civil leaders. While Cordeiro's exhibition reviews foregrounded women artists and did not resort to sexist clichés common among his contemporaries, he nevertheless helped prepare the ground for the gendered representation of the artist via his series of profiles on exclusively male artists in 1952.

The reception of Lygia Clark's solo exhibition at the Ministério da Educação e Saúde (MES) in Rio in November 1952 reveals the almost uniformly male ranks of the art critical profession reeling as they tried to figure out how to assimilate a female abstract artist. In a remarkable account of his first studio visit with Clark, art critic Jayme Maurício did not conceal his discomfort. Building suspense before admitting his error in judgment once he viewed Clark's paintings, Maurício commented at length on the artist's beauty, outfit, and mannerisms, punctuated by the realization that "the girl was really a talent."[65] Though cast as a confession—Maurício narrates his difficulty in assimilating wealth, femininity, and motherhood with Clark's identity as an artist—the article also allows a reader to walk through their own dismissive assessment of Clark before acknowledging her art as a serious endeavor and validating any lingering uneasiness on a reader's part. In his catalogue essay on Clark, Pedrosa too used gender as a frame to understand her work. He deemed "good taste her only feminine quality," targeting what he considered Clark's excessive refinement, and called for her to develop her evident "structural sense."[66]

"The Chick Stopped."[67] So read the title of a two-sentence assessment of Clark in early 1953 in *Habitat.* The short notice quotes Clark's statement to *Visão* (Vision), a news magazine, that she had painted when she was young, but stopped painting for eight years after she had her children with no additional commentary save the title.[68] Possibly a jab at *Visão* for foregrounding a professional woman's personal life, *Habitat* nevertheless participated, like *Correio da Manhã,* in the bafflement about how to interpret an artist who was a woman and a mother. In the same issue of *Habitat,* the members of Grupo

Ruptura are described as "some youths enthusiastic for novelties," where their all-male ranks meant no contortions were required for their acceptance as avant-garde artists.[69] Unmentioned in the takes by *Visão* and *Habitat* was Clark's multiyear study with a succession of artists in Paris from 1950–52, Fernand Léger most notable among them, facts readily proffered by Pedrosa and Maurício to indicate her prestige and requisite professionalization.

Clark was by no means the only woman artist in abstract circles to receive praise in the immediate postwar art scene. However her social class—as the descendant of a well-to-do family and the affluent wife of an engineer—and perceived youth—she was referred to as "*moça*" (young woman) and "a very young artist" by art critics—troubled her assimilation into the description of woman artists as industrious.[70] Both Maria Leontina, in São Paulo, and Djanira da Motta e Silva, in Rio, had received visibility in the art and mainstream press in the early 1950s, where they were viewed as hardworking, integrated members of artistic communities. Djanira, a self-taught artist who ran a guesthouse catering to artists in the bohemian neighborhood of Santa Teresa, was characterized as a modest, productive, and unfailingly generous individual.[71] Leontina, whose solo exhibition at Galeria Domus in 1950 received positive reviews and whom Pedrosa championed in context of the first Bienal and I Salão paulista de arte moderna, was described as a promising artist engaged in a serious study of form.[72] Clark, thirty-two years old at the time of her exhibition at MES in 1952, was only three years younger than Leontina and six years Djanira's junior. The insistence on Clark's youth served to emphasize her recent reappearance on the national scene after being abroad and associated her with avant-garde activities, but it also emerged from appraisals of her appearance and class.

Clark's self-fashioning in a photographic shoot in her Rio studio in 1953 or 1954 reveals the artist negotiating the accepted role of affluent women as the consumers, not producers, of abstract art (fig. 54).[73] While Clark is surrounded by markers of her profession, she also wears fashionable clothes indistinguishable from those of the debutantes, fashion models, and film stars who posed as viewers of abstract art in popular cultural imagery, including a multicolored skirt coordinated to the multihued facets of the array of her paintings. The photographs thus walk a line: Clark is envisioned as both the ideal, sophisticated art viewer and as a protean maker. The overall scene in Clark's studio, replete with signifiers of class privilege, conjures creative and economic abundance.

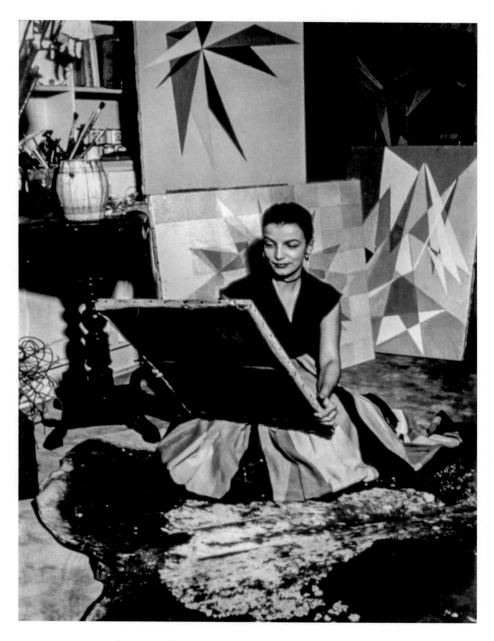

FIGURE 54. Lygia Clark in her studio. c. 1953–1954. Courtesy of "The World of Lygia Clark" Cultural Association.

NATIONAL (CONCRETE) ABSTRACTION?

In late February of 1953, President Vargas and the governors of Minas Gerais, Rio, and São Paulo, the three most prosperous Southeastern states, inaugurated a large horticulture exhibition, sponsored by the agricultural secretary of the state of Rio, at the Hotel Quitandinha in Petrópolis. The exhibition, displaying fruits and flowers cultivated in the state and landscape designs by Roberto Burle Marx, opened concurrently with two smaller ones, a decorative art exhibition and the Exposição nacional de arte abstrata. Journalists at the fervently anti-Vargas newspaper *Tribuna da Imprensa* concluded that the opening of the botany exhibition, along with a succession of luncheons and a ribbon-cutting event, provided a pretext for closed-door meetings over three days without disclosed agendas between Vargas and the governors.[74] Reports in Rio newspapers noted officials "nervously entering and leaving" meetings, dodging questions.[75] The pro-Vargas newspaper *Última Hora,* by contrast, described the president and governors working as a team in "perfect understanding," with the governors expressing fulsome support for Vargas.[76] The month prior had witnessed a labor strike of textile workers in Rio, the first of what would become a series of labor actions demanding increased wages in response to inflation, notably the twenty-four-day "strike of 300,000" in São Paulo in March 1953. The subject of the meetings in Petrópolis was revealed to be discussions of the reorganization of Vargas's cabinet, an attempt to address his administration's weakening political position, and to shore up support of the working class and industrialists in advance of introducing anti-inflation economic policies.[77]

The Exposição nacional de arte abstrata was a modest and hastily assembled display, despite its grand title and sponsorship by municipal and state governments, as well as MAM Rio.[78] It was not an intended centerpiece of the governmental meetings in Petrópolis in February 1953, nor was it viewed at the time as a significant event by the art press (with the exception of Pedrosa). By selecting Hotel Quitandinha, the artist-organizers of the exhibition—the leaders of the Associação Petropolitana de Belas Artes (Petropolitan Association of Fine Arts, APBA)—nevertheless realized the exhibition at a site, and in a city, associated with politics as well as elite leisure and racial discrimination. Hotel Quitandinha, built in the 1930s as a casino and resort catering to local and foreign elite, was known as a luxurious getaway for the rich and famous and as a venue, a close distance from the national capital, for meetings of national and international importance. The city of Petrópolis had long functioned as a political center and elite bastion: initially a summer retreat for the emperor, briefly the empire's capital, and ultimately the site of an

official residence of the president and a mountainous country destination for affluent Rio residents. Via the encouragement of German migration and restriction of Afro-Brazilian populaces, the city is also an exemplar of imperial and post-independence racial whitening policies. While the Exposição nacional de arte abstrata included the prominent Afro-descendant artists Antonio Bandeira and Santa Rosa, the venue furthered the association of abstraction with elite, white consumption and governmental support.[79] It was deemed a suitable backdrop for further publicity by Minas Gerais governor (and future president) Juscelino Kubitschek, who attended the small opening celebration along with former ambassadors and other dignitaries. Furthermore, by including the term "national" in the exhibition's title, the artists sought to claim a space for the idiom of abstraction in the nation's artistic activities. The reception of the exhibition and its organization by Rio-area artists reveal the reconfiguration of the abstract artistic scene in the federal capital, with Serpa emerging as a leader at odds with Pedrosa on the tenets of Brazilian Concretism.

Visitors to the Exposição nacional de arte abstrata would be forgiven for thinking they had stumbled into a painting class in-progress.[80] Approximately fifty small- to medium-format works, predominantly paintings, by twenty-four or twenty-five artists were placed on easels or rested on the floor leaning against easels, at an array of heights (fig. 55).[81] The light-filled enclosed verandas at the enormous, Franco-Norman style hotel differed markedly from the provisional sites of the Bienal and modern art museums in Rio and São Paulo, modernist spaces composed of white cube galleries or of fabric-lined walls with artworks hung from picture wire. In Petrópolis, large floor-to-ceiling windows, broad doorways, overt baseboards, and patterned flooring interrupted and interacted with the densely installed works on view. Artist and critic Edmundo Jorge, one of the exhibition's organizers, recounted that promised wall panels were ultimately not provided by the hotel (instead the organizers borrowed easels), and that the volume of works led some paintings be to placed directly on the floor.[82] The narrowness of the room also seems to have obligated the organizers to the install the works at angles to the walls and close together.

The ad hoc display contrasted with the rhetorical presentation of the exhibition, its governmental and institutional sponsorship, and a prestigious selection jury composed of critic and architect Flávio de Aquino alongside Moniz Sodré and Pedrosa. Jorge and other artists at the APBA, Décio Vieira among them, adopted a triply grandiose title: "national," suggesting the project represented art from across the country; "exhibition," conveying cohesion rather than the come-who-may nature and prize-orientation of a salon; and

"abstract art," declaring a shared style among the artists. Each of these qualities was incompletely fulfilled in the realized project. Artists based in Rio and its environs contributed all the works with one known exception (São Paulo-based Antonio Maluf).[83] Prizes were subsequently awarded to Clark and Vieira.[84] And some of the works were figurative.[85]

The exhibition's catalogue projected a big-tent approach to abstraction while privileging Concrete art. The exhibition recalls the constellation of geometric abstract styles with some gestural works interspersed at the Salon des réalités nouvelles in Paris of the late 1940s and early 1950s. Also like the Paris event, in Petrópolis there was an assortment of known and unknown artists, with teachers exhibited among students, and a diversity of national origins. Bandeira and Fayga Ostrower, both well-regarded gestural abstract artists who had exhibited at the first Bienal and in solo exhibitions, included nonfigurative paintings and prints with referential titles that evoked natural and urban scenes. Such works, intended to be read as nonillusionistic reflections on visible reality, were outnumbered by those bearing nonreferential titles like *Abstract Composition, Composition,* and *Forms.* The one-page essay by Jorge in the catalogue declared illusionism obsolete and noted the predominance in the exhibition of the "young Concretists" engaged in what he described as "direct invention."[86] The work illustrated on the cover broadcast this orientation: Serpa's diagram-like painting composed of bars and rectangles and titled *Composição rítmica* (Rhythmic Composition) of c. 1952–53 (partially visible in fig. 55).

While it is currently possible to identify only a few works in the exhibition with certainty, Serpa's *Composição rítmica* and Maluf's yet-to-be identified work were almost certainly outliers in the exhibition in their interest in mathematical relationships and setting aside of the splayed forms of Cubism. The other works Serpa showed—recent paintings from his *Formas* series of c. 1951–53—and Clark's three paintings—likely her oil on canvas works of 1953 composed of multicolored, intersecting triangular and twisting forms—were more akin to the other geometric abstractions shown (fig. 56). Aluísio Carvão and Lygia Pape, emerging artists in Serpa's orbit, displayed multiple, unidentified paintings titled *Composição* (Composition).[87] It is possible their paintings from 1953 that assemble an interwoven cluster of flatly painted rectilinear and curved forms in the center of uniform white grounds were among those shown (figs. 57–58). By employing tonal colors and varying hues at places that occasionally disobey the contours of the geometric forms, both Carvão and Pape create the effect of a shifting and twisting weightlessness. Practices of abstraction like those of Dias and Flexor that relate their nonobjective forms to local, vernacular culture via palette and title were notably absent from the display.

FIGURE 55. Installation view of paintings by Ivan Serpa at the Exposição nacional de arte abstrata at the Hotel Quitandinha, Petrópolis. 1953. Pictured, on left, Aluísio Carvão and Ivan Serpa. Ref. No. BR_RJANRIO_PH_0_FOT_41896_018, Arquivo Nacional.

Pedrosa authored the most extensive review of the exhibition. He noted inadequacies in the exhibition's presentation, including its dubious claim of a national reach, but nevertheless compared the exhibition to the Grupo Ruptura exhibition two months earlier and observed a shared determination and trajectory by artists of the Rio and São Paulo metropolitan areas.[88] Pedrosa used examples of works on display to articulate what he found to be the most fruitful path in emerging abstraction: the study of form distinct from what he characterized as orthodox Concretism. He singled out for praise paintings by Carvão, Clark, Jorge, and Vieira. Pedrosa also drilled down of the evolution of the practices of several artists: Clark, prominent since her 1952 solo exhibition; Ramiro Martins, who exhibited at the first Bienal and was among the better recognized abstract artists at the time, despite his absence from our current accounts; and Serpa, prize winner at the first Bienal. Although he did not compare Clark and Martins, Pedrosa asserted the same direction was evident in their practices. Namely he argued Clark had set

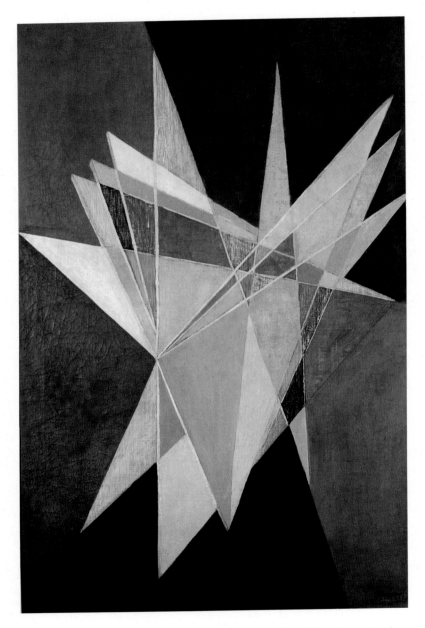

FIGURE 56. Lygia Clark. *Composição*. 1953. Oil on canvas, 40 ⁹⁄₁₆ × 26 ¾ in. (103 × 68 cm).
Private collection. Courtesy of "The World of Lygia Clark" Cultural Association. Photo:
Marcelo Ribeiro Alvares Corrêa.

FIGURE 57. Lygia Pape. *Pintura.* 1953. Oil on canvas, 29 ⅛ × 39 ⅜ in. (75 × 100 cm). Projeto Lygia Pape.

aside "extra-plastic preoccupations"—those pesky feminine qualities—to focus on "problems of forms, space, and rhythm," and Martins had abandoned "lyrical combinations of tones and materials" for "the problem of open forms in space."[89] In contrast to the positive direction in their work, Pedrosa pointedly celebrated Serpa's earlier series of *Formas,* in which "forms open like mature fruits or as the result of an explosion of a central nucleus on a spatially homogeneous background," and not his more recent painting *Composição rítmica,* which Pedrosa deemed formulaic and too emulative of orthodox Concretism.[90]

Serpa never went on record enthusiastically as a Concrete artist, and his relationship to the term fluctuated over the course of the early 1950s. Six months after the Exposição nacional de arte abstrata, later in 1953, he deflected a query about whether his practice was abstract or Concrete as one of mere terminology.[91] In 1954, he distanced himself from his widespread description as a Concretist, arguing that he had shed the rigidness of Concrete

FIGURE 58. Aluísio Carvão. *Composição*. 1953. Oil on canvas, 23 ¹³/₁₆ × 32 ¹/₁₆ in. (60.5 × 81.5 cm). João Sattamini Collection on loan to Museu de Arte Contemporânea de Niterói. Courtesy of Carvão Family. Photo: Paulinho Muniz.

art.[92] In these expressions of wariness about the strictures of Concrete art, Serpa matched and likely followed Pedrosa. In 1952 and early 1953, however, as Serpa participated in the organization of the Petrópolis exhibition, the artist placed some distance between his thinking and that of Pedrosa. This distance is perceptible not only in Pedrosa's negative appraisal of his recent painting, but also Pedrosa's larger body of writing on Serpa. In the midst of praise for many facets of Serpa's production, Pedrosa also bluntly tried to steer the artist away from what Pedrosa viewed as his excessive concern for order, neatness, and finish.[93] Serpa, for his part, defined himself in 1952 as a Concretist without foregrounding the term: he described his practice as free from subjective expression aside from color and highlighted his close study of mathematics and industrial materials.[94]

Absent from Pedrosa's review of the Exposição nacional de arte abstrata is Abraham Palatnik, whose first kinetic light-machine Pedrosa had praised in the highest terms when it was displayed at the first Bienal.[95] Palatnik's most recent apparatus, *Paralelas em azul e laranja*

FIGURE 59. Abraham Palatnik. *Sequência com intervalos*. 1954. Powdered paint on glass, 9 ¹³⁄₁₆ × 17 ¾ in. (25 × 45 cm). Courtesy of Galeria Nara Roesler and the estate of Abraham Palatnik. Photo: Everton Ballardin.

numa sequência horizontal (Parallels in Blue and Orange in Horizontal Sequence), was on display at MAM Rio from January to April 1953, concurrent with the Petrópolis exhibition. There it received extended fanfare in the press, not only from Pedrosa and art critics in daily newspapers, but also in the wide-circulation magazines *Manchete* and *Visão*.[96] The celebratory consensus was that Palatnik's works represented something wholly new, "a true art of the future," as Pedrosa put it.[97] According to curator Frederico Morais, Palatnik exhibited paintings on glass, not kinetic works, in Petrópolis.[98] While the whereabouts of Palatnik's three works listed in the catalogue—*Paralelas n. 3* (Parallels no. 3), *Paralelas amarelo-laranja* (Yellow-Orange Parallels), and *Sequência vertical* (Vertical Sequence)—are unknown, a painting on glass from the following year, 1954, provides insights into the character of the exhibited works (fig. 59). Palatnik used industrial tools, including a spray gun, to layer applications of a specialized powdered paint that the artist formulated to adhere to glass and incised lines to reveal underlying layers. Palatnik's industrial materials and implements aligned with those of the contemporaneous paintings by Grupo Ruptura artists, but his sensibility did not. The paintings evoke ethereal realms with their hazy grounds and saturated palette. In the exhibition catalogue, Jorge described Palatnik as a young Concretist along with Serpa, but it is likely the glass paintings added to the heterodox abstractions on display.

The silence about Palatnik's contributions to the Petrópolis exhibition and his glass paintings was not limited to Pedrosa. It extended to the larger cross-section of the press who were focused on Palatnik in early 1953. This may be because the glass paintings complicated the emerging narrative that Palatnik had abandoned painting for his mechanized experiments with light.[99] Art historian Luiz Camillo Osorio cautions against understanding Palatnik's use of new technology as orienting his practice.[100] Osorio points to multiple "dislocations," including the artist's simultaneous creation, in the early 1950s, of cine-chromatic apparatuses, paintings on glass, and integration of painted glass panels into his furniture design, to argue that Palatnik sought not technophilia, but "to extract from new medias a ludic, creative, unexpected potentiality."[101] The elision of Palatnik's paintings on glass suggests an inflection point in the reception of abstraction wherein earlier, intermedial practices were increasingly sidelined.

The organization of Exposição nacional de arte abstrata contributed to a reconfiguration of the Rio-area nucleus of abstract artists and critics. The first mention of the exhibition occurred in a June 1952 publicized discussion by abstract artists from Petrópolis and Rio about the use of new materials at the APBA.[102] According to news reporting, Serpa was present as the meeting representing Barros, Almir Mavignier, Palatnik, and Margaret Spence. All—with the exception of Spence, a US-born, Rio-based artist who was Serpa's colleague at the school at MAM Rio—had been participants in the Gestaltian get-togethers at Pedrosa's home and visits to Engenho de Dentro psychiatric hospital in the late 1940s and early 1950s. In July 1952, the group again convened and asked the press to attend. At Serpa's home in Rio, in the Zona Norte middle class neighborhood of Meier, the attendees included Palatnik; emerging artists residing between Petrópolis and Rio, Carvão, Jorge, Pape, and Vieira among them; and critic and poet Ferreira Gullar, who had arrived to Rio in 1951.[103] Led by Serpa, the artists and critic discussed the potential of industrial materials, like Ripolin, for abstraction and viewed art by Serpa's students from his children's painting classes at MAM Rio. These regular conversations, and the Exposição nacional de arte abstrata that grew out of them, built on the community formed around Pedrosa and Engenho de Dentro in years prior.[104] The succession of meetings in 1952, however, helped to constitute an expanded community of abstract artists in Rio and its environs, with new members and different focuses. Pedrosa remained a key interlocutor, but Serpa acted as the ringleader, and his one-foot-in, one-foot-out approach to Concretism prevailed over Pedrosa's concern about its doctrinaire tendencies. Moreover, this emerging collective was presented as co-ed and inhabited both public and domestic realms, a contrast to the all-male membership of Grupo Ruptura and their representation

in the press as public intellectuals. Pape was a female practitioner among the assembled artists, and artists' spouses and romantic partners were named as full participants in discussions at both homes and institutions.

Serpa's representative capacity at the first recorded of these collective meetings in June 1952—for artists residing in São Paulo and Paris, respectively, in the cases of Barros and Mavignier, and Rio in the cases of Palatnik and Spence—opens up several interesting possibilities. The first of these is that the "national" in the title Exposição nacional de arte abstrata at its conception was not merely hyperbole, and extended to Brazilian artists residing abroad. Second, if we imagine that Serpa had the permission of the artists whom the news report indicates he represented, Barros's involvement by proxy suggests there is a possible connection between the Petrópolis exhibition and the unrealized *Exposição nacional de arte abstrata e concreta* (National Exhibition of Abstract and Concrete Art), announced in December 1952 on the verso of the Ruptura manifesto, to be held in São Paulo in April 1953.[105] Could this exhibition have been envisioned as the São Paulo iteration of the Petrópolis exhibition? Were there obstacles, practical or intellectual, that led Barros not to participate in the Petrópolis exhibition or that thwarted a collaboration with Grupo Ruptura on the envisioned April 1953 exhibition? Barros actively participated in other exhibitions in Rio that same year, including an exhibition the month prior to the Exposição nacional de arte abstrata and subsequently debuting for a Rio audience his Concrete paintings at the II Salão nacional de arte moderna in May 1953.

Whether or not the Petrópolis exhibition and the unrealized São Paulo project were directly connected, the idea of a "national" abstract art was understood by abstract artists in both metropolitan areas, who came from a diversity of regional and international birthplaces, as something one could envision from the urban centers of the Southeast of the country. The contemporaneous examples of the national modern art salons were only nominally representative of the country: a handful of exhibitors resided in the Southeastern and Southern states of Minas Gerais and Rio Grande do Sul and one or two Bahia, but the vast majority were residents of Rio, São Paulo, and their environs. Despite this myopia, by claiming of the mantle of the national, abstract artists sought not just visibility but also an elevated status for their collectives. For Cordeiro, the dual categories of Concrete and national allowed him to underscore the importance of innovative artistic production.

But what did abstract and Concrete artists have to contribute to the "grave national problems" that Pedrosa vaguely alluded to in his review of the Exposição nacional de arte abstrata?[106] The editorial program and design of *Tribuna da Imprensa* highlighted this very question. The newspaper had relentlessly chastised the nation's leaders for not

acting to protect the well-being of the vulnerable among the populace, first and foremost those devasted by the third year of severe drought centered in the Northeastern state of Ceará. The layout of the newspaper's literary page places Pedrosa's review alongside the nineteenth-century poem "A Fome no Ceará" (Hunger in Ceará) by Guerra Junqueiro and an expressionist drawing of an emaciated individual stalked by destruction. The juxtaposition sheds light on Pedrosa's seemingly innocuous title, "Abstracts at Quitandinha," which underscores the lauding of abstract artists at an iconic center for politics, celebrity, and wealth, while many in the country confronted harrowing conditions. In aggregate this was an indictment of the state's failure to act to head off a crisis, but the newspaper also pressed artists, newly visible and celebrated abstract and Concrete artists especially, on their social responsibility.

A possible and partial response was posed a month later when artists in the Petrópolis exhibition—led by Bandeira, originally from Fortaleza in Ceará—organized a widely publicized art auction in support of drought victims.[107] Ramiro Martins described the event as a critique of the federal government's anemic response.[108] The exhibition and auction occurred in a government building, MES, with collaboration from the ministry, but private charity was substituted for government action. What was also at work in the auction—and, I argue, in the first group exhibitions of Concrete art in Brazil—was the formation of collectives of artists to counter-balance and challenge institutions, public and private, governmental and artistic. As will be examined in chapter 6 and the conclusion, respectively, *Tribuna da Imprensa* would continue to play an outsized role in molding the representation of the abstract artist toward anti-Vargas electoral objectives, and artists in both Rio and São Paulo would, in increasingly sharp conflict with the cultural agenda of the state, craft narratives for Concrete artists and art in society.

Defining Modernism at the Second São Paulo Bienal

A spiral sculpture—composed of reinforced concrete, steel, and sheet metal and rising to a height of thirty-nine feet— was to have heralded a new complex of buildings designed by Oscar Niemeyer, arguably the most celebrated Brazilian architect of the time, for the quadricentennial celebration of the founding of the city of São Paulo (fig. 60).[1] The Comissão do IV Centenário da Cidade de São Paulo (Commission of the Fourth Centenary of the City of São Paulo) selected the design team led by Niemeyer to create buildings for events to be staged over the course of 1954. The approved design consisted of a core of five buildings connected by a central, sinuous covered walkway, or marquise, and an entrance platform containing Niemeyer's monumental *Aspiral* sculpture (fig. 61).[2] The sculpture became a ubiquitous logo for the yearlong festivities—represented by line drawings and black-and-white photographs in the sea of marketing materials and press coverage—and was intended to demonstrate Brazil's technological sophistication and cutting-edge modernity. As a representation of a grand ideal, it spoke to the ambition of the public

FIGURE 60. Oscar Niemeyer. Maquette for *Aspiral*. 1952. Reproduced in *Habitat: Revista das Artes no Brasil,* no. 16 (May–June 1954): 21. Art & Architecture Collection, The New York Public Library. © 2020 Artists Rights Society (ARS), New York/AUTVIS, São Paulo.

and private patrons working to turn the world's attention to the city of São Paulo and the nation of Brazil.

The sculpture itself proved a challenging engineering feat and was erected only temporarily, and in a modified form, in Parque do Ibirapuera at the end of the centennial year in 1954.[3] Declared "a frustrated symbol" by the editor of a prominent architecture and design magazine, the belated, hackneyed erection was seen as revealing the centennial commission's prioritization of appearance and publicity over proper investment in the integrity of Niemeyer's design.[4] Niemeyer also denounced what he called the "mutilation" of his design by the commission.[5] He noted a litany of ways in which his patrons compromised his overall vision, among them the failure to construct elements of his plan.

That Niemeyer's sculptural embodiment of a rising Brazil went unrealized is significant beyond the concerns voiced by the architect and architectural critics. In some respects, no event embodied the aspirations of the quadricentennial celebration better than its inaugural event: the second Bienal. Mounted in two of Niemeyer's just completed buildings, the Bienal constituted a veritable temporary museum of modern art, with more than three thousand artworks from thirty-three countries. The challenges surrounding *Aspiral* illustrate the precarious nature of the Bienal itself, which required organizers in a developing nation to set out every two years to marshal large-scale

FIGURE 61. Oscar Niemeyer. Approved site plan of Parque do Ibirapuera, São Paulo. 1953. Reproduced in Henrique Mindlin, *Modern Architecture in Brazil* (New York: Reinhold Publishing, 1956). © 2020 Artists Rights Society (ARS), New York/AUTVIS, São Paulo.

international support to bring together a collection of art to be displayed for a few months. Furthermore, the Bienal was a hybrid institution, whose leadership sought to provide Brazilian artists and the public with an "active contact" with international art but also to perform the functions more commonly associated with museums, namely tracing a history of art.[6] It was an event that aspired to be both monumental and ephemeral, permanent and temporary. Never was this more the case than at the second Bienal, the most ambitious and historically significant of the exhibition's early iterations, where the displays of historical modernism rivaled and often surpassed those at the postwar Venice Biennale. For two months, from December 1953 to February 1954, representations from nations of the Americas, Asia, Europe, and the Middle East were augmented by presentations of important artists and movements in the history of European and US modern art, as well as historical displays of Brazilian art.[7] Seminal works of European modernism, including Pablo Picasso's *Still Life with Chair Caning* (1912) and Umberto Boccioni's *Unique Forms of Continuity in Space* (1913), as well as Picasso's *Guernica* (1937) and Piet Mondrian's *Broadway Boogie Woogie* (1942–43), were displayed in exhibitions dedicated to major European art movements, and retrospectives of Alexander Calder, James Ensor, Paul Klee, Picasso, Henry Moore, and Edvard Munch.

The second Bienal was an incubator, forum, and model for the redefinition of modernism that abstract artists and aligned critics in Brazil were undertaking. Mário Pedrosa, who directed the European contributions, significantly shaped the story of art that was told, enacting parts of his theory of modernism on the walls in São Paulo. Through in-depth

displays of recent geometric abstract art by artists of the Americas—including numerous works by the participants in the Concrete-oriented art exhibitions in Petrópolis and São Paulo of late 1952 and early 1953—and the organization of the galleries, the second Bienal also visualized a Pan-Americanism that cast Brazil and the United States as hemispheric leaders. The articulation of international and hemispheric identities in the exhibition sometimes dovetailed and often conflicted with the expression of national and local stories. Analysis of organizational priorities, the design and installation, and reception of the second Bienal reveals both the multi-authored grand narratives crafted by the organizers of the Bienal in Niemeyer's open-plan buildings and the geographic and racial erasures that underpinned that cohesion. If at the first Bienal artistic activism targeted the administration of the event, at the second iteration artists enlarged their actions, including successfully lobbying for an exhibition dedicated to the originally excluded medium of photography.

A HISTORY OF EUROPEAN MODERNISM FOR BRAZILIANS

In order to realize a far-reaching presentation of European modernism, the leadership of the Bienal left nothing to chance, as critics argued it had at the first Bienal. The event was robustly staffed, with Francisco Matarazzo Sobrinho, president of the centennial commission; Sérgio Milliet, artistic director of MAM-SP; Wolfgang Pfeiffer, director of MAM-SP; Arturo Profili, secretary general of the Bienal; and Pedrosa, a member of the Comissão Artística (Artistic Commission) of the second Bienal, serving as the event's primary organizers. Ruy Bloem, acting president of MAM-SP during Matarazzo's tenure with the centennial commission, and Paulo Carneiro, the official delegate of the centennial commission in Europe, played administrative roles. In their differing capacities, Milliet, working in São Paulo, and Pedrosa, deployed to Europe for nine months—along with Matarazzo—defined the scope, substance, and caliber of the works of art exhibited and the history of art recounted.[8] Pedrosa, in particular, assembled the European exhibitions with an eye to directing the emerging theory and practice of abstract art among Brazilian artists. The Bienal also enlisted a number of unofficial emissaries to lobby foreign nations, including critics, artists, and patrons Paulo Mendes de Almeida, Cícero Dias, Maria Martins, and Yolanda Penteado.

The event's organizers issued invitations to eleven European countries to contribute special exhibitions and played a definitive role in determining their subjects.[9] In press releases and interviews, Bienal leaders emphasized the didactic goals of the European historical displays as well as the prestige they would generate.[10] These efforts garnered

impressive special exhibitions organized by prominent curators and critics, including Ludwig Grote, Rodolfo Pallucchini, and Willem Sandberg. France, Italy, and the Netherlands assembled exhibitions on Cubism, Futurism, and De Stijl. Belgium, Switzerland, Austria, Norway, and Denmark presented exhibitions of Symbolist artists and Expressionist precursors: James Ensor, Ferdinand Hodler, Oskar Kokoschka, Edvard Munch, and Jens Ferdinand Willumsen. Retrospectives of Klee and Moore were presented by Germany and Great Britain. Among those asked to contribute a special exhibition there was only one absence: Spain did not send the hoped-for exhibition of Joan Miró, likely because the artist was unwilling to participate in a representation organized by Franco's government.[11]

In organizing presentations of historical modernism, the Bienal adopted a practice already underway at the postwar Venice Biennales (1948–1956), and one that would soon be undertaken at the first Documenta exhibition in Kassel, Germany, in 1955. The inclusion of modern art at Venice and Kassel have been understood as some of the earliest systemic, large-scale presentations of art of the prewar past, contributing to an expanding narrative of modern art based in the methods and approaches of art history.[12] The second Bienal was an equally significant early presentation of European modernism. The Bienal, however, operated from the historical and geographic position of a developing nation far from the European continent. In their historical exhibitions, the Italian and German institutions were reflecting on their own national artistic accomplishments and those of geographic neighbors in the context of postwar restitution by the aggressors of World War II.[13] In contrast, the second Bienal was claiming a largely European history of modern art on behalf of Brazilian artists in a moment of optimism for the country's economic and political future.

In addition to the special exhibitions from European nations, the centennial commission and Bienal marshaled its extended network of emissaries—notably Dias, Penteado, and Martins—to realize a large Picasso retrospective, the first ever in South America. Unlike the other historical presentations, the centennial commission underwrote the costs of the Picasso exhibition and hired French critic Maurice Jardot as its curator. The exhibition was composed of fifty-one paintings from European and US private and public collections, including paintings from Picasso's personal collection on extended loan to the Museum of Modern Art, New York (MoMA), and was accompanied by an extensive Portuguese-language catalogue.[14] The assembled works surveyed the major stages of Picasso's work from 1907 through the early 1950s (figs. 62–64). In addition to documenting Picasso's Cubist practice of the teens with works such as *Still Life with Chair Caning* and his

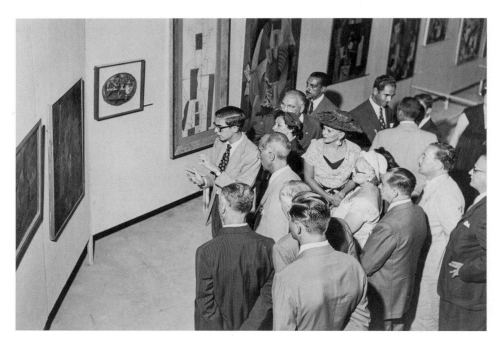

FIGURE 62. Installation view of the Pablo Picasso retrospective at the second Bienal de São Paulo. 1953–1954. The Museum of Modern Art Archives, New York. Digital Image © The Museum of Modern Art/Licensed by SCALA/Art Resource, NY.

engagement with Expressionism and realism in the 1930s in *Guernica* and other paintings, the exhibition included a number of major works from the 1920s, including the classicizing *The Pipes of Pan* (1923) and the Surrealist *Guitar* (1926) and *Nude in an Armchair* (1929).

In his essay, Jardot asserted that Picasso's work had always been "profoundly rooted in reality" and none of his art, not even Cubist works, should be considered abstract.[15] He grounded this claim in Picasso's comment to Christian Zervos in 1935: "There is no abstract art. You must always start with something."[16] Picasso, steeped in the debates of abstraction and realism in Paris before World War II, and Jardot, in their postwar manifestations, each negated the validity of nonobjective abstraction. In São Paulo Jardot proposed that Picasso's production subsisted on realism.

Though Pedrosa contributed to the organization of the Picasso retrospective, he also endeavored to counterbalance the foregrounding of the artist. Specifically, he sought to elevate the assessment of Klee, and he envisioned the Bienal as an unprecedented

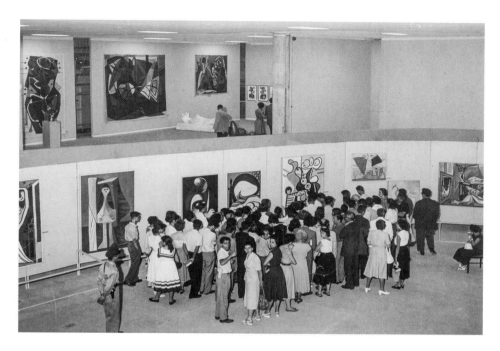

FIGURE 63. Installation view of the Pablo Picasso retrospective (below) and Henri-Georges Adam exhibition (above) at the second Bienal de São Paulo. 1953–1954. Fundação Bienal de São Paulo/Arquivo Histórico Wanda Svevo.

opportunity for Brazilian and international audiences to view the two artists' production in comparison to one another. As Pedrosa articulated in an essay written in January 1953, shortly before he departed for Europe on behalf of the Bienal, he viewed Klee as a key figure in European modernism who defied categorization and whom he hoped to position for Brazilian artists as an essential point of departure.[17] For Pedrosa, Klee's refusal to adhere to a single style and his references to reality even in seemingly abstract works were evidence of a "radical attitude" that "allowed all avenues to remain permanently open before him."[18] In other words, Pedrosa saw Klee as a bulwark against orthodoxy, which he saw locally and internationally in the Communist Party's adoption of social realism as its sanctioned aesthetic as well as in Max Bill and his followers' advocacy of Concrete art to the exclusion of other approaches. Implicit in Pedrosa's elevation of Klee was a challenge to the vision of modernism, promoted locally by established artists Emiliano Di Cavalcanti and Cândido Portinari, that valued expressionistic realism, derided

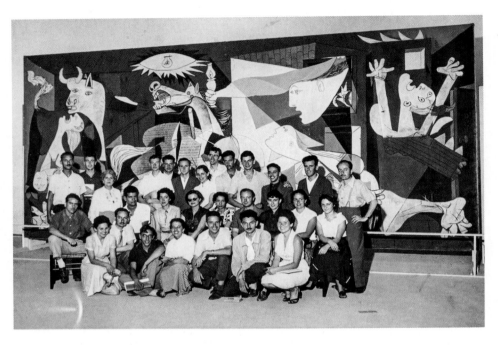

FIGURE 64. Installation view of Pablo Picasso, *Guernica,* 1937, at the second Bienal de São Paulo. 1953–1954. Fundação Bienal de São Paulo/Arquivo Histórico Wanda Svevo.

nonobjective abstraction, and viewed Picasso as a paragon of socially conscious art. He also wanted to supplement the already burgeoning interest in Brazil in Mondrian—an artist to whom Pedrosa warmed considerably by the time of his departure for Europe—with an engagement with the more heterogeneous practice of Klee.[19]

Pedrosa's commitment to bringing a robust Klee exhibition to Brazil was such that he not only derailed the West German government's plans to send a special exhibition dedicated to Die Brücke, but also orchestrated support for the Klee exhibition through a substantial amount of arm-twisting.[20] He traveled to Switzerland, where he secured the participation of Klee's heirs and foundation by promising a "face-to-face" competition between Klee and Picasso; and to West Germany, where he persuaded government authorities by arguing, outlandishly, that their support of a Klee exhibition would be considered internationally as reparation for the Nazi closure of the Bauhaus and would be an opportunity for the "new Germany" to brandish its cultural and artistic openness.[21]

FIGURE 65. Paul Klee. *Individualized Altimetry of Layers*. 1930, 82. Pastel on paper on cardboard, 18 ⁷/₁₆ × 13 ¹¹/₁₆ in. (46.8 × 34.8 cm). Zentrum Paul Klee, Bern. © 2020 Artists Rights Society (ARS), New York.

After Germany's official agreement to a Klee exhibition, Pedrosa continued to champion the project. He argued unsuccessfully for MAM-SP to financially subsidize the catalogue and advocated that publicity for the Bienal should underscore that it would feature the first simultaneous large-scale exhibitions anywhere of Picasso and Klee.[22] The final exhibition, accompanied by a well-illustrated catalogue, was composed of sixty-five paintings and works on paper spanning much of the Klee's career, though the majority were late works and all were lent by the estate or foundation (fig. 65).[23] Pedrosa had hoped for a more complete retrospective, drawn from German and Swiss collections, reflecting the same comprehensiveness as the Picasso exhibition.

As Jardot's and Pedrosa's contrasting visions of realism's role in historical modernism illustrate, more was at stake in the Bienal's panorama of European modernism than São Paulo's international prestige. In the early 1950s, Brazilian critics persisted in speaking about the amateurish or immature quality of the production of local emerging artists, and the account of modern art history presented at the Bienal was, as Milliet stated, meant as a classroom for these artists.[24] Distinct interpretations of modernism at the Bienal competed both to orient domestic artistic practice and to grapple with the place of Brazilian and Latin American production in international accounts. While the selection of works, and intentions motivating those choices, are important, how a story is told and experienced is equally influenced by how, and in what company, it is presented. Put differently, the narratives of modernism ultimately proffered to visitors in São Paulo depended on the account of Brazilian modern art at the event as well as the installation of the exhibitions in Niemeyer's buildings.

NATIONAL AMBITIONS AND HEMISPHERIC AMBIVALENCE

At mid-century, the Bienal was among the most visible platforms for the representation of art of Latin America. The second Bienal vastly expanded its efforts targeting Latin America, extending invitations to all then-independent nations, with eleven countries ultimately participating (compared to seven in the first Bienal). Nevertheless, Brazilian political and cultural leaders viewed the strategic utility of engagement with Latin America with what can politely be described as ambivalence. Hemispheric discourses that gained traction in the realm of the visual arts often did so in active tension with the crafting of metropolitan, regional, and national identities by the elite of a nation that was both affluent relative to its geographic neighbors and the sole Portuguese-speaker. Moreover, Bienal organizers replicated colonial relations in its prioritization, in the event as a whole,

of Western European participation and, in the Americas, of US and Mexican contributions, the only nations from the hemisphere offered special exhibitions. A lack of consistent management of the Latin American representations contributed to the absence of Colombia, Ecuador, and Haiti among the invited Caribbean and South American nations and the belated participation of only one Central American nation, Nicaragua. In contrast, organizers lavished attention on Mexico, but to little avail—the nation was ultimately represented at the event by private initiatives.

The second Bienal was the site of negotiations of hemispheric identity and of the construction of narratives of "American" art. It both drew upon and differed from the Pan-Americanism promoted by US institutions like MoMA in New York and the Pan American Union (PAU, later Organization of American States) in Washington, DC, in the context of the Second World War and immediate Cold War period. On one hand, José Gómez Sicre, head of the Visual Arts Section at PAU, acted as an influential informal advisor and behind-the-scenes lobbyist for a greater focus on Latin America at the event. Gómez Sicre organized the impressive Cuban representation and steered the exhibitions from numerous Latin American nations, meaning the roster of abstract artists exhibited by the Washington, DC–based institution populated the second Bienal.[25] Additionally, Claire Fox argues Gómez Sicre created a particular sphere of influence at PAU in Central America and the northern Andes, advocacy that was evident at the second Bienal.[26] Nicaragua, Peru, and Venezuela were included for the first time, and Gómez Sicre contributed names of artists for those, the representation from Guatemala, and other ultimately unrealized contributions.[27] On the other hand, the second Bienal created a vision of the Americas that de-centered the United States and imagined Brazil as an emergent international and, wittingly and unwittingly, hemispheric leader. In comparison to the modest pan-American exhibitions composed of works by a small number of artists that MoMA and PAU circulated in the late 1940s, the second Bienal was the first large-scale exhibition of the modern art of the Americas in Latin America. Moreover, unlike at the first Bienal, where the Brazilian special exhibitions were a cluster of artist-organized solo displays, in 1953 commissioned curators assembled two ambitious exhibitions dedicated to different facets of Brazilian art. The subjects of the Brazilian special exhibitions, as well as the organizational efforts related to the US contribution, reveal that Bienal organizers sought to suggest a synchrony between the emergence of modernism in Brazil, Europe, and the United States.

Bienal organizers did not attempt to provide a comparably comprehensive accounting of Brazilian modernism from the late nineteenth to mid-twentieth centuries as they did

FIGURE 66. Eliseu Visconti. *O Colar (Retrato de Yvonne Visconti)*. 1922. Oil on canvas, 20 ⅛ × 15 in. (51 × 38 cm). Private collection. Image courtesy of Projeto Eliseu Visconti.

with the special exhibitions from Europe. But they did mount two large-scale, ambitious historical exhibitions in collaboration with the federal government's cultural ministry. One exhibition composed of portrayals of the Brazilian landscape by foreign and Brazilian artists from the seventeenth to the nineteenth centuries was cast as a showcase of cultural patrimony. The retrospective of Brazilian artist Eliseu Visconti, who was active from the late 1800s through the early 1940s, positioned the artist as the pioneer of Impressionism in Brazil (fig. 66).[28] With the exception of Tadeu Chiarelli, historians have largely ignored these exhibitions in their analysis of the Bienal—a notable omission given how seemingly incongruous they were with the mission of the Bienal to showcase modern, non-

academic art.[29] The subject matter of these exhibitions reflected the specific conditions of the second Bienal, namely its role as the inaugural event of a centennial celebration and the consequent interest in recounting a longer history of national artistic expression. But the exhibitions also set an early precedent for the Bienal's inclusion of non-modern art, and illustrate the broad and ambitious history-writing project underway at each iteration in which curators negotiate the inclusion of Brazilian art into global narratives.[30] At the second Bienal, that global narrative was an emphatically Euro-American-centered one. With the Visconti exhibition, curators claimed an origin for Brazilian modernism synchronic with late-nineteenth-century European innovations and thereby provide a longer history of local avant-garde activities, which were more conventionally understood to have begun in the 1910s and 1920s.[31]

The Bienal organizers were unsuccessful in persuading MoMA to realize the historical display they hoped would accompany the US representation—an exhibition dedicated to Albert Pinkham Ryder.[32] In selecting Ryder, a largely self-taught US artist whose work shared characteristics with Symbolism, the Bienal organizers deviated from their established pattern of selecting artists and movements previously featured in the postwar Venice Biennales. The unrealized Ryder exhibition would have complemented the special exhibition dedicated to Visconti, an artist with Symbolist affinities, and suggested an equivalence between the temperaments and chronologies of US and Brazilian modernism. Milliet, less cognizant of contemporary art trends, probably selected Ryder, an artist he had long held in high esteem, thanks in part to the writings of US critic Sheldon Cheney.[33] Cheney argued that Ryder should be understood as a precursor of German Expressionism and "stands first on the list of New World pioneers of modernism."[34] This view of Ryder as a forerunner of Expressionism and a leader of local modernism complemented the interpretation put forward in the Visconti retrospective, and the combination of the exhibitions would have asserted not just a synchrony between Brazilian, European, and US art histories, but also claimed a semi-autonomous status for hemispheric modernism.

In declining the request, MoMA cited the difficulties in locating Ryder's works and conservation concerns, and told Martins during her visits to New York in early 1953 that it was instead considering an exhibition dedicated to Winslow Homer, which would have fulfilled the Bienal's desire for a retrospective dedicated to a late-nineteenth-century US artist.[35] Ultimately, MoMA informed the Bienal that Calder would be the subject of the US special exhibition (fig. 67).[36] Several historians have speculated that emissaries on behalf of the Bienal may have influenced MoMA's selection of Calder, but the archival record does not evidence a Brazilian intervention.[37] It is true that Brazilian critics and

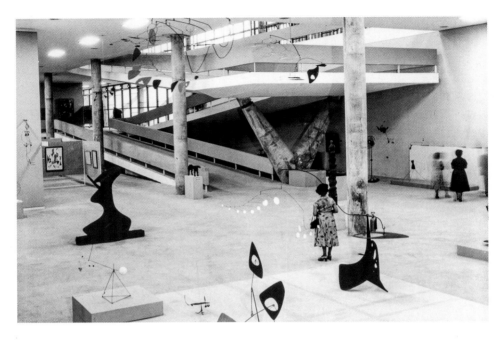

FIGURE 67. Installation view of the Alexander Calder retrospective at the second Bienal de São Paulo. 1953–1954. Fundação Bienal de São Paulo/Arquivo Histórico Wanda Svevo.

institutions had a sustained, pre-existing engagement with the artist, including his solo exhibition in 1948 in Rio and São Paulo and visit to the country the same year. But MoMA also had a longstanding commitment to Calder's work, organizing a solo exhibition in 1943 and actively acquiring his work since the 1930s. Despite an exhibition dedicated to Ryder, Homer, and Thomas Eakins soon after its founding, by mid-century MoMA was decidedly uninterested in chronicling a longer history of US modernism.

Bienal organizers requested from the Mexican government a special exhibition dedicated to José Clemente Orozco, as well as a representation they hoped would be composed of works by Diego Rivera, David Alfaro Siqueiros, and Rufino Tamayo.[38] Taken together, these would have been the first major presentations in South America dedicated to Mexican modernism, then the only Latin American artistic movement widely regarded as a major force in the international history of modern art. Elements of the art press in São Paulo had been vocal in their disappointment at Mexico's absence from the first Bienal—seeing it as evidence of the Bienal's abstract bias—and insisted on the nation's

presence in 1953–1954. The Bienal launched an intense lobbying effort to secure Mexican participation, including two separate trips by representatives to Mexico City, during one of which Martins met with the president of Mexico.[39] Pedrosa also met in London with Fernando Gamboa, director of the Museo Nacional de Bellas Artes (National Museum of Fine Arts).[40] Mexican cultural authorities nevertheless declined to participate, citing economic reasons and the commitment of works to prior international exhibitions. Mexican governmental and cultural leaders—not unlike the Bienal leadership—preferred to dedicate resources to exchange with Europe and the United States.[41] In the case of the second Bienal, the government of Mexico prioritized a major exhibition at the Tate Gallery in 1953. To starve off criticism, and perhaps because leaders held out hope for a change, the Bienal did not announce Mexico's decision, and local newspapers continued to list exhibitions dedicated to Siqueiros and Orozco as part of the second Bienal program a few weeks before the event's inauguration.[42] The country was ultimately represented by an exhibition of works by Tamayo, lent by Knoedler Gallery in New York, and a selection of prints, sent by the Taller de Gráfica Popular. Yet again the Bienal was criticized for failing to mount the promised Mexican representation.[43]

Privately, Gómez Sicre criticized MAM-SP for dedicating its financial and staff resources to Euro-American displays while neglecting an effort to secure a wide array of contributions from the Western hemisphere. In a lengthy letter to Profili in which he championed a hemispheric, rather than international, focus, Gómez Sicre asked: "Don't you think that presenting the same panorama of European art of well-recognized masters is duplicating other similar events in Europe?"[44] The Bienal organizers saw the São Paulo event not as a duplicate, but a peer and rival of the Venice Biennale, and viewed the mapping of a history of European modernism as the central undertaking of the second Bienal. Where Bienal organizers and Gómez Sicre did agree was the solicitation of exhibitions from Latin American nations that reflected current contemporary artistic trends rather than the academic profiles of several of the contributions to the first Bienal. As a result, the representations from Latin American nations were largely composed of recent avant-garde, non-academic artists. The Argentine exhibition included works by Concrete, Madí, and geometric abstract artists, including Martín Blaszko, Alfredo Hlito, and Lidy Prati, and the Uruguayan display featured new nonfigurative art works by José Pedro Costigliolo, María Freire, and Antonio Llorens alongside the work of Joaquín Torres-García and his followers (fig. 68). Similarly, geometric abstract works were prominent in the Cuban and Venezuelan exhibitions by the artists Mario Carreño, Sandú Darié, and Luis Martínez Pedro, from Cuba; and Armando Barrios, Carlos González Bogen, and Mateo Manaure, from Venezuela.

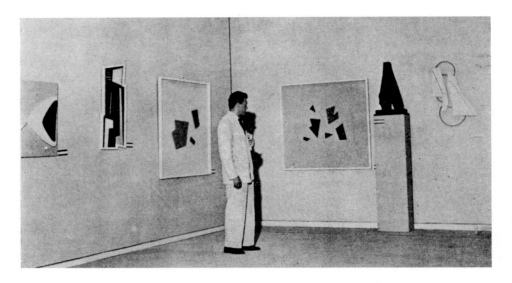

FIGURE 68. Installation view of the Argentine representation at the second Bienal de São Paulo. 1953–1954. Reproduced in *Arte Madí Universal,* no. 7/8 (1954): 31. Benson Latin American Collection, LLILAS Benson Latin American Studies and Collections, The University of Texas at Austin.

The Brazilian section was sprawling, with some four hundred works. Several major figurative painters, including Portinari and Lasar Segall, elected not to submit works and were not included in the exhibition. Critics speculated that these artists abstained from the event because, in their view, the awarding of prizes at the first Bienal had favored abstract works.[45] A significant number of painters practicing abstract tendencies participated. These included Concrete works by members of São Paulo's Grupo Ruptura, including Geraldo de Barros, Lothar Charoux, Luiz Sacilotto, and Anatol Wladyslaw, and geometric abstract paintings by Samson Flexor and members of his newly founded São Paulo-based group Atelier Abstração. A number of artists who exhibited at the Exposição nacional de arte abstrata participated, including many of those who would soon form Rio's Grupo Frente, namely Aluísio Carvão, Lygia Clark, Abraham Palatnik, Ivan Serpa, Décio Vieira, and Franz Weissmann. Taken together, the displays were rich with Concrete and geometric abstract works by artists from Brazil and Latin America, and along with the absence of an exhibition of Mexican muralists and presence of the Calder retrospective, attested to a flourishing contemporary engagement with abstraction by artists of the Americas.

THE DISPLAY OF CONTRASTS IN NIEMEYER'S HALLS

At the São Paulo Bienal, as at the Venice Biennale, national artistic expression reigned: in the national representations and in the historical exhibitions devoted to a single artist or artistic movement from the organizing nation. The interpretations of artistic movements, such as Cubism, Futurism, and De Stijl, were limited to artists working in the style in the respective centers of France, Italy, and the Netherlands. More itinerant—and overtly politicized—movements, such as Dada, were excluded, and no study of the international reach of artistic styles or movements, such as Symbolism, was attempted. Nevertheless, Niemeyer's design for the buildings that housed the second Bienal created the possibility of a flexible account of modern art that was impossible in the buildings of the Venice Biennale. At Venice, the Palazzo Centrale (Central Pavilion) consisted of a rabbit's warren of immutable and disparately sized and shaped rooms, and the Giardini (Gardens), where many national representations were displayed in their own buildings in the midst of a formal garden. At São Paulo, the site, building, and installation designs and the division of works between the two adjacent buildings that housed the Bienal complicated the definition of artistic practice via geopolitical categories, transcending national divisions to suggest cross-cultural dialogues while reifying continental identities. In the process, geographically and temporally defined contrasts between the historical European past and more recent practices of the Americas emerged.

The second Bienal was, like the first, held on public land within an elite residential area and in a new modernist structure, in this case a complex of buildings in Parque do Ibirapuera designed by Niemeyer (fig. 61). The second Bienal occupied two adjacent concrete and glass rectilinear pavilions, the Pavilhão das Nações (Pavilion of Nations) and Pavilhão dos Estados (Pavilion of States), identical but for their facades—glass in the former case and brise-soleils in the latter (fig. 69).[46] The identification of the buildings as pavilions and the geopolitical categories encoded in their titles illustrates that the complex and centennial celebration were modeled on the World's Fair. In a design proposal, from 1952, the Pavilhão de Nações bore the name "Pavilhão das Nações Estrangeiras" (Pavilion of Foreign Nations) in anticipation of the I Feira Internacional de São Paulo (First International Fair of São Paulo), a key event in the centennial year where different buildings would showcase the industrial products of São Paulo, the states of Brazil, and foreign nations.[47] Dropping of the qualifier "foreign" allowed the term "states," in the context of the Bienal, to indicate the countries of the Americas and keyed the nomenclature to that of the United Nations and PAU. At Ibirapuera, Niemeyer and his patrons

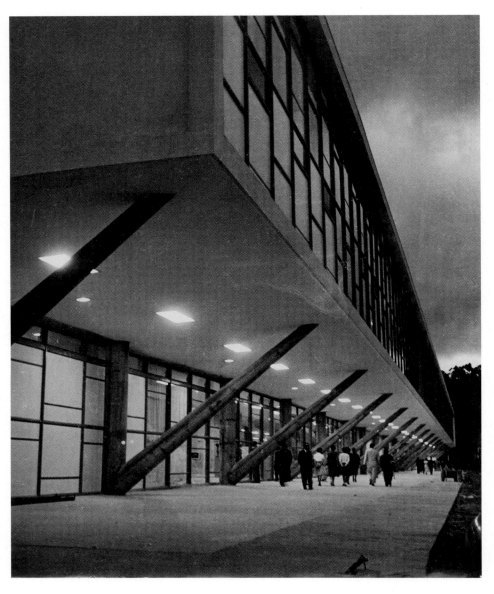

FIGURE 69. Oscar Niemeyer. Pavilhão dos Estados, São Paulo. 1953. Fundação Bienal de São Paulo/Arquivo Histórico Wanda Svevo. © 2020 Artists Rights Society (ARS), New York/AUTVIS, São Paulo.

imagined that collaboration with the states of Brazil, the American hemisphere, and the world would bring about the economic and political ascent of the city of São Paulo and the nation of Brazil as a whole.

As with other modernist buildings government entities erected at mid-century across Brazil, Niemeyer's Ibirapuera design shared the goal of projecting an image of an economically prosperous, forward-looking nation capable of marshaling industrial technologies and materials to construct a modern Brazil. The buildings read in model and from afar as building-block geometric forms—rectangular solids, a dome, and a trapezoidal wedge—assembled around the sinuous marquise. Up close, these deceptively simple masses reveal not only their inventive construction techniques, which allow vast fields of reinforced concrete to appear to float atop a column or piloti placed here and there, but also a wealth of modernist features—brise-soleils, curtain walls, and pilotis of abundant variety. It is not to discount Niemeyer's seriousness, as Max Bill infamously did during his visits to Brazil in 1953, to note that in aggregate these features emphatically underscore the modernism of the buildings, both in terms of the use of an established design lexicon and the deployment of advanced construction techniques.[48]

In the Pavilhão das Nações and Pavilhão dos Estados, Niemeyer relegated the few permanent walls to the perimeter of each two-story building and thereby produced enormous, largely uniform halls supported by columns and reached via the large, central ramp. The interior architects, Jacob Ruchti and Giancarlo Fongaro, and the Bienal organizers, likely led by Milliet and Pfeiffer and assisted by Profili, used a combination of temporary walls, which stretched from floor to ceiling, and freestanding partitions to create distinct spaces.[49] In the areas dedicated to each national representation, visitors were surrounded by works from one artist, style, or nation—as, for example, in the Dutch section where visitors moved from the larger gallery, which contrasted the prewar geometric abstraction of Mondrian, Theo van Doesburg, Friedrich Vordemberge-Gildewart, and Bart van der Leck with the postwar gestural and Expressionist works of CoBrA and other artists, to a monographic wall dedicated to Mondrian's paintings and a cluster of De Stijl works hung on multiple surfaces (fig. 70). But there was also a fluidity between national representations, allowing visitors to wander in and out of partitioned but open spaces. Bienal organizers nonetheless employed the conventional display methods of mounting works on walls, partitions, and pedestals, painted white and gray and placed in a rectilinear plan, foregoing the nontraditional displays that MASP was utilizing in its exhibitions.[50]

The commingling between displays was most overt in the vistas created by the buildings' broad, central ramps and sunken atriums that carve through the interior volume of

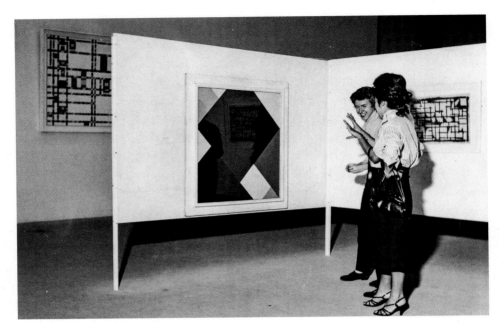

FIGURE 70. Installation view of paintings by Piet Mondrian and Theo van Doesburg in the Dutch representation at the second Bienal de São Paulo. 1953–1954. Fundação Bienal de São Paulo/Arquivo Histórico Wanda Svevo.

the two pavilions. Given the partitioning of each floor during the Bienal, it was the ramps and atriums that most fully retained the qualities of openness, lightness, and "panoramic amplitude" that Niemeyer sought in his design.[51] Organizers utilized these architectural features to suggest connections across national and historical boundaries and to break out of the rigidly defined national categories endemic to the biennial model to compose broader art historical arguments. A visitor could, for example, glance from Picasso's canvases of the 1920s and 1930s up to paintings and sculptures of the 1940s and 1950s by French artist Henri-Georges Adam; and consider Calder's large-scale mobiles with contemporaneous paintings of the early 1950s by Willem de Kooning (see figs. 63, 67).

While the interior plan of Niemeyer's buildings enabled fluid transitions between works of art of different artists, historical moments, and nations, the Bienal organizers divided the exhibition between the two buildings in a manner that underscored hemispheric identity. The works of art sent to the Bienal by each nation were divided along geographic lines: the Pavilhão das Nações included European countries along with a few

Middle Eastern and Asian nations.[52] The Pavilhão dos Estados included Brazil and countries of the Americas, as well as the architecture section. This partitioning facilitated critics' discussion of the Bienal in terms of "European" and "American" (in the hemispheric sense) contributions to art history.

Within these geographic blocs, four countries received the largest amount of space: Brazil, the United States, France, and Italy, with the first two occupying the entire ground floor and atrium of the Pavilhão dos Estados, and the latter two filling the same spaces of the Pavilhão das Nações. These choices reflected historical, societal, and political conditions as well as the importance the Bienal organizers placed on the artistic achievements of these nations. France had founded the fine arts academy in Brazil, and its art had remained at the forefront of the national consciousness throughout the first half of the twentieth century. Cultural exchange with Italy was a more recent phenomenon, spearheaded by the increasingly well-to-do and influential Italian-Brazilian community in São Paulo, including one of its most prominent members, Matarazzo. Meanwhile, the United States, via Nelson A. Rockefeller and MoMA, had been directly involved in shaping Brazil's modern art institutions and was viewed by Matarazzo as an important partner in his goal to transform São Paulo into a world-class artistic center.

Although the consideration of European art as an intelligible entity was commonplace, the discussion of the art of the United States, Mexico, Canada, Central and South America, and the Caribbean in a comparative framework was a newer phenomenon. The Pan-Americanism asserted at the Bienal built upon the existing US formulation, but was no longer predicated on US largesse or singularity. In the installation, Bienal organizers quite literally gave Brazil the pride of place alongside the US display, a stark contrast to the placement of the Brazilian representation in the basement at the first Bienal. Brazil was visualized not as a humble host or one nation among many in Latin America but as an emergent hemispheric leader.

The division of the exhibitions of Europe and the Americas, as well as the content of the displays, resulted in the European contribution being understood by Brazilian critics above all as historical, while the works from the Americas were seen as embodying current and future trends.[53] On one hand, displays dedicated to works by the key figures of the historical avant-garde dominated the principal European exhibitions. Given the quality of these works and the remarkable nature of their presence in a developing nation, they attracted the lion's share of critical and popular attention, none more so than Picasso's *Guernica*. Local periodicals focused, in some cases exclusively, on the exhibitions of European modernism and dedicated lengthy series to their analysis.[54] On the other

hand, the prize jury, composed of European, Latin American, and US critics, recognized a number of the works by young abstract artists of the Americas with acquisition prizes, including paintings by Barros, Hlito, Martínez Pedro, Serpa, and Alexandre Wollner, and sculptures by Calder and Mary Vieira.[55]

Nowhere was the geographically defined distinction between the European past and American present more pronounced than in the Calder and Picasso exhibitions that filled the sunken atriums of the two pavilions. The correspondence between the two shows did not go unnoticed by visitors. As one observer recalled,

> I saw [Calder's mobiles] for the first time about ten years ago, at the Ministério da Educação e Cultura, and then later at the Bienal in Parque do Ibirapuera in celebration of the fourth centenary of the founding of the city of São Paulo. . . . Nearby—or next door, I don't remember exactly—was the Picasso retrospective. Over several days my eyes were alternately attracted and fascinated by two contrasting visions: the tragedy and neutral colors of *Guernica,* and the *festa* and tremendous *joie de vivre* of the mobiles.[56]

In other words, the grand face-off between Picasso and Klee that Pedrosa had envisioned from Europe was not to be. Instead of two artists from the same continent, visitors to the Bienal were asked to weigh the American Calder against the European Picasso.

The comparison of the two shows was further facilitated by the fact that both were retrospectives of a single artist installed to emphasize a particular body of the artist's work. In the case of the Picasso exhibition, Jardot arranged the display chronologically along the curved wall of the atrium, culminating with *Guernica* on one of two rectilinear walls (fig. 71; also see figs. 62–64). For Jardot, *Guernica,* the monumental scene of destruction, painted in black, white, and gray and composed of a flurry of human feet, arms, and agonized faces in the aftermath of a bombing during the Spanish Civil War, embodied the culmination of Picasso's realism, a realism that served as a protest against state violence with continuing, vital efficacy. In effect, by praising Picasso's work of the 1930s and focusing on the realist nature of Picasso's Cubist works, Jardot portrayed Picasso as a historical figure. Rather than foregrounding Calder's works from earlier decades, René d'Harnoncourt, director of MoMA, installed the artist's forty-four sculptures to emphasize his recent work, namely six large-scale mobiles (fig. 67).[57] As can be seen in his sketch of the installation, in which the mobiles are rendered as cloud-like clusters of curved lines, d'Harnoncourt distributed them throughout the entire atrium (fig. 72).

1907

1952

Guernica

ŞISAP/C/67/8/2

FIGURE 71. Maurice Jardot. Sketch of the Pablo Picasso retrospective at the second Bienal de São Paulo. February 23, 1954. Musée national Picasso-Paris, Don Succession Picasso, 1992. Inv. No. 515/AP/C/67/8/2. © RMN-Grand Palais/Art Resource, NY.

And it was Calder that Pedrosa lauded, interpreting him largely in the same terms as he had previously understood Klee, namely as a bulwark against orthodoxy and a model for Brazilian artists.[58] Within days of returning to Brazil and participating in the prize jury, Pedrosa gave several polemical interviews to local newspapers in which he criticized the awarding of the grand prize to Henri Laurens over Calder, denounced the Communist Party as limiting artistic freedom, and argued that abstraction represented the most vanguard approach to art making.[59] Pedrosa expanded on his earlier delineation of modern art history into two distinct trajectories: one expressive, following the example of Picasso, Klee, and Surrealism and including Abstract Expressionism; and the other constructive,

FIGURE 72. René d'Harnoncourt. Sketch of the Alexander Calder retrospective at the second Bienal de São Paulo. c. 1953. René d'Harnoncourt Papers, VI.12. The Museum of Modern Art Archives, New York. Digital Image © The Museum of Modern Art/Licensed by SCALA/Art Resource, NY.

based on Constructivism and De Stijl and including interwar and postwar geometric abstract practices in Europe.[60] He argued that artists who practiced the former treated painting as a catharsis, which he viewed as egotistical and shortsighted; for those who focused on the latter, he wrote, painting "is an effort of stylistic definition with sufficient universality to give our times what they lack: spiritual cohesion."[61] Though he viewed Calder as forgoing allegiance to any movement, Pedrosa felt that the artist's work achieved the lofty aspiration of constructive practices and conveyed an "optimism" and openness that best captured the sensibility of the contemporary moment.[62] Interestingly, in his comments on the second Bienal, Pedrosa sidelined Klee, treating the artist not as singular outlier, but as a creator of deformations and emotionally tempered works like Picasso and others in the expressive wing of modernism.

The Bienal's bifurcation—however artificial and temporary—of the European past and the American present was in itself a radical repositioning. The notion that Brazilian and Latin American artists had equal access and claim to the history of European modernism and that their actions in the artistic sphere were original and non-derivative contributions was by no means a new idea—early-twentieth-century artists in Latin America expended copious ink and paint arguing for just such a reorientation. Nonetheless, the grand scale of the second Bienal and its status as simultaneously the first robust forum for exchange among Latin American artists and the most ambitious vehicle for international cultural exchange in Latin America afforded it a large megaphone.

DEBATING ABSTRACT AND FIGURATIVE GENEALOGIES

Where Pedrosa celebrated the confluence of geometric abstraction among artists from the Americas, for a number of critics the contrasts on display at the Bienal raised concerns about the future of Brazilian art, by which they meant an art tangibly rooted in Brazilian realities. As at the first Bienal, this anxiety was expressed by critics with a range of viewpoints—not just from opponents of abstraction in the Communist press, but also more mainstream critics. Pro-realism critic Antonio Bento, writing for a daily Rio newspaper, interpreted the numerous Concrete works by Latin American artists as the bad fruit of Bill's influence.[63] José Geraldo Vieira, art critic for a daily São Paulo newspaper and new editor of *Habitat: Revista das Artes no Brazil,* explained that his objection to the geometric abstract works by artists of the Americas at the Bienal was not their abstraction per se. Rather in the absence of any allusions to specific geographic, cultural, or historical traits, the style risked becoming a "kind of optimistic Esperanto of geometricizations."[64] The concern that non-objective abstraction represented an encroaching hollow cosmopolitanism, oriented by Euro-American taste rather than local conditions, indicates the limited success of the claim by abstract artists to be a part of the national story in their exhibitions of the preceding years. However, critical responses to the Bienal from Waldemar Cordeiro and the art press affiliated with the Communist Party reveal that locating the expression of national culture in realist or expressionist works, even seminal works like Picasso's *Guernica,* was also far from straightforward.

Critics concerned about a proliferation of "geometrizations" were responding to works by numerous abstract artists both at the Bienal and beyond. A new abstract art group, Atelier Abstração, timed their inaugural exhibition to overlap with the Bienal and likely contributed to the unease. Not only did the production of Atelier Abstração

members closely follow that of their leader and teacher, Flexor, but the representation of the group reinforced the sense that the students/members were following a model rather than creating unique works. Even sympathetic critics commented on the homogeneity of the group's production.[65] In a photograph of the group working in the collective studio in Flexor's home, Flexor and his large canvas were positioned at the head of the class and two students, Jacques Douchez and Leyla Perrone-Moisés, are captured consulting an illustration of a painting by Mondrian (fig. 73).

It is also important to note that the abundance of recent Concrete and abstract art in the displays of the Americas at the Bienal was not without contestation: submitted works by Willys de Castro, Judith Lauand, Lygia Pape, and Maurício Nogueira Lima were rejected by the selection jury, and Cordeiro withdrew his accepted works to protest what he and others argued was the disregard of artists' voting rights in constituting the juries for the Bienal.[66] Moreover, while the prize jury awarded acquisition prizes to geometric abstract works, they withheld an endorsement of the style in the official prizes, a contrast to the feting of Bill at the first Bienal. Instead, a figure like Alfredo Volpi, whose practice was esteemed by those advocating for a recognizably Brazilian art and by those advancing the cause of nonobjective abstraction, was celebrated.

Volpi shared the national painting prize with Di Cavalcanti. Near contemporaries, born just a year apart, and both of Italian descent, the two artists nonetheless occupied distinct positions within the Brazilian art scene: Di Cavalcanti a native-born standard bearer for figuration and Brazilian modernism, Volpi a self-taught immigrant artist whose work retained pronounced tethers to Brazilian popular expression. Di Cavalcanti had been at the center of Brazilian artistic life since the early 1920s, when he participated as a young man in the Semana de Arte Moderna of 1922. A resident alternately of Rio, São Paulo, and Paris, Di Cavalcanti was often characterized as Brazil's quintessential bohemian artist. During the late 1940s and 1950s, he also distinguished himself as a vocal defender of realism and opponent of abstraction. Volpi emigrated to São Paulo as a young child from Italy and worked as a skilled craftsman. In the 1930s he began practicing as an artist, and critics emphasized his working-class background, lack of fine art training, and portrayal of vernacular architecture and culture as evidence of his authentic painting practice.[67] In the early 1950s he was embraced by young abstract artists as a respected elder and autochthonous creator. In the mid- and late 1950s, Volpi would make progressively more abstract works, and exhibit with Concrete artists.

At the second Bienal, Di Cavalcanti and Volpi displayed works that were understood as decidedly Brazilian. In *Pescadores* (Fishermen) of 1951, Di Cavalcanti depicted a coastal

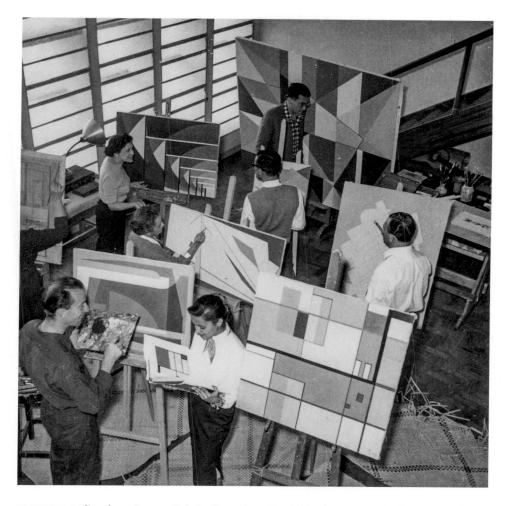

FIGURE 73. Atelier Abstração. 1954. Gelatin silver print, 4 ⅞ × 6 ⅛ in. (12.4 × 15.6 cm). The Museum of Fine Arts, Houston, Hirsch Library, Adolpho Leirner Archive of Brazilian Constructive Art. LIB.383.B. Photo: Jacques Douchez.

scene that recalls the bay surrounding Rio, in which he placed two larger-than-life dark-skinned figures, each with their respective bounties of fish and fruit (fig. 74). The artist represented the Afro-Brazilian couple as the Ur-hunter and gatherer—the bedrocks of the social, economic, and natural systems we glimpse in the background. In contrast, Volpi denuded his paintings, including *Casas* (Houses) of 1953, of human figures and filled

FIGURE 74. Emiliano Di Cavalcanti. *Pescadores*. 1951. Oil on canvas, 45 ⅛ × 63 ¼ in. (114.5 × 162 cm). MAC USP Collection. Gift of the Museu de Arte Moderna de São Paulo. © 2020 Artists Rights Society (ARS), New York/AUTVIS, São Paulo.

his composition from edge to edge with broad, flat sections of rhythmically painted tempera colors (fig. 75).[68] Volpi still represented a Brazilian scene, here the typical arched doorways and windows of the colorful facades of colonial homes. But the architectural features are arranged in a non-realistic manner, serving as conceits for the creation of engaging formal play of geometric forms and colors. The painting thus walks a line between naturalism and nonobjective abstraction while remaining identifiably Brazilian.

In Cordeiro's early 1954 course on modern and contemporary art, partially conducted in the galleries of the second Bienal, he expressed his admiration for Volpi, writing, "For us young Concrete artists, Volpi is a crucial confirmation, the historically grounded proof."[69] Cordeiro's comments make clear that for Concrete artists, inserting themselves into a national art history, as well as an international one, was paramount,

FIGURE 75. Alfredo Volpi.
Casas. 1953. Tempera on
canvas, 31 ⅛ × 18 ¼ in.
(80.4 × 46.2 cm). MAC USP
Collection. Gift of the
Museu de Arte Moderna de
São Paulo. © Apoio
Cultural Instituto Alfredo
Volpi de Arte Moderna.

and the recognition of Volpi at the second Bienal was interpreted as an endorsement of a multivalent abstract trajectory within the nation's artistic production. In the course, Cordeiro also proposed an interpretation of Picasso that complicates what can be read in other bodies of his writing as a dismissal of realism. Without mentioning him by name, Cordeiro reiterated Pedrosa's bifurcation of modern art history, criticizing the expressive branch and celebrating the constructive. Cordeiro nevertheless viewed Picasso's production neither as a foil nor erroneous path, but as a problem to be thought through. He saw Picasso as an artist who requires a "dialectical appreciation."[70] *Guernica* was the epitome of this complexity to his mind, though Cordeiro's explanation for its dialectical nature is confined to pointing out its various interpretations, saying the work is celebrated by both formalists and those emphasizing content.

The ambivalence of critics at *Fundamentos: Revista de Cultura Moderna,* the magazine of Partido Comunista Brasileiro (PCB), regarding Picasso's display at the second Bienal rests, in a sense, on just such a view of the artist as being claimable by multiple agendas. One critic argued that the essence of Picasso's role as a political activist was masked in the exhibition, which excluded recent works like *The Massacre in Korea* (1951) and instead presented Picasso as a cosmopolitan, bohemian artist of myriad styles.

> The presence of *Guernica,* a canvas that is a true symbol of the horror that rallied men of culture of the entire world to the Francoist betrayal, is not sufficient to overcome the perplexity of the unsuspecting spectator who sits there in that extensive Picasso-ian gallery, as if in a fantastic store of nonsense, helpless and unable to recreate the path of the master.[71]

The museum gallery is thus likened to a store indoctrinating new consumers. As is analyzed in chapter 3, the first Bienal had been the target of sustained critique by *Fundamentos* and viewed as an anti-Communist shill for capitalism. And, in keeping with that critique, the magazine asserted that the second Bienal was "*against* culture and, moreover, against *national* culture."[72] Nevertheless, the review of the second Bienal betray a remarkable skepticism toward Picasso's ability to serve as lightning rod for Communist activists and social realist artists in Brazil during the Cold War, or to act as a model for the journal's agenda to elevate and valorize national culture. In fact, Picasso was conspicuously absent from *Fundamentos,* receiving only two dedicated texts in its eight-year run. One wonders whether the Brazilian Communist press's reception of *Guernica* at the second Bienal signals a larger tension in the postwar interpretation of the painting and artist, namely that

Picasso's political relevance had been blunted by the style-based interpretation of works like *Guernica* as one of several apexes in the protean career of a genius.

And the worry of the Communist press was perhaps warranted. After all, Getúlio Vargas—the former dictator democratically returned to power—served as the honorary president of the second Bienal and presided over ceremonies praising artists and intellectuals whom his prior administration had censored and imprisoned, Pedrosa principal among them. While Vargas himself was savvy enough not to be pictured in front of a work considered a symbol of resistance to totalitarianism, Vargas-allied politicians including Juscelino Kubitschek, governor of Minas Gerais and Lucas Nogueira Garcez, governor of São Paulo, happily arrayed themselves before it for photo ops, trading on the work's prestige and seeking to be cast as leaders of a globally ascendant Brazil.

ERASURES AT THE SECOND BIENAL

To analyze the second Bienal is to necessarily enter the realm of speculation. The Sala de fotografia (Gallery of Photography), for example, was a last-minute, hastily assembled addition organized by the Foto Cine Clube Bandeirante (FCCB) (fig. 76). Neither the exhibition nor its contents were listed in the Bienal catalogue. There is no trace of the display in the copious textual and photographic documentation held in the institution's archive. A checklist has not been located. This dearth of records brings into relief the selective, interpretative nature of the historical record of the Bienal as a whole. MAM-SP did not photographically document the majority of the exhibition, meaning there are no known visual records in the Bienal's archive of the installations of the representations from Asia, Canada, Eastern Europe, Latin America, and the Middle East, with the exception of a few snapshots at the opening. This practice extended to the Brazilian contributions: there are no installation views commissioned by the museum of the special exhibitions nor of the general section.[73] Instead, the leadership of MAM-SP focused its photographic documentation on those exhibitions it deemed the most important, namely those from the United States and Western European nations, including object views of almost every painting by Picasso.

The Sala de fotografia was organized in the days before the event opened to the public to fill gallery space left vacant by cancelled and delayed exhibits. The regulations of the second Bienal excluded photography; the only place photography was to have appeared in the event was as documentation in the architectural section.[74] FCCB leaders and

FIGURE 76. Installation view of the Sala de fotografia at the second Bienal de São Paulo. 1953–1954. Reproduced in *Boletim Foto-Cine* 8, no. 87 (February–March 1954).

members, Barros among them, took full advantage of the late-breaking opportunity to include photography in the prestigious event and exhibit the works of its São Paulo-based membership outside the club's annual salons. Periodicals printed a few installation views and a dozen object views, allowing for speculative identification of some of the sixty or so photographs exhibited, such as Barros's *Fotoforma n. 12* (see related work in fig. 17).[75] The selection foregrounded geometric abstract and experimental modernist styles, as photography historian Helouise Costa has noted, and the picturesque and realist practices common among club members were excluded.[76] The photography exhibition was the subject of only four known dedicated texts, two of which appeared in *Boletim Foto-Cine,* published by FCCB.[77] The journal's readership did not reach far beyond the club's membership, making the Sala de fotografia a virtually undiscussed entity in the deluge of local and international art criticism surrounding the Bienal.[78]

In the physical space of the Bienal, the photography exhibition functioned as a threshold between geographies and genres. It was located on the second floor of the Pavilhão dos Estados, which displayed, at one end, the architectural section, or the II Exposição internacional de arquitetura (II International Exhibition of Architecture), composed of documentation of more than two hundred projects and occupying a third of the floor. The remainder of the floor held representations of varying sizes dedicated to nations of the Americas and dominated by painting, culminating in the special exhibition of Tamayo.

The ground floor and sunken atrium below boasted special exhibitions dedicated to Calder, Visconti, and Brazilian landscape paintings, as well as the US and Brazilian representations. Based on textual accounts and FCCB's photographic documentation of the installation, it is possible to conclude that the Sala de fotografia was placed in the first of a series of rooms in the middle section of the second floor, near the central ramp and representations from Caribbean and South and Central American nations. A visitor would have walked by the entrance to the photography display when entering the architectural section, and the first wall of the special exhibition dedicated to architect Walter Gropius is captured in the background of one installation view of the photography exhibition.

Thus, the Sala de fotografia was positioned between documentation of architectural projects and fine art (predominantly paintings), and also between the displays dedicated to Canada and Latin America and the architectural section dominated by Brazilian, European, Japanese, and US contributions. It is revealing that the photography exhibition occupied a space originally intended to present the sole Caribbean nation (Haiti) and was facilitated by uncertainty about the arrival of a representation from a Central American nation (Nicaragua). The medium of photography, which was initially excluded, ultimately was present at the Bienal in part because of the organization's lack of cultivation of participation from Latin American nations it deemed minor.

The photography exhibition's in-between status—Barros described it as an "annex"—was amplified by choices made about its design and signage.[79] The style of partition used in the exhibition were the same double-depth ones used in the architectural section, not the single panels deployed elsewhere in the Bienal. This decision conveyed a skepticism, in Brazil and beyond, toward photography's status as a fine art and instead encoded it, like architecture, as a technically oriented design practice. This was further underscored by the absence of signage standard elsewhere at the Bienal, where plaques printed in uniform, sans-serif modernist typefaces announced the name of a given country or, for special exhibitions, the country name with the addition of a style or artist name, such as "France: Picasso" and "Italy: Futurism." Instead, a pennant bearing the logo and name of FCCB appeared outside the gallery, replacing country, style, and artist with a local organization.

Historian Barbara Weinstein argues that the larger quadricentennial celebration, which the Bienal inaugurated, consolidated a multidecade intellectual and political construction of the identity of the city and state of São Paulo as the righteous innovator, racially coded as white, leading forward a backward nation, racially coded as black.[80] The name Foto Cine Clube Bandeirante invokes a central figure of that regional identity: the

bandeirante, a colonial raider reconceived in mid-century São Paulo as an emblem of the disruptive character of the city and state as a national leader. The FCCB pennant—present as an afterthought in the massive event—nevertheless makes legible a racialized and neo-colonial discourse of progress, and underscores the explicitly Western cultural imaginary mapped in the biennial event as a whole. At the second Bienal, Brazil, with an industrialized, European-descent São Paulo as its standard-bearer, was positioned as a central actor in the Euro-American world and as a privileged nation within Latin America.

Let me concluding by noting that the Sala de fotografia was a product of collective artistic activism. Like the abstract art groups, FCCB created spaces—exhibitionary, pedagogical, and social—for its members that collaborated and conflicted with the modern art institutions. Barros, who bridged the photography and Concrete art groups, was the most visible organizer of the coordinated display. But in a first-hand account published soon after the Bienal closed, he was at pains to address what he viewed as the emerging misconception about his authorship of the exhibition.[81] Instead he underscored that the selection and installation was executed by FCCB without input from the MAM-SP or Bienal leadership, and identified a large community of artists and art professionals as responsible for conceiving, realizing, and advocating for the project.[82] This type of collective action is what Cordeiro theorized in his writing and the Concrete-oriented abstract art exhibitions enacted in the early 1950s. A new abstract art group, Grupo Frente, would expand these strategies and practices in the mid-1950s, as is examined in the next chapter.

Artist as Model Citizen

Grupo Frente and Rio Institutions

1954 in the federal capital of Rio was a seismic year. Getúlio Vargas, in the third year of his term as president, was markedly weakened. The reshuffling of his cabinet the prior year—the political background to the Exposição nacional de arte abstrata in Petrópolis discussed in chapter 4—had not resulted in the desired renewal of power and several cabinet members were forced to resign under pressure from anti-Vargas forces.[1] The president's administration was buffeted by sensational leaks from former ministers, a worsened economic situation, and denouncements and court challenges of Vargas's economic and foreign policies from both opposition political parties and the military. Early in August, Vargas's close associates arranged for the assassination of Carlos Lacerda, a vocal opposition journalist and radio broadcaster, a plot which resulted in Lacerda's injury and the death of the Air Force officer guarding him. An official investigation revealed the assassination plot reached into the presidential guard. By late August a group of Army generals issued a public statement demanding Vargas's resignation, and the

following day Vargas took his own life. The presidency was occupied by caretaker governments until the January 1956 inauguration of Juscelino Kubitschek, the governor of Minas Gerais who had been associated with Vargas, and his running mate João Goulart, former labor minister to Vargas. Anti-Vargas figures, Lacerda and elements of the military principal among them, mounted campaigns calling for a coup during and after the election in October 1955 of Kubitschek and Goulart to try, unsuccessfully, to keep them from office.

With its exhibitions spanning exactly two years, from June 1954 to June 1956, Grupo Frente, the third abstract artistic group established in the country, produced collective displays in Rio and its environs during these turbulent political times. The group was led by Ivan Serpa and supported by critics and poets Ferreira Gullar, Macedo Miranda, Mário Pedrosa, and Lucy Teixeira. Grupo Frente consisted of largely Rio-based artists, including a significant number of Serpa's former students from his painting courses at the Museu de Arte Moderna do Rio de Janeiro (MAM Rio)—Aluísio Carvão, Elisa Martins da Silveira, Hélio Oiticica, and Carlos Val among them—as well as more established artists such as Lygia Clark, Abraham Palatnik, Lygia Pape, Décio Vieira, and Franz Weissmann. The group nearly doubled from its initial eight members to fifteen, staging two exhibitions in 1954 and 1955 in Rio and two exhibitions in 1956 in the cities of Resende and Volta Redonda in the state of Rio de Janeiro.[2] Members hailed from different places—the majority were not native to the Rio area, three were émigrés from Western Europe, and Palatnik had resettled in Brazil after growing up in Tel Aviv.[3] The geographic diversity was largely that of middle-class mobility, with members like Carvão and João José da Silva Costa from the North and Northeast having moved to the capital to earn academic degrees, or Oiticica having spent a period of his childhood in Washington, DC while his father had a fellowship. Although the majority of Grupo Frente artists practiced Concretism, the production of the participating artists was heterogeneous, ranging from hard-edged, painterly, and kinetic geometric abstraction to expressionist and so-called primitive works in multiple fine and applied media, including furniture and jewelry.

The group's association with the suicide of one president and the election of another challenged by coup attempts went beyond coincidence. Grupo Frente envisioned the artist as an ethical, nonideological citizen, a stance that served as an important touchstone in the debates and electoral mobilization of the mid-1950s. These beliefs were articulated and visualized by the artists and their interlocutors most effectively around, on one hand, the group's leader Serpa and his larger circle of child students at MAM Rio and, on the other, the three female members of the group, Clark, Martins, and Pape. Pedrosa

explicitly situates the resistance of Grupo Frente to a uniform stylistic identity in an assessment of the state of Brazilian political participation, writing,

> Nowadays, the idea of a 'group' is suspect—especially in a country like ours, of malleable if not imbecilic individualists always ready to let themselves be mobilized by the first street vendor to come along. Particularly when the street vendor dresses loudly or hawks the wondrous virtues of political propaganda.[4]

This is a condescending image of Brazilian citizens as easily manipulated sheep, though one Pedrosa can be said to have come to honestly, given the personal toll he and his family had endured, with periods of persecution, imprisonment, separation, and exile under the demagogic Estado Novo. In contrast to that low assessment, Pedrosa celebrated Grupo Frente's refusal of a facile stylistic program in favor of what he describes as a unified conviction in art's revolutionary social mission, and what others characterized as a refreshing absence of dogma. The rhetoric by and about the group's inclusive ethos of experimentation paralleled contemporaneous oppositional political speech, skeptical of ideology and framed as anti-corruption and anti-populist.

Grupo Frente has long been discounted by scholars as merely a step toward Neoconcretism, following critic Ronaldo Brito's seminal study in which he described the group as a "starting point for many future Neoconcretists," and detailed a rivalry with Grupo Ruptura that preceded the Neoconcrete break.[5] As I have argued elsewhere, Grupo Frente must be distinguished from Neoconcretism and recognized as both the consolidation of Pedrosa's and Serpa's challenge to a style-based definition of art and the articulation of an alternate proposition for an art grounded in, as Pedrosa wrote, "ethical discipline and creative discipline."[6] Here I argue that Grupo Frente artists enlarged the theory of abstraction and examine the interaction between Grupo Frente and modern art institutions and the press to ask what politics informed the laudatory reception of the group and whose interests were served by the member artists' proposals and production.[7] In so doing, I reveal a different target for the rhetoric by and about Grupo Frente: not a purported intra-abstraction contest with Grupo Ruptura, but rather evolving, multiauthored attempts to represent the artist as a model, democratic citizen.

THE STATE AND THE MODERN ART MUSEUM AND PRESS IN RIO

MAM Rio is commonly understood to have fostered Grupo Frente, and descriptions of the group's relationship with the museum, as expressed by members and supporters in

interviews and texts, were notably free of the polemics of Grupo Ruptura members toward MAM-SP and the Bienal. As a journalist for *Tribuna da Imprensa* wrote in a glowing assessment of the museum that culminated in a discussion of Grupo Frente, "This group is the museum's own image, in its dynamism, its constant discovery of new fields of research, its attempt to renovate Brazilian art."[8] Such accounts gave short shift to other institutional actors. Notably, the cross-section of artists, poets, and critics based in Rio and Petrópolis that formed Grupo Frente had begun meeting to organize the Exposição nacional de arte abstrata at the Associação Petropolitana de Belas Artes in Petrópolis. It is nevertheless the case that MAM Rio served manifold and key roles for the artists in the group, including employing several (Serpa and Vieira taught classes) and educating many (ten members studied there).[9] It was the site of the largest of Grupo Frente's exhibitions, in 1955, and a sponsor of the group's final exhibition, in 1956, in addition to collecting and featuring member artists in exhibitions. Via extensive and glowing coverage in its bulletin and the aligned newspaper *Correio da Manhã*, MAM Rio could also be described as the group's unofficial booster.

Sociologist Sabrina Parracho Sant'Anna argues that the leadership of MAM Rio, via its support of Grupo Frente, drew attention to its dual pedagogical mission of educating the public and artists.[10] Sant'Anna also notes that while officially Pedrosa's role at MAM Rio was limited to service on various advisory councils beginning in 1953, he acted as an unofficial consultant to director Niomar Moniz Sodré, organized several exhibitions, and authored essays for museum catalogues.[11] The latter was the case with Grupo Frente in 1955, and Sant'Anna's findings open up the likelihood that Pedrosa also participated in the museum's decision to exhibit the group and perhaps in its installation. Art historian Aleca Le Blanc analyzes what she characterizes as "the confounding nature of the relationship between private and public institutions in Rio," arguing that Moniz Sodré, in a succession of savvy negotiations in the 1950s, aligned the museum with the ministry of education and culture to such an extent that the museum "carried out part of the federal agency's cultural agenda."[12] Le Blanc also examines the sites of Grupo Frente's exhibitions, ranging from a binational cultural institution funded by the US government (Instituto Brasil-Estados Unidos, IBEU) and MAM Rio to a country club in Resende (Itatiaia Country Club) and the national steel mill (Volta Redonda), a constellation delineating support for the group in an elite network with access to the highest levels of government.[13] She focuses on the last venue and argues that the choice to exhibit at a site of singular national importance for the country's image as an industrial power put the abstract group and the exhibition sponsor, MAM Rio, in line with Kubitschek's developmentalist policies.[14] Building

on the scholarship of Le Blanc, Sant'Anna, and others, I look closely at how and why Grupo Frente was understood as being in concert with MAM Rio, the relationship between MAM Rio and the state, and the larger circle of institutions that supported the group, namely the Rio newspapers *Correio da Manhã* and *Tribuna da Imprensa.*

In late 1952 MAM Rio, established only three years earlier, received pledges of generous financial support from the federal government and a donation of prime land adjacent to downtown on the Bay of Guanabara from the municipal government.[15] This and future support allowed the museum to construct a series of building designed by Affonso Eduardo Reidy, the first of which was inaugurated in 1958. In the interim, MAM Rio moved in January 1952 from a floor of a corporate office building to occupy a temporary space at a world-famous federal building centrally located in downtown Rio, the Ministério de Educação e Cultura, now known as the Palácio Gustavo Capanema or MEC.[16]

Oscar Niemeyer designed the provisional space for MAM Rio, sited under the pilotis in the public plaza, extending northward from the ground floor of the Palácio Gustavo Capanema, along the major downtown thoroughfare of Rua da Imprensa (fig. 77).[17] Composed of wooden, curvilinear exterior walls, the 500-square-meter (1640-square-foot) interior space created was a largely windowless, unpartitioned volume punctuated by six massive marble pilotis. For the inaugural exhibition at the space, in January 1952, art professionals at MAM Rio covered the non-planar walls from ceiling to floor with light-toned curtains, and hung paintings from picture wires on the curtained walls.[18] The provisional site of MAM Rio was inaugurated in a dramatic fashion—with a landmark building transformed, an exhibition of the prize-winning works from the first Bienal installed in the cavernous space, and an arsenal of high-profile guests. The first lady and cabinet members attended the opening events, and the exhibition served as the backdrop for a ceremony inducting Matarazzo and Penteado, benefactors and authors of the Bienal, into the highest civilian order. In 1953 the museum extensively renovated the provisional space. A system of white walls, independent of the curtained walls, created a rectilinear gallery (fig. 78).[19] In addition to transforming the museum into a white cube gallery within the lofty, columned, and curved space, the renovation created functional storage spaces, out of view of visitors.

MAM Rio's occupation, albeit temporarily, of a governmental space demonstrates that the museum's status as a private institution was far from obvious. The headquarters of a powerful federal agency was altered to provide it an institutional home. A Rio resident reading the extensive coverage of the museum's activities in local newspapers would have encountered visual and textual accounts of the entanglement of private and public

FIGURE 77. Oscar Niemeyer. Provisional site of the Museu de Arte Moderna do Rio de Janeiro at the Ministério da Educação e Saúde, Rio do Janeiro. c. January 1952. MAM Rio Collection. © 2020 Artists Rights Society (ARS), New York/AUTVIS, São Paulo.

institutions, with openings of exhibitions presided over by federal, state, and local elected and appointed officials and peopled by diplomats and their spouses alongside artists, writers, and art professionals. Exhibitions at MAM Rio in the 1950s thereby served as official, state events in a manner parallel to the Bienal. Perhaps the museum's location in Rio, the federal capital until 1960, and its patrons, high-placed in governmental, journalistic, and cultural circles, would have, in any case, given MAM Rio access to generous governmental support. The institution's cohabitation with a federal agency for five years, however, no doubt solidified working relationships between the leadership of the museum and governmental officials. Interestingly, the merging of private and public monies at MAM Rio, which included foreign support from Nelson A. Rockefeller, did not elicit a critique on the part of the Communist press comparable to that directed at the Bienal. This silence

FIGURE 78. Plan for interior renovation of the provisional site of the Museu de Arte Moderna do Rio de Janeiro. c. 1953. MAM Rio Collection.

was despite the fact that MAM Rio moved to MEC and received pledges of governmental support in the midst of Vargas's hotly debated creation of Petrobrás, the national petroleum company, as a semi-public entity between 1951 and 1953.

One result of MAM Rio's imbrication with the federal government was its role in generating exhibitions created for export. While MAM-SP continued to oversee the São Paulo Bienal and the Brazilian representations at the Venice Biennale, long looked to as the most visible of Brazil's forays in the international art world, MAM Rio also

importantly shaped the narratives of modern and contemporary Brazilian art circulating both inside and outside the country. At first in collaboration with MAM-SP, MAM Rio participated in the organization of notable exhibitions, namely an exhibition of contemporary Brazilian artists in Paris and a far-reaching exhibition of pre-Columbian to contemporary Brazilian art and visual culture in Neuchâtel, Switzerland.[20] In the late 1950s, MAM Rio continued, without the involvement of MAM-SP and in partnership with the Brazilian ministry of foreign affairs and foreign binational and diplomatic missions, to organize exhibitions, including ambitious shows that toured South America in 1957 and Europe in 1959.[21] Art historian María Amalia García has demonstrated that these and other efforts were part of a soft diplomacy strategy by the Brazilian government during the Cold War to establish regional cultural hegemony.[22] An effect of MAM Rio's collaboration with the federal government was the dissemination of an account of Brazilian modernism shaped by the intellectual priorities of Pedrosa, namely the foregrounding of the art of children, psychiatric patients, and the self-taught alongside works of geometric abstraction, as well as the highlighting of Rio-based artists.

The ascendancy of MAM Rio, and its patronage by the federal government, coincided with financial and infrastructural challenges at MAM-SP. In May 1955, in what was described as a crisis by the Rio and São Paulo press, the São Paulo state governor withdrew the generous annual subsidy previously awarded to MAM-SP. The third São Paulo Bienal, realized from June to October 1955, was a modest affair, and the subject of widespread criticism for the jury's rejection of a large number of submissions to the general section. Plans for an artist-organized *salon des refusés* were announced, as were Clark's and sculptor Zélia Salgado's proposed exhibition of women artists to draw attention to the Bienal's overzealous selection process that eliminated, for example, Pape's paintings.[23] Critic Leonor Amarante recounts that the third Bienal opened incompletely installed, and journalists and jurors wandered the halls of the Pavilhão dos Estados with numerous galleries closed off.[24] Dysfunction between the imperious Matarazzo and his curatorial staff and advisors played out publicly in the press.[25] And misfortune continued to strike: in January 1957, a fire destroyed the museum's well-regarded film collection.

As MAM Rio gained stature, meanwhile, the Rio press praised its activities. Both *Correio da Manhã* and *Tribuna da Imprensa* showered attention on Grupo Frente. The artists' youth, exploration of new materials, and relations with industry were trumpeted as "renovating" the national artistic scene.[26] This characterization of the group not only traded in notions of a youthful avant-garde, but also mapped artists into a developmentalist narrative, viewing artists as producers working toward Brazil's increased economic

development. Both newspapers, center-right and center-left respectively, opposed Vargas, yet were at odds over the election of Kubitschek: *Correio da Manhã* favored his election, while *Tribuna da Imprensa* vehemently opposed it, attempted to foment a coup, and was unsuccessfully targeted by Kubitschek for closure after his inauguration. The papers' shared celebration of Grupo Frente despite their ideological and partisan divergences reveals the range of politics Grupo Frente, intentionally or not, served in mid-1950s Rio.

Correio da Manhã, arguably the most influential Rio daily newspaper, owned by Paulo Bittencourt, husband of Moniz Sodré, catered to the elite and upper middle classes and had a reputation as an oppositional force, most famously in the postwar period in its open criticism of the Estado Novo dictatorship in 1945.[27] *Correio da Manhã* also vocally opposed a number of the initiatives of the Vargas administration, but the paper also became increasingly conservative, as evidenced by Lacerda's dismissal in 1949 after his investigation of corruption in the municipal government included friends of Bittencourt.[28] Pedrosa served in varying capacities at the paper between 1943 and 1951, including as art critic and creator of the first visual art column in a Rio periodical, and he continued to be a revered, cited figure in the paper's cultural coverage.[29] *Correio da Manhã* favorably covered center-right Kubitschek, who united Vargas's former supporters in the Partido Trabalhista Brasileiro (Brazilian Labor Party, PTB) in the cities and his own Partido Social Democrático (Social Democratic Party, PSD) constituents of the interior.[30]

Lacerda founded *Tribuna da Imprensa* in 1949 and aligned it with the principal anti-Vargas party, União Democrática Nacional (UDN), and the conservative and moderate middle classes. Historian Bryan McCann has noted the paper's low circulation, its coverage limited to local political events, and hasty production, writing, "The publication was more of an engaged journal on a narrow range of issues than a major urban daily."[31] The paper nevertheless provided frequent, positive reporting on Grupo Frente since its first exhibition and sponsored one of its exhibition in 1956. In fact, the quantity of coverage given to the group exceeded that in *Correio da Manhã,* notable because the latter had a more extensive cultural section and was aligned with MAM Rio. Pedrosa served as the art critic for *Tribuna da Imprensa* between 1951 and 1954, when he was forced out over his criticism of Lasar Segall and Cândido Portinari.[32] But, as at *Correio da Manhã,* he remained a revered figure in the paper, referred to as both an art critic of international statute and a prominent socialist activist courted to join the ranks of UDN.[33] However, the prominence afforded to Grupo Frente and its members cannot be fully accounted for by Pedrosa's advocacy. Coverage of the group and its artists slipped out of the cultural pages.

The group and its members participated in the political platforms of *Tribuna da Imprensa:* in 1953, Serpa, Pape, and other artists who soon established Grupo Frente publicly supported an anti-corruption, press freedom initiative of the newspaper and, on election day in 1955, Clark went on record along with other prominent women in Rio in favor of Juarez Távora, the UDN presidential candidate supported by the newspaper.[34] McCann has noted Lacerda's concerted mobilization of middle-class urban women toward anti-Vargas and anti-Communist candidates.[35] The coverage in *Tribuna da Imprensa* of women artists and other creative and academic professionals can be understood as a facet of that mobilization, providing vivid visualizations, and idealizations, of the engaged urban woman "with long pants," as one article put it.[36] In other words, the representation of Grupo Frente members went hand-in-glove with the paper's electoral politics.

IVAN SERPA'S PEDAGOGY AND THE PROTO-CITIZEN

The art school of MAM Rio, which opened in 1952 with Serpa as lead teacher, was arguably the institution's most visible initiative in the early and mid-1950s, with coverage and photographs of its teachers and courses filling Rio daily newspapers and works by students exhibited at the museum and in exhibitions it sent abroad. Commentators identified the school and the MAM Rio galleries as the progenitors of Grupo Frente. The school offered instruction grounded in nonobjective abstraction and immersing students in modern art history, alternatives to the training oriented by naturalism, Expressionism, and Cubism at Rio's Escola Nacional de Belas Artes (National School of Fine Arts, ENBA).[37]

Like the Instituto de Arte Contemporânea in São Paulo (IAC) analyzed in chapter 3, MAM Rio also distanced itself from the notion of educating fine artists per se. In the case of MAM Rio, the archetypal student was not the designer of posters and products, but a child dressed in a smock with a paintbrush in hand. According to Pedrosa, Serpa's approach to the instruction of children, in particular, was a testament to the larger role that art education should play in a democratic society.[38] One description of the experiences awaiting students in Serpa's adult painting classes reveals the grafting of artistic education with a politics focused on individual liberty:

> An address for all who wish to liberate themselves from emotional inhibition, from sensorial prohibition, from all constraint of instinct. A room for free manifestation of aesthetic impulses, for the longed-for equilibrium, the much-desired rhythm through painting.[39]

An over-the-top account, no doubt, but one that underscores the societal stakes of the title Serpa gave his course, "Atelier livre de pintura para adultos" (Free painting workshop for adults). The freedom at stake was not just an open-ended, non-prescriptive pedagogy, but a challenge to normative social habits and a valorization of individual experience. The liberated citizen embodied by the figure of Serpa's child students—and by Hélio Oiticica and Carlos Val most visibly—constituted an important subject position in Brazil's young democracy. Centered by Pedrosa in his writing about Serpa's teaching in 1954 and by Grupo Frente and its interlocutors, the child artist, whose inherent creativity was cultivated rather than sublimated in Serpa's classroom, would be fundamental to a visualization of a nonideological, ethical member of society.

In contrast to Bardi's and Ruchti's efforts to position IAC as a successor to the Bauhaus in Brazil, the teachers at MAM Rio did not purport to share a unified approach. Samson Flexor, Fayga Ostrower, Tomás Santa Rosa, Salgado, Margaret Spence, Vieira, and other artists taught a range of courses, from drawing, ceramics, modeling, painting, printmaking, and sculpture to theory of painting and composition. But it was the museum's first teacher, Serpa, whose painting classes for children and adults captured the popular and critical imagination of his contemporaries and provided an identity for the new school.[40] Serpa had a reputation as both an established, internationally regarded abstract artist and children's art instructor.[41] At MAM Rio he taught a number of burgeoning abstract artists—Eric Baruch, Carvão, Vincent Ibberson, Rubem Ludolf, César Oiticica, Hélio Oiticica, and Costa—as well as figurative artists Martins and Val, all of whom would soon fill the ranks of Grupo Frente.

Contemporary commentators, historians, and Serpa alike often discussed his pedagogy in terms of his openness to experimentation and freedom of expression.[42] While this is not inaccurate—a hallmark of Serpa's teaching was his mentoring of both figurative and abstract artists—the rhetoric has overshadowed a more nuanced account of his approach. Moreover, the vision of Serpa's classrooms as self-directed, unstructured spaces does not account for the rigorous study of geometry, color, and materials evident in the visual production of students in his painting class for adults, nor for the degree to which Serpa's instruction was informed by Bauhaus pedagogy. If IAC's relationship to the Bauhaus was overdetermined, Serpa's incorporation of Bauhaus techniques in his teaching at MAM Rio is a conspicuous blind spot in both contemporaneous and historical accounts.

Pedrosa, Serpa's most vocal advocate and interpreter, largely set the parameters for our understanding of the artist's teaching in texts from the late 1940s through the mid-1950s. In *Crescimento e criação* (Growth and Creation), the book-length publication

Pedrosa and Serpa produced in 1954, Pedrosa emphasized that the artist synthesized experimentation with technical and compositional know-how. He argued that Serpa countered "academic preconceptions," but did so while improving his students' ability to manipulate materials and to organize forms and marks in a composition.[43] Focusing on Serpa's instruction of children, Pedrosa cast Serpa as an educator-cum-social-reformer participating in an international reimagining of the education of youth.[44] At the international level, the intellectual context for this valorization of the creativity of children included the development-oriented discourse of organizations like the United Nations and UNESCO and the conception of "visual thinking" by early- and mid-twentieth-century pedagogues and psychologists, including Rudolf Arnheim, about whom Pedrosa wrote in detail in *Crescimento e criação*. In Brazil, and specifically within the Rio artistic milieu, Serpa's classroom was understood to stand alongside the art studio that artist Almir Mavignier established at the psychiatric hospital Engenho de Dentro, discussed in the second chapter. Both were seen as models for a reorientation of the understanding of creativity as possessed by art.

That Pedrosa elected to understand Serpa's approach in relationship to Arnheim and theories of visual perception, rather than suggesting parallels with the interests in the creativity of children and outsiders by Surrealists, members of the Bauhaus, or the likes of Jean Dubuffet, is noteworthy. It was not for lack of knowledge or contact—he was related to Surrealist poet Benjamin Péret by marriage and participated in art-critical circles in France, Germany, and the United States, residing in the latter two countries in the late 1920s and late 1930s through the mid-1940s, respectively.[45] But Pedrosa's larger intellectual project—orienting an inclusive conception of modernism based on the art of non-artists and providing a place for "autochthonous resistance to international taste"—made the likelihood of him asserting a one-to-one lineage between Serpa's teaching and the Bauhaus remote.[46] So too did the critic's skepticism toward what he saw as a misconstruing of Bauhaus principles, and Paul Klee's ideas in particular, as a basis for "solipsistic self-absorption" among gestural abstract artists and their champions.[47]

Moreover, Max Bill's presence in Brazilian artistic discussions in the early 1950s meant that relating Serpa's pedagogy to the Bauhaus was a decidedly unattractive option for Pedrosa. Bill's visit to Brazil in May and June 1953, on the occasion of his lectures at MAM Rio, are best known for the scandal his critique of Brazilian architecture caused in the local artistic and architectural communities.[48] Yet he also spoke at length about his plans for a new Bauhaus in Ulm, Germany, the Hochschule für Gestaltung (Institute of Design, HfG), which would teach its first classes in August of that year.[49] Bill acknowledged the

significance of early Bauhaus instruction, particularly the teachings of Vasily Kandinsky and Klee, but in his remarks he was more critical of that early pedagogy than he had been in contemporaneous publications (where he emphasized that HfG directly descended from the Bauhaus).[50] In Rio, Bill asserted that the approach at HfG was an advance over what he viewed as the more rudimentary, less scientific theories of the historic Bauhaus. The interpretation of the Bauhaus that Bill put forward thus differed significantly from the interests of Pedrosa, already skeptical of what he considered to be Bill's doctrinaire approach. For Pedrosa, the Concrete art steeped in mathematics of mid-century artists like Bill did not supplant the importance of the work of Kandinsky, Klee, Kazimir Malevich, Piet Mondrian, and other early-twentieth-century figures, as well as the art of children, untrained artists, and the mentally ill.

In remarks following Bill's visits to Rio, Serpa continued to express enthusiasm for Bill among a host of other figures, such as Sophie Taeuber-Arp and Mondrian.[51] Grupo Frente as a collective, however, was at pains to distinguish their project from that of Bill, an indication of the diminished stature of the Swiss artist within the Rio artistic milieu. In November 1954, they feigned relative ignorance of Bill's production, stating, "The knowledge we have, at the moment, of Bill's work, does not permit us to judge the artist, who nevertheless seems very sectarian to us."[52] While Rio-based artists did not have ready access to his 1951 MASP retrospective, Bill's works had been exhibited at MAM Rio, including a sculpture acquired for the permanent collection and *Tripartite Unity* (1948–49). Further, Bill's texts and interviews had appeared in Rio newspapers and arts magazines since the early 1950s to such a degree that he was portrayed, and presumably recognizable, in illustrated caricatures.[53]

In contrast to sectarianism, Serpa's classroom was held out as a space of free expression, where a nine-year-old Val could cultivate his "violent intuition," as Gullar put it, with a rigor and autonomy that allowed him, at sixteen, to exhibit as a founding member of an avant-garde group.[54] He was lauded as a prodigy, "a Rimbaud of painting."[55] Val spoke of his lack of interest in current trends. Rather, his drawing practice was driven by "an interior force" and pursuit of "artistic truth."[56] Serpa's classroom thus maintained an insider-outsider status, operated by a modern art museum subsidized by the state yet held out as a space of independence from the constraints of the official art world and conformist society, capable of fostering artists portrayed as innate geniuses whose insights Pedrosa and others viewed as paradigm shifting.

Hélio Oiticica studied with Serpa beginning in March of 1954 at age sixteen (his brother César began at the same time, at age fourteen). This period reveals an

engagement with Expressionism and nonmimetic naturalism along with nonobjective abstraction, and expands our understanding of the genealogy of Brazilian Concretism. The cross-pollinations evident in the work of Oiticica, true of other students, undoubtedly informed Pedrosa's refusal of any facile conflation of the pedagogy of Serpa and the Bauhaus, or, for that matter, of Brazilian Concretism with Bill's Concrete art.

Serpa allowed both Hélio Oiticica and his brother César to join his adult painting classes despite their age, and the brothers came to view Serpa as a mentor and close collaborator. Through Serpa, Oiticica gained access to Pedrosa's ideas and focused his already voracious reading habits on modern art and theory.[57] Scholars have insightfully commented on the far-ranging impact of Serpa's teaching on the material and technical makeup of Oiticica's early production, from his adoption of specific tools to his serial approach. Paulo Herkenhoff, Mari Carmen Ramírez, and Irene Small have demonstrated that Serpa led his adult students in explorations of nonobjective abstraction focused on color theory, application of materials, and modern art history, requiring those he taught to complete an extensive number of works, often serial investigations of form and color. These historians persuasively relate this mandate to the large quantity of, and the distinct formal groupings within, Oiticica's gouache production of the mid-to-late 1950s.[58] In light of the consistent, even persistent character of Oiticica's early gouaches, the work and writing he produced in the context of Serpa's classroom in 1954 and early 1955 are surprisingly heterodox, revealing an artist immersed in a larger discussion of the nature of creativity. His questioning of conventional hierarchies allowed Oiticica to preserve intuition and geometric abstraction as nonmutually exclusive categories.

Oiticica's student work was diverse. He created figurative sketches, each accompanied by notes focused on the geometric organization of the composition and scale calculations for realization as oil paintings, as well as nonobjective geometry and color studies, mathematical notations, and small-scale gouache and pen-and-ink drawings. The sketches, studies, and finished works show him experimenting with varied mark-making and biomorphic and flat geometric forms. Concurrent with the start of his study with Serpa, Oiticica began a notebook of writings oriented by the rhetoric of maxims and an almost animate conception of form and color found in texts like Kandinsky's *Concerning the Spiritual in Art* (1911) and Klee's *Creative Confession* (1920).[59] In brief entries, he attempted to define the role of the artist and included often lyrical observations about nature and music. He criticized so-called social painters, likely referring to Brazilian artists such as Portinari and his followers, as purveyors of mediocre sentimentality who misunderstood the objective of art, which he described as creating works that supersede a given time to

capture essential truth. For Oiticica, this process was grounded in close observation of both one's interior rhythms and those of nature. There is certainly a quality of a young artist thinking grandiosely, as signaled by the notebook's title "Veritas: Art, Literature, Philosophy." Nevertheless, the attention to nature and to nature as evoked by music, from air and water currents to the movements of an ant, and the supposition that such often imperceptible phenomena provide access to larger truths speak to an important component of Oiticica's nascent conception of art. His interest in geometry was not divorced from his observation of the real world, and he considered geometry alight with vital potentialities.

In January 1955 Oiticica created several pen-and-ink studies related to Klee's practice (figs. 79–80).[60] He did not reproduce specific works but riffed on everything from the intimate scale of Klee's compositions and the artist's practice of captioning works in a hieroglyphic-like script to the diverse qualities of the mark-making. In a pair of sketches, Oiticica thought through Klee's production of the early 1930s, most probably *Hovering* (1930) and *The Light and So Much Else* (1931), which share a double-page spread in Will Grohmann's 1954 Klee monograph, a book held in the Oiticica family library. Working from black-and-white reproductions, Oiticica renders all compositional and chromatic activity in the Klee works via line alone in his sketches. Areas of abbreviated lines and dots are intersected and contained by rectilinear lines and by the empty or ruled page, creating fluctuating spaces.

As discussed earlier, Geraldo de Barros also dedicated close study to Klee. Like Oiticica, he paid particular attention to the diversity of Klee's mark making and was oriented in his interpretation of Klee by contact with Pedrosa. Both Oiticica and Barros understood Klee's repertoire of marks as an entry to what they considered the Swiss artist's more truthful, intuition-based reflections on the world. Barros, however, treated Klee as a model of deskilling, citing Klee's much-quoted statement, "I want to be as though newborn, knowing absolutely nothing about Europe, ignoring poets and fashions, to be almost primitive."[61] Oiticica cast himself not as a new primitive but as a researcher.[62] He viewed Klee's organization of compositional spaces via nonobjective mark making as potential maps for works that transcended formal and representational play.

Possibly in mid-1955, Oiticica created several precisely ruled and flatly painted gouache on cardboard works that possess a flickering quality related to his Klee-based sketches. In one, the dense checkerboard pattern of alternating warm yellow and orange rectangles is interrupted by the subdivision and recoding of a few units in green, purple, and black (fig. 81). The palette and facture are closer to Mondrian than Klee. Rather than

FIGURES 79–80. Hélio Oiticica. Notebook drawings. 1955. Left: ink on paper, 12 ⅝ × 8 ¹¹/₁₆ in. (32 × 22 cm); right: pen on paper mounted on cardstock, 12 ⅝ × 8 ¹¹/₁₆ in. (32 × 22 cm). Collection of César and Claudio Oiticica, Rio de Janeiro. © César and Claudio Oiticica.

a range of nocturnal and luminous tones inflected by visible brushstrokes and graphic lines, opaque and flat quadrants of gouache are rendered in a restricted palette. Though he strayed from the straight primaries of De Stijl, Oiticica nevertheless limited himself to a few secondary and tertiary colors. Oiticica's study of Mondrian is evident in this and other 1955 works, particularly the thick, controlled paint application and the rhythmic and chromatic pulsations of finite passages in works like *Broadway Boogie Woogie* (1942–43), which Oiticica saw in person at the second Bienal (fig. 70).[63] But there is an errant quality to the organization of the green, purple, and black rectangles within Oiticica's composition that relates to his study of Klee (fig. 65), interest in natural phenomena, and

FIGURE 81. Hélio Oiticica. *Grupo Frente.* c. 1955. Gouache on cardboard, 17 11/₁₆ × 23 13/₁₆ in. (46 × 60.5 cm). Collection Eugênio Pacelli Pires dos Santos. © César and Claudio Oiticica. Photo: Thales Leite.

desire to hold on to intuition as a component of his artistic practice. It feels as though something—light, current—has acted on a pictorial surface.

ALTERITY AS ETHOS IN GRUPO FRENTE'S RHETORICAL AND EXHIBITION STRATEGIES

The artists of Grupo Frente and critics writing in support of the group repeatedly underlined the group's stylistic diversity despite the fact that, on a numerical basis, geometric abstraction predominated. In essays and interviews in the mid-1950s, Serpa, Gullar, and

Pedrosa positioned Grupo Frente's agnostic approach to style as inherent to its innovation. Their rhetoric was taken up by the wider art press, where Grupo Frente was described as without dogma and unified by the study of form, as well as their youth and camaraderie.[64] The group's exhibition and catalogue designs highlighted the few figurative artists within a rubric defined by nonobjective abstraction broadly speaking and Concretism in particular. The insistence on difference held together and constituting an ethos, of an alterity than does not dissolve into eclecticism, underpinned Pedrosa's positioning of Grupo Frente as modeling nonconformist, ethical citizenship.

Gullar, in his essay for the catalogue for the first Grupo Frente exhibition, in 1954, asserted that the group represented an exception to the "conformism" that characterized the national scene.[65] In interviews while the first exhibition was on view, Serpa similarly emphasized that Grupo Frente was not a "clique," and "there is not a preoccupation with being abstract or Concrete."[66] He described the predominance of nonfiguration in the group as "merely accidental," and narrated the emergence of the idea for the group from his classroom at MAM Rio, saying he sought a space where each student/artist could have greater independence, and where his former students and other artists could work side by side.[67] Serpa said the group intended to launch a manifesto and planned biweekly meetings, rotating between the homes of members Pedrosa, Gullar, and Teixeira, to determine its focus. He underscored consensus, stating that "the launch of the manifesto depends on the exchange of everyone's ideas."[68] At least one critic, poet Macedo Miranda writing for *Tribuna da Imprensa,* openly questioned whether a manifesto was necessary, casting the imperative that visual artists put words to the page to better define their art as demoralizing and symptomatic of what he viewed as the unnecessarily polemical manner in which art was treated in the Rio artistic milieu by artists, journalists, and government officials.[69] Miranda understood Grupo Frente's first exhibition, with its inclusion of expressionist Val as a member and the knowledge that figurative Martins was an "adherent," as a welcome break from the predominant treatment of artistic differences as a sports competition.[70] The group did not ultimately produce a manifesto, and the positioning of Grupo Frente as agnostic or apolitical pervades Serpa's rhetoric as well: he, for example, declined Miranda's invitation to denounce Communist criticism of abstraction and instead said that the feeling between Communists and himself was one of mutual disregard.[71]

In his essay for the catalogue of the group's second exhibition, in 1955, Pedrosa provided the most extended theorization of Grupo Frente. He emphasized that the exhibited artists did not seek any sort of programmatic stylistic cohesion, writing that Grupo Frente

was not "an academy in which little rules and recipes to make abstractionism, Concretism, Expressionism, Futurism, Cubism, realism, neo-realism, and other isms are taught and learned."[72] Rather than style, Pedrosa asserted that the group shared an ethos of experimentation, which he described as "the freedom of creation."[73] The ethics at stake, according to Pedrosa, were manifestly social and the group's openness was cast as the ideal for all producers and cultural workers. Pedrosa's criticism of academies can be understood as a bludgeon against the strictures of Grupo Ruptura as well as the academicism of Flexor's group Atelier Abstração. But both Pedrosa and Gullar initially viewed the artists of Exposição nacional de arte abstrata and Grupo Frente as in league with other young artists in São Paulo and Rio in a renewal of Brazilian art.[74] Similarly, in writings of the mid-1950s, Gullar and Oiticica distinguished Grupo Frente not from other abstract practices, but from the stagnation and "quagmire" of Portinari and social realism.[75] Moreover, Pedrosa's emphasis on freedom had a target that exceeded an intra-abstraction discussion: he positioned the artists as revolutionaries at odds with the interests of the economic and political elite. He wrote of Grupo Frente:

> To them, art is not an activity of parasites, nor is it at the service of the lazy rich or political causes or the paternalistic state. An autonomous and vital activity, it aspires to an exalted social mission, namely to give the age style and to transform men, teaching them to fully exercise their senses and to shape their emotions.[76]

Pedrosa's denunciation of the parasitic nature of the relationship between artists and the economic and political elites was a broadside against the corrupting potential of patronage, but also likely a veiled denunciation of social realism. In rhetoric that overlaps with his writing on art education, Pedrosa asserted that art, rather than serve the state or elites, should focus on transforming humanity via sensorial and expressive attunement.

Pedrosa's interpretation reigned in the presentations of Grupo Frente in 1956. In the catalogue for the third exhibition, Miranda ceded his space, as he said, to quote extended passages from Pedrosa's essay that had been written for the MAM Rio catalogue. Similarly, the typed handout that accompanied the final Grupo Frente exhibition in Volta Redonda reprinted Pedrosa's essay in its entirety.[77] A particular facet of Pedrosa's argument was underscored in 1956, namely the critic's assertion that Grupo Frente stood apart from the corrupting force of the state and the wealthy and pursued a lofty social mission to liberate citizens via sensorial experiences.[78] In a text published in the magazine *Forma* in March 1956, while the third Grupo Frente exhibition was on view, Miranda was more pessimistic

than Pedrosa about the possibility of bridging what he described as a divorce between modern art, whether figurative or nonobjective, and non-elite, wider audiences. However, like Pedrosa, he viewed MAM Rio—as well as new and planned museums of modern art in the interior—as catalysts for expanding the publics engaged, and transformed, by art.[79] In other words, thinkers close to Grupo Frente were grappling with how art could act socially.

Grupo Frente exhibitions coincided with high-profile events, both inside and outside the art world, resulting in amplified coverage by Rio press outlets and beyond for the group's inception and two-year existence. The first Grupo Frente exhibition in 1954 at the gallery at IBEU overlapped with several other exhibitions featuring artists in the group, Clark and Serpa prominent among them. The third Salão nacional de arte moderna closed the day before and included Carvão, Clark, and Vieira; the twenty-seventh Venice Biennale had opened a week before and featured Clark's paintings and Serpa's collages; and Serpa's solo exhibition at the Pan American Union in Washington, DC, opened a month after the Grupo Frente exhibition closed. The second exhibition in 1955 was likely timed, by the leadership at MAM Rio or the group's artists, to occur during the run of the third São Paulo Bienal, where works by ten of its members were displayed and Martins and Serpa received acquisition prizes. The third and fourth exhibitions in 1956 were staged at prominent sites in cities several hours from Rio. The third occurred at a private club near Resende, inaugurated a few years earlier and frequented by Rio elite, to draw attention to the expansion of tourism to the beaches, lakes, and mountains between Rio and São Paulo, today called the *Costa verde* (Green Coast). The fourth marked the tenth anniversary of the Companhia Siderúgica Nacional (National Steel Company) at its main facility in Volta Redonda, the first integrated steel production site in Latin America built with US investment following World War II.

According to press accounts, there were other, unrealized exhibitions: shows at the Petite Galerie in Rio in January 1956 and at MAM-SP in November 1956 were announced, suggesting Grupo Frente sought or was sought by other venues.[80] While it is possible the press reports were inaccurate, the public mention of other exhibitions—and the identification of a larger circle of artists and thinkers who convened as Grupo Frente—indicate that there was a buzz around the group that resulted in continued discussion and speculation about its next activities.[81] Moreover, Serpa's initiatives with children's art in Rio, including annual exhibitions at MAM Rio and the establishment—with the assistance of Grupo Frente members, César and Hélio Oiticica prominent among them—of a museum

FIGURE 82. João José da Silva Costa. Cover of the *Grupo Frente: segunda mostra coletiva* exhibition catalogue. 1955. MAM Rio Collection.

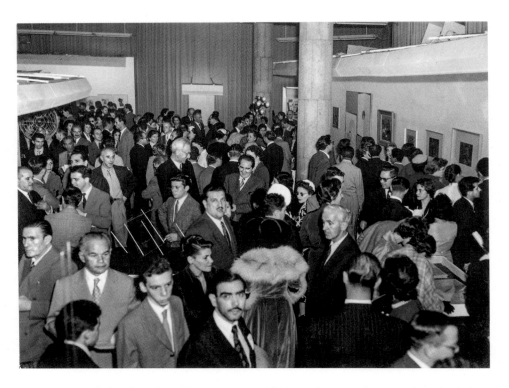

FIGURE 83. Installation view of second Grupo Frente exhibition at the Museu de Arte Moderna do Rio de Janeiro. 1955. Prints by Lygia Pape (rear left); paintings by Ivan Serpa and Elisa Martins da Silveira (rear right); collectively executed albums (vitrine, front right); sculpture by Franz Weissmann (front left). MAM Rio Collection.

of children's art in the Copacabana neighborhood in Zona Sul, in 1956, and of the Instituto de Arte Infantil (Institute of Children's Art) in Serpa's neighborhood of Meier in Zona Norte, in 1957, kept Grupo Frente in the news and connected to the creative activities of non-artists.[82]

Illustrated catalogues were produced for all but the final exhibition in 1956. Their modernist design visualizes a manner in which the group privileged nonobjective abstraction despite its lauded integration of figuration. Group member Costa's design of the cover for the 1955 exhibition consists of gridded clusters of white squares on a black background (fig. 82). Costa evoked letterpress printing and collage processes while simultaneously producing the quality of quickly changing televised images. The design suggests the

Grupo Frente artists' close attention to materials of diverse types and their interest in practical applications and emerging technologies.

While there is little photographic documentation of Grupo Frente's 1954 and 1956 exhibitions, the group's second exhibition at MAM Rio in 1955 was well documented, albeit when the museum was chock-a-block full of people attending the opening (fig. 83).[83] The layout of works at the second Grupo Frente exhibition at MAM Rio likely involved input from group members, but also suggests a collaboration between Serpa and Pedrosa that was not without tensions. The heterogeneity of the group's practice was emphasized: multimedia works were placed throughout the exhibition space and nonobjective abstraction, figuration, and Expressionism were juxtaposed. However, the dispersal of Serpa's paintings and Weissmann's sculptures throughout the central gallery, when other artists' works were concentrated in monographic blocks, privileged Concretism, positioning geometric abstraction as the lens through which to make sense of the group's stylistic diversity.

The media in the 1955 exhibition ranged from painting and sculpture of fine art and industrial materials to printmaking, mixed media works on paper, assemblages, architectural maquettes, furniture, and jewelry. Pape's five woodcut prints were concentrated on a single wall to visitors' left when they entered. Five wire sculptures by Weissmann were distributed in the space. A case likely displaying the collective material experimentation notebooks by the group was located at a short distance from a wall where what appear to be smaller-scale works on paper were hung, possibly works by Val and the Oiticica brothers. The latter also exhibited mixed-media works, including experimental prints by Hélio composed of carbon paper impressions and gouache on cardboard, in which the artist ran an iron over elements of the composition (fig. 84).[84] Carvão included a medium-format suspended sculpture constructed of a mass of empty matchboxes painted in primary colors in various states of disassembly (fig. 85).[85] Clark's three architectural models may have been placed in one of the small auxiliary spaces off the central gallery, and her paintings composed of industrial materials were presented on the second longest wall in the central gallery. It is unclear from the known photographic documentation where Palatnik's furniture and Pape's jewelry were displayed, though one photograph shows Serpa on what is likely a bench by Palatnik in the central gallery.

In his accompanying catalogue essay Pedrosa dwelled on the albums created collaboratively by the group, including the newest "recruits," describing them as "containing the most varied experiments with textures, with every sort of material from bobbin lace and typewriter letter keys to cheap wrapping paper"—an account that distinctly recalls the texture and material studies in the Bauhaus preliminary course.[86] Ramírez

FIGURE 84. Hélio Oiticica. *Sem título.* 1955. Carbon copy and gouache on cardboard, 12 × 18 ⅛ in. (30.5 × 40.8 cm). Collection of César and Claudio Oiticica, Rio de Janeiro. © César and Claudio Oiticica.

has persuasively argued that albums containing material and texture experiments were likely an outgrowth of Serpa's classroom.[87] Pedrosa argued that this collective research, as well as the new material study evident in the individual artists' practice, entailed the rigorous formation of a plastic language and of material and technical knowledge that would allow the artists to create not only vital works of art but also enlightened design and art for an industrialized society and a larger, non-art-viewing public that would be on a par with medieval craftwork.[88] The analogy between the modern and the medieval is reminiscent of Walter Gropius's conception of the Bauhaus as a "new guild of craftsmen," a medieval masons' lodge in all but name.[89] Without evoking the Bauhaus, the vision Pedrosa proposed of an ethical, experimental postwar avant-garde nevertheless corresponded with elements of the Cold War reinterpretation of the German school: both share an understanding of creativity as a wellspring of

FIGURE 85. Aluísio Carvão with *Construção*, 1955, at the second Grupo Frente exhibition at the Museu de Arte Moderna do Rio de Janeiro. 1955. MAM Rio Collection. Courtesy of Carvão Family.

FIGURE 86. Lygia Pape. *Tecelar*. 1955. Woodcut on paper, 16 ⅜ × 10 ⅞ in. (41.5 × 27.5 cm). Projeto Lygia Pape.

humanism and an optimism about the utility of a nonobjective, abstract artistic training for industry.[90]

Pape's prints, the first works a visitor saw upon entering the exhibition, importantly complemented the collective albums. In January 1955 Pape published an album of ten small-format woodcuts, and the prints on view at the July 1955 exhibition share with those earlier works a collage sensibility. In the prints, geometric shapes composed of impressions of wood grains of varying scales and orientations abut and overlap in playful, teetering compositions (fig. 86). Many shapes are printed in black, though the tones read as gray and black depending on the quality of the wood grain, and one or two forms appear in another color, which range from primary and secondary colors to tones of violet and brown. The pronounced wood grain grants the planar works a texture and physicality; the two-dimensional prints feel like things of the world assembled, cut, and pasted together.

It is noteworthy that Serpa elected not to exhibit his collages—works that had been featured widely in domestic and international exhibitions, including the first Grupo Frente exhibition—in the 1955 exhibition. He instead showed his largest-scale paintings to date. Serpa's choice suggests distance from Pedrosa in their approach to the exhibition. It also indicates that Serpa desired for his painting practice to be assessed alongside that of Clark, who had rivaled Serpa in visibility in the Rio art world over the prior two years.[91] In his numerous essays on Serpa since the late 1940s, Pedrosa had frequently tempered his praise with criticism of what he saw as the painter's tendency toward orthodoxy, a caveat he dropped in his thorough excitement about Serpa's collages. In his catalogue essay, Pedrosa's comments on Serpa are ambiguous: he underlines the inventiveness of the collages, not shown in the exhibition, and suggests that unspecified recent works concerned with texture, transparency, and opacity extend the concerns of the collages to submerge a viewer "in the contingencies of the precarious sensorial reality."[92] Pedrosa perhaps was referring to Serpa's paintings on view, but more likely, to my mind, he meant Serpa's continued collage practice. Regarding Clark, however, there was no such ambiguity: Pedrosa lauded her new series *Superfície modulada* (Modulated Surface) as a true synthesis of the arts, and when he gave a talk in the exhibition, he made his preference clear, sitting in front of her work.[93]

Passages of the installation staged pointed encounters with the disparate practices and identities of Grupo Frente sought to hold together while simultaneously centering Serpa. Occupying a sightline from the entrance of the museum, paintings by Serpa and Martins, side by side, served as a concise announcement of the creative heterodoxy of Grupo Frente (fig. 83).[94] Serpa's large 5 × 6½ feet oil on canvas painting was centered between two paintings half its size, one identifiable as by Martins and the other likely by her. Serpa's

FIGURE 87. Elisa Martins da Silveira. *Praça Paris.* 1953. Oil on canvas, 31 ⅞ × 39 ⁷⁄₁₆ in. (81 × 100.2 cm). MAC USP Collection. Gift of the Museu de Arte Moderna de São Paulo.

unfurling curvilinear forms, precisely rendered on a shifting rectilinear ground, contrasted with Martins's depiction of folkloric and popular mainstays of Brazilian everyday life (fig. 87).[95] At the opposite end of the gallery, Serpa's other two paintings flanked a sculpture by Carvão (fig. 88). The decision to display Serpa's works alongside those of his students—a woman and man whose practices spanned so-called primitivist painting and nonobjective abstraction and who hailed from the Northeastern and Amazonian regions—signaled Serpa's leadership of the group and underscored the inclusivity of his pedagogy.[96] This elevation of Serpa, who figured in the exhibition as the pioneering practitioner of Concretism with a prolific painting production (the serial titles emphasized the breadth of his production, such as *Pintura n. 158*), dovetailed with contemporaneous profiles that

FIGURE 88. Installation view of the second Grupo Frente exhibition at the Museu de Arte Moderna do Rio de Janeiro. 1955. MAM Rio Collection.

cast him—a *carioca,* Francophile, white male—as a benevolent, cosmopolitan teacher.[97] In other words, the vision of non-conformism on the walls of MAM Rio did not quite rise to Pedrosa's revolutionary rhetoric. Instead geographic and gender diversities and material experimentation were marshaled by the Concretist grid.

The mechanisms by which artists like Martins were understood as distinct from abstract artists, moreover, requires further scrutiny beyond the laudatory rhetoric utilized by Grupo Frente and its supporters. Classified variously by critics as a naive, primitivist, or self-taught artist, Martins, who moved to Rio in 1945 in her thirties from her birthplace in the Northeastern state of Piauí, studied with Serpa in his adult painting classes at MAM Rio beginning in 1952. Martins gained visibility as an artist within a few

short years via her association with MAM Rio and Grupo Frente, as well as her receipt of a prize at the second Bienal and the acquisition of her work by MAM Rio. In a profile of Martins in 1955, the headline quotes the artist stating, "I do not know if I am a primitive painter," an acknowledgement by the artist and art press of the imprecision of the term and its obfuscation of a whole set of social and formal relations.[98] She went on: "I work spontaneously and I have not had the opportunity to deepen my art studies."[99] Being an autodidact and working "spontaneously" were common attributes of primitive artists as defined in postwar Brazil, and pillars for the understanding of the work of Martins as "pure aesthetic manifestations," as Gullar put it.[100] It is true that Martins did not study at the ENBA. Yet it is inaccurate to present Martins as self-taught and not apply the term to Carvão or Oiticica—who also studied solely with Serpa—or, indeed, to the vast majority of postwar Brazilian artists who did not train at an art academy.

Masquerading as a term that described autodidacts, the notion of the primitive artist was a racialized and class-based description applied to non-affluent Afro-descendant and white artists who portrayed Afro-Brazilian and popular culture. The term also functioned as a stylistic and iconographic category denoting flat, colorful figurative scenes depicting vernacular cultural practices. A brief news piece covering the second Bienal points to the prominent yet circumscribed roles artists labeled as primitive were assigned within the art worlds of Rio and São Paulo. Under a reproduction of a painting by Heitor dos Prazeres, who had received an acquisition prize at the first Bienal, the caption reads, "The artist who reached such success at the first Bienal, ceded the place this time to another primitive—Elisa Martins da Silveira, discovered by the Museu de Arte Moderna do Rio."[101] This perceived exchangeability among artists like Martins—a white woman from the Northeast—and Prazeres—an Afro-Brazilian man from the Southeast—reveals how the category of primitive art allowed for the cordoning off of popular culture and non-elite artists, integrated into modern art circles of Brazil's cosmopolitan centers, but in a subsidiary role. In addition to the Bienal, paintings by Martins, Prazeres, Djanira, or José Antonio da Silva were invariably included in exhibitions of Brazilian art abroad in the 1950s. Representations of regionally specific cultural practices and histories, primitivist paintings functioned in a manner similar to social realist works by Portinari at mid-century: they provided a non-Brazilian viewer with purportedly authentic information about Brazilian culture and life, with the added benefit of presenting the Brazilian art world as racially diverse.

The heralding of the diversity of Grupo Frente fell away by the final two exhibitions in 1956, and Concretism predominated. At the third Grupo Frente exhibition in March 1956 at a private club near Resende, neither Martins nor Val were highlighted in

FIGURE 89. Aluísio Carvão. *Composição.* c. 1953–1956. Industrial paint on wood, 23 ⅛ × 39 ⅛ in. (60 × 100 cm). João Sattamini Collection on loan to Museu de Arte Contemporânea de Niterói. Courtesy of Carvão Family. Photo: Paulinho Muniz.

the catalogue nor the press coverage, only geometric abstract works. The extensive press coverage in *Tribuna da Imprensa,* the exhibition's sponsor, heralded the exhibition with headlines that read: "Grupo Frente wants to bring Concrete art to the interior," "Concretist art will scale the mountain," and "Young artists exhibit in the sierra."[102] Such reporting not only tied the exhibition to the promotion of tourism in the area—the events around the opening included busing in attendees from Rio and a hike in the nearby national park—but also traded the emphasis on stylistic openness and ideological non-conformism to portray the group in a more conventional avant-garde guise that had always been an element of the group's reception. Gullar, for example, wrote that the Oiticica brothers embodied the inception of a new artistic language and underlined their youth, referring to them as *meninos* (boys), while broader coverage described the group as a whole as *moços* (youths).[103]

The inclusion of Clark's maquettes in the Resende exhibition pointed to the multimedia engagement that had characterized the 1955 exhibition. Several other artists, however, traded the varied array of materials showcased in the prior exhibition for industrial

FIGURE 90. Hélio Oiticica. *Três tempos (quadro 1)*. 1956. Oil on eucatex, 19 ¼ × 19 ¼ in. (49 × 49 cm). João Sattamini Collection on loan to Museu de Arte Contemporânea de Niterói. © César and Claudio Oiticica. Photo: Jaime Acioli.

paint.[104] Carvão exhibited a medium-format industrial paint on wood panel painting in which he overlaid a series of crisp, flatly painted bars on a two-tone ground, a contrast to not only to his matchbox assemblage, but also to the playful low-reliefs integrating found-objects he included at the third Bienal (fig. 89).[105] Similarly, Oiticica showed medium-format gouache on cardboard and oil on Eucatex paintings originally titled

Construção (Construction), including a painting now titled *Três tempos (quadro 1)* (Three Times [Painting 1]) (fig. 90). He used a *tira-linhas,* or ruling pen, to create ultraprecise contours that he then filled with flat areas of matte color.[106] Like Carvão, he replicated an uncomplicated arrangement of forms in different proportions, colors, and orientations within each composition, creating works that evoke transposition and amplification. The title *Construction,* used by the Oiticica brothers and Serpa in their titles at the third exhibition and by Carvão and Serpa since the year prior, suggested a physicality and monumentality was at play in these two-dimensional paintings. For Oiticica, the term "construction" signaled a setting aside of a stylistic understanding of Constructivism and a recognition of the role of artists as "constructors" within society.[107] *Três tempos (quadro 1)* is also an early example of Oiticica's exploration of the effects of surface texture. He chose to paint on the rough side of the Eucatex, and the indented woven surface is perceptible in his opaque quadrants of unmodulated oil paint.

The production and rhetoric of Grupo Frente shifted in its two short years of collective exhibitions, as changes in works by Carvão and Oiticica, and by Clark and Pape, reveal. Rather than the heterodox, experimental, and multimedia production by artists conceived as revolutionaries, the works showcased in 1956 were subtly topographic, rectilinear objects created by artists understood as societal constructors. Pedrosa's ideals without a doubt informed both positions, but the stature of the non-artist in Grupo Frente's imaginaries was ultimately diminished in favor of the adoption of a more uniformly Concretist orientation. This straightening up of the representation of Grupo Frente into a more conventional, vanguard guise also parallels the emphatically capitalist spaces of their later exhibitions in 1956, a country club and steel mill.

LYGIA CLARK, GENDER, AND SURFACE

Clark stood apart from the other artists in Grupo Frente in significant ways. She had not studied with Serpa, nor was she taken by Pedrosa's centering of the creativity of non-artists. This put her at odds with not only Palatnik and Serpa, both enthusiasts of the Engenho de Dentro art studio since the late 1940s, but also Carvão, the Oiticica brothers, Pape, and Vieira, all involved in MAM Rio's educational programs. Upon Clark's return to Brazil in 1952 after a year-and-a-half stay in Paris, she disrupted the gendered binary between male artist and female viewer in Brazil's cosmopolitan centers by fashioning herself as both the ideal sophisticated art viewer and as a protean maker of cutting-edge abstract work. In the mid-1950s, Clark continued to modify her presentation of self and

work to challenge gendered expectations, particularly, I propose, countering Pedrosa's critique of her excessive refinement as her "only feminine quality" with increasingly aggressive, masculinist rhetoric and works that set aside fine art materials.[108]

Clark's re-entrance to the Brazilian art world, and her quickly established status as a leading abstract artist, was disruptive in another way: she contributed to an enlargement of the theory of abstraction and Brazilian Concretism. The theorization of form, led by Pedrosa and Cordeiro, had oriented the practice of emerging geometric abstract artists in Rio and São Paulo, Barros, Palatnik, and Serpa among them, since the late 1940s. With form, artists and theorists highlighted the perceptual work underway in the production and reception of abstract works; signaled a working across and merging of media; and forged versatile conceptions of Concretism. Like the artists in Pedrosa's and Cordeiro's circles, Clark abandoned referential content in her work and worked across media and disciplines, in her case designing theater sets and vitrines as well as experimenting with architectural design that extended to an announced collaboration with Niemeyer.[109] She did not, however, take up the term *forma;* instead she drew viewers' attention to the work of creating and experiencing surface, a subject she developed in concert with fellow Grupo Frente artists, Carvão, Oiticica, Pape, and Weissmann among them. Clark articulated a conception of surface as an interdisciplinary node between art, design, and architecture.

Scholarship on Clark's contribution to early Brazilian abstraction often centers on her use of the phrase *linha orgânica* (organic line), which the artist privileged in retrospective accounts as the formal and theoretical key to her early work. Clark deployed the term—first in a lecture at the architecture school at the federal university in her birthplace, Belo Horizonte, in 1956, and subsequently in published texts and interviews—to define a revelation she dated to 1954 and considered foundational to her subsequent practice.[110] No longer graphic marks rendered in a fine art medium, Clark created lines that were physical gaps between the surfaces of her paintings, which she argued connected her nonobjective abstract works to spatial and lived realms. She stated that the lines had their genesis in observation of the real world, specifically "functional lines of doors, seams of materials and clothes, etc., in order to modulate a whole surface," calling to mind instances of disjuncture—gaps, rips, holes—that can interrupt a surface.[111] The narrative in which "Lygia discovered something she called an 'organic line'" was consolidated in late 1950s texts by Pedrosa, Gullar, and the artist, in some cases positioning Clark's collage practice as the first place she observed a virtual line between elements that appeared or disappeared depending on color choices.[112]

However, the "discovery of the organic line" is not the only story Clark told of her early work, nor the only way she told the story.[113] (The turn of language, for example, is absent from her known notebook writings of the 1950s.)[114] The organic line persists as the origin story for her production in part because of its suitability to a narrative of the increasingly and radically participatory nature of Clark's practice. Focusing on other stories of the mid-1950s, I argue her interdisciplinary interests and reconception of surface cannot be separated from her gender politics, and furthermore, that her approach to gender must be understood in the context of Grupo Frente and the political events of the mid-1950s.

Clark underscored the social and extra-formal stakes of her enterprise. In her lecture in Belo Horizonte in 1956, she criticized professional and social hierarchies, closing her talk by calling out architects' treatment of artists as afterthoughts in projects, present merely to decorate the walls, as "patriarchal."[115] In a scenario keyed to the reputation for hospitality among inhabitants of her native state, she described architects as indistinguishable from the man "from the countryside who, in offering a good spread of food to his friend, leaves his wife behind the kitchen door, listening to the praise which the friend gives out of the food which she herself has prepared."[116] Following several decades during which Brazilian modernist architecture had received almost universal international praise and in the midst of a building boom in the country, Clark vividly situated her call for a redefined collaboration between architecture and visual art as a challenge to patriarchy. Clark did not do so in a vacuum. The Rio press covered creative and intellectual women from a host of fields. Some understood women's professionalism as a challenge to conformist, constraining social norms and an embodiment of liberated, modern citizenship, while others more cravenly catered to the purchase power of a growing female readership. In the case of *Tribuna da Imprensa,* Lacerda sought to mobilize middle-class urban women toward his anti-Vargas electoral preferences.[117] Articles in *Tribuna da Imprensa* featured Clark, when profiling the community of women artists in Copacabana, and when she, along with other prominent women in Rio, went on record in favor of the UDN presidential candidate running in opposition to Kubitschek.[118]

At the third national salon of modern art in 1954, Clark joined other artists in pressuring the federal government to adjust the prohibitively high taxes on imported fine art materials. For the event, which became known at the Black and White Salon, artists adopted black-and-white palettes to dramatize the effect that lack of access to high-quality oil paints would have on the nation's artistic output.[119] Clark extended the protest enacted at the salon by removing the canvas and exhibiting a composite of frames. She titled her

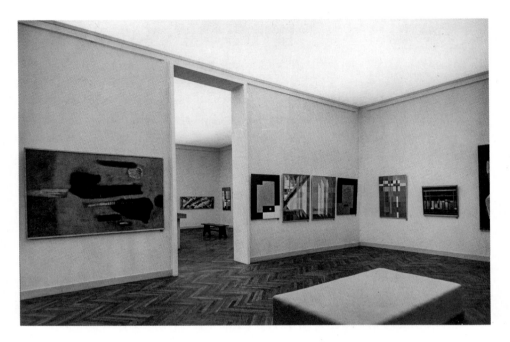

FIGURE 91. Installation view of paintings by Lygia Clark (center) at the Brazilian representation at the twenty-seventh Venice Biennale. 1954. Archivio Storico della Biennale di Venezia, ASAC.

contribution *Quadro objeto,* which could be read doubly as a statement of fact—Picture Frame—and a declaration of nonobjective abstraction—Painting Object.[120] Far from the technically complex and polished works she had exhibited previously, most recently at the second Bienal, where she displayed richly hued oil-on-canvas paintings composed of tessellated geometric forms, *Quadro objeto* possesses an experimental, provisional character.

In her selection of five works for the twenty-seventh Venice Biennale, in 1954, Clark suggested a formal relationship between her oil-on-canvas paintings and her new composite canvas-and-frame works, which she later retitled *Quebra da moldura* (Breaking the Frame) and *Descoberta da linha orgânica* (Discovery of the Organic Line) (fig. 91). Her accounts of the "discovery of the organic line" situates its origins in the materiality of architecture, textiles, and collages. The story Clark narrated in Venice, by contrast, positioned complex chroma and geometries as grounds for her shift toward a more rudimentary and stripped-down palette and forms.[121] Rather than a radical break, she mapped a transition that included references to European modernism, particularly Cubism, De

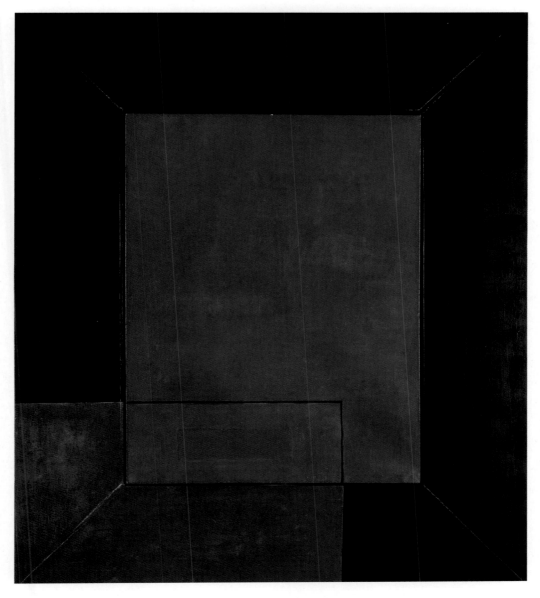

FIGURE 92. Lygia Clark. *Quebra da moldura, Composição n. 5.* 1954. Oil and oleoresin on canvas and wood, 41 15/16 × 35 13/16 × 13/16 in. (106.5 × 91 × 2 cm.) The Museum of Modern Art, New York, Gift of Patricia Phelps de Cisneros through the Latin American and Caribbean Fund. Courtesy of "The World of Lygia Clark" Cultural Association. Photo: Gregg Stanger.

Stijl, and Suprematism, and presented the organic line as the descendant of analysis of the European and Russian early-twentieth-century avant-gardes.

At Venice, Clark sequentially numbered her uniformly titled *Compositions,* all dated 1954, and proposed an evolution starting with a triad of oil-on-canvas paintings of identical height. *Composição n. 4* (Composition no. 4)—now *Quebra da moldura n. 4*—and *Composição n. 5* (Composition no. 5)—now *Quebra da moldura, Composição n. 5* (fig. 92)—are slightly smaller and combine painted wood frames and inset canvases with compositions that emphasize the notable gap between frame and canvas. Clark set aside overtly fine art techniques—oil paint mixed to create a seemingly endless variety of colors—that characterized the first three works and her early production. Instead, she applied both out-of-the-tube oil paint with a brush and oleoresinous house paint with a spray gun.[122] In the composite canvas-and-frame works, Clark explicitly alluded to and distilled the work of the European historical avant-garde, adopting basic geometric forms and the uniform grounds of figures like Malevich and Taeuber-Arp. With the display, she presented the genesis of her composite canvas-and-frame works and the organic line not as things in the world—wall, door, fabric, collage—but as the formal intricacies of abstract painting.

In 1955 Clark premiered her new series *Superfície modulada* at two overlapping high-profile exhibitions, the third São Paulo Bienal and the second Grupo Frente exhibition at MAM Rio. The series, which she created from 1955 to 1957, was materially and conceptually connected to the composite canvas-and-frame works of the year before, but she positioned these works as something new. She set aside the title *Composition,* oil paint, and canvas. She instead adopted industrial materials and a title that prompted viewers to scrutinize the paintings—at first glance flat and graphic—and understand them as modulated surfaces.

Her technical innovation in the *Superfície modulada* series moved quickly. Between January and May 1955, in the works she submitted to the third Bienal (numbered one through three), the technical process derives from the *Quebra da moldura* works, and a tension between figure and ground, frame and picture, and graphic and physical lines undergirds the visual activity.[123] By July 1955, in paintings she exhibited at the second Grupo Frente exhibition (numbered four through six), Clark had developed a different technique and the visual action was no longer destabilization of the distinction between painting and frame, but grasping the all-over patterned and low-relief surfaces. In *Superfície modulada n. 5* (Modulated Surface no. 5), she cut a large sheet of compressed wood into five pieces and then affixed the pieces onto another sheet of compressed wood and painted the jigsaw puzzle assemblage (fig. 93). Compared to the organic lines in her

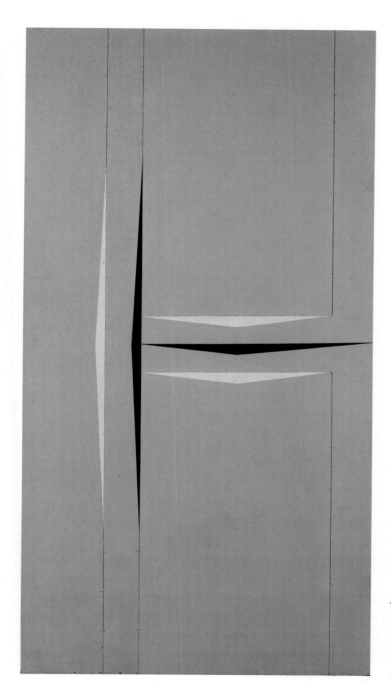

FIGURE 93. Lygia Clark.
Superfície modulada n. 5. 1955.
Duco on compressed wood,
45 ¹¹⁄₁₆ × 28 ³⁄₈ in. (116 × 72 cm).
João Sattamini Collection on
loan to Museu de Arte
Contemporânea de Niterói.
Courtesy of "The World of
Lygia Clark" Cultural
Association. Photo: Jaime Acioli.

earlier works, the gaps achieved via this technique are narrow, a quality Clark accentuates in *Superfície modulada n. 5* with the precise tapering points of the black-and-white elongated triangles painted on to the acid green background. The elongated triangles also recall Serpa's repertoire of forms from his 1953 paintings (fig. 25). This may suggest Clark drew on Serpa's work, and it also reveals their shared use of Vicente Nadal Mora's 1942 geometric construction manual.[124]

When *Superfície modulada n. 5* was illustrated by Lucy Teixeira, who worked closely with Clark while writing her thesis under Lionello Venturi at the University of Rome, it bore the title *Bozzetto per le pareti dipinte* (Sketch for Painted Wall), pointing to Clark's aspiration for the architectural application of the modulated surfaces she crafted.[125] As Pedrosa wrote about her *Superfície modulada* works, Clark "eliminates the intrinsic difference existing between the picture, the inserted panel, a façade, a wall, a door, a piece of furniture."[126] Rather than decorations to be inserted in an entablature, Clark's halting patterns disrupt as we try to make sense of the planes, materials, and colors. Clark thus enacted an integration with architecture that sought to upend the understanding of walls and paintings—surfaces—as passive backdrops.[127] Clark also envisioned the (female) artist and visual art as equals to the (male) architect and architecture.

With her jigsaw puzzle-like construction technique, Clark also articulated a conceptual innovation—the creation of a surface via the multiplication of surfaces: surface made of multiple surfaces; surface doubled by adhering surfaces on the same plane to a support surface; and surface made thick by building up uniformly sprayed layers of paint. Clark created multiple versions of individual paintings in the *Superfície modulada* series, a strategy she would continue throughout the 1950s and eventually signaled with the inclusion of first, second, and third versions in her titles. The word choice "version" could suggest a search for perfection across stages, but the aim was not to ask viewers to differentiate and compare. Clark had in mind something more radical: a challenge to the production and consumption of painting as unique, singular objects by arguing that her artworks were more like prints and books—that is, reproducible.[128] Clark's reproductive operations often entailed her altering the palette or scale between works with identical compositions. In *Superfície modulada n. 20* (Modulated Surface no. 20), her reproduction lays bare the material construction of the work and suggests that elements of the painting could be rearranged (fig. 94). She created two versions of this work, one with seemingly incomplete passages of warm white at the far left and upper right discontinuous with the jagged bands of blue, white, gray, and black, and the other with those passages completed.[129] The overall pattern, subdivided into vertical columns, is interrupted, inverted, repeated, and,

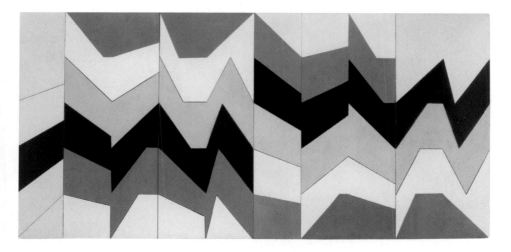

FIGURE 94. Lygia Clark. *Superfície modulada n. 20.* 1956. Industrial paint on wood, 23 ⅝ × 47 ⅝ in. (60 × 121 cm). Coleção Fundação Edson Queiroz. Courtesy of "The World of Lygia Clark" Cultural Association. Photo: Mario da Costa Grisolli.

in the case of the "incomplete" version, voided, activating the viewer to imagine altering the work through reordering and reassembly.

While Clark credited Weissmann with the idea to create versions of her paintings, Pape's printmaking played an critical role in the coupling of the disassembly and reconstruction of surface with the creation of multiples among Grupo Frente artists.[130] As I have studied elsewhere, Pape, the sole printmaker in Grupo Frente, was concurrently sidelining her medium's traditional reproductive and technical capacities and foregrounding its elemental, material components in order to create new types of conceptual spaces that she would later characterize as "sensitive and non-discursive."[131] Pape reconceived of the print as a contingent original rather than the finite product of a reproducible technical process. The artist allowed for a great deal of indeterminacy in the prints. She did not systematically sign and date her prints at the moment of creation and, by the mid-1950s, she stopped consistently indicating the edition size and proof numbers on the prints and began exhibiting impressions of the same print with different mountings and orientations. These practices resulted in the creation, paradoxically, of multiple originals. In around 1957, she also shifted away from creating line and form by juxtaposing surfaces composed of wood grains and cut her line directly from wood blocks

FIGURE 95. Lygia Pape. *Tecelar.* 1959. Woodcut, composition and sheet: 19 ½ × 19 ½ in. (49.5 × 49.5 cm). Publisher and printer: Lygia Pape, Rio de Janeiro. Edition: 4. The Museum of Modern Art, New York. Gift of Patricia Phelps de Cisneros in memory of Marcantônio Vilaça. Digital image © The Museum of Modern Art/Licensed by SCALA/Art Resource, NY.

composed of peroba, a tropical wood with a porous, fine texture. In a work variously dated 1956, 1957, and 1959, the artist created a dense, black printed area inflected by a smooth, subtle wood grain and precisely cut parallel lines (fig. 95).[132] Pape moved from foregrounding the assembly methods of collage to the physical slicing of a resistant

FIGURE 96. Lygia Clark at work. Reproduced in *Diário de Notícias, Revista Feminina,* no. 26 (October 13, 1957): 9. Biblioteca Nacional. Courtesy of "The World of Lygia Clark" Cultural Association.

surface. The resulting woodcuts are riveting; they juxtapose the precision of a blade-cut edge with the irregularity of wood's natural grain.

When asked in 1957 if art by women is distinct, Clark replied, "No. Art does not have a gender. It is a question of individual temperament to be more precious or monumental."[133] She then explained her adoption of industrial paint and wood panels as a decidedly non-precious undertaking. Turning the noun *pistola* (pistol)—a paint gun used for spray-painting cars—into a verb, she stated, "I pistol modulated surfaces," and enumerated the steps of her physical labor: cutting, sanding, assembling, and painting with a paint gun.[134] In other words, Clark used her industrial working process to counter gender stereotypes. In a photograph that appeared in the "feminine magazine" of a daily Rio newspaper in 1957, Clark is captured, automotive paint gun in hand and mask on her face, crouched over a work table spraying paint onto a thin rectilinear support, presumably a compressed wood panel (fig. 96).[135] Here is a woman artist pictured as modernist artist pictured as skilled manual laborer creating a flat, nonobjective abstract surface. As much a masquerade as any self-presentation, Clark has traded underscoring her fine art training and

wealth for metaphorically arming herself with the tools of industry in order to mount the assault on patriarchy she announced in her 1956 lecture. The surface—arrived at via her multifaceted process—and Clark's action on it are presented as the dual centers of her practice.

The multimedia exploration of the mutability of form, theorized by Pedrosa and Cordeiro in the late 1940s and early 1950s, persisted among Rio and São Paulo Concrete artists well into the second half of the 1950s. But the trajectory of the production of Clark, Carvão, Oiticica, and Pape toward dense, interwoven, and textured edifice-like compositions, and the shift from manifestly multimedia works showcased in early Grupo Frente exhibitions to the predominance of paintings composed of industrial materials in the final exhibitions, evidence the emergence of another facet of Brazilian Concretism: the slicing and reconstruction of surfaces. The sense of potential monumentality and unexpected materiality created by these artists, including in modestly scaled works by Oiticica and Pape (works that challenge Clark's division between the minute and momentous), signaled a continued interest in working across media. As many group members' deployment of the term construction and Clark's self-fashioning make clear, Grupo Frente artists—initially defined by an ethos of alterity—adopted and coopted masculinist, avantgarde guises to stake out a space in which the conceptual and social ramifications of their works could be appreciated. With differences, Grupo Frente artists, like those of Grupo Ruptura, asserted Concrete art's nonmimetic imbrication in the world—a common cause on display, and tested, at a collective exhibition examined in the conclusion.

Conclusion

The **Exposição nacional de arte** concreta (National Exhibition of Concrete Art), held in São Paulo in December 1956 and Rio in February 1957, has long been recognized as a moment of unity among Brazil's Concrete artists and poets that soon fractured into discord along geographic lines. The event was the focus of the first theorizations of purportedly essential differences between the Rio and São Paulo practices of Concretism by Waldemar Cordeiro, Ferreira Gullar, Mário Pedrosa, and others. Depending on the commentator, the approach of *carioca* Concretists to color was deemed expressive and spatially innovative, or plagued by retrograde lyricism; and *paulista* Concretists were accused of an excessive "visual discipline," in response to which they defended their "structural rigor."[1] Cordeiro subsequently proposed, in a 1958 text, that the contribution of the visual artist to society resided in the willingness to assume the "rigor and responsibility" of executing works in a predetermined and standardized system drawn from "a rational language."[2] This vision indeed differed from the premium on anti-dogmatic,

experimental openness by Grupo Frente artists in Rio, and was fervently contested by Gullar.[3] These debates laid conceptual and interpersonal groundwork for the Neoconcrete rupture in 1959, to use critic Ronaldo Brito's now canonical construction.[4]

Despite the consequences this future rupture would have, the exhibition and its original objectives warrant consideration in their own right. The exhibition was open for two weeks at MAM-SP and, in a hastily arranged second venue, for two weeks at the Ministério da Educação e Cultura (MEC) in Rio.[5] In 2006, Lorenzo Mammì, João Bandeira, and André Stolarski collaborated on an in-depth study of the exhibition, bringing to light previously unknown, detailed installation photography of the São Paulo iteration by Hermelindo Fiaminghi.[6] Building on this research and analysis of the texts that accompanied the exhibition as well as contemporaneous, parallel debates about pedagogy and architecture, I argue that contrary to the polemics that would follow, the exhibition did not propose an ideal of the artist producing rigorously standardized products. Instead, the artist- and poet-organizers of the Exposição nacional de arte concreta sought to carve out an identity for the Concrete artist that was neither instrumentalized nor romanticized while simultaneously claiming the mantle of a national artistic practice. They navigated an increasingly technocratic discourse about architecture, which had long been deployed by the state as a vehicle and symbol of the nation's development. The exhibition was mounted during the second year of Juscelino Kubitschek's administration, when the design competition for Brasília was front-page news in both the mainstream and art press. Lúcio Costa's planning and Oscar Niemeyer's architecture for the new capital emblematized an ultramodern future for the country and helped rally support for Kubitschek's economic policies.

As I have argued in the preceding chapters, nonobjective abstraction was not a denial of the national in favor of the international. Rather, region, nation, and world functioned as complementary, as well as oppositional, terms in nonmimetic artworks and their displays. The presentations of Concrete-oriented abstract art at the new modern art museums served as loci for the articulation of individual and collective identities keyed to the political exigencies of Brazil's return to democracy post-1945, and the ongoing Cold War. In different ways, Grupo Ruptura, Grupo Frente, and aligned critics visualized models of Brazilian citizenship. Concurrently these artists and their artworks were mobilized, most notably at the early iterations of the São Paulo Bienal, as evidence of the country's modernity. It is not hard to see why Concrete art and modern architecture and design in postwar Brazil have long been understood as parallel phenomena, sharing an internationalist ethos in sync with the developmentalist policies of the state. My larger project, however,

complicates such a flattening of Concretism and internationalism. At the Exposição nacional de arte concreta we witness Concrete artists disputing their portrayal as vectors of national progress, most notably in the exclusion of applied arts and design.

In the mid-1950s, both MAM Rio and MAM-SP were again being remade by the patrons and leadership in their respective cities. Francisco Matarazzo Sobrinho initiated the move of the São Paulo institution from its downtown site to occupy a floor in the Niemeyer-designed Parque do Ibirapuera complex, and the museum's treasurer, Isaí Leirner, founded an annual art prize for contemporary art, which acquired works for MAM-SP.[7] In Rio, Niomar Moniz Sodré directed the international fundraising effort for the construction of the new building complex designed by Affonso Eduardo Reidy, with gardens by Roberto Burle Marx, on a prominent site adjacent to downtown on the Bay of Guanabara, on land donated by the municipal government. MAM Rio expanded its ambitious traveling exhibition program in concert with the federal government. Nongovernmental entities like UNESCO targeted Brazilian art institutions, including MAM Rio, in campaigns to standardize museum practices. Moniz Sodré also initiated a reorientation of the museum's pedagogical program that threatened to sideline the experiential instructional approach pioneered by Ivan Serpa and championed by Pedrosa, in favor of a curriculum designed by Argentine artist and designer Tomás Maldonado oriented toward technical training and industrial application.[8] The pedagogical reorientation was ultimately unsuccessful and less relevant to the rising international profile of MAM Rio than its building and exhibition programs. Nevertheless, the tension around approaches to art education sheds new light on not only the near absence of Serpa—among the originators of Concrete art in the country—from the Exposição nacional de arte concreta, but also on how Concrete artists were wrestling anew with the place of art in society.

The Brazilian art press also changed substantially in the mid-1950s, heightening the engagement of artists and art critics in the debate over architecture. Lina Bo Bardi and Pietro Maria Bardi announced their resignation from *Habitat: Revista das Artes no Brasil* in 1954, a move necessitated by the demands of their upcoming extended travel abroad with an exhibition of the MASP collection. Acknowledging that the polemical tone of the magazine had been grating to some, the Bardis argued that *Habitat,* now joined by a number of other art, architecture, and design periodicals, had been fundamental to creating a "climate of revisions" and critical, interdisciplinary discussion of the arts in Brazil.[9] Two examples of the efflorescence of new publications the Bardis pointed to would serve as the key intellectual forums for discussions of Concretism in 1956 and 1957: *AD: Arquitetura e Decoração* (AD: Architecture and Decoration), a São Paulo-based magazine begun in 1953,

and the Suplemento Dominical (Sunday supplement) of the Rio newspaper *Jornal do Brasil,* inaugurated in 1956 and led by critic and journalist Reynaldo Jardim.[10] In 1957 Pedrosa returned to authoring a regular art column for the main section of *Jornal do Brasil,* and his articles were often reprinted in the Suplemento Dominical.

The relation of art and architecture, and the status of architecture and the architect, were the subjects of active, critical discussion by Concrete artists and aligned critics in the mid-1950s. During and after the Exposição nacional de arte concreta, Cordeiro, as well as Pedrosa and Lygia Clark, published texts and gave lectures about the relationship between art and architecture. In her much-cited lecture in late 1956 in Belo Horizonte, discussed in the prior chapter, Clark framed her call for a more collaborative and equal relationship between architects and artists as a challenge to patriarchy. Cordeiro, too, called for reform of the unequal relations between the two fields, which he framed in terms of class, not gender. In early 1957, at the same time as he issued polemical texts critiquing *concretismo carioca* as part of the debates following the Rio iteration of the exhibition, Cordeiro authored a series of essays on the relation between architecture, art, and society. In one, he noted the more elevated professional and social status of the architect in Brazilian society, viewed as technical experts in productive service of industry and the elite, which he contrasted to the artist, still considered a bohemian one "can buy with a *cachaça*."[11] But Cordeiro cautioned architects from too easily assimilating the technocratic discourse and neglecting an interest in visual art, arguing that the field's proximity to, and collaboration with, visual art was key both to its differentiation from engineering and to its potentially transformative social capacity.[12] Pedrosa also published considerations of architecture in which he expressed alarm about an overly functionalist conception of the discipline, arguing for understanding architecture as a work of art and not merely as technical innovation or "civil construction."[13] These public calls by artists and art critics reveal a skepticism toward utilitarian justifications of the arts, and require us to approach the Exposição nacional de arte concreta, and indeed the assessment of Brazilian Concretism at its moment of institutionalization by the Brazilian art scene, with fresh eyes.

Cordeiro invited the founders of the poetry journal *Noigandres*—São Paulo Concrete poets Augusto de Campos, Haroldo de Campos, and Décio Pignatari—to organize the poetry component of the Exposição nacional de arte concreta.[14] A São Paulo newspaper reported that participating São Paulo artists and poets installed the exhibition, and it appears Rio-based artists and poets were not involved in the exhibition's installation and only came to town after its inauguration.[15] Based on currently known documentation, it

is unclear how the Rio artists and poets were selected and invited to participate.[16] It is likely that Gullar and possibly critic Oliveira Bastos, coeditors of the visual arts section of the Suplemento Dominical, collaborated in the exhibition's organization. The newly established Suplemento Dominical announced the exhibition weeks before any São Paulo press outlet.[17] Aside from breaking the news of the exhibition, Gullar exhibited poems at the exhibition and was the sole contributor from Rio of a text to the accompanying publication. Talks by Bastos, as well as Cordeiro, Pedrosa, and Pignatari, were advertised for the run of the show. Gullar and Bastos, via the visual arts section of the Suplemento Dominical and directly with MEC, also actively campaigned for securing the Rio venue and referred to the exhibition as "our exhibition."[18]

The absence of architectural and applied design in the Exposição nacional de arte concreta asserted the importance of the visual artist at a time when the architect and designer were more celebrated figures. This exclusion was made despite many of its exhibitors' active professions as designers and the precedent for such multimedia displays just the year before in the second Grupo Frente exhibition. Unexhibited were photographs of landscape designs by Cordeiro; architectural maquettes by Clark; graphic design by Geraldo de Barros, Fiaminghi, Serpa, and Alexandre Wollner; furniture by Barros (or Abraham Palatnik, absent from the show entirely); and jewelry by Lygia Pape. The exhibition instead emphasized the relationship between visual art and poetry. It is important to note, as Sergio Delgado Moya writes, that "connections among art, poetry, and the emerging industries of design, marketing, and advertising took place not only at the level of production, with many avant-garde artists and poets of the period working for these industries, but also at the level of theoretical reflection."[19] While design was not among the displayed objects at the exhibition, the field reverberated in the accompanying rhetoric and the material and theoretical construction of the art and poems shown. This included an exhibition design that closely corresponded with the layout of the twentieth issue of *AD*, designed by Fiaminghi and distributed at the exhibition as the de facto exhibition catalogue. In the issue, artworks and poems are illustrated side-by-side, without distinction or borders, across the white expanse of the spreads, providing a model for how to realize the multidisciplinary display in three-dimensional space. That being said, the contents of the poems displayed were decidedly nature-bound, and excluded the direct engagement with consumer culture in Concrete poetry of the late 1950s and 1960s. Based on the installation and composition of the exhibition and its programmatic texts, the project can be read as an attempt to chart a non-romantic conception of artistic practice that did not collapse into economic determinism.

A visitor to the Exposição nacional de arte concreta at MAM-SP in December 1956 encountered the entire museum turned over to the exhibition, in contrast to the Grupo Ruptura exhibition four years prior, which was confined to the so-called "small room." The exhibition was composed of seventy to eighty works by twenty-four artists and poets and occupied the large gallery, hallway, and small room, an honor previously afforded to the museum's inaugural exhibition *Do figurativismo ao abstracionismo* of 1949.[20] The scale of the Concrete art exhibition announced the growing ranks of Concrete artists and poets, trumpeted MAM-SP's endorsement of the style, and pointed to the centrality of the museum itself in the national art scene.

The Exposição nacional de arte concreta created concentrated encounters with a sensorial, material experience of Concrete poetry and art, priorities articulated in Cordeiro's and Pignatari's essays in the twentieth issue of *AD*. The poet and artist centered the term "object" in their texts: Cordeiro's essay was titled "O objeto" (The Object), and Pignatari's "Arte concreta: objeto e objetivo" (Concrete Art: Object and Objective). The other, less acknowledged shared term was "sensitive."[21] Cordeiro and Pignatari grappled with the status of the arts in relationship to design, ultimately asserting the artist and poet must be understood in non-expressionist and non-productivist terms. Both dwelled on the distinction between geometry and geometric art. Pignatari introduced architecture to underscore the point, writing, "Geometric painting is to geometry as architecture is to engineering. The logic of the eye is sensitive and sensorial, artistic; that of geometry, conceptual, discursive, scientific ultimately."[22] Similarly, Cordeiro's endorsement of thinking with images was humanist and experiential: "Sensibility is the key to an entire world of values. Art represents the qualitative moments of sensibility elevated to thought."[23] Pignatari and Cordeiro argued for the specific, unique character of the kind of knowledge embodied and imparted by visual art and poetry.

As in the Ruptura Manifesto and its defense by Cordeiro examined in chapter 4, the ideas of Konrad Fiedler remained central to his essay in *AD*. But Cordeiro also proposed, for the first time, that the Concretist project aspired to participate in Antonio Gramsci's vision of the role of culture in a Marxist social reformation, writing: "We believe with Gramsci that culture only comes into being historically when it creates a unity of thought among the 'simple' people and the artists and intellectuals."[24] Cordeiro would subsequently develop his engagement with Gramsci, but in the 1956 text his deployment of the Italian philosopher's social theory is more suggestive than resolved.[25] Scholars frequently cite another passage from the essay—"Art is, in short, not an *expression*, but a *product*"—to define the emerging conceptual fissure between São Paulo and Rio Concrete artists.[26]

Cordeiro's insistence on the object and product status of the work of art represented an apparent radicalization of his prior advocacy for what he called an art of creation. The text also continued his longstanding critique of Expressionism, whereas Rio artists would embrace in the following years the term "expression" to define Neoconcretism. In a study that challenges the view of Cordeiro's essay as embodying the excessive discipline of São Paulo practitioners, Sérgio Martins characterizes "O objeto," and the priorities of Ruptura artists, as "programmatic" rather than dogmatic.[27] Martins interprets Cordeiro's essay as not in disagreement with Pedrosa's thinking about how abstract art activates and acts on a viewer, but as an attempt to steer Concrete art toward a "clear-cut conception."[28] I would add that measured against the larger contents of the essay and the exhibition, Cordeiro's evocation of art as product was primarily rhetorical, aiming to assert the primacy of Concrete art as a form of knowledge and as a politically potent unifier between the masses and intellectuals. Far from collapsing art into design, the objects he had in mind were the precise, yet hand-crafted, works of art that filled the exhibition.

Within a sea of seemingly indistinguishable geometric painted, typed, drawn, and sculpted forms, the installation design of the Exposição nacional de arte concreta primed a viewer to perceive differences in sensibility and materiality (figs. 97–98). The mounting of the works emphasized their status as physical objects. Paintings were either unframed, the edges methodically painted by the artist, or framed with simple strip wood frames, and the sculptures rested on pronounced bases. A number of paintings were mounted onto wooden box constructions that projected the works out from the wall. Poems were mounted directly on walls, adhered to simple panels, or suspended under sheets of acrylic affixed to the wall, display techniques not normally associated with the fine arts. In this field of two- and three-dimensional objects, the viewer was confronted by the physical thickness of each material.

The overall impression of the installation in the large gallery, as conveyed in Fiaminghi's black-and-white photographs, is of cohesion: precise geometric forms and lines of text rendered on uniform grounds or freestanding in space.[29] Yet each wall—composed of a pair of artists punctuated by a centered poem-poster loosely bracketing several works by a given painter—possessed its own character. On the right wall in the large gallery, Clark's medium- to large-scale *Superfície modulada* (Modulated Surface) paintings appear alongside Vieira's large-scale oil on canvas paintings, as they had in the Grupo Frente exhibition in 1955, each utilizing acidic greens and light yellows (partially visible in fig. 97). On the left wall, Luiz Sacilotto's and Cordeiro's medium-format paintings and low-relief works were hung together, each deploying uniform grounds, mainly black, white, and primary colors, and centered compositions (fig. 98). The target wall visible from the entrance to the gallery

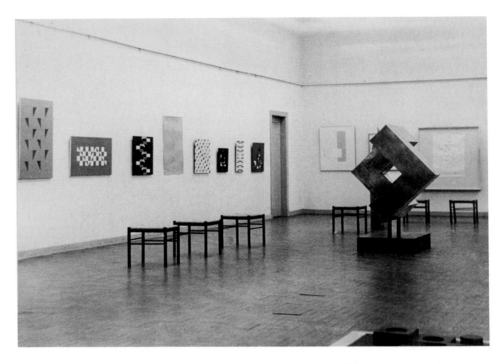

FIGURE 97. Hermelindo Fiaminghi. Installation view of Exposição nacional de arte concreta at the Museu de Arte Moderna de São Paulo. 1956. Acervo Instituto de Arte Contemporânea—Fundo Hermelindo Fiaminghi.

contained two paintings by Alfredo Volpi alongside five paintings by Fiaminghi (fig. 97). There, the interlocking white triangles and squares on a vibrant red ground in Volpi's *Composição concreta branca e vermelho* (White and Red Concrete Composition) of 1955 matched Fiaminghi's palettes of red, white, and gray, interest in diagonal movement, and alternating forms. A small wall displayed a painting by Barros and a low relief by Franz Weissmann, and a windowed side wall held two paintings by Barros.

Within this scene of closely drawn relations, contrasts were also underlined. Sculptures by Kazmer Fejér and Weissmann were distributed throughout the space, most prominently Weissmann's large-scale *Cubo vazado* (Emptied Cube) of the mid-1950s (fig. 97).[30] Weissmann's sculptures delineate space with intersecting rectilinear metal elements of varied thicknesses, including some composed of narrow bars painted black

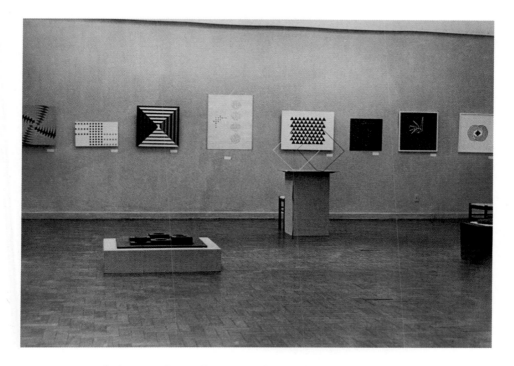

FIGURE 98. Hermelindo Fiaminghi. Installation view of Exposição nacional de arte concreta at the Museu de Arte Moderna de São Paulo. 1956. Acervo Instituto de Arte Contemporânea—Fundo Hermelindo Fiaminghi.

and white. Fejér's "massive blocks," as one reviewer put it, were horizontally oriented, low-relief sculptures installed on low pedestals (fig. 98).[31] Clark, Cordeiro, and Sacilotto, the most lauded practitioners of Concretism—save Serpa, absent from the exhibition, and Barros, marginalized in the display—squared off across the gallery.[32] The contrasts on display here—between palettes composed mainly of black, white, and primary colors and those dominated by secondary and tertiary colors; between oil on canvas paintings, in the case of Vieira, and industrial enamel painted on aluminum, in the case of Sacilotto—would be fodder for the differentiation of Concretism as practiced in Rio and São Paulo when the exhibition traveled to Rio. Reviews of the São Paulo iteration took the measure of Clark, described as a reigning artist in Rio, and found her *Superfície modulada* paintings lacking, in comparison to, for example, Fiaminghi's craftsmanship and

Cordeiro's clarity of conception.[33] However, the reception of the exhibition in São Paulo wrestled more with the justification of the show as a whole rather than distinguishing between artists.[34]

The poem-posters by Augusto de Campos, Pignatari, and unidentified authors were installed as loose sheets mounted directly onto the wall in the large gallery. The scale of the sheets echoed the scale of the surrounding artworks. The placement of poems bolstered the sense of cohesion, both formal and conceptual, and suggested dynamic, fertile interchanges between visual art and poetry. The cascading and intertwining of the words "ovo" and "novelo" rendered in Campos's poem *ovo novelo* (ovum skein) of 1955 recall the repeating patterns of Sacilotto's works and the concentric, spiraling forms in Cordeiro's paintings and low relief (fig. 98). In *AD,* a different version of the poem also appears next to Cordeiro's relief (fig. 99). The titles by Sacilotto and Cordeiro—*Concreção* (Concretion) and *Ideia visível* (Visible Idea), respectively—differ from the bodily allusions of Campos's poem: the poem moves from egg to womb to birth to death, interlaced with evocations of a ball of yarn, knots, and the sun. Yet Sacilotto's and Cordeiro's titles help to describe what a reader encounters in the poem: words rendered as visual forms, ideas made visible and concrete. Similarly, Campos's multiplication of layered fragments that compose and accrue to narrate a universally human experience of conception, life, and death conjure the grandness Concrete art aspired to: art as a form of knowledge and creation.[35]

In the small room, paintings by Judith Lauand and Maurício Nogueira Lima, poems by Pignatari, and sculptures by Fejér and Weissmann occupied the central sightline upon entering the space (fig. 100). Surrounding these works were paintings, drawings, and sculptures by Aluísio Carvão, Lothar Charoux, Rubem Ludolf, and Weissmann, and poems by Ronaldo Azeredo and Haroldo de Campos, among others. Four years earlier, in the Grupo Ruptura exhibition, paintings by Anatol Wladyslaw and Cordeiro and sculptures by Leopoldo Haar had occupied the same central space (fig. 44). To an art world insider, this microcosm of the installation communicated the expansion of the São Paulo Concrete art movement beyond the original Grupo Ruptura members—to Nogueira Lima, an adherent since 1953, and Lauand, who exhibited with Concrete artists in 1955 at the IV Salão paulista de arte moderna.[36] The small room also evidenced a more uniformly hard-edged orientation, with the more heterodox Haar and Wladyslaw absent.[37]

Monographic passages of two-dimensional artworks interspersed with poems organized the walls in the small room as in the large gallery, but with several divergences, perhaps to accommodate the irregular space. Rather than a single poem punctuating a sequence of paintings, the pattern was altered on the central wall and two poems by

FIGURE 99. Hermelindo Fiaminghi. *AD: Arquitetura e Decoração* 20 (December 1956). Acervo Instituto de Arte Contemporânea—Fundo Hermelindo Fiaminghi.

Pignatari were displayed: *terra* (earth) of 1956 and *stèle pour vivre 2* (stele for living 2) of 1955. The poems bracketed Nogueira Lima's nautilus-like, off-center configuration of black triangles on a white ground, animating the nonobjective painting with metaphors of light, earth, and white fields. The allusions to nature in both the poems and painting were interrupted and incomplete. The installation as a whole thus staged layered comparisons and contrasts among the practitioners and works.

A notable absence in the exhibition was Serpa, who the year before had won a prize at the third Bienal and several months earlier organized the final Grupo Frente exhibition.[38] Serpa disavowed any discord between him and Rio or São Paulo Concrete artists and said practical reasons prevented his inclusion, but economic pressures and conceptual concerns were likely at play in Serpa's omission. The Suplemento Dominical briefly noted that Serpa would exhibit in the Rio iteration of the exhibition and framed his absence from the São Paulo exhibition in the context of his decision to also stop teaching courses at MAM Rio in early 1957.[39] In March 1957 Gullar subsequently published an extended

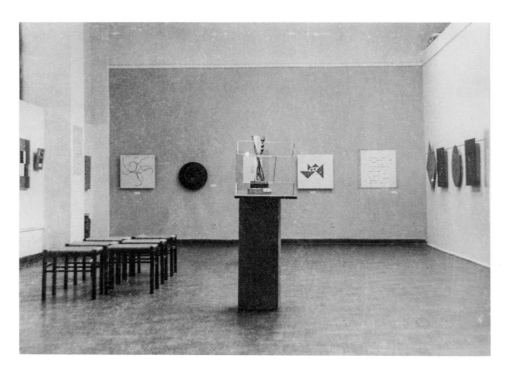

FIGURE 100. Hermelindo Fiaminghi. Installation view of Exposição nacional de arte concreta at the Museu de Arte Moderna de São Paulo. 1956. Acervo Instituto de Arte Contemporânea—Fundo Hermelindo Fiaminghi.

interview with Serpa to contest rumors that Serpa had abandoned Concrete art and of a rift between him and MAM Rio.[40] Serpa contended that his lack of participation in the Exposição nacional de arte concreta in São Paulo and participation in Rio with only one work did not signal a break with the movement; he simply did not have new works completed in time due to his onerous employment obligations.[41] Serpa professed that his leave of absence from teaching at MAM Rio was merely to allow him time to research pedagogy and his commitment to his courses remained steadfast, assertions borne out by his subsequent return to teaching at the museum. He nevertheless added, "I do not believe in programs, only in experiences."[42] This was likely a barb against the proposed development of a new school at MAM Rio, designed by Maldonado and focused on industrial application, as well as perhaps an expression of skepticism toward the exhibition itself.

Barros, for his part, appears to have been a reluctant participant in the Exposição nacional de arte concreta. His displayed paintings were not recent (they dated from the early 1950s) and his name is absent from the rosters of organizers and participants in the installation at MAM-SP. The organizers—Cordeiro and the São Paulo poets—similarly did not center Barros: his paintings appeared at the margins of the large gallery, and his work was not illustrated in the accompanying publication and did not appear in Fiaminghi's installation photographs subsequently published in *AD*.[43] Indeed, Barros's creative endeavors in the mid-1950s focused on furniture and industrial design, fields absent from the exhibition.[44]

While the tensions among artists and with their institutional patrons, evident in the cases of Barros and Serpa, may have been fleeting, they also reflected real fissures. The character of the Concretism on display in 1956 at MAM-SP differed from the heterodox, multimedia experimentation they and others in Pedrosa's circle had pioneered under the watchword of *forma*. It also lacked the diversity of abstractions seen at the Grupo Ruptura and Grupo Frente exhibitions just a few years before. The Exposição nacional de arte concreta signaled the changed position of Brazilian Concrete artists—from upstarts to accepted, esteemed figures in the country's story of modernism. But the exhibition also shows the artists challenging the terms of that assimilation, asserting the sensitive, sensorial, and artistic qualities of Concretism.

U·S·A: 146 ml·p·g·
6×7· e·
5×7· e·

CHILE: 80 ml·
6×12· e·

INGLATERRA: 96 ml·
6×12· e·

URUGUAY·
62 ml·p·g·

HOLANDA·
62 ml·p·g·

MARIA MARTINS · 8×4

BRECHERET · 8×4

BRUNO GIORGI · 8×4

GOELDI · 12ml

ABRAHO ·12ml

Di Cavalcanti·

·18ml·

Segall·

·18 ml·

Portinari·

·18 ml·

DEP·

H·

M·

Abbreviations

Unless otherwise noted, all translations are my own. The following abbreviations appear throughout the Notes.

AAA	Archives of American Art, Smithsonian Institution, Washington, DC
ACLC	Associação Cultural "O Mundo de Lygia Clark," Rio de Janeiro
AGB	Arquivo Geraldo de Barros, Geneva
AHO/PHO	Arquivo Hélio Oiticica/Projeto Hélio Oiticica, Rio de Janeiro
AHWS	Arquivo Histórico Wanda Svevo, Fundação Bienal de São Paulo
AIS	Arquivo Ivan Serpa, Rio de Janeiro
ALA, MFAH	Adolpho Leirner Archives, MFAH
AMP, BN	Arquivo Mário Pedrosa, Biblioteca Nacional, Rio de Janeiro
AN	Arquivo Nacional, Rio de Janeiro
APESP	Arquivo Público do Estado de São Paulo
ARQ. MAC USP	Arquivo do MAC USP
ARQ. MAM RIO	Arquivo de Artes Visuais, MAM Rio
AWC	Arquivo Waldemar Cordeiro, São Paulo
BIB. MAM-SP	Biblioteca Paulo Mendes de Almeida, MAM-SP
CB	Cinemateca Brasileira, São Paulo
CDWC	CD-ROM Waldemar Cordeiro (São Paulo: Analívia Cordeiro and Galeria Brito Cimino, 2010)

CP, MASP	Centro de Pesquisa, MASP
FMS	Fundo Francisco Matarazzo Sobrinho, AHWS
FS, ASAC	Fondo Storico, Archivio Storico delle Arti Contemporanee, Fondazione La Biennale di Venezia
HVRF, SRGM	Hilla von Rebay Foundation Archive, Solomon R. Guggenheim Museum Archives, New York
IAC	Instituto de Arte Contemporânea, MASP
IBEU	Instituto Brasil-Estados Unidos, Rio de Janeiro
IC/IP	International Council and International Program Records, MoMA Archives, NY
IMS	Instituto Moreira Salles, Rio de Janeiro and São Paulo
LD, MNAM	Fonds Léon Degand, Bibliothèque Kandinsky, Mnam-Cci, Centre Pompidou, Paris
MAC USP	Museu de Arte Contemporânea da Universidade de São Paulo
MAM	Fundo Museu de Arte Moderna de São Paulo, AHWS
MAM RIO	Museu de Arte Moderna do Rio de Janeiro
MAM-SP	Museu de Arte Moderna de São Paulo
MASP	Museu de Arte de São Paulo (now Museu de Arte de São Paulo Assis Chateaubriand)
MEC	Ministério da Educação e Cultura, Rio de Janeiro
MES	Ministério da Educação e Saúde, Rio de Janeiro
MFAH	The Museum of Fine Arts, Houston
MOMA	The Museum of Modern Art, New York
MOMA ARCHIVES, NY	The Museum of Modern Art Archives, New York
NAR, RAC	Nelson A. Rockefeller Papers, Rockefeller Family Archives, Rockefeller Archive Center, Sleepy Hollow, NY
PINACOTECA	Pinacoteca do Estado de São Paulo
PLP	Projeto Lygia Pape, Rio de Janeiro
RDH	René d'Harnoncourt Papers, MoMA Archives, NY

Notes

INTRODUCTION

1. "O maior acontecimento artístico da América: a Bienal," *Última Hora* (Rio), October 20, 1951, 1.

2. The latter questions build on US-based artist group Group Material's methodology. See Group Material, "On Democracy" (1990), in *Participation,* ed. Claire Bishop (Cambridge, MA: MIT Press, 2006), 135–37.

3. Brodwyn Fischer, *A Poverty of Rights: Citizenship and Inequality in Twentieth-Century Rio de Janeiro* (Palo Alto, CA: Stanford University Press, 2008); James Holston, *Insurgent Citizenship: Disjunctions of Democracy and Modernity in Brazil* (Princeton, NJ: Princeton University Press, 2008).

4. Fischer, *A Poverty of Rights,* 5.

5. Holston, *Insurgent Citizenship,* 3–4, 104. The illiteracy rate for those over fifteen years of age was 56.1 percent in 1940 and 50.6 percent in 1950. In practice, the vote was extended to many employees in the urban public and private sectors, but eligibility and participation remained low. In the 1945 presidential election, 30.6 percent of adults were eligible and 25.4 percent voted; in the 1950 presidential election, 41.6 percent were eligible and only 30 percent voted. See Holston, *Insurgent Citizenship,* 92–93, 101; Leslie Bethell, "Politics in Brazil under Vargas, 1930–1945," in *The Cambridge History of Latin America,* ed. Leslie Bethell (Cambridge, UK: Cambridge University Press, 2008), 26, 74.

6. Barbara Weinstein, *The Color of Modernity: São Paulo and the Making of Race and Nation in Brazil* (Durham, NC: Duke University Press, 2015), 11–14, 224–32.

7. Ibid., 14.

8. Denise Ferreira da Silva, *Toward a Global Idea of Race* (Minneapolis: University of Minnesota Press, 2007), 223.

9. International Council and International Program Records, I.B.124, MoMA Archives, NY.

10. Tony Bennett, "The Exhibitionary Complex," *New Formations* 4 (Spring 1988): 73–102.

11. Ibid., 76.

12. Donald Preziosi, *Brain of the Earth's Body: Art, Museums, and Phantasms of Modernity* (Minneapolis: University of Minnesota Press, 2003).

13. Models for my study include: Andrea Giunta, *Avant-Garde, Internationalism, and Politics: Argentine Art in the Sixties* (Durham, NC: Duke University Press, 2007); Anna Indych-López, *Muralism Without Walls: Rivera, Orozco, and Siqueiros in the United States, 1927–1940* (Pittsburgh: University of Pittsburgh Press, 2009); Mary K. Coffey, *How a Revolutionary Art Became Official Culture: Murals, Museums, and the Mexican State* (Durham, NC: Duke University Press, 2012); Claire F. Fox, *Making Art Panamerican: Cultural Policy and the Cold War* (Minneapolis: University of Minnesota Press, 2013).

14. The precursors to the São Paulo Bienal are the Venice Biennale, established in 1895, and the Carnegie International, established in 1896.

15. Silviano Santiago, "Universality in Spite of Dependency," in Silviano Santiago, *The Space In-Between: Essays on Latin American Culture,* ed. Ana Lúcia Gazzola (Durham, NC: Duke University Press, 2001), 61.

16. Stefan Zweig, *Brazil: Land of the Future* (New York: Viking Press, 1941).

17. Weinstein, *The Color of Modernity;* Fox, *Making Art Panamerican.*

18. Mari Carmen Ramírez, "Between *corpus solidum* and *quasi-corpus:* Color in Concretismo and Neoconcretismo," in *Building on a Construct: The Adolpho Leirner Collection of Brazilian Constructive Art at the Museum of Fine Arts, Houston,* ed. Héctor Olea and Mari Carmen Ramírez (Houston: MFAH, 2009), 271–89; Kaira M. Cabañas, *Learning from Madness: Brazilian Modernism and Global Contemporary Art* (Chicago: University of Chicago Press, 2018); Luiz Camillo Osorio, ed., *Calder and Brazilian Art* (São Paulo: Itaú Cultural, 2018).

19. María Amalia García, *Abstract Crossings: Cultural Exchange between Argentina and Brazil* (Berkeley: University of California Press, 2019). This is the English translation of the 2011 Spanish edition.

20. See, for example, Caroline A. Jones, *The Global Work of Art: World's Fairs, Biennials, and the Aesthetics of Experience* (Chicago: University of Chicago Press, 2016); Charles Green and Anthony Gardner, *Biennials, Triennials, and Documenta: The Exhibitions That Created Contemporary Art* (London: Wiley, 2016).

21. Caroline Jones, for example, turns to poet Oswald de Andrade's theory of *antropofagia* (anthropophagy) from the 1920s to understand the critical moves at the early Bienal. But Andrade's ideas were not recuperated by Brazilian artists and thinkers until the late 1960s, and this approach, to my mind, risks flattening our understanding of Brazil's rich, intellectual legacies of the twentieth century. See Jones, *The Global Work of Art,* 114.

22. Foundational texts include Ronaldo Brito, "Neoconcretismo," *Malasartes* 3 (April–June 1976): 9–13; Aracy A. Amaral, ed., *Projeto construtivo brasileiro na arte (1950–1962)* (Rio: MAM Rio; São Paulo: Pinacoteca, 1977); Ronaldo Brito, *Neoconcretismo: vértice e ruptura do projeto construtivo brasileiro* (Rio: Funarte, 1985); Aracy A. Amaral, *Arte para quê? A preocupação social na arte brasileira, 1930–1970,* 3rd ed. (1984; São Paulo: Studio Nobel, 2003), 229–71. Ferreira Gullar and Mário Pedrosa, critics and fellow travelers of postwar abstract artists, also emphasized this question and influenced the approaches of Brito, Amaral, and others.

23. C.A., "Conversa com Alfred Barr Jr.," *O Estado de São Paulo,* September 28, 1957, Suplemento Literário, 7.

CHAPTER 1. TURNABOUT IS FAIR PLAY

1. There is excellent, extensive scholarship on the early history of MAM-SP, including Aracy A. Amaral, "The History of a Collection," in *Perfil de um acervo: Museu de Arte Contemporânea da Universidade de São Paulo,* ed. Aracy A. Amaral (São Paulo: Techint, 1988), 11–51; Serge Guilbaut, "Dripping on the Modernist Parade: The Failed Invasion of Abstract Art in Brazil, 1947–1948," in *Patrocinio, colección y circulación de las artes: XX Coloquio Internacional de Historia del Arte,* ed. Gustavo Curiel (Mexico City: Universidad Nacional Autónoma de México, 1997), 807–16; Regina Teixeira de Barros, "Revisão de uma história: a criação do Museu de Arte Moderna de São Paulo, 1946–1949" (MA thesis, Universidade de São Paulo, 2002); Annateresa Fabris, "'A Flash in the Pan that is Really Gold': Considerations on the Inception of the Museu de Arte Moderna de São Paulo," in *MAM 60,* ed. Annateresa Fabris and Luiz Camillo Osorio (São Paulo: MAM-SP, 2008), 14–89; Serge Guilbaut, "*Ménage à trois:* Paris, New York, São Paulo, and the Love of Modern Art," in *Internationalizing the History of American Art: Views,* ed. Barbara Groseclose and Jochen Wierich (University Park: Pennsylvania State University Press, 2009), 159–77; Ana Gonçalves Magalhães, "A disputa pela arte abstrata no Brasil: revisitando o acervo inicial do Museu de Arte Moderna de São Paulo, 1946–1952," *Resgate: Revista Interdisciplinar de Cultura* 25, no. 1 (January–June 2017): 7–28.

2. Lourival Gomes Machado, "Introdução," in *I Bienal do Museu de Arte Moderna de São Paulo: catálogo,* 2nd ed. (São Paulo: MAM-SP, 1951), 14.

3. See, for example, Mário Pedrosa, "A Bienal de cá para lá" (1970), in *Textos escolhidos,* ed. Otília Arantes, vol. 1, *Política das artes* (São Paulo: Edusp, 1995), 217; Paulo Mendes de Almeida, *De Anita ao museu* (São Paulo: Editora Perspectiva, 1976), 220–21; Yolanda Penteado, *Tudo em cor-de-rosa* (Rio: Nova Fronteira, 1976), 178; Leonor Amarante, *As*

Bienais de São Paulo, 1951 a 1987 (São Paulo: Projeto, 1989), 12–13; Dalton Sala, "Arquivo de arte de Fundação Bienal de São Paulo," *Revista USP,* no. 52 (December 2001–February 2002): 124–25; Francisco Alambert and Polyana Canhête, *As Bienais de São Paulo: da era do museu à era dos curadores (1951–2001)* (São Paulo: Boitempo, 2004), 37–38.

4. Caroline A. Jones, *The Global Work of Art: World's Fairs, Biennials, and the Aesthetics of Experience* (Chicago: University of Chicago Press, 2016), 114, 126. There are factual inaccuracies in the book chapter focused on the São Paulo Bienal and in her earlier, related article, as art historian Sérgio Martins has noted in the latter case. See Caroline A. Jones, "Anthropophagy in São Paulo's Cold War," *ARTMargins* 2, no. 1 (February 2013): 3–36; Sérgio B. Martins, "Letter to the Editor," ARTMargins, February 20, 2014, https://artmargins.com/letter-to-the-editor.

5. On cultural policy under Vargas from 1930 to 1945, see Daryle Williams, *Culture Wars in Brazil: The First Vargas Regime* (Durham, NC: Duke University Press, 2001).

6. Flávio de Carvalho, epigraph, *RASM: Revista Anual do Salão de Maio,* no. 1 (1939); "Roosevelt's Message to the Art Museum," *New York Times,* May 11, 1939, 29.

7. Flávio de Carvalho, "Manifesto of the III Salão de Maio," *RASM,* no. 1 (1939).

8. Luís Martins, "Arte moderna e Estado Novo," *Diário de São Paulo,* May 20, 1945, in *Luís Martins: um cronista de arte em São Paulo nos anos 1940,* ed. Ana Luisa Martins and José Armando Pereira da Silva (São Paulo: MAM-SP, 2009), 203–4.

9. Sérgio Milliet, "Pintura moderna," *O Estado de São Paulo,* July 22, 1938, 3.

10. Ibid.

11. Luís Martins, "O futuro museu de belas-artes," *Diário de São Paulo,* October 9, 1943, in Martins and Silva, *Luís Martins,* 76.

12. Luís Martins, "Museus de arte," *Diário de São Paulo,* October 17, 1943, in Martins and Silva, *Luís Martins,* 77.

13. Luís Martins, "Pintura e poesia," *Diário de São Paulo,* January 29, 1944, in Martins and Silva, *Luís Martins,* 92.

14. Fabris, "'A Flash in the Pan,'" 16. Also see Lisbeth Rebollo Gonçalves, *Sérgio Milliet, crítico de arte* (São Paulo: Perspectiva; Edusp, 1992), 77.

15. Luís Martins, "A Seção de Arte da Biblioteca," *Diário de São Paulo,* January 22, 1945, in Martins and Silva, *Luís Martins,* 247; Gonçalves, *Sérgio Milliet,* 77; Fabris, "'A Flash in the Pan,'" 16.

16. Carlos Guilherme Motta, *Ideologia da cultura brasileira: pontos de partida para uma revisão histórica* (São Paulo: Ática, 1977), 138; Gonçalves, *Sérgio Milliet,* 173.

17. Motta, *Ideologia da cultura brasileira,* 140n17.

18. *Primeiro Congresso Brasileiro de Escritores* (São Paulo: Associação Brasileira de Escritores, 1945), trans. in Thomas Skidmore, *Politics in Brazil, 1930–1964: An Experiment in Democracy* (Oxford: Oxford University Press, 2007), 49.

19. Skidmore, *Politics in Brazil,* 48–49.

20. See, for example, Luís Martins, "Museus de arte moderna," *Diário de São Paulo,* April 12, 1946, in Martins and Silva, *Luís Martins,* 269; Sérgio Milliet, "A propósito de um museu de arte moderna," *O Estado de São Paulo,* May 17, 1946, 6.

21. Historians underline the continuity between the constitutions enacted under Vargas, in 1934 and 1937, and the constitution approved in September 1946 that helped to usher in redemocratization. See Brodwyn Fischer, *A Poverty of Rights: Citizenship and Inequality in Twentieth-Century Rio de Janeiro* (Palo Alto, CA: Stanford University Press, 2008), 116–17.

22. [Sérgio Milliet], "Precisamos de um museu de arte moderna," *O Estado de São Paulo,* April 10, 1946, 5; "Museu de Arte Moderna em S. Paulo," *Diário de São Paulo,* April 11, 1946. Barros attributes the first text to Milliet and Fabris accepts this attribution (Barros, "Revisão de uma história," 69–70, 182; Fabris, "A Flash in the Pan," 18). It is possible the second text was by Martins.

23. [Milliet], "Precisamos de um museu de arte moderna."

24. "Museu de Arte Moderna em S. Paulo."

25. Barros, "Revisão de uma história," 268–84.

26. Luís Martins, "Carta ao literato Abrahão Ribeiro," *Diário de São Paulo,* April 19, 1946, in Martins and Silva, *Luís Martins,* 272–73.

27. Abrahão Ribeiro, "Carta ao artista Luís Martins," *Diário de São Paulo,* April 26, 1946, 3.

28. Barros, "Revisão de uma história," 68–84, 181–83.

29. See Tadeu Chiarelli, *Um jeca nos vernissages* (São Paulo: Edusp, 1995).

30. [José Bento] Monteiro Lobato, "Carta ao prefeito de São Paulo," *Diário de São Paulo,* April 30, 1946, 4, quoted in Barros, "Revisão de uma história," 73.

31. Abrahão Ribeiro, "Museu de Arte Moderna," *Diário de São Paulo,* May 12, 1946, quoted in Barros, "Revisão de uma história," 77.

32. Elizabeth Anne Cobbs, *The Rich Neighbor Policy: Rockefeller and Kaiser in Brazil* (New Haven, CT: Yale University Press, 1992), 100–89; Cary Reich, *The Life of Nelson A. Rockefeller: Worlds to Conquer, 1908–1958* (New York: Doubleday, 1996), 406.

33. For an insightful analysis of OIAA, its institutional connections with MoMA and the Pan American Union, and a demonstration of ideological continuity in the arena of hemispheric cultural diplomacy between pre- and post-World War II, see Claire F. Fox, *Making Art Panamerican: Cultural Policy and the Cold War* (Minneapolis: University of Minnesota Press, 2013), 41–88.

34. Reich, *The Life of Nelson A. Rockefeller,* 383, 407.

35. The Inter-American Treaty of Reciprocal Assistance, a hemispheric defense agreement known as the Rio Treaty, was signed at the conference. See Leslie Bethell and Ian Roxborough, "The Postwar Conjuncture in Latin America: Democracy, Labor, and the

Left," in *Latin America Between the Second World War and the Cold War, 1944–1948*, ed. Leslie Bethell and Ian Roxborough (Cambridge, UK: Cambridge University Press, 1992), 21–24.

36. Paul Vanorden Shaw, "Rockefeller panamericanista," *O Estado de São Paulo,* November 22, 1946, 14.

37. Fabris, "'A Flash in the Pan,'" 20; Barros, "Revisão de uma história," 92n24.

38. [Alfred H. Barr, Jr.] to Nelson A. Rockefeller, November 13, 1946, folder 1464, series L-148, RG 4, NAR, RAC. "A estada do sr. Nelson Rockefeller em São Paulo," *O Estado de São Paulo,* November 23, 1946, 8.

39. Aracy A. Amaral, *MAC: uma seleção do acervo na Cidade Universitária* (São Paulo: MAC USP, 1983), 13; Amaral, "The History of a Collection," 13; Fabris, "'A Flash in the Pan,'" 20.

40. [Barr] to Rockefeller, November 13, 1946. Though Barr's letter to Rockefeller in RAC is unsigned, records in the Barr papers at AAA and MoMA Archives, NY establish its authorship and Barr's and Miller's purchase of works. For detailed discussion, see Adele Nelson, "The Monumental and the Ephemeral: The São Paulo Bienal and the Emergence of Abstraction in Brazil, 1946–1954" (PhD diss., New York University, 2012), 34n81.

41. Guilbaut, "*Ménage à trois,*" 164.

42. For example, Rockefeller proposed an exhibition of US and US-resident European refugee artists in São Paulo as the first project of exchange between MoMA and the future modern art museum of São Paulo: "Quadros dos maiores artistas modernos doados ao Museu de Arte Moderna de São Paulo," *Diário de São Paulo,* November 23, 1946.

43. Barros, "Revisão de uma história," 86–88.

44. Carleton Sprague Smith to Milliet and Rodrigo de Mello Franco, November 30, 1946, Nelson A. Rockefeller folder, Bib. MAM-SP. This transfer did not occur and the works remained at the Biblioteca Municipal. Barros, "Revisão de uma história," 89; Fabris, "'A Flash in the Pan,'" 22n10.

45. Carleton Sprague Smith to various recipients in Rio and São Paulo, December 1946, folder 1467, series L-148, RG 4, NAR, RAC; René d'Harnoncourt Papers, II.38, MoMA Archives, NY.

46. Sérgio Milliet, "O IV Salão de Maio," *O Estado de São Paulo,* October 28, 1947, 6.

47. Penteado, *Tudo em cor-de-rosa,* 174.

48. Beyond the dialogues I trace here based on Brazilian, French, and US archives, there were others with Italy. (ASAC holdings, examined in chapter 3, do not shed light on the founding of MAM-SP). Annateresa Fabris has speculated that the Galleria Nazionale d'Arte Moderna in Rome was an inspiration for Matarazzo. Ana Gonçalves Magalhães has reconstructed the role of Margherita Sarfatti and other Italian agents in Matarazzo's acquisition of Italian works. I thank Vera Beatriz Siqueira for sharing that the archive of Raymundo de Castro Maya, a founder of MAM Rio, indicates that the Rome museum was considered in that institution's founding. Fabris, "'A Flash in the Pan,'" 28; Ana

Gonçalves Magalhães, ed., *Classicismo, realismo, vanguarda: pintura italiana no entreguerras* (São Paulo: MAC USP, 2013); Magalhães, "A disputa pela arte abstrata no Brasil."

49. Francisco Matarazzo Sobrinho to Carlos Pinto Alves, February [18, 1947], folder 1, História do MAM-SP, Bib. MAM-SP; Francisco Matarazzo Sobrinho to Carlos Pinto Alves, March 15, [1947], folder 1, História do MAM-SP, Bib. MAM-SP; Barros, "Revisão de uma história," 94n4.

50. Carlos Pinto Alves to Carleton Sprague Smith, [January 18, 1947], folder 1, História do MAM-SP, Bib. MAM-SP; Matarazzo to Pinto Alves, March 15, [1947]; Rino Levi to Carleton Sprague Smith, October 13, 1947, folder 1467, series L-148, RG 4, NAR, RAC.

51. "Ata da fundação e constituição da Galeria de Arte Moderna de São Paulo," May 10, 1947, folder 2, MAM-SP, FMS, AHWS. AHWS has recatalogued their holdings; the folder and box numbers throughout correspond to the old cataloguing system.

52. Carleton Sprague Smith to Carlos Pinto Alves, July 23, 1947, box 1, MAM-SP, MAM, AHWS.

53. Francisco Matarazzo Sobrinho to Carlos Pinto Alves, July 2, [1947], folder 9, Arquivo Moussia Pinto Alves, Bib. MAM-SP; folder 1, História do MAM-SP, Bib. MAM-SP.

54. The seasons indicated in this chapter are of the northern hemisphere. Léon Degand, "Un critique d'art en Amérique du Sud," unpublished text, 1, folder 7, São Paulo box, LD, Mnam. Degand's papers hold a handwritten and typed version of this unpublished chronicle; the pagination I indicate is from the typed version.

55. Léon Degand, untitled report, folder 9, Arquivo Moussia Pinto Alves, Bib. MAM-SP; Léon Degand folder, MAM, AHWS. The report, which was hand-delivered by Magnelli to Matarazzo in Davos, dates to before July 2, 1947, when Matarazzo sent it to Pinto Alves. Matarazzo to Pinto Alves, July 2, [1947]; Léon Degand to Francisco Matarazzo Sobrinho, July 9, 1947, Léon Degand folder, MAM, AHWS.

56. Karl Nierendorf to Hilla Rebay, August 14, 1947, folder 37, box 125, series II, HVRF, M0007, SRGM; Cícero Dias to Francisco Matarazzo Sobrinho, May 18, 1948, box 11, MAM-SP, MAM, AHWS; folder 2, História do MAM-SP, Bib. MAM-SP; Penteado, *Tudo em cor-de-rosa,* 174, 177; Degand, "Un critique d'art en Amérique du Sud," 1.

57. Karl Nierendorf to Francisco Matarazzo Sobrinho, undated and hand-delivered in Davos between March 15–October 13, 1947, folder 1, MAM-SP, FMS, AHWS.

58. See, for example, Rino Levi to Carleton Sprague Smith, April 27, 1947, folder 1467, series L-148, RG 4, NAR, RAC; Sprague Smith to Pinto Alves, July 23, 1947; Levi to Sprague Smith, October 13, 1947; Rino Levi to Carleton Sprague Smith, October 21, 1947, folder 1467, series L-148, RG 4, NAR, RAC.

59. Levi to Sprague Smith, October 13, 1947, and enclosed draft program of Instituto de Arte Moderna, folder 1467, series L-148, RG 4, NAR, RAC. Sprague Smith shared the October 13, 1947 letter and draft program, as well as Levi's letter of October 21, 1947, with

Rockefeller, including a note indicating that Sprague Smith took Levi's news as a positive development. Carleton Sprague Smith to Nelson A. Rockefeller, November 6, 1947, folder 1467, series L-148, RG 4, NAR, RAC. There is no record of criticism by MoMA staff of the name or scope of the proposed Instituto in internal or external correspondence.

60. Architectural historian Zeuler R.M.A. Lima mentions this iteration of the name for MAM-SP, but does not cite or analyze Levi's proposal. Zeuler R.M.A. Lima, "Nelson A. Rockefeller and Art Patronage in Brazil after World War II: Assis Chateaubriand, the Museu de Arte de São Paulo (MASP) and the Museu de Arte Moderna (MAM)," *Rockefeller Archive Center Research Reports Online* (2010): 10, www.rockarch.org /publications/resrep/lima.pdf, accessed March 11, 2011.

61. Levi to Sprague Smith, October 13, 1947.

62. "Instituição da Fundação de Arte Moderna," January 12, 1948, Folder 002, MAM-SP, FMS, AHWS.

63. Vera D'Horta Beccari, "O Museu de Arte Moderna de São Paulo," in *MAM: Museu de Arte Moderna de São Paulo* (São Paulo: DBA Artes Gráficas, 1995), 19–20; Barros, "Revisão de uma história," 105.

64. Fabris also argues that the incorporation of the MoMA model was partial. Fabris, "'A Flash in the Pan,'" 28, 30.

65. Rather than dividing the authority of overseeing board meetings and general supervision of the museum between the chairman of the board and president—as at MoMA, for example—the president of the Fundação de Arte Moderna assumed both powers. The president of the Brazilian institution also served for life, while all officers at MoMA were elected annually. "Escritura de instituição da Fundação de Arte Moderna," January 12, 1948, Registro de Títulos e Documentos, São Paulo; Barros, "Revisão de uma história," appendix; "By-Laws of the Museum of Modern Art as amended to May 9, 1946," Reports and Pamphlets: 11.4, The Museum of Modern Art Archives, New York.

66. Carleton Sprague Smith to Rino Levi, March 4, 1948, box 1, MAM-SP, MAM, AHWS; Nelson A. Rockefeller to Francisco Matarazzo Sobrinho, March 5, 1948, box 1, MAM-SP, MAM, AHWS; folder 1467, series L-148, RG 4, NAR, RAC; Carleton Sprague Smith to Carlos Pinto Alves, March 5, 1948, box 1, MAM-SP, MAM, AHWS; Nelson A. Rockefeller to Carlos Pinto Alves, March 8, 1948, folder 1467, series L-148, RG 4, NAR, RAC; René d'Harnoncourt to Rino Levi, April 2, 1948, folder 1467, series L-148, RG 4, NAR, RAC.

67. "Escritura de instituição da Fundação de Arte Moderna."

68. Francisco Matarazzo Sobrinho to Cícero Dias, December 8, 1947, box 9, MAM-SP, MAM, AHWS; Rino Levi to Carleton Sprague Smith, February 2, 1948, folder 1464, series L-148, RG 4, NAR, RAC; Carlos Pinto Alves to Carleton Sprague Smith, February 2, 1948, box 1, MAM-SP, MAM, AHWS; Carlos Pinto Alves to Nelson A. Rockefeller, February 2, 1948, box 1, MAM-SP, MAM, AHWS; folder 1467, series L-148, RG 4, NAR, RAC.

69. Almeida, *De Anita ao museu,* 205–6.

70. "Museu de Arte Moderna de São Paulo: extrato de seus estatutos sociais," *Diário Oficial,* September 28, 1948, Bib. MAM-SP.

71. "Museu de Arte Moderna, São Paulo, Brasil: estatutos" pamphlet, folder 6, MAM-SP, FMS, AHWS.

72. MAM-SP retained the right to its name and reestablished itself later in 1963 in what historians describe as the second phase of the museum.

73. For example, writing to Sprague Smith in February 1948, Pinto Alves described "the initial donation from Mr. Matarazzo" as the foundation of the museum's collection (Pinto Alves to Sprague Smith, February 2, 1948).

74. This was the first press discussion of the effort to found MAM-SP since Rockefeller's visit in November 1946. A copy of the article was retained by Matarazzo's office and d'Harnoncourt received a translation of it (Sérgio Milliet, "O Museu de Arte Moderna," *O Estado de São Paulo,* March 4, 1948, 6, folder 8, MAM-SP, FMS, AHWS; RdH, II.38, MoMA Archives, NY).

75. Almeida, *De Anita ao museu,* 212.

76. Léon Degand, "Une équipée artistique au Brésil," *Les Beaux-Arts* 18, no. 647 (April 9, 1954): 1, unnumbered folder, São Paulo box, LD, Mnam.

77. According to Degand, he was appointed director on July 23, 1948 and he began sending correspondence with this title by July 29, 1948. Degand, "Un critique d'art en Amérique du Sud," 6; Léon Degand to Willem Sandberg, July 29, 1948, box 1, MAM-SP, MAM, AHWS.

78. "Programa do Museu de Arte Moderna de São Paulo," folder 001/001, box 1, MAM-SP, Arq. MAC USP; folder 1467, series L-148, RG 4, NAR, RAC. Milliet quoted from the program and noted it was distributed to the press; see Sérgio Milliet, "O Museu de Arte Moderna de S. Paulo," *O Estado de São Paulo,* September 10, 1948, 6. Matarazzo sent the program to Rockefeller (Francisco Matarazzo Sobrinho to Nelson A. Rockefeller, September 15, 1948, folder 1467, series L-148, RG 4, NAR, RAC; box 9, MAM-SP, MAM, AHWS; RdH, II.38, MoMA Archives, NY).

79. "Programa do Museu de Arte Moderna de São Paulo (projeto)," folder 001/001, box 1, MAM-SP, Arq. MAC USP; folder 7, São Paulo box, LD, Mnam.

80. Invitations from Francisco Matarazzo Sobrinho to various recipients, box 10, MAM-SP, MAM, AHWS; [Luís Martins], "Inaugura-se o Museu de Arte Moderna de São Paulo," *O Estado de São Paulo,* March 1, 1949, in Martins and Silva, *Luís Martins,* 345–46.

81. Lawrence Alloway, *The Venice Biennale, 1895–1968: From Salon to Goldfish Bowl* (Greenwich, CT: New York Graphic Society, 1968), 135, 154n4; Hans Belting, *Art History After Modernism* (Chicago: University of Chicago Press, 2003), 37–43.

82. Guilbaut, "Dripping on the Modernist Parade"; Guilbaut, "*Ménage à trois.*"

83. Guilbaut, "*Ménage à trois,*" 166–67.

84. Carleton Sprague Smith to Rino Levi, March 4, 1948, box 1, MAM-SP, MAM, AHWS; Matarazzo to Rockefeller, September 15, 1948. Rockefeller's comment appears on the original of the letter at RAC.

85. From the copious correspondence, see, for example, René d'Harnoncourt to Yolanda Penteado, October 15, 1948, RdH, II.38, MoMA Archives, NY; folder 1467, series L-148, RG 4, NAR, RAC; "Loans to Foreign Countries from the Museum Collection, 1945–1950: Loans to South America," June 22, 1950, folder 1470, series L-148, RG 4, NAR, RAC.

86. Guilbaut, "*Ménage à trois,*" 167–73; Jones, *The Global Work of Art,* 118–19, 131–32.

87. Nierendorf to Rebay, August 14, 1947.

88. Rino Levi to Francisco Matarazzo Sobrinho, August 29, 1947, box 11, MAM-SP, MAM, AHWS; Francisco Matarazzo Sobrinho to Carlos Pinto Alves, September 4, [1947], box 9, MAM-SP, MAM, AHWS; folder 1, História do MAM-SP, Bib. MAM-SP.

89. Matarazzo to Pinto Alves, September 4, [1947]. The copies of this letter at AHWS and Bib. MAM-SP are difficult to read and combine Portuguese and Italian. The quoted passage follows the partial transcription by Regina Teixeira de Barros preserved at Bib. MAM-SP, with slight modification.

90. Nierendorf to Rebay, August 14, 1947.

91. Alfred H. Barr, Jr., *Cubism and Abstract Art,* rev. ed. (1936; repr., New York: MoMA, 1966), 200.

92. Guilbaut, "Dripping on the Modernist Parade," 809–10; Guilbaut, "*Ménage à trois,*" 169. On date of Degand's termination at *Les lettres françaises,* see Anne Maisonnier-Lochard, "Léon Degand: Biographie," in Daniel Abadie, *Un art autre, un autre art* (Paris: Artcurial, 1984), 63.

93. Nierendorf to Rebay, August 14, 1947; Guilbaut, "Dripping on the Modernist Parade," 809; Guilbaut, "*Ménage à trois,*" 169.

94. Matarazzo to Pinto Alves, September 4, [1947].

95. Cícero Dias to Francisco Matarazzo Sobrinho, November 3, 1947, box 11, MAM-SP, MAM, AHWS.

96. Cícero Dias to Francisco Matarazzo Sobrinho, [after November 13, 1947], box 11, MAM-SP, MAM, AHWS; folder 1, História do MAM-SP, Bib. MAM-SP; Cícero Dias to Francisco Matarazzo Sobrinho, late November 1947, box 11, MAM-SP, MAM, AHWS; folder 1, História do MAM-SP, Bib. MAM-SP; "Texte du Comité de Paris," undated, folder 8, São Paulo box, LD, Mnam.

97. Francisco Matarazzo Sobrinho telegram to Cícero Dias, December 1, 1947, box 9, MAM-SP, MAM, AHWS; Francisco Matarazzo Sobrinho to Cícero Dias, December 8, 1947, box 9, MAM-SP, MAM, AHWS.

98. René Drouin, "Organization d'une exposition internationale d'Art Abstrait à São Paulo," January 29, 1948, box 11, MAM-SP, MAM, AHWS.

99. Léon Degand to Francisco Matarazzo Sobrinho, April 20, 1948, folder 2, História do MAM-SP, Bib. MAM-SP; Paul Cummings, "Interview with Leo Castelli," May 14, 1969, 28–29, AAA. The Leo Castelli and Sidney Janis papers do not have records related to this exhibition and Castelli noted that his correspondence with Drouin had been lost. See Cummings, "Interview with Leo Castelli," 30; Donna Turco, Leo Castelli Gallery, email to author, February 5, 2005; Carol Janis, email to author, September 17, 2010.

100. Matarazzo to Pinto Alves, September 4, [1947].

101. "Texte du Comité de Paris."

102. Léon Degand to Francisco Matarazzo Sobrinho, May 22, 1948, folder 2, História do MAM-SP, Bib. MAM-SP.

103. "São Paulo à frente do movimento pictórico do continente," *Diário de Pernambuco,* July 15, 1948, 3.

104. Leo Castelli to Francisco Matarazzo Sobrinho, July 21, 1948 and enclosed checklist, box 1, MAM-SP, MAM, AHWS; folder 10, São Paulo box, LD, Mnam. Of the historical artists Degand listed in his May 22, 1948 letter, Castelli secured loans of all but two: Klee and Vordemberge-Gildewart. Klee was included in the ultimate checklist at Matarazzo's request. See Francisco Matarazzo Sobrinho telegram to Leo Castelli, July 29, 1948, box 9, MAM-SP, MAM, AHWS; Francisco Matarazzo Sobrinho to Leo Castelli, July 30, 1948, box 1, MAM-SP, MAM, AHWS; Leo Castelli telegram to Francisco Matarazzo Sobrinho, August 5, 1948, box 1, MAM-SP, MAM, AHWS; Leo Castelli to Francisco Matarazzo Sobrinho, August 7, 1948, box 1, MAM-SP, MAM, AHWS.

105. Marcel Duchamp to Francisco Matarazzo Sobrinho, August 5, 1948, box 12, MAM-SP, MAM, AHWS.

106. Francisco Matarazzo Sobrinho to Nelson A. Rockefeller, January 30, 1948, box 1, MAM-SP, MAM, AHWS; folder 1467, series L-148, RG 4, NAR, RAC; folder 1464, series L-148, RG 4, NAR, RAC; Matarazzo to Rockefeller, September 15, 1948.

107. Cícero Dias to Francisco Matarazzo Sobrinho, November 10, 1948, box 11, MAM-SP, MAM, AHWS; Cummings, "Interview with Leo Castelli," 18–19, 29–30; Annie Cohen-Solal, *Leo and His Circle: The Life of Leo Castelli* (New York: Alfred A. Knopf, 2010), 216.

108. Drouin had only covered $1,500 (approximately $13,500 in today's dollars) of the $3,500 (approximately $31,700 in today's dollars) total expenses. Mauricio Verdier telegram to Francisco Matarazzo Sobrinho, September 30, 1948, box 11, MAM-SP, MAM, AHWS; Mauricio Verdier telegram to Francisco Matarazzo Sobrinho, October 5, 1948, box 11, MAM-SP, MAM, AHWS.

109. Matarazzo had paid Drouin $5,000 (approximately $45,000 in today's dollars). Also see Nelson, "The Monumental and the Ephemeral," 75n215.

110. Léon Degand to Nina Kandinsky, December 23, 1948, box 1, MAM-SP, MAM, AHWS. Also see Léon Degand to Cícero Dias, November 24, 1948, box 1, MAM-SP, MAM, AHWS; folder 10, MAM-SP, FMS, AHWS; Degand, "Un critique d'art en Amérique du Sud," 8.

111. For installation views of the exhibition in LD, Mnam, see Glória Ferreira, *Brasil: figuração × abstração no final dos anos 40* (São Paulo: Instituto de Arte Contemporânea, 2013), 58, 151.

112. "Museu de Arte Moderna, X—os abstracionistas puros," *O Estado de São Paulo,* April 21, 1949, 6; Michel Simon, "A propósito do Museu de Arte Moderna de São Paulo," *Correio da Manhã,* March 27, 1949, 1. See chapter 2 for analysis of Cordeiro's early writing.

113. "Museu de Arte Moderna, X"; Simon, "A propósito do Museu de Arte Moderna de São Paulo." Also see Sérgio Milliet, "Flexor na Galeria Domus," *O Estado de São Paulo,* October 16, 1948, 6; Sérgio Milliet, "Cícero Dias no Museu de Arte Moderna," *O Estado de São Paulo,* July 24, 1949, 8.

114. In addition to his essay for the catalogue of *Do figurativismo ao abstracionismo* and published texts and interviews in Brazilian newspapers, Degand gave lectures between August and November 1948 in São Paulo and lectures in Rio in April and May 1949.

115. Aracy A. Amaral, *Arte para quê? A preocupação social na arte brasileira, 1930–1970,* 3rd ed. (São Paulo: Studio Nobel, 2003), 229.

116. Emiliano Di Cavalcanti, "Realismo e abstracionismo," *Fundamentos: Revista de Cultura Moderna,* no. 3 (August 1948): 242.

117. Mário Pedrosa, "As duas alas do modernismo" (1949), in Ferreira, *Brasil,* 176–89. Works from *Do figurativismo ao abstracionismo* were included in a larger exhibition of modern artworks in Rio at the insurance company Sul-América Terrestres Marítimos e Acidentes in 1949, and the accompanying publication served as an anthology of the main texts in the figuration and abstraction debate, with texts by Degand, Di Cavalcanti, Pedrosa, and several other Brazilian critics. See *Inaugurado . . . O novo edifício da Sul América Terrestres Marítimos e Acidentes* (Rio: Sul Americana, 1949).

118. "Museu de Arte Moderna, III—história do abstracionismo," *O Estado de São Paulo,* March 20, 1949, 6; "Museu de Arte Moderna, IV—a exposição do figurativismo ao abstracionismo," *O Estado de São Paulo,* March 24, 1949, 6; Simon, "A propósito do Museu de Arte Moderna de São Paulo."

119. See, for example, Degand to Nina Kandinsky, December 23, 1948; Francisco Matarazzo Sobrinho to Marcel Duchamp, January 3, 1949, box 9, MAM-SP, MAM, AHWS.

120. Diretoria Executiva, "Apresentação," in *Do figurativismo ao abstracionismo* (São Paulo: MAM-SP, 1949), 13–14.

121. Matarazzo to Pinto Alves, September 4, [1947].

122. MAM-SP's appeals to the French, US, and British authorities are the most detailed. See Francisco Matarazzo Sobrinho to Louis Joxe, December 11, 1948, box 9, MAM-SP, MAM, AHWS; Francisco Matarazzo Sobrinho to Joseph Privitera, January 24, 1949, box 9, MAM-SP, MAM, AHWS; Francisco Matarazzo Sobrinho to Leonard Downes, February 9, 1949, box 9, MAM-SP, MAM, AHWS.

123. Matarazzo to Privitera, January 24, 1949.

124. See, for example, Belgian Consulate to Léon Degand, December 14, 1948, box 4, MAM-SP, MAM, AHWS; Leonard Downes to Léon Degand, May 11, 1949, box 4, MAM-SP, MAM, AHWS.

125. *A nova pintura francesa e seus mestres: de Manet a nossos dias* (São Paulo: MAM-SP, 1949), box 6, MAM-SP, MAM, AHWS; "Atividades do Museu de Arte Moderna de S. Paulo de março de 1949 (inauguração) a setembro de 1956," 1956, box 12, MAM-SP, MAM, AHWS.

126. Sérgio Milliet to Francisco Matarazzo Sobrinho, May 31, 1949, box 11, MAM-SP, MAM, AHWS; folder 1603, Correspondência pessoal destacada (hereafter Corres. pes.), FMS, AHWS; Sérgio Milliet to Francisco Matarazzo Sobrinho, June 27, 1949, box 11, MAM-SP, MAM, AHWS; folder 1603, Corres. pes., FMS, AHWS.

127. See, for example, Lourival Gomes Machado to Giacomo Manzú, December 1, 1949, box 1, MAM-SP, MAM, AHWS; Lourival Gomes Machado to Gabrielle Mineur, December 13, 1949, box 2, MAM-SP, MAM, AHWS.

128. Francisco Matarazzo Sobrinho to René d'Harnoncourt, April 25, 1949, RdH, II.38, MoMA Archives, NY.

129. Nelson A. Rockefeller to Dean Acheson, December 19, 1949, folder 1468, series L-148, RG 4, NAR, RAC; Dean Acheson to Nelson A. Rockefeller, January 9, 1950, folder 1468, series L-148, RG 4, NAR, RAC; Dean Acheson to Nelson A. Rockefeller, January 18, 1950, folder 1468, series L-148, RG 4, NAR, RAC; RdH, IV.282, MoMA Archives, NY.

130. Sérgio Milliet to Francisco Matarazzo Sobrinho, May 20, 1949, box 11, MAM-SP, MAM, AHWS; folder 1603, Corres. pes., FMS, AHWS.

131. Milliet to Matarazzo, May 31, 1949; Milliet to Matarazzo, June 27, 1949.

132. "A exposição Bienal do Museu de Arte Moderna de São Paulo," press release, January 13, 1950, folder 012/101, box 7, MAM-SP, Arq. MAC USP. To the best of my knowledge, the first recorded, internal mention of the Bienal is in the draft statutes of MAM-SP, which are dated February 2, 1948 in AHWS cataloguing: "Estatutos do 'Museu de Arte Moderna de São Paulo,'" folder 3, MAM-SP, FMS, AHWS. Amaral, Fabris, and Ana Paula Nascimento have identified the first currently known external mention of the Bienal in November 1948. This is Ibiapaba Martins, "Duas entrevistas oportunas," *Correio Paulistano,* November 14, 1948, 9; see Amaral, *Arte para quê?,* 237; Ana Paula Nascimento, "MAM: museu para o metrópole" (MA thesis, Universidade de São Paulo, 2003), 114–15, 136n84, 137n86; Fabris, "'A Flash in the Pan,'" 80n88.

133. "Agreement between the Museu de Arte Moderna of São Paulo and the Museum of Modern Art of New York," folder 1468, series L-148, RG 4, NAR, RAC; RdH, II.39, MoMA Archives, NY; "Acordo entre o Museu de Arte Moderna de São Paulo e o Museu de Arte Moderna de Nova York," folder 001/005, box 1, MAM-SP, Arq. MAC USP; folder 4, História do MAM-SP, Bib. MAM-SP.

134. Untitled MAM-SP report, mid-July 1950, folder 1467, series L-148, RG 4, NAR, RAC. Lourival Gomes Machado also linked these three efforts in his analysis of the early history of MAM-SP and the Bienal ("4, Quase 5 Bienais," *Il Progresso Italo-Brasiliano* 3 (1959): 3, 12).

135. Untitled MAM-SP report, mid-July 1950. The amount MAM-SP received from the state government was twice that given to any other cultural institution; see "Lei n. 600, de 22 de abril de 1950," *Diário Oficial,* April 25, 1950, box 1, MAM-SP, MAM, AHWS.

136. Nelson A. Rockefeller to Francisco Matarazzo Sobrinho and Yolanda Penteado, July 27, 1950, RdH, II.38, MoMA Archives, NY.

137. Nelson A. Rockefeller to Dean Acheson, November 2, 1950, folder 1468, series L-148, RG 4, NAR, RAC; RdH, II.38, MoMA Archives, NY; Francisco Matarazzo Sobrinho to Eurico Gaspar Dutra, November 20, 1950, box 10, MAM-SP, MAM, AHWS.

138. See, for example, untitled MAM-SP report, mid-July 1950. On MAM-SP's "permanent financial crisis," see Amaral, "The History of a Collection," 28–30.

139. Machado, "Introdução," 14.

140. Machado, "4, Quase 5 Bienais."

CHAPTER 2. *FORMA*

1. In addition to *Do figurativismo ao abstracionismo* discussed in the first chapter, other key early exhibitions—Alexander Calder (1948, MES; MASP) and Max Bill (1951, MASP)—have received thoughtful recent study. See Aleca Le Blanc, "Traveling Through Time and Space: Calder in Brazil," in *Calder and Abstraction: From Avant-Garde to Iconic,* ed. Stephanie Barron and Lisa Gabrielle Mark (Los Angeles: Los Angeles County Museum of Art, 2013), 120–35; Sérgio B. Martins, "Wind Chimes of Modernity: Calder's 1948 Trip to Brazil," in *Alexander Calder: Performing Sculpture,* ed. Achim Borchardt-Hume (New Haven, CT: Yale University Press, 2015), 54–65; María Amalia García, *Abstract Crossings: Cultural Exchange between Argentina and Brazil* (Berkeley: University of California Press, 2019), 130–42.

2. In 1950, MES announced an ultimately unrealized art magazine titled *Forma*. In 1954, Luiza Elza Massena established the art magazine *Forma* in Rio, and Carlo and Ernesto Hauner opened a furniture and houseware store called *FORMA* in São Paulo. See Alencastro, "Crônicas," *Habitat: Revista das Artes no Brasil,* no. 1 (October-December 1950): 19; *Forma,* no. 1–6 (June 1954–March 1956); "A nova loja: 'Forma,'" *AD: Arquitetura e Decoração,* no. 7 (October 1954).

3. Max Bill, *Form: Eine Bilanz über die Formentwicklung um die Mitte des XX. Jahrhunderts, A Balance Sheet . . .* (Basel: Verlag Karl Werner, 1952).

4. Ibid, 7.

5. In 1951, MASP also established an art school that focused on the study and theory of form, the Instituto de Arte Contemporânea (IAC). See chapter 3.

6. Herbert Read, "Preface," in *Aspects of Form: A Symposium on Form in Nature and Art,* ed. Lancelot Law Whyte (Bloomington: Indiana University Press, 1951), 1–2. On Pedrosa's understanding of Read and Rudolf Arnheim, see Paulo Herkenhoff, "Rio de Janeiro: A Necessary City," in *The Geometry of Hope: Latin American Abstract Art from the Patricia Phelps de Cisneros Collection,* ed. Gabriel Pérez-Barreiro (Austin: Blanton Museum of Art, University of Texas at Austin, 2007), 56.

7. Mário Pedrosa, *Arte, necessidade vital* (Rio: Casa do Estudante do Brasil, 1949); Mário Pedrosa, *Panorama da pintura moderna* (Rio: MES, 1952).

8. Mário Pedrosa, "The Vital Need for Art," in *Mário Pedrosa: Primary Documents,* ed. Glória Ferreira and Paulo Herkenhoff (New York: MoMA, 2015), 103–12.

9. Otília Arantes is an exception, and her thoughtful analysis of Pedrosa's methodological approach and early writings has informed my thinking, as has Francisco Alambert's analysis of the role of Pedrosa's Marxism in his art criticism. See Otília Arantes, "Apresentação," in Mário Pedrosa, *Textos escolhidos,* ed. Otília Arantes, vol. 4, *Modernidade cá e lá* (São Paulo: Edusp, 2000), 11–23; Otília Arantes, *Mário Pedrosa: itinerário crítico,* 2nd ed. (São Paulo: Cosac Naify, 2004), 53–106; Francisco Alambert, "1001 Words for Mário Pedrosa," *Art Journal* 64, no. 4 (Winter 2005): 85–86.

10. Pedrosa, *Panorama da pintura moderna,* 46–47.

11. Ibid., 47.

12. Pedrosa, "The Vital Need for Art," 105.

13. Ibid., 111.

14. Kaira M. Cabañas, *Learning from Madness: Brazilian Modernism and Global Contemporary Art* (Chicago: University of Chicago Press, 2018), 83–107; Sérgio B. Martins, *Constructing an Avant-Garde: Art in Brazil, 1949–1979* (Cambridge, MA: MIT Press, 2013), 17–48; Irene V. Small, "Exit and Impasse: Ferreira Gullar and the 'New History' of the Last Avant-Garde," *Third Text* 26, no. 1 (January 2012): 91–101.

15. Almir Mavignier and Daniela Name, "Name / Mavignier: Entrevista," in *Almir Mavignier* (Rio: Memória Visual, 2013), 133.

16. Mário Pedrosa, "Da natureza afetiva da forma na obra de arte," *Arte, forma e personalidade, 3 estudos* (São Paulo: Kairós, 1979), 12–82.

17. Otília Arantes, "Prefácio," in Pedrosa, *Arte, forma e personalidade,* 4.

18. Pedrosa, *Panorama da pintura moderna,* 47–49.

19. Cabañas, *Learning from Madness,* 91.

20. Ibid., 104.

21. Waldemar Cordeiro, "Abstracionismo," *Artes Plásticas,* no. 3 (January–February 1949): 3; Waldemar Cordeiro, "Ainda o abstracionismo," *Revista dos Novíssimos* 1, no. 1 (January–February 1949): 27–28. Héctor Olea insightfully discusses these texts, though he dates the first text to 1948. Olea, "Waldemar Cordeiro: From Visible Ideas to the Invisible Work," in

Building on a Construct: The Adolpho Leirner Collection of Brazilian Constructive Art at the Museum of Fine Arts, Houston, ed. Héctor Olea and Mari Carmen Ramírez (Houston: MFAH, 2009), 135–36, 153n23.

22. Cordeiro, "Ainda o abstracionismo," trans. in Mónica Amor, *Theories of the Nonobject: Argentina, Brazil, Venezuela, 1944–1969* (Berkeley: University of California Press, 2016), 80.

23. Amor, *Theories of the Nonobject,* 80.

24. To the best of my knowledge, Cordeiro's earliest mention of Gestalt is in Waldemar Cordeiro, "I Bienal do Museu de Arte Moderna: um consórcio das formas da visualidade estética moderna," *Folha da Manhã,* December 22, 1951, 6.

25. Waldemar Cordeiro, "Resumo e notas: 'Michel Seuphor, L'art abstrait: ses origines, ses premiers meitres, maght [sic] Paris 1949,'" n.d., AWC.

26. Cordeiro, "Abstracionismo," in *Waldemar Cordeiro: fantasia exata,* ed. Analívia Cordeiro (São Paulo: Itaú Cultural, 2014), 37.

27. Givaldo Medeiros, "Dialética concretista: o percurso de Waldemar Cordeiro," *Revista do IEB,* no. 45 (September 2007): 63–86.

28. Waldemar Cordeiro, "Vaca na paisagem," in Cordeiro, *Waldemar Cordeiro,* 99, with modification.

29. Cordeiro wrote art criticism for *Folha da Manhã* (São Paulo) from 1948 to 1952. Pedrosa wrote for a succession of newspapers: *Correio da Manhã* (Rio, 1943–51), *Tribuna da Imprensa* (Rio, 1951–54), and *Jornal do Brasil* (Rio, 1957).

30. See Almir Mavignier to Geraldo de Barros, January 26, 1953, AGB; Mário Pedrosa, "A Bienal de cá para lá," in Mário Pedrosa, *Textos escolhidos,* ed. Otília Arantes, vol. 1, *Política das artes* (São Paulo: Edusp, 1995), 258; Michel Favre, "Interview of Hermelindo Fiaminghi," in *Geraldo de Barros: isso,* ed. Fabiana de Barros (São Paulo: Edições SESC, 2013), 350.

31. Mário Pedrosa, "Almir Mavignier," in *Almir Mavignier* (São Paulo: MAM-SP, 1951).

32. Mário Pedrosa, "Almir Mavignier," *O Estado de São Paulo,* September 7, 1951, 6.

33. Pedrosa, "Almir Mavignier," in *Almir Mavignier.*

34. Kaira M. Cabañas, "A Strategic Universalist," in Ferreira and Herkenhoff, *Mário Pedrosa,* 26.

35. Waldemar Cordeiro, "Formas que não são formas: a mostra de Almir Mavignier no Museu de Arte Moderna," *Folha da Manhã,* September 26, 1951, 6.

36. Gabriela Suzana Wilder states that Cordeiro had an example of Pedrosa's thesis, but to the best of my knowledge, he did not comment on it or the ideas within, nor has a copy been located in the artist's papers. In contrast, another reviewer of Mavignier's exhibition, possibly Sérgio Milliet (who held a copy of the thesis), noted that Mavignier's works attempted to illustrate concepts in Pedrosa's study of Gestalt theory. Gabriela Suzana Wilder, *Waldemar Cordeiro: pintor vanguardista* (MA thesis, Universidade de São

Paulo, 1982), 294; [Sérgio Milliet?], "Almir Mavignier," *O Estado de São Paulo,* September 16, 1951, 8.

37. Cordeiro, "Formas que não são formas."

38. Cordeiro, "Ainda o abstracionismo."

39. Waldemar Cordeiro, "Arte moderna e naturalismo: os preconceitos artísticos da imitação e do sentido—fundamento e superação da teoria da duplicidade do fato artístico," *Folha da Manhã,* December 9, 1951, 7, in Cordeiro, *Waldemar Cordeiro,* 81, with modification.

40. Waldemar Cordeiro, "Os artistas na vida e na arte: Volpi, o pintor de paredes que traduziu a visualidade popular," *Folha da Manhã,* April 20, 1952, 7; "Os pintores na vida e na arte: Sacilotto, poeta da economia moderna," *Folha da Manhã,* May 11, 1952, 7; "Os artistas na vida e na arte: Milton, boêmio apesar de tudo," *Folha da Manhã,* June 8, 1952, 9; "Os artistas na vide e na arte: Grassmann, o gravador demoníaco," *Folha da Manhã,* July 20, 1952, 5, 7.

41. Cordeiro, "Os pintores na vida e na arte: Sacilotto, poeta da economia moderna," in Cordeiro, *Waldemar Cordeiro,* 161.

42. Ibid.

43. Heloisa Espada and Adrian Anagnost have contributed insightful scholarship on Cordeiro's relation to the Italian postwar context. See Adrian Anagnost, "Internationalism, *Brasilidade,* and Politics: Waldemar Cordeiro and the Search for a Universal Language," *Hemisphere: Visual Cultures of the Americas* III (2010): 23–41; Heloisa Espada, "Waldemar Cordeiro, the Rome Art Club and its Consequences on the Ruptura Manifesto," XIII Brazilian Studies Association Conference, Brown University, April 2, 2016.

44. Max Bill, "Schönheit aus Funktion und als Funktion," *Werk* 36, no. 8 (August 1949): 272–74; "Beleza provinda da função e beleza como função," *Habitat,* no. 2 (January–March 1951): 61–64. On Bill's revision for *Habitat,* see Adele Nelson, "The Bauhaus in Brazil: Pedagogy and Practice," *ARTMargins* 5, no. 2 (June 2016): 34n21.

45. Max Bill, "Beauty from Function and as Function," in Max Bill, *Form, Function, Beauty = Gestalt,* ed. Brett Steele (London: Architectural Association London, 2011), 32.

46. Cordeiro, "Arte moderna e naturalismo," in Cordeiro, *Waldemar Cordeiro,* 79.

47. Mário Pedrosa, "Exposição de artistas brasileiros," *Tribuna da Imprensa,* April 26–27, 1952, 8. Pedrosa had previously made this assertion. See Mário Pedrosa, "A Bienal de São Paulo (V): a representação brasileira," *Tribuna da Imprensa,* December 1–2, 1951, 7.

48. Mário Pedrosa, "Apresentação de Geraldo de Barros" (unpublished manuscript, [1951?]), 1, 4n16, 50, AMP, BN.

49. Pedrosa, "Apresentação de Geraldo de Barros."

50. The AGB holds letters of introduction that Waldemar Cordeiro wrote to Rome-based artists Enrico Prampolini, Pietro Consagra, and Joseph Jarema on January 13, 1951, and that Barros took with him to Europe.

51. Waldemar Cordeiro, "Ponto parágrafo na pintura brasileira," *Folha da Manhã,* January 7, 1951, 5.

52. Cordeiro, "Ponto parágrafo na pintura brasileira," in Cordeiro, *Waldemar Cordeiro,* 142.

53. Ibid.

54. Barros departed for Brazil in 1952 before the opening of the exhibition *Abstractions* in Nantes—which included Barros, Mavignier, and Morellet, among other US, French, and Paris-based expat artists, including Ellsworth Kelly—and the inclusion of his work in the Salon de mai. See *Abstractions* (Nantes, France: Galerie Bourlaouën, 1952), AGB; *Catalogue Salon de Mai* (Paris: Palais de New York, 1952).

55. See, for example, Sérgio Milliet, "Geraldo de Barros," *O Estado de São Paulo,* August 26, 1952, 6.

56. Walter Zanini, "Geraldo de Barros: jovem pesquisador, corpo e alma integrados na formulação da arte viva," *O Tempo,* March 8, 1953, Suplemento Dominical, AGB.

57. Helouise Costa and Renato Rodrigues da Silva, *A fotografia moderna no Brasil* (São Paulo: Cosac Naify, 2004); Heloisa Espada, "Fotoformas: a máquina lúdica de Geraldo de Barros" (MA thesis, Universidade de São Paulo, 2006); Annateresa Fabris, *O desafio do olhar: fotografia e artes visuais no período das vanguardas históricas,* vol. 2 (São Paulo: Martins Fontes, 2013); Barros, *Geraldo de Barros;* Heloisa Espada, ed., *Geraldo de Barros e a fotografia* (São Paulo: IMS; Edições SESC, 2014). Also see Sérgio Pizoli, *Geraldo de Barros: precursor* (Rio: Centro Cultural Banco do Brasil, 1996); Danielle Stewart, "Geraldo de Barros: Photography as Construct," *H-ART,* no. 2 (January–June, 2018): 73–92.

58. Fabris, *O desafio do olhar,* 338–39; Heloisa Espada, "Verdadeira, só a arte concreta," in Espada, *Geraldo de Barros,* 8; Heloisa Espada, "*Fotoformas:* luz e artifício," in Espada, *Geraldo de Barros,* 21, 25–28, 32–33.

59. Correspondence in the AGB recently made available to researchers permits more detailed dating of Barros's departure and return dates to Europe in 1951–52 than previously possible. He arrived in Rio on February 8, 1951, to begin his five-leg journey to Paris (Rio-Recife-Dakar-Lisbon-Paris), which he reached by February 12, 1951. He arrived back in Brazil in approximately mid-January 1952, first to Rio and then to São Paulo. See Geraldo de Barros to Zulmira de Barros, February 8, 1951, AGB; Geraldo de Barros to Zulmira de Barros, February 12, 1951, AGB; Danielle Morellet to Geraldo de Barros, January 16, 1952, AGB; Abraham Palatnik to Geraldo de Barros, February 4, 1952, AGB. The archive also holds several incompletely identified pieces of correspondence, one dated January 3, 1952, and another January 17, 1952, related to Barros working in Rio to get reestablished in his position at the Banco do Brasil. A press interview appeared soon after his return: "Intensa repercussão da Bienal na França: o pintor Geraldo Barros, de regresso de Paris," *Última Hora* (Rio), February 11, 1952, 10.

60. Barros had previously exhibited two prints from the series at the first Bienal, for which he won a prize.

61. *Geraldo de Barros* (São Paulo: MAM-SP, 1952); Paul Klee, "Extracts from the Journal of the Artist," in *Paul Klee*, 3rd ed. (New York: MoMA, 1946), 8.

62. See, for example, Mário Pedrosa to Geraldo de Barros, [July] 1951, AGB.

63. On Matarazzo's efforts to borrow works by Klee for MAM-SP, see chapter 1. On the announced, unrealized exhibition at MASP, see Italo Faldi, "Paul Klee," *Habitat*, no. 3 (April–June 1951): 79.

64. [Wolfgang Pfeiffer], untitled text, in *Geraldo de Barros* (São Paulo: MASP, 1952).

65. Milliet, "Geraldo de Barros."

66. Miguel (sic) Germano [José Geraldo Vieira], "A exposição de Geraldo de Barros," *Folha da Manhã*, August 19, 1952, 6; "Um técnico às voltas com a poesia: visão geral da obra gráfica de Geraldo de Barros," unidentified newspaper, August 1952, AGB.

67. Louis Wiznitzer, "Poderá haver fotografia abstrata?," *A Manhã*, August 10, 1952, Suplemento Letras e Artes, 7, 10.

68. Barros visited Carcassonne in March and July of 1951 and wrote his mother an extended description of the site, saying it transported him to the Middle Ages. Geraldo de Barros to unidentified, March 12, 1951, AGB; Geraldo de Barros to Zulmira de Barros, March 24, 1951, AGB; Geraldo de Barros to Electra Pereira do Valle Delduque (later Electra de Barros), July 21, 1951, AGB; Geraldo de Barros to Zulmira de Barros, July 21, 1951, AGB. The relationship between Carcassonne and the lithograph *City to Conquer* is suggested in the juxtaposition of illustrations of a photograph of the site and the print in Barros, *Geraldo de Barros*, 114–15.

69. Wiznitzer, "Poderá haver fotografia abstrata?"

70. Zanini, "Geraldo de Barros."

71. Radha Abramo, who, along with her husband Cláudio Abramo, lived in the same hotel as Barros in Paris and accompanied him on travels in Europe, has noted Barros's interest in pre-Renaissance space and artworks, an insight confirmed by his correspondence. See Radha Abramo, *Geraldo de Barros: 12 anos de pintura, 1964–1976* (1977), in *Geraldo de Barros*, ed. Rubens Fernandes, Jr., vol. 3, *Collection of Essays on Geraldo de Barros* (São Paulo: Cosac Naify, 2006), 6–7.

72. Submissions for the IV Centenário poster competition were due by June 30, 1952, and the winners were announced on September 10, 1952. See "Concurso de cartazes instituído pela Comissão do IV Centenário," *Correio Paulistano*, April 30, 1952, 13; "Concurso de cartazes," *Diário de São Paulo*, September 11, 1952, AGB.

73. Abramo, *Geraldo de Barros*, 7.

74. Geraldo de Barros to Mário Pedrosa, February 11, 1951, 50, 2, 2n19, AMP, BN; Mário Pedrosa to Geraldo de Barros, c/o Paulo Emílio Salles Gomes, February 20, 1951, AGB.

75. Geraldo de Barros to Joana (Joaninha) Cunha Bueno, September 17, 1951, AGB.

76. Barros's itinerary of his year abroad in Europe was as follows: from February 8 to 12, 1951, he was in transit to Paris, where he remained for a month until he traveled from c. March 10 to 24, 1951 (to Switzerland and Austria). He then briefly returned to Paris before departing for a month-long trip, from c. March 30 to April 24, 1951, to cities in Germany, Austria, and Switzerland. He likely began classes in Paris at the start of May, where he remained until late July (aside from short trips to London and Zurich). From late July through mid-November, he undertook several extended trips interrupted by week-long stays in Paris: first, he traveled to Spain (c. July 21 to August 6, 1951); London and Scotland (c. August 10 to 15, 1951); the Netherlands and Belgium (c. August 29 to September 11, 1951); Italy (c. September 26 to November 14, 1951). He then resided in Paris for close to two months until his departure before January 16, 1952.

77. Barros to Cunha Bueno, September 17, 1951.

78. Ibid.

79. Arantes, "Prefácio," 4.

80. Pedrosa, "Da natureza afetiva da forma na obra de arte," 21.

81. Germano [Vieira], "A exposição de Geraldo de Barros."

82. Ibid.

83. Ibid.

84. Wiznitzer, "Poderá haver fotografia abstrata?." The date of Wiznitzer's interview of Barros does not appear in the article. Wiznitzer, a Europe-based correspondent, writes of interviewing Barros as he prepared to return to Brazil, which would suggest a timing of December 1951 or January 1952.

85. Ibid.

86. Espada, "*Fotoformas:* luz e artifício," 17.

87. In addition to Bill's studio visit to Barros discussed below, Barros helped to install Bill's exhibition at MASP in February 1951, immediately before departing for his year in Europe. He visited Zurich in March and July 1951. According to some accounts he met Bill in person, though, to the best of my knowledge, this proposal is not supported in primary documentation. Michel Favre, "Chronology," in *Geraldo de Barros,* ed. Rubens Fernandes, Jr., vol. 2, *Sobras* (São Paulo: Cosac Naify, 2006), 192; Giovanna Bragaglia, "Cronologia: Geraldo de Barros (1923–1998)," in Espada, *Geraldo de Barros,* 287.

88. The most common dating of the photographs has been from 1946 or 1947 to 1951, with the latest works consisting of the photographs he shot in Europe, and the photograms and cut-negative works tending to bear the date of c. 1949–50. As Espada notes, the dating of the photographs is largely retrospective, completed by the artist beginning in the late 1970s and most comprehensively in the context of a 1994 publication (Espada, "*Fotoformas:* luz e artifício," 34n18; *Fotoformas: Geraldo de Barros, fotografias / photographies* [São Paulo: Raízes, 1994]).

89. Zanini, "Geraldo de Barros."

90. Geraldo de Barros to Mário Pedrosa, [June 12, 1953], AGB. This letter was first published by Heloisa Espada, who dated it to the second half of 1953. The day and month I propose are based on a partially legible postmark on the envelope, as well as the contextual events referred in the letter and the dates of Bill's first visit to São Paulo from June 5 to c. June 11, 1953. See Espada, "*Fotoformas:* luz e artifício," 30–31; "Acha-se desde ontem em São Paulo o conhecido arquiteto suíço Max Bill," *Folha da Manhã,* June 6, 1953, 8; "Max Bill, a arquitetura e outro problemas atuais," *O Estado de São Paulo,* June 11, 1953, 6.

91. Zanini, "Geraldo de Barros."

92. Ibid.

93. Barros to Pedrosa, [June 12, 1953].

94. Barros to Pedrosa, [June 12, 1953]. Emphasis in the original. Espada understands Barros to write "photogravures," not "photograms." Espada, "*Fotoformas:* luz e artifício," 30.

95. Barros to Pedrosa, [June 12, 1953].

96. Geraldo de Barros, "A sala de fotografia," *Boletim Foto-Cine* 8, no. 87 (February–March 1954): 13, in Barros, *Geraldo de Barros,* 338.

97. *Fotoforma n. 13* and *Fotoforma n. 14* were displayed in an exhibition of Brazilian art in Switzerland in 1955 and a photographic salon in Spain in 1954, respectively. See A. Plécy, "Redacteur en Chef, Point de Vue-Images du monde to President, Federação Brasileira de Fotografia," October 6, 1954, AGB; *Le Brésil: arts primitifs et arts modernes* (Neuchâtel, Switzerland: Musée d'Ethnographie, 1955); Isabel Teixeira, *MASP FCCB: Coleção Museu de Arte de São Paulo Foto Cine Clube Bandeirante* (São Paulo: MASP, 2016), 84–85.

98. In the absence of an exhibition or periodical record, Barros's comments to Zanini in March 1953—that abstract photography bridged his Klee-inflected drawings and Concrete painting—and to Pedrosa in June 1953—that he had begun a series of photograms—suggest a dating of 1952–53. Zanini, "Geraldo de Barros;" Barros to Pedrosa, [June 12, 1953].

99. I am grateful to Lee Ann Daffner, Krista Lough, and Erika Mosier, conservators at MoMA, for the suggestion that Barros may have used internegatives. Andres Burbano has revised his initial analysis that the works were created from direct printing from punch cards to note the artist's likely use of translucent or transparent paper. Andres Burbano, "Photo(info)graphy: Geraldo de Barros and the New Media," in Barros, *Geraldo de Barros,* 326; Andres Burbano, "Fotoformas, 1949–1951: Photography and Algorithmic Devices, An Early Interaction," Re-Create: Theories, Methods and Practices of Research-Creation in the Histories of Media Art, Science and Technology, Montreal, November 6, 2015.

100. Barros to Pedrosa, [June 12, 1953].

101. Alexander Alberro, *Abstraction in Reverse: The Reconfigured Spectator in Mid-Twentieth Century Latin American Art* (Chicago: University of Chicago Press, 2017), 21.

102. An installation photograph published by João Bandeira established the inclusion of *Função diagonal* in the Grupo Ruptura exhibition (João Bandeira, *Arte concreta paulista: documentos* [São Paulo: Cosac Naify, 2002], 48). Also see the detailed analysis of the work in Aleca Le Blanc, "The Material of Form: How Concrete Artists Responded to the Second Industrial Revolution in Latin America," in *Making Art Concrete: Works from Argentina and Brazil in the Colección Patricia Phelps de Cisneros,* ed. Aleca Le Blanc (Los Angeles: Getty Publications, 2017), 9–10; Pia Gottschaller, "Making Concrete Art," in Le Blanc, *Making Art Concrete,* 41–42.

103. The related works are a near-identical painting from 1953 in the collection of Ricardo and Susana Steinbruch and two drawings, one illustrated by Zanini and the other held by AGB. The panel, planned for the Edifício Siriuba in São Paulo designed by architect Oswaldo Bratke, was not realized. See Zanini, "Geraldo de Barros"; Geraldo de Barros to Erico Stickel, n.d., AGB.

104. While this photograph is not held by the AHWS, object views of Barros's exhibited paintings, photographic documentation of the design of the partition walls and labels, and textual documentation of the works that Barros submitted to the exhibition, as well as published installation view of the photography section of the Bienal showing Barros and his wife in identical outfits, confirm that the view is of the second Bienal. Espada has commented on the conflicting identification of a closely related installation view (first published by Aracy Amaral) and argues for it being from the Grupo Ruptura exhibition. See Aracy A. Amaral, ed., *Projeto construtivo brasileiro na arte (1950–1962)* (Rio: MAM Rio; São Paulo: Pinacoteca, 1977), 99; Espada, "Fotoformas: a máquina lúdica de Geraldo de Barros," 8–10; Barros, "A sala de fotografia," 14.

105. The titles appeared with works by Barros and Cordeiro in the following exhibitions: *Exposição do Grupo Ruptura* (São Paulo: MAM-SP, 1952); *II Salão paulista de arte moderna* (São Paulo: Salão do Antigo Trianon, 1952); *II Salão nacional de arte moderna: catálogo* (Rio: MES, 1953). Cordeiro withdrew the 1953 paintings that he submitted to the second Bienal, but they were titled *Ideia-objeto.*

106. Geraldo de Barros, Ficha de identidade do artista, April 26, 1953, box 02/17, folder 4, 02 Bienal de São Paulo (hereafter 02BSP), MAM, AHWS; Geraldo de Barros, Fichas de inscrição de obra apresentada, April 28, 1953, box 02/18, folder 2, 02BSP, MAM, AHWS. In the original inscription forms with the *Forma-objeto* titles, the dates of the painting are given as March and April 1953. In the revised forms with the titles that appear in the catalogue, the dates are given as 1953 with no indication of month.

107. Artists submitted inscription forms by May 1, 1953, but the works were not physically delivered to the museums of modern art in Rio and São Paulo until August 30, 1953 for consideration by the selection jury during the months of September and October.

108. Irene V. Small, *Hélio Oiticica: Folding the Frame* (Chicago: University of Chicago Press, 2016), 31.

109. Ibid., 24, 32.

110. Jayme Maurício, "Ivan Serpa, concreto feliz entre as crianças," *Correio da Manhã,* August 2, 1953, 11.

111. *Ivan Serpa: exposição de pinturas e desenhos* (Rio: IBEU, 1951); *Ivan Serpa: Collage and Painting* (Washington, DC: Pan American Union, 1954). In the 1950s, Serpa participated in the twenty-sixth and twenty-seventh Venice Biennales in 1952 and 1954, as well as the first through fourth São Paulo Bienals (1951–57).

112. Pedrosa noted Serpa's interest in Taeuber-Arp, though he suggested that the artist first encountered her work at the first Bienal. See Mário Pedrosa, "Ivan Serpa expõe em Washington, E.U.A," *Forma,* no. 3 (October 1954); Mário Pedrosa, "Ivan Serpa, pintor brasileño," *Ver y Estimar* 2, no. 8 (June 1955): 3.

113. Serpa held the catalogue of the Rio exhibition. *Catálogo da exposição de pintura e escultura sob os auspícios do Ministério de Educação e Saúde* (Rio: Edifício da SulAmérica Terrestres, Marítimos e Acidentes, 1949), AIS. This archive, which I accessed with the artist's family in Rio, is now held by the Instituto de Arte Contemporânea in São Paulo.

114. "Abstracionismo e Ripolin na casa de Serpa," *Correio da Manhã,* July 12, 1952, 7; Giulia Villela Giovani, Maria Alice Honório Sanna Castello Branco, Alessandra Rosado, and Luiz Antonio Cruz Souza, "Ivan Serpa: colores, materiales y técnicas," in *18a Jornada de Conservación de Arte Contemporáneo* (Madrid: Museo Nacional Centro de Arte Reina Sofía, 2017), 255–62.

115. *Collage a compressão* appeared in his checklist of the 1954 Washington, DC exhibition. Ivan Serpa notebook, c. 1954–c. 1964, AIS. For the Venice Biennale in 1954, he used the related *Collage a pressione* (Pressure Collage). Serpa also used *Colagem* (Collage) and *Construção* (Construction).

116. "Exposição de Ivam Serpa e pintura de crianças nos EE.UU.," *Correio da Manhã,* June 5, 1954, 11.

117. Pedrosa, "Ivan Serpa expõe em Washington, E.U.A."; Pedrosa, "Ivan Serpa, pintor brasileño"; Mário Pedrosa, "As colagens de Ivan Serpa," *Jornal do Brasil,* June 25, 1957, 8.

118. Pedrosa, "Ivan Serpa expõe em Washington, E.U.A."

119. Ibid.

120. Serpa also saw the collages as relating to the experience of film. See Ivan Serpa, "Note on *Construção 75* (1955)," Ivan Serpa notebook, c. 1954–c. 1964, AIS.

121. Luiz Camillo Osorio, ed., *Abraham Palatnik* (São Paulo: Cosac Naify, 2004).

CHAPTER 3. NATIONAL CULTURE AND ABSTRACTION AT THE FIRST SÃO PAULO BIENAL

1. Zeuler R.M.A. Lima and Vera M. Pallamin, "An Uncommon Common Space," in *Encountering Urban Places: Visual and Material Performances in the City,* ed. Lars Frers and Lars Meier (Aldershot, UK: Ashgate, 2007), 81–96.

2. Hélio Herbst, *Pelos salões das Bienais, a arquitetura ausente dos manuais: contribuições para a historiografia brasileira (1951–1959)* (São Paulo: Annablume; Fapesp, 2011), 122–23.

3. Robert Stam, *Tropical Multiculturalism: A Comparative History of Race in Brazilian Cinema and Culture* (Durham, NC: Duke University Press, 1997), 135.

4. Andrea Giunta, *Avant-Garde, Internationalism, and Politics: Argentine Art in the Sixties* (Durham, NC: Duke University Press, 2007), 9.

5. Perry Anderson, "Internationalism: A Breviary," *New Left Review* 14 (March–April 2002): 5.

6. Barbara Weinstein, *The Color of Modernity: São Paulo and the Making of Race and Nation in Brazil* (Durham, NC: Duke University Press, 2015), 9.

7. João Batista Vilanova Artigas, "A Bienal é contra os artistas brasileiros," *Fundamentos: Revista de Cultura Moderna* 4, no. 23 (December 1951): 10–12.

8. In her seminal account of the debates surrounding the first Bienal, first published in 1984, Amaral persuasively identifies Artigas as an agitator for the protests of the Bienal. However, she incorrectly dates Artigas's article in *Fundamentos* to September 1951 and argues that it, along with essays by critic Fernando Pedreira in *Fundamentos,* created the environment for the protest of the Bienal at the Clube dos Artistas e Amigos da Arte in November 1951. Artigas's *Fundamentos* article followed the meeting at the club, though he did participate in the earlier activism against the Bienal with an essay in the periodical *Hoje*. See João Batista Vilanova Artigas, "A 'Bienal' expressão da decadência burguesa," *Hoje,* August 12, 1951, quoted in Leonor Amarante, *As Bienais de São Paulo, 1951 a 1987* (São Paulo: Projeto, 1989), 16–17, 390; Aracy A. Amaral, *Arte para quê? A preocupação social na arte brasileira, 1930–1970,* 3rd ed. (São Paulo: Studio Nobel, 2003), 248.

9. Amaral, *Arte para quê?,* 245. Building on Amaral's study, historians have focused on the opposing positions of Artigas and Pedrosa to narrate the ideological debate about the Bienal. See Amarante, *As Bienais de São Paulo,* 16–17; Francisco Alambert and Polyana Canhête, *As Bienais de São Paulo: da era do museu à era dos curadores (1951–2001)* (São Paulo: Boitempo, 2004), 43–48; Michael Asbury, "The Bienal de São Paulo: Between Nationalism and Internationalism," in *Espaço aberto/Espaço fechado: Sites for Sculpture in Modern Brazil,* ed. Stephen Feeke and Penelope Curtis (Leeds: Henry Moore Institute, 2006), 74–75.

10. Amaral, *Arte para quê?,* 245–61.

11. Correspondence between the administrations of the Venice Biennale, MAM-SP, and MASP in ASAC indicates that MAM-SP had been designated to organize the Brazilian representation by January 1950, but the first announcement of the museum's organization of the representation which I have located dates to April 1950. See folder Brasile 1950, box 5 Brasile, FS, ASAC; "Para a 25ª exposição Bienal de Veneza," *O Estado de São Paulo,* April 4, 1950, 7.

12. The meeting in protest of the Venice Biennale was held on April 3, 1950; see "XXV Bienal de Veneza: protesto dos artistas," unidentified newspaper, [by April 11, 1950], CDWC, fig. 5–20.

13. Paulo Mendes de Almeida, *De Anita ao museu* (São Paulo: Editora Perspectiva, 1976). The title refers to Anita Malfatti and MAM-SP, and the book compiles articles published in *O Estado de São Paulo* from 1958 to 1963.

14. Mário de Andrade, "Fazer a história" (1944), quoted in Almeida, *De Anita ao museu*, 9.

15. Ibiapaba Martins, "O sôro da esterilidade," *Fundamentos* 4, no. 23 (December 1951): 8–9.

16. "XXV Bienal de Veneza."

17. "XXV Bienal de Veneza"; "Os artistas plásticos e a Bienal de Veneza," unidentified newspaper, [April 1950], CDWC, fig. 5–19. By contrast, Milton Dacosta and Alfredo Volpi, who signed the protest statement, participated in the exhibition.

18. "A exposição Bienal de Veneza," *O Estado de São Paulo,* April 23, 1950, 6; "A 'Bienale,'" *O Estado de São Paulo,* June 6, 1950, 7. Organizers of the Venice Biennale had asked Matarazzo to send a representation composed of three solo exhibitions of prominent artists and there was discussion of displays dedicated to Di Cavalcanti, Portinari, and Segall. However, Matarazzo—and likely others at MAM-SP—ultimately decided to send a larger group exhibition. See Giovanni Ponti to Francisco Matarrazo Sobrinho, January 7, 1950, folder Brasile 1950, box 5 Brasile, FS, ASAC; Francisco Matarrazo Sobrinho to Giovanni Ponti, February 9, 1950, folder Brasile 1950, box 5 Brasile, FS, ASAC; Rodolfo Pallucchini to Francisco Matarrazo Sobrinho, March 25, 1950, folder Brasile 1950, box 5 Brasile, FS, ASAC.

19. Zeuler R.M.A. Lima, *Lina Bo Bardi* (New Haven, CT: Yale University Press, 2013), 47. Like MASP and MAM-SP, Habitat Editora was located in the headquarters of Chateaubriand's media company, Diários Associados, in downtown São Paulo.

20. Alencastro, "Crônicas," *Habitat: Revista das Artes no Brasil,* no. 1 (October–December 1950): 92. Silvana Rubino and Zeuler R.M.A. Lima state that the *crônicas* section, attributed to "Alencastro," was compiled by Bardi and Bo Bardi and, according to Lima, brought together anonymous comments by themselves and others. Silvana Rubino, "Introdução: a escrita de uma arquitetura," in *Lina por escrito: textos escolhidos de Lina Bo Bardi, 1943–1991,* ed. Silvana Rubino and Marina Grinover (São Paulo: Cosac Naify, 2009), 36; Zeuler R.M.A. Lima, "Nelson A. Rockefeller and Art Patronage in Brazil after World War II: Assis Chateaubriand, the Museu de Arte de São Paulo (MASP) and the Museu de Arte Moderna (MAM)," *Rockefeller Archive Center Research Reports Online* (2010): 18, www.rockarch.org/publications/resrep/lima.php, accessed March 11, 2011.

21. "A representação brasileira na 'XXV Biennale' de Veneza," press release, February 3, 1951, folder 012/103, box 7, MAM-SP, Arq. MAC USP. I have not located Bardi's text in *A Época* referenced by Matarazzo in his correspondence (Francisco Matarrazo Sobrinho to Ciro Mendes, December 29, 1950, box 10, MAM-SP, MAM, AHWS; Francisco Matarrazo Sobrinho to Sérgio Milliet, January 2, [1951], box 10, MAM-SP, MAM, AHWS).

22. Antonio Bento, "Os brasileiros na Bienal," *Diário Carioca,* January 17, 1951, 6.

23. Tomás Santa Rosa, "A Bienal de Veneza e coisas do Brasil," *A Manhã,* January 21, 1951, Suplemento Letras e Artes, 8.

24. Ibid.

25. Letter from Pietro Maria Bardi to Tomás Santa Rosa, in Alencastro, "Crônicas," *Habitat,* no. 2 (January–March 1951): 96.

26. "Northeastern Pottery," *Habitat,* no. 2 (January–March 1951): 72, trans. in the issue's front matter.

27. This argument is indebted to architect Paulo Tavares's installation work *Des-Habitat* (2008), composed in part of altered facsimiles of *Habitat* and drawing attention to the decontextualization of indigenous references and popular material and visual culture in a modernist, aesthetic framing.

28. Maria Arminda do Nascimento Arruda, "Empreendedores culturais imigrantes em São Paulo de 1950," *Tempo Social: Revista de Sociologia da USP* 17, no. 1 (June 2005): 138. Arruda and Jeffrey Lesser differ on the scale of European and non-European immigration in the 1950s; see Jeffrey Lesser, *Negotiating National Identity: Immigrants, Minorities, and the Struggle for Ethnicity in Brazil* (Durham, NC: Duke University Press, 1999), 8, 168–69.

29. Arruda, "Empreendedores culturais imigrantes em São Paulo de 1950," 142. Also see Maria Arminda do Nascimento Arruda, *Metrópole e cultura: São Paulo no meio século XX* (São Paulo: EDUSC, 2001), 331–421.

30. Arruda, "Empreendedores culturais imigrantes em São Paulo de 1950," 142–43; Ernani Silva Bruno, *Almanaque de memória: reminiscências, depoimentos, reflexões* (São Paulo: Hucitec, 1986), 52–53.

31. Arruda, "Empreendedores culturais imigrantes em São Paulo de 1950," 139.

32. Lesser, *Negotiating National Identity,* 3.

33. The vote count occurred on September 4, 1951, and was overseen by representatives of the Sindicato dos Artistas Plásticos de São Paulo and Clube dos Artistas as well as of MAM-SP ("I Bienal de São Paulo: instalado o júri de seleção," *O Estado de São Paulo,* September 4, 1951, 7).

34. The first Bienal selection jury was composed of Santa Rosa, Campofiorito, Clóvis Graciano, and Luís Martins; Matarazzo presided.

35. Lourival Gomes Machado to Sérgio Milliet, March 2, 1951, folder 8, box 1/09, 01 Bienal de São Paulo (hereafter 01BSP), MAM, AHWS.

36. "Protestam os artistas plásticos contra a cessão do Trianon à I Bienal de Arte," *Jornal de Notícias,* November 9, 1951, 12.

37. Artigas, "A Bienal é contra os artistas brasileiros," 10–12.

38. Fernando Pedreira, "A Bienal—impostura cosmopolita," *Fundamentos* 4, no. 21 (August 1951): 14–15.

39. Rita Alves Oliveira, "Bienal de São Paulo: impacto na cultura brasileira," *São Paulo em Perspectiva* 15, no. 3 (2001): 18–28.

40. Ibid., 18. Oliveira also states that union activists and political militants protested outside the Bienal at the inauguration. I have not found coverage of this protest.

41. Aydano do Couto Ferraz, "A Bienal—propaganda: ideológica do imperialismo," *Voz Operária,* August 25, 1951, 3; Pedreira, "A Bienal—impostura cosmopolita," 15. Also see "A Bienal da IBEC," *Hoje,* August 15, 1951, Hemeroteca 01 Bienal de São Paulo, AHWS.

42. Fernando Pedreira, "A Bienal e seus defensores," *Fundamentos* 4, no. 22 (September 1951): 12–13.

43. J.E. Fernandes, "Dois documentos, duas culturas," *Fundamentos* 4, no. 21 (August 1951): 3–6.

44. Hideo Onaga, "Tumulto no Clube dos Artistas por causa do abstracionismo," *Folha da Noite,* November 27, 1951, 1, 3. For an insightful analysis of the press coverage of the Clube dos Artistas meeting, see Amaral, *Arte para quê?,* 255–58.

45. Onaga, "Tumulto no Clube dos Artistas por causa do abstracionismo."

46. Ibiapaba Martins, "Cadeiradas e trocadilhos no Clube dos Artistas: agitados e exaltados os debates sobre a primeira Bienal," *Correio Paulistano,* November 29, 1951, 8.

47. "Mesa redonda de artistas para apreciar a I Bienal," *A Época,* November 14, 1951, CDWC, fig. 1–39.

48. Bardi's collaborators at IAC included Vilanova Artigas, Bo Bardi, Kneese de Mello, Levi, Ruchti, and Segall, all of whom met on March 20, 1950 to discuss the school's curriculum. The archival holdings at CP, MASP only record Bardi's role in establishing the school, but scholars, former participants, and contemporary accounts view Bo Bardi as Bardi's co-director. See, for example, Lima, *Lina Bo Bardi,* 47.

49. The first purchases related to the creation of the school began in March 1952 ("Relação do material para 'Oficina de gravura," n.d, Escola de artesananto, MAM, AHWS).

50. Quirino da Silva, "Mais uma escola," *Diário da Noite* (São Paulo), April 30, 1952, 4; Nelson Nóbrega, *Escola de artesanato do Museu de Arte Moderna: exposição de trabalhos dos alunos* (São Paulo: MAM-SP, 1953).

51. Though MAM-SP mounted exhibitions dedicated to the school in 1953 and 1956, there was a pause in its functioning in 1954 and an internal effort to convert it into an autonomous entity in 1955. It ultimately closed in 1959. See "Comunicação do Museu de Arte Moderna de São Paulo," *Correio da Manhã*, July 18, 1954, 11; Wolfgang Pfeiffer memo and agreement with Nelson Nóbrega, March 3, 1955, Escola de artesanato, MAM, AHWS. Also see Maria Luisa Luz Tavora, "O campo artístico da gravura em São Paulo: ensino, produção e circulação, 1950/70," in *Anais do XXXVII Colóquio do Comitê Brasileiro de História da Arte: história da arte em transe* (Salvador, 2017), 397–99, accessed

February 8, 2021, www.cbha.art.br/coloquios/2017/anais/pdfs/Maria%20Luisa%20Luz %20Tavora.pdf.

52. Recent scholarship offers starkly divergent interpretations of the early history of MASP; see Adrian Anagnost, "Limitless Museum: P.M. Bardi's Aesthetic Reeducation," *Modernism/Modernity* 26, no. 4 (November 2019): 687–725; Tómas Toledo, "Lina Bo Bardi's Popular Museums," in *Habitat: Lina Bo Bardi,* ed. Adriano Pedrosa (São Paulo: MASP, 2020), 122–35.

53. Ethel Leon, "The Instituto de Arte Contemporânea: The First Brazilian Design School, 1951–53," Design Issues 27, no. 2 (Spring 2011): 116–19. See also Ethel Leon, *IAC: primeira escola de design do Brasil* (São Paulo: Blücher, 2014).

54. Jacob Ruchti, "Instituto de Arte Contemporânea," *Habitat,* no. 3 (April–June 1951): 62; Pietro Maria Bardi, "Diseño industrial en São Paulo," *Nueva Visión: Revista de Cultura Visual,* no. 1 (December 1951): 9. On Ruchti's trip, see Marlene Milan Acayaba, *Branco e preto: uma história de design brasileiro nos anos 50* (São Paulo: Instituto Lina Bo e P.M. Bardi, 1994), 34.

55. See, for example, "No Museu de Arte: instalação do 'Instituto de Arte Contemporânea,' o belo a serviço da indústria—Fundamentos no desenho," *Diário da Noite* (São Paulo), February 8, 1950, folder 1, box 1, IAC, CP, MASP; Ruchti, "Instituto de Arte Contemporânea," 62.

56. Bardi wrote, in English, to directors and registrars at Black Mountain College, Cranbrook Academy of Art, and Rhode Island School of Design, as well as at the Akron Art Institute (now Akron Art Museum) and the Toledo Museum of Art. Although Bardi's correspondence to Serge Chermayeff, Director of the Illinois Institute of Technology—where, since 1949, the Institute of Design had been based—is not preserved in the archive, Chermayeff's reply is, in which he shared information on the institute's curriculum and recommended books. See Pietro Maria Bardi to Director, Cranbrook Academy of Art, March 10, 1950, folder 1, box 1, IAC, CP, MASP; Serge Chermayeff to P.M. Bardi, March 13, 1950, folder 1, box 1, IAC, CP, MASP.

57. The archival holdings at MASP include no mention of HfG in Bill's and Bardi's copious correspondence regarding Bill's 1951 exhibition, though Bardi did write to others of his desire for Bill and other international figures to teach at IAC.

58. On the Bauhaus preliminary course, see Rainer K. Wick, *Teaching at the Bauhaus* (Ostfildern, Germany: Hatje Cantz, 2000); Leah Dickerman, "Bauhaus Fundaments," in *Bauhaus, 1919–1933: Workshops for Modernity,* ed. Bergdoll and Dickerman (New York: MoMA, 2009), 15–18; Hal Foster, "Exercises for Color Theory Courses," in Bergdoll and Dickerman, *Bauhaus, 1919–1933,* 196–99.

59. For further analysis of IAC's curriculum, see Adele Nelson, "The Bauhaus in Brazil: Pedagogy and Practice," *ARTMargins* 5, no. 2 (June 2016): 27–49.

60. Maluf attended IAC from its opening in March 1951 until at least June 1951. "Cursos regulares do Instituto de Arte Contemporânea, Museu de Arte," attendance book, folder 2, box 1, IAC, CP, MASP.

61. The gouache, entitled *Equação dos desenvolvimentos em progressões crescentes e decrescentes* (Equation of Developments in Ascendant and Descendant Progressions), dates to March 1951, when Maluf was enrolled in Ruchti's class. Leon has published notes from this class, which replicate a diagram and cite ideas in Kandinsky's 1926 Bauhaus book, *Punkt und Linie zu Fläche,* a book held in the CP, MASP. See Vasily Kandinsky, *Punkt und Linie zu Fläche: Beitrag zur Analyse der Malerischen Elemente* (Munich: A. Langen, 1926); Jacob Ruchti, *Composição: notas de aula* (São Paulo: IAC, 1951), in Ethel Leon, "IAC, Instituto de Arte Contemporânea: escola de desenho industrial do MASP (1951–1953)" (MA thesis, Universidade de São Paulo, 2006), appendix 5, 205–25; Regina Teixeira de Barros, ed., *Antonio Maluf* (São Paulo: Centro Universitário Maria Antônia da Universidade de São Paulo, 2002), 12.

62. Scholars have not previously suggested that Albers or his series *Graphic Tectonic* were a reference for Maluf's poster design, though the series was widely reproduced at the time and the formal parallels are evident. It is possible that Bill's poster for the 1948 exhibition *Josef Albers, Hans Arp, Max Bill* at Galerie Herbert Hermann in Stuttgart, which illustrates Albers's *Introitus (Dedication)*, was among the posters and books displayed in the 1951 MASP exhibition; see Max Bill, "Constatations concernant la participation de Max Bill à la 'Bienal de São Paulo,'" August 2, 1951, folder 13, box 3, Exp. Bill, CP, MASP. Late in his life, Maluf related his poster design to Albers by casting the poster as a predecessor to Albers's *Homage to the Square* series (1949–1976); see Antonio Maluf to Adolpho Leirner, November 23, 1998, folder 2005.1016, Antonio Maluf Files, ALA, MFAH.

63. Vasily Kandinsky, *Point and Line to Plane* (1926), trans. Howard Dearstyne and Hilla Rebay (New York: Solomon R. Guggenheim Foundation, 1947), 62, 65.

64. "Ata de reunião do júri de premiação do concurso de cartazes da primeira Bienal no Museu de Arte Moderna de São Paulo," June 23, 1951, Box 1/28, 01BSP, MAM, AHWS. The poster competition jury was composed of three figures close to MAM-SP: Levi, elected by the designers and artists who submitted to the competition; Pedrosa, selected by Machado; and printmaker Lívio Abramo, selected by Matarazzo.

65. The approximately ninety submitted posters were exhibited at MAM-SP in June 1951 and the jury deliberated between June 21–23, 1951. See "Ata de reunião do juri de premiação do concurso de cartazes da primeira Bienal no Museu de Arte Moderna de São Paulo"; "Cartazes da I Bienal do Museu de Arte Moderna," *Folha da Manhã,* July 11, 1951, 6.

66. Maluf executed the revised poster design in gouache on paper, a layout that was approved by the jury on July 20, 1951. The drawing, which is signed and dated on the verso by two of the jurors and Pedrosa in absentia, is now in the Pinacoteca collection.

67. Lourival Gomes Machado, "Introdução," in *I Bienal do Museu de Arte Moderna de São Paulo: catálogo* (São Paulo: MAM-SP, 1951), 14.

68. Ernesto Simões Filho, quoted in Antonio Bento, "Inaugurada a 1ª Bienal de Arte," *Diário Carioca,* October 21, 1951, 6.

69. The photographic record of the special exhibition from AHWS and press coverage does not document some galleries. However, a floor plan of the ground floor by Jacob Ruchti, the exhibition designer for the first Bienal, provides the scale and sequence of the galleries dedicated to each of the invited artists. Jacob Ruchti, "I Bienal do Museu de Arte Moderna de São Paulo, distribuição dos painéis: Europa, América do Sul," floor plan, September 15, 1951, AHWS (see ill. p. 268).

70. Machado, "Introdução," 14–23.

71. Tadeu Chiarelli, "Art in São Paulo and the Modernist Segment of the Collection," in *Coleção Nemirovsky,* ed. Maria Alice Milliet (São Paulo: MAM-SP, 2003), 81–90. Michael Asbury notes the dichotomy between the attention to new abstract and established modern art at the first Bienal, but attributes it to ambivalence. Asbury, "The Bienal de São Paulo," 73–83.

72. The book series "Artistas brasileiros contemporâneos," which ran from 1953 to 1955, was directed by Milliet, and included volumes on Abramo, Amaral, and Di Cavalcanti. Planned books on Brecheret, Alberto da Veiga Guignard, Malfatti, Portinari, José Pancetti, Segall, and Alfredo Volpi were not realized.

73. In 1952, the inaugural year of the series, five publications focused on visual art. Pedrosa's book is analyzed in chapter 2.

74. Waldemar Cordeiro, "Tarsila do Amaral," *Folha da Manhã,* December 31, 1950, 4, in *Waldemar Cordeiro: fantasia exata,* ed. Analívia Cordeiro (São Paulo: Itaú Cultural, 2014), 46–47, with modification.

75. Sérgio Milliet, *Diário crítico,* vol. 7, *julho 1949–dezembro 1950* (São Paulo: Livraria Martins, 1953), 370.

76. Machado, "Introdução," 17–18.

77. For an insightful analysis of social realism, see Alejandro Anreus, Diana L. Linden, and Jonathan Weinberg, eds., *The Social and the Real: Political Art of the 1930s in the Western Hemisphere* (University Park: Pennsylvania State University Press, 2006).

78. "Brazil's Cavalcanti," *Time,* November 12, 1951, 76.

79. Serafim, "O repórter na Bienal," *Habitat,* no. 5 (October–December 1951): 7.

80. For an account of the mid-century reception and production of Malfatti, see Marta Rosseti Batista, *Anita Malfatti no tempo e no espaço,* vol. 1, *Biografia e estudo da obra* (São Paulo: Edusp, 2006), 442, 448–53.

81. The lecture was held on October 25, 1951 ("A chegada da arte moderna ao Brasil," *O Estado de São Paulo,* October 23, 1951, 6).

82. Mário Pedrosa, "A Bienal de São Paulo (IV): A representação brasileira," *Tribuna da Imprensa,* December 1–2, 1951, 7.

83. Paul A. Schroeder Rodríguez, *Latin American Cinema: A Comparative History* (Berkeley: University of California Press, 2016), 149.

84. Annateresa Fabris, *Cândido Portinari* (São Paulo: Edusp, 1996), 124, 129. On criticism of Portinari at the first Bienal, see Antonio Bento, "Surpresas da Bienal de São Paulo," *Diário Carioca,* October 27, 1951, 6; Serafim, "O repórter na Bienal," 4; Pedrosa, "A Bienal de São Paulo (IV)."

85. This analysis builds on the interpretation of Barreto and Portinari in Durval Muniz de Albuquerque Jr., *The Invention of the Brazilian Northeast* (Durham, NC: Duke University Press, 2014), 149–50, 180–84, 196–97.

86. The biennial catalogue also matter-of-factly visualized this gambit for equality, juxtaposing on a page spread the names of nineteen foreign countries represented at the Bienal with the names of the invited Brazilian artists.

87. Antonio Bento, "A Bienal de S. Paulo," *Diário Carioca,* June 15, 1951, 6; "Regulamentos" in *I Bienal do Museu de Arte Moderna de São Paulo,* 24, 26–27.

88. Ariel Jiménez, "The Challenge of the Times, 1949–1974," in *Alfredo Boulton and His Contemporaries: Critical Dialogues in Venezuelan Art, 1912–1974,* ed. Ariel Jiménez (New York: MoMA, 2008), 162.

89. Mário Pedrosa, "Os prêmios políticos do Salão Moderno," *Tribuna da Imprensa,* November 10–11, 1951, 7; Antonio Bento, "Brasileiros na I Bienal: contradições do júri," *Diário Carioca,* November 4, 1951, 2, 10.

90. Bento, "Surpresas da Bienal de São Paulo"; Antonio Bento, "Queixas contra as decisões da Bienal," *Diário Carioca,* October 28, 1951, 6; Antonio Bento, "Os prêmios da I Bienal paulista," *Diário Carioca,* October 28, 1951, 2, 6; Yvonne Jean, "O júri e os premiados da Bienal de São Paulo," *Correio da Manhã,* October 23, 1951, 8; Serafim, "O repórter na Bienal," 9. Also see Amarante, *As Bienais de São Paulo,* 23–24.

91. See, for example, Bento, "Os prêmios da I Bienal paulista," 2; Jean, "O Júri e os premiados da Bienal de São Paulo"; Serafim, "O repórter na Bienal," 9; "A primeira Bienal de São Paulo V: o primeiro prêmio nacional de pintura," *O Estado de São Paulo,* November 11, 1951, 7.

92. Bento, "Queixas contra as decisões da Bienal."

93. Pedrosa, "A Bienal de São Paulo (IV)."

94. Ibid.; Rubem Braga, "Heitor dos Prazeres: a pintura começa aos 40," *Manchete,* no. 41 (January 31, 1953): 17–19. Quote from the latter source.

95. Pedrosa, "A Bienal de São Paulo (IV)."

96. For insightful analysis of Prazeres's prize, see Bruno Pinheiro, "Modernismos negros na diáspora africana," lecture, Museu de Arte do Rio Grande do Sul, July 16, 2021. On the

racism embedded in the collection of so-called "modern primitives" by MoMA, including a work by Prazeres in 1942, see Charlotte Barat and Darby English, "Blackness at MoMA: A Legacy of Deficit," in *Among Others: Blackness at MoMA*, ed. Darby English and Charlotte Barat (New York: MoMA, 2019), 27.

97. M. Bernandez M., "Na hora H . . . ," *Última Hora* (Rio), October 24, 1951, 2. On *Última Hora*, see Bryan McCann, "Carlos Lacerda: The Rise and Fall of a Middle-Class Populist in 1950s Brazil," *Hispanic American Historical Review* 83, no. 4 (November 2003): 672–74.

98. "Vargas e o pintor," *Última Hora* (Rio), October 30, 1951, 3–4; Francisco de Assis Barbosa, "O sambista-boêmio arrebatou o prêmio de pintura da Bienal de São Paulo," *Última Hora* (Rio), October 31, 1951, 8.

99. María Amalia García, "Max Bill on the Map of Argentine-Brazilian Concrete Art," in *Building on a Construct: The Adolpho Leirner Collection of Brazilian Constructive Art at the Museum of Fine Arts, Houston,* ed. Héctor Olea and Mari Carmen Ramírez (Houston: MFAH, 2009), 61.

100. See, for example, Jean, "O júri e os premiados da Bienal de São Paulo"; "Atribuídos os prêmios da primeira Bienal de arte," *Folha da Manhã,* October 24, 1951, 6; Maria de Lourdes Teixeira, "Unidade tripartida" *Folha da Manhã,* December 2, 1951, 9.

101. Matarazzo asked the winners of official prizes to donate the awarded work to the collection of MAM-SP. In Bill's case, the museum offered to compensate him for the material costs of the sculpture, an offer that seems to have been accepted. Francisco Matarazzo Sobrinho to Max Bill, December 28, 1951, box 1/07, 01BSP, MAM, AHWS.

102. Beverly Adams, "Locating the International: Art of Brazil and Argentina in the 1950s and 1960s" (PhD diss., University of Texas at Austin, 2000), 57–58, drawing on the analysis of Frederico Morais, *Artes plásticas na América Latina: do transe ao transitório* (Rio: Civilização Brasileira, 1979), 78–91.

103. Max Bill, "The Mathematical Approach in Contemporary Art" (1949), in Tomás Maldonado, *Max Bill* (Buenos Aires: Editorial Nueva Visión, 1955), 37.

104. The placement of Bill's sculpture at the threshold of the basement is documented in a photograph held by AHWS and in 16 mm film footage (7:37 minutes) held by CB. The film footage from November 3, 1951, was recorded under the auspices of the *Jornal Imagens do Dia* program and composed of extended shots of the prize-winning artworks. Based on Ruchti's floor plan of the ground floor (see ills. pp. 268, 334), we know representations of Austria, Bolivia, Canada, Cuba, Dominican Republic, Haiti, Japan, and Panama appeared in the basement. Ruchti, "I Bienal do Museu de Arte Moderna de São Paulo."

105. Swiss officials had declined the suggestion by MAM-SP that Bill be included in the representation, but Keller discusses Bill's importance, nevertheless (Heinz Keller, "Suiça," in *I Bienal do Museu de Arte Moderna de São Paulo,* 122–23). For an analysis of the Swiss representation that emphasizes its heterogeneity, see Heloisa Espada, "Além da ordem e da razão: a participação suíça na 1ª Bienal do Museu de Arte Moderna de São Paulo,"

MODOS: Revista de História de Arte 5, no. 1 (January-April 2021): 179–91, accessed March 1, 2021, https://periodicos.sbu.unicamp.br/ojs/index.php/mod/article/view/8664232.

106. To the best of my knowledge of the archival records at AHWS and press coverage, it does not appear that Keller or a Swiss representative traveled to São Paulo to install the exhibition.

107. There is very limited installation photography and film footage of the basement displays, but in object photographs (newly available to researchers at AHWS), portions of adjacent works are visible and provide details about Machado's arrangement.

108. García, "Max Bill on the Map of Argentine-Brazilian Concrete Art," 53.

109. Palatnik's kinetic work is no longer extant. For Palatnik's black and white photographs of the work, see Luiz Camillo Osorio, ed., *Abraham Palatnik* (São Paulo: Cosac Naify, 2004), 134–43, 165.

110. Mário Pedrosa, "A primeira Bienal (I)," *Tribuna da Imprensa,* October 23, 1951, 7; "Itinerário da primeira Bienal VIII, Suíça," *O Estado de São Paulo,* December 28, 1951, 4; Jorge Romero Brest, "Primera Bienal de San Pablo," *Ver y Estimar* 8, no. 26 (November 1951): 13–14, 35–39.

111. On the acquisition of Bill's work, see n101 above. On the acquisition of Lohse's and Taeuber-Arp's works, see Secretaria I Bienal to Horacio Costa, Metalúrgica Brasileira, January 30, 1952, folder correspondência geral, box 1/14, 01BSP, MAM, AHWS; Arturo Profili to Lauro Salazar, Banco Moreira Salles, March 25, 1952, folder compra e venda, lista de obras adquiridas, box 1/17, 01BSP, MAM, AHWS.

112. Serafim, "O repórter na Bienal," 13. Silvana Rubino has suggested that Serafim, like Alencastro, was a pseudonym for the Bardis. I agree that Serafim is likely a pseudonym, but the review occasionally strikes an anti-abstraction tone that is out of sync with the exhibition program of the Bardis at MASP. The Bardis temper the negative review with an unsigned first-page editorial, commending the Bienal and calling for its continuation despite its flaws. See "Bienal," *Habitat,* no. 5 (October–December 1951): 1; Silvana Rubino, "Rotas de modernidade: trajetória, campo e história na atuação de Lina Bo Bardi, 1947–1968" (PhD diss., Universidade Estadual de Campinas, 2002), 127.

113. Sérgio Milliet, "Últimos livros: à margem da 1ª Bienal," *O Estado de São Paulo,* October 23, 1951, 6.

114. Murilo Mendes, "Perspectivas de uma exposição," *Diário Carioca,* November 11, 1951, 10.

115. See, for example, Serafim, "O repórter na Bienal," 7.

116. Walter Zanini, ed., *História geral da arte no Brasil,* vol. 2 (São Paulo: Instituto Walther Moreira Salles, 1983), 602, 1023.

117. "Convite ao surrealismo," *Manchete,* no. 22 (September 20, 1952): 21.

118. Serafim, "O repórter na Bienal," 6.

119. Ibid, 2. *O Estado de São Paulo* also criticized the lack of an educational orientation. See "A Bienal e outras exposições," *O Estado de São Paulo,* December 9, 1951, 8.

120. Serafim, "O repórter na Bienal," 6. The reviewer may have been reacting in part to photographs of women posed with the Bill sculpture, examples of which are held at the APESP.

121. "A primeira exposição Bienal de São Paulo II," *O Estado de São Paulo,* October 18, 1951, 7; "I exposição Bienal de arte," *O Estado de São Paulo,* October 20, 1951, 6.

122. José Tavares Sobrinho, "Cem mil pessoas visitaram a I Bienal," *Folha da Noite,* December 24, 1951, 3.

123. On the experience of internal migrants to São Paulo, see Paulo Fontes, *Migration and the Making of Industrial São Paulo* (Durham, NC: Duke University Press, 2016), 37–47.

124. The 16mm film footage (2:27 minutes) is held by CB and was shot on October 24, 1951, under the auspices of the *Jornal Imagens do Dia* program.

CHAPTER 4. COLLECTIVE, CONCRETE ABSTRACTIONS

1. María Amalia García, *El arte abstracto: intercambios culturales entre Argentina y Brasil* (Buenos Aires: Siglo Veintiuno Editores, 2011), 154–56; Alexander Alberro, *Abstraction in Reverse: The Reconfigured Spectator in Mid-Twentieth-Century Latin American Art* (Chicago: University of Chicago Press, 2017), 180. Though it is assumed based on Cordeiro's participation in the Italian Communist Party that he was exposed to Gramsci's writing before his move to Brazil in 1946, to the best of my knowledge, Cordeiro's first published reference to the thinker occurred in 1956. See conclusion on Cordeiro's use of Gramsci in the mid-1950s. Also see Waldemar Cordeiro, "O objeto," *AD: Arquitetura e Decoração* 20 (December 1956); Givaldo Medeiros, "Dialética concretista: o percurso de Waldemar Cordeiro," *Revista do IEB,* no. 45 (September 2007): 66; Adrian Anagnost, "Internationalism, *Brasilidade,* and Politics: Waldemar Cordeiro and the Search for a Universal Language," *Hemisphere: Visual Cultures of the Americas* 3, no. 1 (2010): 29–34.

2. In the late 1940s and 1950s, *Folha da Manhã* was a middle-brow, wide-circulation paper that had shed its earlier Trotskyist orientation to become an "independent" paper without a distinctive political affiliation. "Summary of Brazilian Press Reaction to the U.S. Representation at the II Bienal do Museu de Arte Moderna, São Paulo," October 1, 1956, IC/IP I.A.367, MoMA Archives, NY; Afonso de Albuquerque, "Journalism and Multiple Modernities: The *Folha de S. Paulo* Reform in Brazil," *Journalism Studies* 20, no. 11 (2019): 1547–48, 1556.

3. Ana Maria Belluzzo, "Rupture and Concrete Art," in *Arte construtiva no Brasil: coleção Adolpho Leirner/Constructive Art in Brazil: Adolpho Leirner Collection*, ed. Aracy A. Amaral (São Paulo: DBA Artes Gráficas, 1998), 100.

4. Waldemar Cordeiro, "A volta do artista à vida coletiva," *Folha da Manhã,* March 9, 1952, 11.

5. Ibid., 9, 11.

6. See, for example, Waldemar Cordeiro, "Salão paulista de arte moderna," *Folha de Manhã,* March 18, 1951, 9.

7. "Mesa redonda de artistas para apreciar a I Bienal," *A Época,* November 14, 1951, CDWC, fig. 1–39; Ibiapaba Martins, "Cadeiradas e trocadilhos no Clube dos Artistas: agitados e exaltados os debates sobre a primeira Bienal," *Correio Paulistano,* November 29, 1951, 8.

8. The exhibition title also appeared as *Ruptura: exposição do grupo abstracionista* (Rupture: Exhibition of the Abstractionist Group) on the invitation.

9. Rejane Cintrão and Ana Paula Nascimento, *Grupo Ruptura* (São Paulo: Cosac Naify, 2002), 15.

10. For floor plans, see Marlene Yurgel, ed., *Vilanova Artigas: projetos digitalizados,* vol. 19 (São Paulo: Faculdade de Arquitetura e Urbanismo da Universidade de São Paulo, 2010), 3373–78. Also see Hélio Herbst, *Pelos salões das Bienais, a arquitetura ausente dos manuais: contribuições para a historiografia brasileira (1951–1959)* (São Paulo: Annablume, Fapesp, 2011), 74–75.

11. Regarding the number of paintings in the exhibition, Cintrão and Nascimento propose that each artist did not exhibit more than five works. In installation views, six works are visible by Cordeiro and only two sculptures by Haar, but I broadly agree with their conclusion.

12. For additional installations view, see "Arte abstrato-concretista," unidentified newspaper, December 1952, CDWC, fig. 5–35; João Bandeira, *Arte concreta paulista: documentos* (São Paulo: Cosac Naify, 2002), 48.

13. For insightful, detailed analysis of the congruencies and contrasts between Charoux and Wladyslaw's 1952 production, based on works in the collection of Adolpho Leirner, now at MFAH, see Belluzzo, "Rupture and Concrete Art," 102–6.

14. The display method was widely adapted among Grupo Ruptura artists during or soon after the inaugural exhibition. Several works displayed at the II Salão paulista de arte moderna in late 1952 employed the box mounts. While it is not possible to conclude definitively from known installation views of the Grupo Ruptura exhibition that Barros and Sacilotto also mounted their displayed works on wooden box constructions, Barros's *Diagonal Function* has adhesive residue on its verso, indicating that, at one point, it was mounted in this way, and both artists used the technique at the second Bienal in late 1953. It is possible the artists first noted this display technique in Richard Paul Lohse's paintings exhibited at the first Bienal.

15. Pia Gottschaller, "Making Concrete Art," in *Making Art Concrete: Works from Argentina and Brazil in the Colección Patricia Phelps de Cisneros,* ed. Aleca Le Blanc (Los Angeles: Getty Publications, 2017), 44.

16. Waldemar Cordeiro, "As novas posições artísticas: a atualidade do futurismo—a mostra de Wladyslaw na Galeria Domus," unidentified newspaper, [March] 1951, CDWC, fig. 1–38.

17. I believe that the Grupo Ruptura exhibition closed on December 20, 1952. It was listed every day in *O Estado de São Paulo* beginning with its opening, but no longer appeared on December 21, 1952.

18. This proposal draws on João Bandeira's research on the salon. Bandeira, *Arte concreta paulista,* 10–11, 51, 54.

19. For installation views of the salon in the pavilion built for the first Bienal at Trianon, see "Concretistas," *AO: Atualidades Odontológicas* (January–February 1953), ALA, MFAH.

20. H.M. Berard, "A proposito da votação dos artistas modernos," unidentified newspaper, [late November 1952], CDWC, fig. 5–29; Ibiapaba Martins, "Ruptura: brigam os artistas," *Última Hora* (São Paulo), December 10, 1952, in Bandeira, *Arte concreta paulista,* 51.

21. Nogueira Lima was invited by Cordeiro to join the group in 1953. According to Nogueira Lima, Cordeiro extended an invitation to students at IAC to join Grupo Ruptura. Fellow IAC student Alexandre Wollner did not recount this invitation. Aracy A. Amaral, *Projeto construtivo brasileiro na arte (1950–1962)* (Rio: MAM Rio; São Paulo: Pinacoteca, 1977), 216; André Stolarski, *Alexandre Wollner e a formação do design moderno no Brasil* (São Paulo: Cosac Naify, 2005); Pedro Nery, "Maurício Nogueira Lima," in *Arte construtiva na Pinacoteca do Estado de São Paulo,* ed. Regina Teixeira de Barros (São Paulo: Pinacoteca, 2014), 116n1.

22. "Artistas premiados nos salões anteriores," *IV Salão paulista de arte moderna* (São Paulo: Salão Paulista de Arte Moderna, 1955).

23. Waldemar Cordeiro, "Ruptura," *Correio Paulistano,* January 11, 1953, Suplemento, 3, in *Waldemar Cordeiro: fantasia exata,* ed. Analívia Cordeiro (São Paulo: Itaú Cultural, 2014), 170, with slight modification. Also see Domingos de Lucca Junior, "Um jantar, no 'Clubinho', para comemorar os resultados do II Salão paulista de arte moderna," *Folha da Manhã,* February 8, 1953, 8.

24. "Concretistas." The art press also noted the unified display of abstract works, in one case referring to it as "the vanguard wing." See José Geraldo Vieira, "Aspectos e impressões do II Salão paulista de arte moderna," *Folha da Manhã,* January 11, 1953, 1.

25. Lucca Junior, "Um jantar, no 'clubinho', para comemorar os resultados do II Salão paulista de arte moderna."

26. Cordeiro, "Ruptura," in Cordeiro, *Waldemar Cordeiro,* 171.

27. Waldemar Cordeiro, "Roteiro crítico do primeiro Salão paulista de arte moderna: tendência da arte nacional contemporânea," *Folha da Manhã,* December 16, 1951, 8, in Cordeiro, *Waldemar Cordeiro,* 130. Also see Waldemar Cordeiro, "A nova alegoria: considerações em torno da exposição de Flexor no Museu de Arte Moderna," *Folha da Manhã,* April 27, 1950, 8.

28. Waldemar Cordeiro, "Concreta, arte," typed document, undated [1959 or later], CDWC, fig. 4–10. Also see Cordeiro's 1959 interview in which he commented on leading artists in the Concrete group to "take" the II Salão paulista de arte moderna (Jaime Maurício, "Conversa com Waldemar Cordeiro," *Correio da Manhã,* April 5, 1959, 18).

29. See chapter 3 on criticism of Venice Biennale selection in 1950, and chapter 5 on how, at the second Bienal, Cordeiro withdrew works and Barros contributed to the realization of a photography exhibition. Also see María Amalia García on the protest statement in advance of second Bienal (*Abstract Crossings, 155–56*).

30. Antonio Bento, "Portinari na próxima Bienal de Veneza," *Diário Carioca*, May 8, 1954, 6.

31. "Manifesto Ruptura" (1952), in *Inverted Utopias: Avant-Garde Art in Latin America*, ed. Mari Carmen Ramírez and Héctor Olea (Houston: MFAH, 2004), 494.

32. CDWC, fig. 1–43. This is the only combining of documents I am aware of in Cordeiro's papers.

33. Cordeiro, "Ruptura," in Cordeiro, *Waldemar Cordeiro, 170–74*.

34. Patrick Iber, "Anti-Communist Entrepreneurs and the Origins of the Cultural Cold War," in *De-centering Cold War History: Local and Global Change*, ed. Jadwiga Pieper-Mooney and Fabio Lanza (London: Routledge, 2013), 176.

35. According to Givaldo Medeiros, Cordeiro had been a member of the Italian Communist Party and elected not to join PCB because he disagreed with the party's aesthetic program supporting social realism. In addition to his attendance of CCC, Cordeiro participated in at least one documented PCB-organized protest against sending troops to the Korean War. See "Intelectuais paulistas manifestam-se contra o envio de tropas para a Coreia," *Fundamentos: Revista de Cultura Moderna* 4, no. 21 (August 1950): 19; Medeiros, "Dialética concretista: o percurso de Waldemar Cordeiro," 68; Augusto de Campos, interview, December 12, 2017, for the film *Fantasia exata* (provisional title, in production).

36. See, for example, Cordeiro, "Salão paulista de arte moderna."

37. Press accounts vary on whether the manifesto was distributed at the opening or once the exhibition was already on view. See "Pintores abstratos," *Tribuna da Imprensa*, December 1, 1952, 2; "Exposição de arte abstrata," *O Estado de São Paulo*, December 12, 1952, 8.

38. Martins, "Ruptura"; "Arte moderna não é ignorância; nós somos contra a ignorância," *Folha da Noite*, December 11, 1952, 2; "Abstracionismo? Figurativismo ou arte concreta? Elegância em todo o caso . . . ," *Folha da Manhã*, December 14, 1952, 17.

39. The notes at AGB are six handwritten loose pages, and the draft is typed with handwritten changes. The draft manifesto was first published by Bandeira. Fabiana de Barros and Analívia Cordeiro have identified their fathers' handwriting among the handwritten notes. See "Notas," [1952], AGB; "Rascunho do manifesto Ruptura" (1952), in Bandeira, *Arte concreta paulista*, 47.

40. "Rascunho do manifesto Ruptura."

41. "Manifesto Ruptura," in *Inverted Utopias*, 494, with modification.

42. Waldemar Cordeiro, "O problema da expressão plástica: relação entre a escultura, pintura e arquitetura—a propósito de um artigo de Sérgio Milliet," *Folha da Manhã*, January 4, 1950, 6; Waldemar Cordeiro, "Impõe-se uma revisão de valores na pintura e na escultura

nacionais: a realidade presente e a crítica dogmática," *Folha da Manhã,* February 17, 1950, 10; Cordeiro, "A nova alegoria"; Belluzzo, "Rupture and Concrete Art," 100, 140n5.

43. Sérgio Milliet, "Duas exposições," *O Estado de São Paulo,* December 13, 1952, 6. Also see Lisbeth Rebollo Gonçalves, *Sérgio Milliet, crítico de arte* (São Paulo: Perspectiva, 1992), 93–98.

44. Cordeiro stopped writing art criticism for *Folha da Manhã* in the middle of 1952.

45. Cordeiro, "Ruptura," in Cordeiro, *Waldemar Cordeiro,* 172.

46. "Manifesto Ruptura" (1952), in Ramirez and Olea, *Inverted Utopias,* 494.

47. In his 1953 article "Ruptura," Cordeiro cites the 1945 Italian translation of a portion of a posthumous 1914 publication of Fielder's writings; the Italian publication is the likely source for the unattributed quotation in the manifesto. Cordeiro, "Ruptura"; Konrad Fiedler, "Aphorismen" in *Konrad Fiedlers Schiften über Kunst,* vol. 2, ed. Hermann Konnerth (Munich: R. Piper & Co., 1914), 59; Konrad Fiedler, *Aforismi sull'arte,* ed. Antonio Bann (Milan: A. Minuziano, 1945), 128.

48. Cordeiro, "Ruptura"; Fiedler, *Aforismi sull'arte,* 78.

49. There are three undated typed manuscripts for "palestras" (lectures) in Cordeiro's papers, which I propose were delivered in early 1954. Two refer to works on view at the second São Paulo Bienal. Waldemar Cordeiro, "Arte concreta," CDWC, fig. 4–04; Waldemar Cordeiro, "Concretismo como arte de criação contraposta à arte de expressão," CDWC, fig. 4–05, in Cordeiro, *Waldemar Cordeiro,* 206–12. There is also a script for remarks dedicated exclusively to Fiedler. See Waldemar Cordeiro, "O suprematismo, o neo-plasticismo e o construtivismo, do ponto-de-vista da pura visualidade," CDWC, fig. 4–03, in Cordeiro, *Waldemar Cordeiro,* 91–97.

50. Cordeiro's course was held between January 10–February 1, 1953, in Teresópolis, and February 2–20, 1954, in São Paulo. Argentine artist Gyula Kosice and Brazilian poet Décio Pignatari were also teachers in the 1953–54 iteration of the holiday course program. Cordeiro assembled a small Concrete exhibition, including himself, Nogueira Lima, and others, at Teresópolis. See Ibiapaba Martins, "Poesia e pintura juntas na Bienal: Waldemar Cordeiro está fazendo falta no Ibirapuera," *Correio Paulistano,* December 27, 1953, 24; "Em Teresópolis," *Correio da Manhã,* January 6, 1954, 9; "Curso internacional de férias em Teresópolis," *Correio da Manhã,* February 9, 1954, 11; "V Curso internacional de férias," *Última Hora* (Rio), February 12, 1954, 3.

51. Cordeiro, "Concretismo como arte de criação contraposta à arte de expressão," in Cordeiro, *Waldemar Cordeiro,* 206, with modification.

52. Cordeiro, "Arte concreta."

53. Cordeiro, "Concretismo como arte de criação contraposta à arte de expressão," in Cordeiro, *Waldemar Cordeiro,* 208.

54. Ibid. Emphasis in the original.

55. Waldemar Cordeiro, "O geométrico, o informal," CDWC, fig. 4–04c, in Cordeiro, *Waldemar Cordeiro,* 100–1.

56. See, for example, "V Curso internacional de férias"; Bento, "Portinari na próxima Bienal de Veneza"; "As artes em São Paulo," *Correio da Manhã,* June 9, 1954, 11.

57. See *Exposição nacional de arte concreta* (São Paulo: MAM-SP, 1956; Rio: MEC, 1957); *Seis concretistas* (São Paulo: Galeria de Arte das Folhas, 1958); *Exposição de arte concreta: retrospectiva, 1951–1959* (Rio: MAM Rio, 1960). See conclusion on the first exhibition.

58. Cordeiro, "Concretismo como arte de criação contraposta à arte de expressão," in Cordeiro, *Waldemar Cordeiro,* 206–12.

59. Ibid., 212, with slight modification.

60. "Abstracionismo? Figurativismo ou arte concreta? Elegância em todo o caso. . . . " I thank Adrian Anagnost for identifying the Le Corbusier tapestry in the bottom photograph.

61. Ibid.

62. Ibid.

63. On the continued vitality of the Clube dos Artistas community of abstract and figurative artists, discussed in chapter 3, in relation to press coverage of Grupo Ruptura, see Ana Gonçalves Magalhães and Adele Nelson, "Introduction: Abstract Art in Brazil, New Perspectives," *MODOS: Revista de História da Arte* 5, no. 1 (January–April 2021): 107–8, https://periodicos.sbu.unicamp.br/ojs/index.php/mod/article/view/8664175.

64. Martins, "Ruptura," in Bandeira, *Arte concreta paulista,* 51.

65. Jayme Maurício, "Uma nova e talentosa pintora," *Correio da Manhã,* October 26, 1952, 11.

66. Mário Pedrosa, *Lygia Clark 1950–1952: desenhos, guaches, óleos* (Rio: MES, 1952).

67. Alencastro, "O brotinho parou," in *Habitat: Revista das Artes no Brasil,* no. 10 (January–March 1953): 94.

68. "Briga de cores: verdadeira salada de tendências da pintura," *Visão* (December 12, 1952): 44–45.

69. Alencastro, "Ruptura," *Habitat,* no. 10 (January–March 1953): 93.

70. Maurício, "Uma nova e talentosa pintora"; Pedrosa, *Lygia Clark 1950–1952.*

71. Gasparino Damata and Roger Padine, "Djanira: os anjos e as crianças," *Manchete,* no. 8 (June 14, 1952): 20–22.

72. Waldemar Cordeiro, "O verbo plástico e a alegoria na pintura: a propósito da exposição individual de Maria Leontina Franco," *Folha da Manhã,* March 19, 1950, 15; Mário Pedrosa, "Os prêmios políticos do salão moderno," *Tribuna da Imprensa,* November 10–11, 1951, 7; Mário Pedrosa, "O salão paulista," *Tribuna da Imprensa,* November 17–18, 1951, 7.

73. The context for this photo shoot is unclear. To the best of my knowledge, they were not reproduced at the time, with the exception of a headshot that appeared in the catalogue of the first Grupo Frente exhibition. See *Grupo Frente* (Rio: IBEU, 1954).

74. "A reunião de Petrópolis: menos ministérios a decisão tomada, as posições de Minas e São Paulo na reforma ministerial," *Tribuna da Imprensa,* February 23, 1953, 10; "A conferência," *Tribuna da Imprensa,* February 23, 1953, 4.

75. "Três exposições em Quitandinha," *Correio da Manhã,* February 24, 1953, 11. Also see "Movimento político muito intenso em Petrópolis," *Correio da Manhã,* February 21, 1952, 12.

76. "Lucas Garcez à imprensa em Quitandinha: perfeito entendimento com o Presidente Vargas," *Última Hora* (Rio), February 21, 1953, 3.

77. "A reunião de Petrópolis"; "A conferência"; Thomas Skidmore, *Politics in Brazil, 1930–1964: An Experiment in Democracy* (Oxford: Oxford University Press, 2007), 112–15. Vargas did not reorganize his cabinet until June–July 1953. Another subject of discussion was the campaign for the mayor of São Paulo, with São Paulo governor, Lucas Nogueira Garcez, hoping to enlist Vargas's help against Jânio Quadros.

78. The exhibition opened on February 20, 1953 and remained open at least through February 28, 1953. Its closing date is unclear, given the scarcity of press coverage, but it was closed by March 7 when an exhibition of children's art opened. See "Exposição de pintura de crianças no Hotel Quitandinha," *Boletim do Museu de Arte Moderna do Rio de Janeiro,* no. 6 (March-April 1953): 5.

79. According to press accounts, the exhibition was originally planned for the Museu Imperial in Petrópolis, but one organizer recalled that they sought out the hotel, known for past art exhibitions, as the venue. See "Exposição abstracionista em Petrópolis," *Correio da Manhã,* January 7, 1953, 7; Edmundo Jorge, "I Exposição nacional de arte abstrata," in Frederico Morais, *Ciclo de exposições sobre arte no Rio de Janeiro: 2. Grupo Frente, 1954–1956, 3. I Exposição nacional de arte abstrata, Hotel Quitandinha, 1953* (Rio: Galerie de Arte BANERJ, 1984).

80. One reviewer described it as poorly presented (Celso Kelly, "Arte abstrata," *A Noite,* February 23, 1953, 3).

81. Pedrosa states there were twenty-five artists ("Abstratos em Quitandinha," *Tribuna da Imprensa,* February 28, 1953, 9). I have only been able to document twenty-four. For illustrations of another installation view and the cover of the catalogue, see Morais, *Ciclo de exposições sobre arte no Rio de Janeiro.*

82. Edmundo Jorge, "O que foi a 1ª Exposição de arte abstrata no Brasil," *Módulo: Revista de Arquitetura e Artes Plásticas,* no. 76 (1983): 49–51.

83. Maluf participated at the invitation of Pedrosa. Jorge recounts that the intended national range of the exhibition was limited by the lack of administrative support and that works arrived while the exhibition was underway, including from Bahia ("I Exposição nacional de arte abstrata.") See Regina Teixeira de Barros, "Antonio Maluf: da matemática à poesia," in *Antonio Maluf,* ed. Regina Teixeira de Barros (São Paulo: Centro Universitário Maria Antônia da Universidade de São Paulo, 2002), 12.

84. "Em Petrópolis: Prêmios, abstracionistas e Museu de Arte Brasileira," *Correio da Manhã,* May 3, 1953, 11.

85. Margaret Spence and José Mattos, possibly others, exhibited figurative works. There was a dust-up when Serpa tried to have some of these works removed from the exhibition. See "Exposição de arte abstrata em Quitandinha," *Correio da Manhã,* February 21, 1953, 11; Jorge, "I Exposição nacional de arte abstrata."

86. Edmundo Jorge, "Advertência aos leigos," in *Exposição nacional de arte abstrata* (Petropólis: Associação Petropolitana de Belas Artes, 1953).

87. In 1952, Carvão began studying with Serpa at MAM Rio and Pape moved to Rio, where Vieira introduced her to Serpa. See Vivian A. Crockett, "Chronology," in *Lygia Pape: A Multitude of Forms,* ed. Iria Candela (New York: Metropolitan Museum of Art, 2017), 168.

88. Pedrosa, "Abstratos em Quitandinha."

89. Ibid.

90. Ibid.

91. "Ivan Serpa, concreto feliz entre as crianças . . . ," *Correio da Manhã,* August 2, 1953, 11.

92. "Exposição de Ivam Serpa e pintura de crianças nos EE.UU.," *Correio da Manhã,* June 5, 1954, 11.

93. Mário Pedrosa, "A experiência de Ivan Serpa," *Tribuna da Imprensa,* August 18–19, 1951, 7; Mário Pedrosa, "Ivan Serpa expõe em Washington, E.U.A," *Forma,* no. 3 (October 1954).

94. "Lhote visita o Museu de Arte Moderna," *Correio da Manhã,* July 23, 1952, 7; "Abstracionismo e Ripolin na casa de Serpa," *Correio da Manhã,* July 12, 1952, 7.

95. Mário Pedrosa, "A primeira Bienal (I)," *Tribuna da Imprensa,* October 23, 1951, 7.

96. Mário Pedrosa, "A coleção do Museu de Arte Moderna," *Tribuna da Imprensa,* January 17–18, 1953, 9, in *Boletim Museu de Arte Moderna do Rio de Janeiro,* no. 5 (February 1953): 13–14; Jayme Maurício, "Palatnik, um jovem fascinado pela luz," *Correio da Manhã,* January 13, 1953, 11; Rubem Braga, "Abraham Palatnik pinta com luz e movimento," *Manchete,* no. 47 (March 14, 1953): 28–29; Celso Kelly, "Abstracionismo cinemático," *A Noite,* February 9, 1953, 2, in *Boletim do Museu de Arte Moderna do Rio de Janeiro,* no. 6 (March–April 1953): 1–2; "Pintura sem pincel: O 'cine-cromático' tenta revolucionar a pintura," *Visão* 2, no. 4 (February 20, 1953): 33.

97. Pedrosa, quoted in Braga, "Abraham Palatnik pinta com luz e movimento," 28.

98. Frederico Morais, "Abraham Palatnik: um pioneiro da arte tecnológica," in Luiz Camillo Osorio, ed., *Abraham Palatnik* (São Paulo: Cosac Naify, 2004), 169.

99. See, for example, Maurício, "Palatnik, um jovem fascinado pela luz."

100. Luiz Camillo Osorio, "Abraham Palatnik: perceber, inventar, jogar," in Osorio, *Abraham Palatnik,* 73.

101. Ibid., 61–62, 66.

102. "Ainda o abstracionismo," *Correio da Manhã,* June 28, 1952, 9.

103. "Abstracionismo e Ripolin na casa de Serpa," *Correio da Manhã,* July 12, 1952, 7.

104. Jorge states there were weekly group meetings in 1952 ("I Exposição nacional de arte abstrata").

105. AIS, inclusive of Serpa's correspondence, is now held at the Instituto de Arte Contemporânea in São Paulo (not to be confused with the IAC at MASP). At the time of writing, these materials were not yet available to researchers. Among the correspondence I have examined between Barros, Mavignier, and Pedrosa, there is no mention of this exhibition or its organization.

106. Pedrosa, "Abstratos em Quitandinha."

107. The auction was held on March 23, 1953: see "Os artistas auxiliam as vítimas da seca," *Tribuna da Imprensa,* March 14–15, 1953, 6.

108. Ramiro Martins, quoted in ibid.

CHAPTER 5. DEFINING MODERNISM AT THE SECOND SÃO PAULO BIENAL

1. "Exposição do IV Centenário," *Acrópole,* no. 185 (1954): 210; Stamo Papadaki, *Oscar Niemeyer: Works in Progress* (New York: Reinhold Publishing, 1956), 131.

2. *Aspiral* is a composite of *espiral* (spiral) and *aspirar* (aspire).

3. Hugo Segawa, "Ibirapuera: o varziano que virou centro," in *Fantasia brasileira: o balé do IV Centenário* (São Paulo: Edições SESC, 1998), 102.

4. Eduardo Corona, "Um símbolo frustrado," *AD: Arquitetura e Decoração,* no. 9 (January–February 1955).

5. [Oscar Niemeyer], "Mutilado o conjunto do Parque Ibirapuera," *Módulo: Revista de Arquitetura e Artes Plásticas,* no. 1 (March 1955): 18.

6. Lourival Gomes Machado, "Introdução," in *I Bienal do Museu de Arte Moderna de São Paulo: catálogo* (São Paulo: MAM-SP, 1951), 14.

7. The nations represented at the second Bienal, excluding Brazil, were, in alphabetical order: Argentina, Austria, Belgium, Bolivia, Canada, Chile, Cuba, Denmark, Dominican Republic, Egypt, Finland, France, Germany, Great Britain, Indonesia, Israel, Italy, Japan, Luxembourg, Mexico, Netherlands, Nicaragua, Norway, Paraguay, Peru, Portugal, Spain, Switzerland, United States, Uruguay, Venezuela, and Yugoslavia.

8. Pedrosa departed Brazil on March 17, 1953 and was in Europe from about March 20, 1953 until sometime before December 14, 1953. See [Francisco Matarazzo Sobrinho] to Paulo Carneiro, March 10, 1953, Folder 3.5.2, AMP, BN; box 2/26, folder 4, 02 Bienal de São Paulo (hereafter 02BSP), MAM, AHWS; Mário Pedrosa to Francisco Matarazzo Sobrinho, March 31, 1953, Folder 3.5.1, AMP, BN; box 2/6, folder 11, 02BSP, MAM, AHWS; "Mário Pedrosa na Europa," *Boletim do Museu de Arte Moderna do Rio de Janeiro,* no. 6 (March–April 1953): 6; "Instalado o júri da II Bienal," *Folha da Manhã,* December 15, 1953, 5.

9. In Matarazzo's initial invitations beginning in September 1952, he suggested a specific artist or artistic movement to be featured in a special exhibition—requests that were in many cases fulfilled.

10. See, for example, "Boletim n. 2: O critério artístico," press release, March 1953, box 1, 02BSP, MAM, AHWS; "Artistas e críticos falam sobre a Bienal de São Paulo: Wolfgang Pfeiffer, representou iniciativa pioneira, jovem e viva, e constituiu um sucesso," *Folha de Manhã,* November 30, 1952, 7; Yvonne Jean, "As salas especiais da Bienal," *Diário Carioca,* December 20, 1953, 3; "Artistas e críticos falam sobre a Bienal de São Paulo: Sérgio Milliet apresentação de menor número de pintores com maior número de obras," *Folha da Manhã,* November 23, 1952, 7.

11. Miró was also absent from Spanish representations to the poswar Venice Biennales and the Bienal Hispanoamericana de Arte. Spanish authorities stated that the artist's dealers owned the majority of his works and they were not interested in lending works for São Paulo.

12. Lawrence Alloway, *The Venice Biennale, 1895–1968: From Salon to Goldfish Bowl* (Greenwich, CT: New York Graphic Society, 1968), 135; Hans Belting, *Art History After Modernism* (Chicago: University of Chicago Press, 2003), 37–43.

13. Alloway, *The Venice Biennale,* 134; Belting, *Art History After Modernism,* 37.

14. Maurice Jardot, *Exposição Picasso: II Bienal do Museu de Arte Moderna de São Paulo* (Paris: André Tournon et Cie.; São Paulo: Comissão do Quarto Centenário de São Paulo, 1953).

15. Ibid., 12.

16. Christian Zervos, "Conversation avec Picasso," *Cahiers d'Art,* no. 7–10 (1935), trans. in *Art in Theory, 1900–2000: An Anthology of Changing Ideas,* ed. Charles Harrison and Paul Wood (London: Blackwell, 2003), 508; Jardot, *Exposição Picasso,* 10.

17. Mário Pedrosa, "Klee, o ponto de partida" (1953), in Mário Pedrosa, *Textos escolhidos,* ed. Otília Arantes, vol. 4, *Modernidade cá e lá* (São Paulo: Edusp, 2000), 189–92. For discussion of Pedrosa's earlier writing on Klee, see chapter 2.

18. Ibid., 192. Pedrosa asserts a parallel in Klee's approach to art and phenomenology, and deploys several turns of language to connect Klee to Edmund Husserl's ideas, including "radical attitude."

19. Mário Pedrosa, "Mondrian e a natureza" (1953), in Pedrosa, *Textos escolhidos,* vol. 4, 193–96.

20. Matarazzo had proposed the focus of Die Brücke. See Wolfgang Krauel to Ruy Bloem, October 3, 1952, box 2/01, folder 2, 02BSP, MAM, AHWS.

21. Mário Pedrosa to Francisco Matarazzo Sobrinho, June 1, 1953, folder 3.5.1, AMP, BN; partial copy in box 2/06, folder 11, 02BSP, MAM, AHWS; Mário Pedrosa to Arturo Profili, July 8, 1953, Folder 3.5.1, AMP, BN; box 2/25, folder 5, 02BSP, MAM, AHWS. Pedrosa repeated this explanation of his tactic with the West German government in an interview

(J.C. Ribeiro Penna, "A batalha secreta do grande prêmio da II Bienal," *Folha da Noite,* December 17, 1953, 5).

22. Mário Pedrosa to Francisco Matarazzo Sobrinho, July 7, 1953, box 2/06, folder 11, 02BSP, MAM, AHWS; Pedrosa to Profili, July 31, 1953; Arturo Profili to Mário Pedrosa, August 7, 1953, box 2/25, folder 6, 02BSP, MAM, AHWS; Arturo Profili to Mário Pedrosa, August 14, 1953, box 2/25, folder 6, 02BSP, MAM, AHWS; Mário Pedrosa to Sérgio Milliet, August 31, 1953, box 2/07, folder 10, 02BSP, MAM, AHWS.

23. *Paul Klee, 1879–1940* (Munich: Prestel Verlag, 1953).

24. Jean, "As salas especiais da Bienal."

25. On the Cuban representation to the second Bienal, see Abby McEwen, *Revolutionary Horizons: Art and Polemics in 1950s Cuba* (New Haven, CT: Yale University Press, 2016), 127, 149–50.

26. Claire F. Fox, *Making Art Panamerican: Cultural Policy and the Cold War* (Minneapolis: University of Minnesota Press, 2013), 17, 122.

27. Fox states that Gómez Sicre organized the Chilean and Venezuelan representations to the second Bienal. Though he played a seminal role in the form that they and other Latin American representations took, he is only credited as curator of the Cuban representation. Arturo Profili to José Gómez Sicre, January 28, 1953, box 2/25, folder 3, 02BSP, MAM, AHWS; José Gómez Sicre to Arturo Profili, February 4, 1953, box 2/25, folder 3, 02BSP, MAM, AHWS; Fox, *Making Art Panamerican,* 122.

28. On Visconti, see Paulo Herkenhoff, "Eliseu Visconti: moderno antes do modernismo," *5 Visões do Rio na Coleção Fadel* (Rio: Edições Fadel, 2009).

29. Tadeu Chiarelli, "Art in São Paulo and the Modernist Segment of the Collection" in *Coleção Nemirovsky,* ed. Maria Alice Milliet (São Paulo: MAM-SP, 2003), 83–84.

30. Other notable instances include the sixth and twenty-fourth Bienals organized in 1961 by Pedrosa and in 1998 by Paulo Herkenhoff, respectively. See Adele Nelson, "Mário Pedrosa, el museo del arte moderno y sus márgenes" in *Mário Pedrosa: de la naturaleza afectiva de la forma,* ed. Gabriel Pérez-Barreiro and Michelle Sommer (Madrid: Museo Nacional Centro de Arte Reina Sofía, 2017), 54–63; Lisette Lagnado, ed., *Cultural Anthropophagy: The 24th Bienal de São Paulo 1998* (London: Afterall, 2015).

31. Chiarelli similarly interprets the special exhibitions at the second Bienal to evidence MAM-SP's "desire to construct a real genealogy of modern art in Brazil" and "seek out the 'antecedents' of the Modern Week of '22" ("Art in São Paulo and the Modernist Segment of the Collection," 83).

32. Francisco Matarazzo Sobrinho to Nelson A. Rockefeller, September 21, 1952, folder 1467, series L-148, RG 4, NAR, RAC. Also see Francisco Matarazzo Sobrinho to René d'Harnoncourt, November 11, 1952, box 2/02, folder 4, 02BSP, MAM, AHWS.

33. Sérgio Milliet, *A pintura norte-americana: bosquejo da evolução da pintura nos EE.UU.* (São Paulo: Livraria Martins, 1943), 28. Milliet translated Cheney's writing into Portuguese. See Sheldon Cheney, *The Story of Modern Art* (New York: Viking Press, 1941); Sheldon Cheney, *História da arte,* trans. Sérgio Milliet (São Paulo: Livraria Martins, 1949).

34. Cheney, *The Story of Modern Art,* 423, 426.

35. Martins visited with individuals at MoMA, including René d'Harnoncourt, to discuss the Bienal in late February 1953 (Francisco Matarazzo Sobrinho to Maria Martins, February 13, 1953, box 2/06, folder 10, 02BSP, MAM, AHWS; Maria Martins to Francisco Matarazzo Sobrinho, March 1, 1953, box 2/06, folder 10, 02BSP, MAM, AHWS). She had subsequent meetings, after her trips to Cuba and Mexico, in April 1953. See Francisco Matarazzo Sobrinho to Maria Martins, April 7, 1953, box 2/06, folder 1, 02BSP, MAM, AHWS; Porter McCray to Arturo Profili, April 28, 1953, RdH, VI.11, MoMA Archives, NY.

36. Porter McCray to Arturo Profili, June 15, 1953, RdH, VI.11, MoMA Archives, NY. This decision was preceded by internal discussions of working floor plans, suggesting MoMA curators tailored their selection to Niemeyer's design (Dorothy Miller to René d'Harnoncourt, May 6, 1953, IC/IP I.A.380, MoMA Archives, NY).

37. Roberta Saraiva proposes that Martins may have guided the selection of Calder, and Francisco Alambert and Polyana Canhête argue that Dias negotiated the exhibition for the second Bienal directly with Calder in Paris. See Francisco Alambert and Polyana Canhête, *As Bienais de São Paulo: da era do museu à era dos curadores (1951–2001)* (São Paulo: Boitempo, 2004), 58; Roberta Saraiva, *Calder in Brazil: The Tale of a Friendship* (São Paulo: Cosac Naify, 2006), 167; Francisco Alambert, "El Goya vengador en el Tercer Mundo: Picasso y el Guernica en Brasil," in *El Guernica de Picasso entre Europa, Estados Unidos y América Latina,* ed. Andrea Giunta (Buenos Aires: Biblos, 2009), 63.

38. Francisco Matarazzo Sobrinho to Fernando Gamboa, September 11, 1952, box 2/03, folder 7, 02BSP, MAM, AHWS. Bienal organizers modeled their choice on the Mexican representation at the Venice Biennale in 1950.

39. Profili, in October or November 1952, and Martins, in March or April 1953, travelled to Mexico. Francisco Matarazzo Sobrinho to Fernando Gamboa, November 4, 1952, box 2/03, folder 7, 02BSP, MAM, AHWS; Maria Martins telegram to Francisco Matarazzo Sobrinho, March 20, 1953, box 2/03, folder 8, 02BSP, MAM, AHWS; Arturo Profili to José Gomez Sicre, April 10, 1953, box 2/25, folder 4, 02BSP, MAM, AHWS.

40. Pedrosa was in London in April 1953. See Mário Pedrosa to Francisco Matarazzo Sobrinho, April 2, 1953, Folder 3.5.1, AMP, BN; Mário Pedrosa to Paulo Carneiro, April 27, 1953, box 2/26, folder 10, 02BSP, MAM, AHWS.

41. Pedrosa to Carneiro, April 27, 1953; Francisco Matarazzo Sobrinho to Fernando Gamboa, June 12, 1953, box 2/03, folder 8, 02BSP, MAM, AHWS; Fernando Gamboa to Francisco Matarazzo Sobrinho, August 25, 1952, box 2/03, folder 8, 02BSP, MAM, AHWS.

42. See, for example, "Inaugura-se a 12 de dezembro a II Bienal de São Paulo," *Correio da Manhã,* November 27, 1953, 10.

43. See, for example, "A Bienal—obra de cultura?," *Fundamentos: Revista de Cultura Moderna* 5, no. 34 (December 1954): 37.

44. José Gómez Sicre to Arturo Profili, December 2, 1952, box 2/25, folder 2, 02BSP, MAM, AHWS.

45. See, for example, Antonio Bento, "Os brasileiros na II Bienal de S. Paulo," *Diário Carioca,* September 22, 1953, 6; Antonio Bento, "Portinari, Segall e a Bienal de São Paulo," *Diário Carioca,* February 2, 1954, 6.

46. Papadaki, *Oscar Niemeyer,* 135.

47. *Anteprojeto da Exposição do IV Centenário de São Paulo* (São Paulo: D.G. Paglia, 1952); Paulo César Garcez Marins, "O Parque Ibirapuera e a construção da identidade paulista," *Anais do Museu Paulista* 6–7, no. 7 (2003): 26.

48. For an insightful analysis of the degree to which Bill's dismissal of the Ibirapuera project set the stage, and the terms, for the ebb in the international praise for Brazilian modern architecture, see Valerie Fraser, *Building the New World: Studies in Modern Architecture of Latin America, 1930–1960* (London: Verso, 2000), 252–55.

49. Pedrosa was still in Europe during the installation and does not seem to have participated in the design. To the best of my knowledge, there is no documentation at the AHWS detailing the installation process. Press accounts variously portray Milliet, Pfeiffer, and Profili as in charge: see Antonio Bento, "Notas diversas," *Diário Carioca,* October 30, 1953, 6; "II Bienal de São Paulo: A maior exposição internacional do continente," *Correio da Manhã,* December 5, 1953, 12; "Amanhã, em S. Paulo: Calder, Picasso e Moore, na Bienal," *Tribuna da Imprensa,* December 11, 1953, 2.

50. On exhibition design at MASP in its early history, see Adrian Anagnost, "Limitless Museum: P.M. Bardi's Aesthetic Reeducation," *Modernism/Modernity* 26, no. 4 (November 2019): 705–14.

51. [Niemeyer], "Mutilado o conjunto do Parque Ibirapuera," 20. Also see ill. p. viii.

52. The non-European exhibitions from Indonesia, Israel, and Japan were rarely discussed in the art press, aside from their mention as evidence of the global reach of the Bienal. See, for example, "Artistas de 40 nações far-se-ão representar na II Bienal do Museu de Arte Moderna de São Paulo," *Folha da Manhã,* November 1, 1953, 1.

53. An exception to this view was expressed by pro-realism critic Bento ("Características da II Bienal de S. Paulo," *Diário Carioca,* December 20, 1953, 3).

54. *Habitat: Revista das Artes no Brasil,* for example, dedicated its initial review of the second Bienal solely to the historical displays; see "Uma exposição para o grande público: A 2ª Bienal," *Habitat,* no. 14 (January–February 1954): 29–39. *Folha da Manhã* created a series of articles entitled "Didática da Bienal" (Didactic of the Bienal) that ran, on average,

once a week over the course of two months and was mainly dedicated to the European historical displays.

55. The prize jury included Max Bill, Jorge Romero Brest, Bernard Dorival, Eberhard Hanfstaengl, Emile Langui, Juan Ramón Masoliver, Sérgio Milliet, Rodolfo Pallucchini, Mário Pedrosa, Wolfgang Pfeiffer, Herbert Read, Tomás Santa Rosa, James Johnson Sweeney, and Willem Sandberg.

56. Willy Lewin, "Os 'móbiles' de Calder," *Jornal do Comércio,* October 11, 1959, trans. in Saraiva, *Calder in Brazil,* 220, with slight modification.

57. Margaret Miller, curator at MoMA, selected the works included in the Calder exhibition and all but the prints in the US representation ("Show [ICE-F-12–53] Itinerary," IC/IP, II Bienal, I.A.366, MoMA Archives, NY).

58. For analysis of Pedrosa's earlier writing on Calder, see Sérgio B. Martins, "Wind Chimes of Modernity: Calder's 1948 Trip to Brazil," in *Alexander Calder: Performing Sculpture* (New Haven, CT: Yale University Press, 2015), 54–65; Kaira M. Cabañas, "A Strategic Universalist," in *Mário Pedrosa: Primary Documents,* ed. Glória Ferreira and Paulo Herkenhoff (New York: MoMA, 2015), 23–34; Luiz Camillo Osorio, "Calder after Pedrosa," lecture, University of Texas at Austin, December 5, 2019.

59. Penna, "A batalha secreta do grande prêmio da II Bienal"; Jayme Maurício, "Picasso e Klee realizaram a catarse de sensibilidade moderna," *Correio da Manhã,* December 20, 1953, 13, 15. Pedrosa had lobbied unsuccessfully for Calder to be awarded the grand prize.

60. Maurício, "Picasso e Klee realizaram a catarse de sensibilidade moderna," 15.

61. Ibid.

62. Mário Pedrosa, "Tensão e coesão na obra de Calder" (1948), trans. in Saraiva, *Calder in Brazil,* 127; Penna, "A batalha secreta do grande prêmio da II Bienal." The quoted phrase is from the latter.

63. Antonio Bento, "Abstratos e concretos na Bienal," *Diário Carioca,* December 22, 1953, 6.

64. Manuel Germano [José Geraldo Vieira], "Observações concretas do visitante abstrato," *Habitat,* no. 16 (May–June 1954): 49. Also see "Bienal e cultura," *Forma,* no. 1 (June 1954).

65. Sérgio Milliet, *Ateliê Abstração* (São Paulo: Instituto de Arquitetos do Brasil, 1953); "Exposição dos pintores do 'Ateliê Abstração,'" *Folha da Manhã,* November 26, 1953, 7.

66. "Provocou agitação nos meios artísticos de São Paulo a divulgação da carta-circular," *Folha da Manhã,* April 26, 1953, 1, 7.

67. See, for example, Waldemar Cordeiro, "Os artistas na vide e na arte: Volpi, o pintor de parades que traduziu a visualidade popular," *Folha da Manhã,* April 20, 1952, 7; Mário Pedrosa, "Volpi, 1924–1957" (1957), in Mário Pedrosa, *Textos escolhidos,* ed. Otília Arantes, vol. 3, *Acadêmicos e modernos* (São Paulo: Edusp, 2004), 261–69. For an analysis of the portrayal of Volpi as a naive painter, see Rodrigo Naves, "Where Alfredo Volpi Starts to Get Complex: The Painter's Dialogue with Both Concretistas and Neoconcretistas," in

Building on a Construct: The Adolpho Leirner Collection of Brazilian Constructive Art at the Museum of Fine Arts, Houston, ed. Héctor Olea and Mari Carmen Ramírez (Houston: MFAH, 2009), 253–69.

68. *Casas* is included in the artist's catalogue raisonné (forthcoming). Instituto Alfredo Volpi de Arte Moderna, catalogue raisonné no. ACOAV 0931.

69. For discussion of Cordeiro's course, see chapter 4. See also Waldemar Cordeiro, "Concretismo como arte de criação contraposta à arte de expressão," n.d., CDWC, fig. 4–05, in Analívia Cordeiro, ed., *Waldemar Cordeiro: fantasia exata* (São Paulo: Itaú Cultural, 2014), 209, with slight modification.

70. Ibid., 208.

71. "A Bienal—obra de cultura?," 37.

72. Ibid., 33.

73. AHWS holds object views of some Brazilian and a few Latin American works displayed.

74. Helouise Costa notes that the absence of photography at the Bienal contrasts with MAM-SP's support of modern photography in its early exhibitions ("Da fotografia como arte à arte como fotografia: a experiência do Museu de Arte Contemporânea da USP na década de 1970," *Anais do Museu Paulista* 16, no. 2 [July–December 2008]: 134–41).

75. R.T.S. "Fotografias na II Bienal," *Folha da Manhã,* January 3, 1954, 4; "Artes plásticas," *Correio da Manhã,* February 21, 1954, 11; "Artes plásticas," *Correio da Manhã,* February 27, 1954, 11; "Arte fotográfica na II Bienal," *Correio da Manhã,* February 28, 1954, 11; *Boletim Foto-Cine* 8, no. 87 (February–March 1954): 9–11, 14–15, 18–19, 23.

76. Helouise Costa, "O Foto Cine Clube Bandeirante no Museu de Arte de São Paulo," in Isabel Teixeira, *MASP FCCB: Coleção Museu de Arte de São Paulo Foto Cine Clube Bandeirante* (São Paulo: MASP, 2016), 14. Also see Costa, "Da fotografia como arte à arte como fotografia," 131–73.

77. Wolfgang Pfeiffer, "A fotografia e a II Bienal," *Boletim Foto-Cine* 8, no. 87 (February–March 1954): 8–9; Geraldo de Barros, "A sala de fotografia," *Boletim Foto-Cine* 8, no. 87 (February–March 1954): 12–14; R.T.S. "Fotografias na II Bienal"; "Mesa redonda," *O Tempo,* n.d., in *Boletim Foto-Cine* 8, no. 87 (February–March 1954): 24–25.

78. Geraldo de Barros writes ("A sala de fotografia") of raves from a host of local critics—Geraldo Ferraz, Maria Eugênia Franco, Sérgio Milliet, Mário Pedrosa, José Geraldo Vieira, and others—as well as visiting foreigners, including Max Bill, Jorge Romero Brest, Walter Gropius, and Bernard Dorival. To the best of my knowledge these individuals did not comment in print on the exhibition, so these communications likely were personally addressed to Barros.

79. Ibid., 13.

80. Barbara Weinstein, *The Color of Modernity: São Paulo and the Making of Race and Nation in Brazil* (Durham, NC: Duke University Press, 2015).

81. Barros, "A sala de fotografia," 12.

82. Ibid., 12–13. Within FCCB ranks, Barros attributed the original idea to Francisco Albuquerque and Ademar Manarini; described himself, Manarini, Eduardo Salvatore, and José V.E. Yalenti as selecting and installing the works; and noted the help of Mário Fiori, Alfio Trovato, R. Francesconi, and Tuffy Kanji. Barros credited Pfeiffer and Milliet with persuading the leadership of MAM-SP, and Bernard Dorival and Moore, both of whom were on site installing exhibitions, with winning Matarazzo's crucial support.

CHAPTER 6. ARTIST AS MODEL CITIZEN

1. Thomas Skidmore, *Politics in Brazil, 1930–1964: An Experiment in Democracy* (Oxford: Oxford University Press, 2007), 122–42.

2. The first exhibition was held from June 30 to July 27, 1954 at IBEU in Rio and included Aluísio Carvão, Lygia Clark, João José da Silva Costa, Vincent Ibberson, Lygia Pape, Ivan Serpa, Carlos Val, and Décio Vieira. The second Grupo Frente exhibition was held from July 14 to August 14, 1955 at MAM Rio. It included the original members plus Eric Baruch, Rubem Ludolf, Elisa Martins da Silveira, César Oiticica, Hélio Oiticica, Abraham Palatnik, and Franz Weissmann. The third and fourth exhibitions, with the same fifteen artists, opened on March 17 or 18, 1956 at the Itatiaia Country Club in Resende, RJ, and on June 23, 1956 at the Companhia Siderúrgica Nacional, Volta Redonda, RJ.

3. The European-born were from Austria, England, and Holland. Of the Brazilian-born, their birthplaces were in the Southeast (Rio and its environs, 5; Minas Gerais, 2); Northeast (Alagoas, 1; Piauí, 2; Rio Grande do Norte, 1); and North (Pará, 1).

4. Mário Pedrosa, "Grupo Frente" (1955), in *Mário Pedrosa: Primary Documents,* ed. Glória Ferreira and Paulo Herkenhoff (New York: MoMA, 2015), 269, with slight modification.

5. Ronaldo Brito, *Neoconcretismo: vértice e ruptura do projeto construtivo brasileiro* (Rio: Funarte; Instituto Nacional de Artes Plásticas, 1985), 92.

6. Pedrosa, "Grupo Frente," 270. See Adele Nelson, "There is No Repetition: Hélio Oiticica's Early Practice" in *Hélio Oiticica: To Organize Delirium,* ed. Lynn Zelevansky, Elisabeth Sussman, James Rondeau, and Donna De Salvo (Pittsburgh: Carnegie Museum of Art, 2016), 43–56.

7. These queries build on US-based Group Material's articulation of their methodology. See Group Material, "Democracy" (1990), in *Participation,* ed. Claire Bishop (Cambridge, MA: MIT Press, 2006).

8. "Picasso é quem manda agora onde mandou Salvador de Sá," *Tribuna da Imprensa,* July 15, 1955, 8.

9. At MAM Rio, Baruch, Carvão, Ibberson, Ludolf, César and Hélio Oiticicia, Costa, Martins, and Val studied with Serpa, and Pape studied with Fayga Ostrower. The question of whether Pape studied with Serpa requires more research; she is not listed in Arq. MAM Rio as a student in Serpa's courses, though the rosters are limited to 1954. In the

first Grupo exhibition catalogue (1954), she is listed as having studied with both Serpa and Ostrower, but subsequently her study with Serpa is no longer mentioned in biographies, interviews, and contemporaneous writing.

10. Sabrina Parracho Sant'Anna, *Construindo a memória do futuro: uma análise da fundação do Museu de Arte Moderna do Rio de Janeiro* (Rio: FGV, 2011), 102–4, 197–217. Also see Natália Quinderé, "Pedrosa and Malraux," in *Art Museums of Latin America: Structuring Representation,* ed. Michele Greet and Gina McDaniel Tarver (New York: Routledge, 2018), 79–80.

11. Sant'Anna, *Construindo a memória do futuro,* 206–7. Sant'Anna describes Pedrosa's role at the museum as a connoisseur; I have followed the description by others of his role as a consultant. See Quinderé, "Pedrosa and Malraux," 88n16; Quito Pedrosa, "Chronology," in Ferreira and Herkenhoff, *Mário Pedrosa,* 444.

12. Aleca Le Blanc, "Incendiary Objects: An Episodic History of the Museu de Arte Moderna, Rio de Janeiro," in Greet and Tarver, *Art Museums of Latin America: Structuring Representation,* 63–65, 71n19. Le Blanc also notes that Kubitschek was a board member since 1951 and remained on board while president of the nation.

13. Aleca Le Blanc, "Tropical Modernisms: Art and Architecture in Rio de Janeiro in the 1950s" (PhD diss., University of Southern California, 2011), 233–310.

14. Ibid., 272.

15. The lower house of Congress pledged an initial 10 million cruzeiros for the construction of a building to MAM Rio, and the municipal government subsequently announced its donation of 40,000 square meters (approximately 130,000 square feet) of prime land to MAM Rio ("O estado e a cultura," *Correio da Manhã,* November 15, 1952, 4).

16. The federal agency originally housed in the building, MES, underwent a transition in 1953 when, as part of Vargas's reorganization of his cabinet, the federal administration of health was assigned to a separate ministry, and a standalone ministry focused on education and culture, the MEC, was created and occupied the landmark building.

17. The description of the original configuration of MAM Rio's provisional site is based on the scholarship of Roberto Serge, including a digital simulation produced by Laboratório de Análise Urbana e Representação Digital (Laurd). See Roberto Serge, *Ministério da Educação e Saúde: ícone urbano da modernidade brasileira, 1935–1945* (São Paulo: Romano Guerra Editora, 2013), 464–66.

18. Photographs are held by Arq. MAM Rio and APESP. For verbal descriptions of the space, see "Últimos preparativos para a inauguração do Museu de Arte Moderna," *Correio da Manhã,* January 13, 1952, 1; "Inaugurado ontem o Museu de Arte Moderna do Rio," *Correio da Manhã,* January 16, 1953.

19. The plan in the Arq. MAM Rio is undated and unattributed. The renovation of the space occurred in the first half of 1953 (after January 1953, when works are still installed on the curtained walls in a display of the permanent collection, and by May 1953, when white

walls are visible in the installation views of Portinari's retrospective). Photography of an exhibition of Argentine art in August 1953 corresponds to the space detailed in the plan.

20. *Artistes brasiliens* (Paris: Galeria Mirador, 1955); *Arts primitifs et modernes brésiliens* (Neuchâtel: Musée d'Ethnographie, 1955).

21. *Arte moderno en Brasil: esculturas, pinturas, dibujos, grabados* (Buenos Aires: Museo Nacional de Bellas Artes; Rosario: Museo Municipal de Bellas Artes; Santiago: Museo de Arte Contemporáneo 1957; Lima: Museo de Arte, 1957); *Brasilianischer Kunstler* (Munich: Haus der Kunst, 1959).

22. María Amalia García, "Hegemonies and Models of Cultural Modernization in South America: The Paraguay-Brazil Case," *ARTMargins* 3, no. 2 (2014): 28–30. For a detailed discussion of the 1957 exhibition in Buenos Aires, see María Amalia García, *Abstract Crossings: Cultural Exchange between Argentina and Brazil* (Berkeley: University of California Press, 2019), 200–9.

23. "Exposição paralela à Bienal," *Tribuna da Imprensa,* September 30, 1953, 8.

24. Leonor Amarante, *As Bienais de São Paulo, 1951 a 1987* (São Paulo: Projeto, 1989).

25. Aracy A. Amaral, ed., *Perfil de um acervo: Museu de Arte Contemporânea da Universidade de São Paulo* (São Paulo: Techint, 1988), 26–30.

26. See, for example, Jayme Maurício, "No Museu de Arte Moderna: gente moça renovando a paisagem artística," *Correio da Manhã,* July 15, 1955, 12, 14; "Grupo Frente: o que há de mais importante na arte brasileira," *Tribuna da Imprensa,* March 15, 1956, 5.

27. Later, the newspaper was targeted by the military dictatorship with the imprisonment of its leaders and closure in 1974. Ana Paula Goulart Ribeiro, *Imprensa e história no Rio de Janeiro dos anos 50* (Rio: e-papers, 2007), 64–71.

28. Bryan McCann, "Carlos Lacerda: Rise and Fall of a Middle-Class Populist in 1950s Brazil," *Hispanic American Historical Review* 83, no. 4 (November 2003): 671–72.

29. Catherine Bompuis, "A Revolution of Sensitivity," in Ferreira and Herkenhoff, *Mário Pedrosa,* 52, 55; Pedrosa, "Chronology," 443.

30. On the gradual, tentative nature of the positive coverage of Kubitschek in *Correio da Manhã,* and for insights on the ideological commitments of Rio and São Paulo newspapers in the mid-1950s, see Alzira Alves de Abreu, "Revistando os anos 1950 através da imprensa," in *O moderno em questão: a década de 1950 no Brasil,* ed. André Botelho, Elide Rugai Bastos, and Glaucia Villa Bôas (Rio: Topbooks, 2008), 211–35.

31. McCann, "Carlos Lacerda," 672.

32. "O Brasil está condenado ao moderno," *Tribuna da Imprensa,* December 26–27, 1953, 6. As Pedrosa and Otília Arantes recount, the protests of other press outlets led to Pedrosa's dismissal from *Tribuna da Imprensa.* See Mário Pedrosa, "Dentro e fora da Bienal," *Diário Carioca,* March 14, 1954, in Mário Pedrosa, *Dos murais de Portinari,* ed. Aracy A. Amaral

(São Paulo: Perspectiva, 1981), 47–54; Otília Arantes, *Mário Pedrosa: itinerário crítico* (São Paulo: Cosac Naify, 2004), 16–17.

33. "Vozes da cidade," *Tribuna da Imprensa,* November 27–28, 1954, 2.

34. "Apoio à campanha da Tribuna da Imprensa," *Tribuna da Imprensa,* July 6, 1953, 2; "Mulheres de várias atividades antecipam a sua escolha," *Tribuna da Imprensa,* October 3, 1955, 9.

35. McCann, "Carlos Lacerda," 666.

36. "Mulheres de calças cumpridas prendem artistas ao bairro," *Tribuna na Imprensa,* July 8, 1955, 6.

37. Classes were not held at MAM Rio until the 1958 inauguration of the "bloco escolar" at the permanent site of the museum due to the spatial constraints at MEC. They were instead held in leased spaces downtown.

38. Mário Pedrosa, "A força educadora da arte" (1947) in Mário Pedrosa, *Textos escolhidos,* ed. Otília Arantes, vol. 2, *Forma e percepção estética* (São Paulo: Edusp, 1996), 61–62. For insightful analyses of MAM Rio's education program in light of discourses of democracy and developmentalism, see Le Blanc, "Tropical Modernisms," 180–232; Irene V. Small, *Hélio Oiticica: Folding the Frame* (Chicago: University of Chicago Press, 2016), 135–39.

39. "O setor didático do Museu de Arte Moderna do Rio: atelier livre de pintura para adultos," *Correio da Manhã,* July 3, 1954, 11.

40. Serpa began teaching courses at MAM Rio on May 10, 1952, and his classes in the early 1950s included painting classes for children and adults as well as a theory of painting course.

41. Serpa had taught children's art classes at his home since 1947 and organized domestic and international exhibitions of his students' works. See Vera Beatriz Siqueira, "Insistently Current," in Fabiana Werneck Barcinski et al., *Ivan Serpa* (Rio: Silvia Roesler; Instituto Cultural The Axis, 2003), 159.

42. See, for example, "Pincel e calças curtas: o que é e como funciona a escolinha de Ivan Serpa," *Tribuna da Imprensa,* May 29, 1954, 1; Siqueira, "Insistently Current," 159, 161, 164, 166–67; Hélio Márcio Dias Ferreira, "Ivan Serpa, Artist-Educator," in Barcinski, *Ivan Serpa,* 201–7.

43. Mário Pedrosa and Ivan Serpa, *Crescimento e criação* (1954), in Pedrosa, *Textos escolhidos,* vol. 2, 72.

44. Mário Pedrosa, "Arte infantil" (1952), in Pedrosa, *Textos escolhidos,* vol. 2, 63–70; "Crescimento e criação" in Pedrosa, *Textos escolhidos,* vol. 2, 71–80.

45. Pedrosa also lived in Paris later in his life, and in Belgium and Switzerland as an adolescent.

46. Mário Pedrosa, "A Bienal de cá para lá" (1970), in Mário Pedrosa, *Textos escolhidos,* ed. Otília Arantes, vol. 1, *Política das artes* (São Paulo: Edusp, 1995), 265.

47. Pedrosa, "A Bienal de cá para lá," 268.

48. Bill visited Brazil twice in 1953, in May and June (when he lectured at MAM Rio) and in December (when he served on the jury of the second Biennial). For analysis of Bill's criticisms of Brazilian architecture, see Valerie Fraser, *Building the New World: Studies in the Modern Architecture of Latin America, 1930–1960* (London: Verso, 2000), 252–55; Aleca Le Blanc, "Palmeiras and Pilotis: Promoting Brazil with Modern Architecture," *Third Text* 26, no. 1 (January 2012): 103–5.

49. See "A conferência de Max Bill," *Correio da Manhã,* May 31, 1953, 11; "Max Bill esclarece pontos de vista e desfaz mal entendidos (I)," *Correio da Manhã,* June 7, 1953, 11; "Max Bill: visita ao Brasil do famoso escultor modernista," *Boletim do Museu de Arte Moderna do Rio de Janeiro,* no. 9 (July 1953): 5–6, 8.

50. See, for example, Max Bill, "The Bauhaus Idea from Weimar to Ulm," *Architects' Year Book* 5 (1953): 29–32. Bill also sharply distinguished HfG and the Bauhaus in private correspondence in 1953. See Nicola Pezolet, "Bauhaus Ideas: Jorn, Max Bill, and Reconstruction Culture," *October,* no. 141 (Summer 2012): 100–1.

51. Jayme Maurício, "Ivan Serpa, concreto feliz entre as crianças," *Correio da Manhã,* August 2, 1953, 11.

52. "A arte deve influir sobre o homem contemporâneo," *Tribuna da Imprensa,* November 20–21, 1954, 4.

53. See, for example, Max Bill, "Forma, função, beleza," *Tribuna da Imprensa,* November 20–21, 1954, 4.

54. Ferreira Gullar, "Apresentação" in *Grupo Frente* (Rio: Galeria IBEU, June 1954). Val first took French classes with Serpa at a secondary school, then studied in children's art classes at Serpa's home, and subsequently in adult painting classes at MAM Rio.

55. Murilo Mendes, quoted in "'As pessoas morrem, a arte fica,'" *Tribuna da Imprensa,* March 17, 1955, 6.

56. Carlos Val, quoted in ibid.

57. Among the books Oiticica owned were surveys of European modernism by Mário Pedrosa and Jorge Romero Brest, the latter of which he inscribed March 15, 1955. He cited Henri Focillon's *La vie des formes* (1934) in his early writings and had access to his brother's copy of a Spanish edition of Wilhelm Wörringer, a thinker important to Pedrosa. Postwar issues of numerous French art journals and of the Argentine journal *Ver y Estimar* were in the family library. Mário Pedrosa, *Panorama da pintura moderna* (Rio: MES, 1952); Jorge Romero Brest, *La pintura europea contemporánea, 1900–1950* (Mexico City: Fondo de Cultura Económica, 1952); Wilhelm Wörringer, *Problemática del arte contemporáneo* (Buenos Aires: Ediciones Nueva Visión, 1955); Hélio Oiticica, "Veritas: arte, literatura, filosofia," 1954, AHO/PHO 0302.54, 5–6.

58. Paulo Herkenhoff, "Rio de Janeiro: A Necessary City," in *The Geometry of Hope: Latin American Abstract Art from the Patricia Phelps de Cisneros Collection,* ed. Gabriel

Pérez-Barreiro (Austin: Blanton Museum of Art, University of Texas at Austin, 2007), 56–57; Ramírez, "The Embodiment of Color," in *Hélio Oiticica: The Body of Color,* ed. Mari Carmen Ramírez (Houston: MFAH, 2007), 35–36, 61, 71n43; Irene V. Small, "Hélio Oiticica and the Morphology of Things" (PhD diss., Yale University, 2008), 46n22.

59. Hélio Oiticica, notebook, March 13, 1954–January 15, 1955, AHO/PHO 0302.54, 1–18. In the Oiticica family library, there is a French translation of the Kandinsky text and several monographs that include passages of Klee's text. Daniel Henry Kahnweiler, *Klee* (Paris: Braun & Cie, 1950); Vasily Kandinsky, *Du spirituel dans l'art et dans la peinture en particulier* (Paris: Editions de Beaune, 1954); Will Grohmann, *Paul Klee* (New York: Abrams, 1955). The description of Klee's and Kandinsky's conceptions of color is indebted to Hal Foster, "Exercises for Color Theory Courses," in *Bauhaus, 1919–1933: Workshops for Modernity,* ed. Barry Bergdoll and Leah Dickerman (New York: MoMA, 2009), 266.

60. Oiticica grouped the two sketches with one other drawing, and the proposed date for these sketches is based on its date, January 16, 1955.

61. *Geraldo de Barros* (São Paulo: MAM-SP, 1952); Paul Klee, "Extracts from the Journal of the Artist," in *Paul Klee,* 3rd ed. (New York: MoMA, 1946), 8.

62. He used the term *pesquisador* (researcher) in an early entry in the notebook. See Hélio Oiticica, notebook entry, n.d., AHO/PHO 0302.54, 3.

63. Ariane Figueiredo, María C. Gaztambide, and Daniela Matera Lins, "Chronology (1937–1980)" in Ramírez, *Hélio Oiticica,* 346.

64. See, for example, A.L. Quadros, "Grupo Frente," *Forma,* no. 2 (August 1954); "Ivan Serpa, a III Bienal e o 'Grupo Frente,'" *Correio da Manhã,* July 10, 1955, 14. Frederico Morais states that A.L. Quadros is a pseudonym under which Anna Letycia and Serpa co-authored the text (*Ciclo de exposições sobre arte no Rio de Janeiro: 2. Grupo Frente, 1954–1956, 3. I Exposição nacional de arte abstrata, Hotel Quitandinha, 1953* [Rio: Galeria de Arte BANERJ, 1984]).

65. Gullar, "Apresentação."

66. "Queremos uma arte de vanguarda," *Tribuna da Imprensa,* June 30, 1954, 5.

67. "Ivan Serpa, a III Bienal e o 'Grupo Frente.'"

68. "Queremos uma arte de vanguarda."

69. Macedo Miranda, "Janela sobre o mundo," *Tribuna da Imprensa,* July 3–4, 1954, 4.

70. Ibid.

71. Ibid.

72. Pedrosa, "Grupo Frente," 269.

73. Ibid., 270.

74. Ferreira Gullar, "Apresentação"; Mário Pedrosa, "Abstratos em Quitandinha," *Tribuna da Imprensa,* February 28, 1953, 9.

75. "Grupo Frente: o que há de mais importante na arte brasileira." Also see Hélio Oiticica, notebook entry, January 15, 1955, AHO/PHO 0302.54, 16–17.

76. Pedrosa, "Grupo Frente," 270. This passage of Pedrosa's essay was reprinted in "Arte concretista vai escalar a montanha," *Tribuna da Imprensa,* March 9, 1956, 5. In a collective interview in November 1954, members of Grupo Frente expressed similar ideas. See "A arte deve influir sobre o homem contemporâneo," *Tribuna da Imprensa,* November 20–21, 1954, 4.

77. *Grupo Frente* (Volta Redonda, Brazil: Companhia Siderúrgica Nacional, 1956), AHO/PHO 1840.56.

78. Pedrosa spoke at the opening and quotes from his 1955 essay were reprinted in the press. "Iniciativa que pode brotar em cimento," *Tribuna da Imprensa,* March 17–18, 1956, 5; "Arte concretista vai escalar a montanha."

79. Macedo Miranda, "Um problema da arte moderna," *Forma,* no. 6 (March 1956).

80. "Petite Galerie," *Tribuna da Imprensa,* November 4, 1955, 3; "Grupo Frente," *Tribuna da Imprensa,* January 16, 1956, 2; "Programação do MAM de São Paulo para 1956," *Tribuna da Imprensa,* April 30, 1956, 6.

81. Amilcar de Castro, for example, was identified on multiple occasions as part of Grupo Frente, though he did not exhibit with the group. Edmundo Jorge, the lead organizer of the Exposição nacional de arte abstrata, was also described as part of the group in 1954. "Queremos uma arte de vanguarda"; "Serpa em Belo Horizonte," *Tribuna da Imprensa,* January 14, 1955, 5.

82. See, for example, "Em Copacabana, é o primeiro do mundo: crianças já tem um museu de arte," *Tribuna da Imprensa,* February 9, 1956, 2; "51 Crianças expõem no Museu de Arte Moderna," *Tribuna da Imprensa,* December 3, 1957, 3.

83. It is possible to identify works displayed in the exhibitions at IBEU, Itatiaia Country Club, and Volta Redonda, but not, based on currently known archival and press records, to reconstruct their installations. On the IBEU exhibition, including note of the institution's lack of archival holdings related to its early artistic activities, see Tarcila Soares Formiga, "Instituto Brasil-Estados Unidos: uma experiência no campo artístico carioca" (MA thesis, Universidade do Estado do Rio de Janeiro, 2009). On the Volta Redonda exhibition, see Le Blanc, "Tropical Modernisms," 233–310.

84. For further discussion of Oiticica's mixed-media works, see Nelson, "There is No Repetition," 48, 55n30.

85. The whereabouts of this work are not known. Details about its materiality and palette are drawn from art criticism. See "Aluísio Carvão," *Forma,* no. 6 (March 1956).

86. Mário Pedrosa, "Grupo Frente," trans. in Ramírez, "The Embodiment of Color," 71n43.

87. Ramírez, "The Embodiment of Color," 35, 71n43. To the best of my knowledge, researchers have not located the Grupo Frente notebooks.

88. Pedrosa, "Grupo Frente," 270.

89. Walter Gropius, "Program of the Staatliche Bauhaus in Weimar" (1919), in Hans Maria Wingler, *The Bauhaus: Weimar, Dessau, Berlin, Chicago* (Cambridge, MA: MIT Press, 1978), 31. On Gropius's use of medieval allusions, see Charles W. Haxthausen, "Walter Gropius and Lyonel Feininger, Bauhaus Manifesto, 1919," in Bergdoll and Dickerman, *Bauhaus, 1919–1933*, 64–67.

90. As Irene V. Small has noted, there is a surprising celebration of capitalist applications for artistic experimentation in socialist Pedrosa's discussion of Serpa's teaching. Small, *Hélio Oiticica*, 147.

91. MAM Rio, a stalwart supporter of Serpa, had begun supporting Clark with similar enthusiasm, acquiring and commissioning work and selecting her for exhibitions. Both artists were also included in the Brazilian representation to the twenty-seventh Venice Biennale (1954). In the context of the latter, Serpa noted his regret that the selection for the Venice Biennale, by Pedrosa and others, had been limited to his collages and excluded his recent paintings. See Luiza Elza Massena, "Arte concreta brasileira em Veneza," *Forma*, no. 1 (June 1954).

92. Pedrosa, "Grupo Frente," 270.

93. "Contra as belas-artes," *Manchete*, no. 174 (August 20, 1955): 4.

94. Pedrosa offered this juxtaposition to the reader of his essay as a confirmation of the openness of the group: "Well then look, just look: here is Eliza alongside Serpa" ("Grupo Frente," 269). The other pairings he envisioned, between Clark and Val, Weissmann and Pape, Ibberson and Costa, and Vieira and Carvão, do not appear to have been realized in the exhibition, based on known documentation.

95. Martins exhibited three paintings, one of which—*Boi Preto* (Black Ox) of 1955—is illustrated in the catalogue, but their whereabouts are unknown.

96. While the geographic diversity of the group's membership was not the headline in press coverage, it was a recurrent subject in relationship to Martins and Carvão. Pedrosa, for example, referred to Carvão as "a young artist who came from the Amazon rainforest . . . to the metropole" ("Iniciativa que pode brotar em cimento").

97. See, for example, "Ivan Serpa: pintor," *Manchete*, no. 191 (December 17, 1955): 37.

98. "'Não sei se sou uma pintora primitiva,'" *Tribuna da Imprensa*, March 11, 1955, 1.

99. Ibid.

100. Ferreira Gullar, "Etapas da pintura contemporânea XXXIX, arte concreta V: arte concreta no Brasil," *Jornal do Brasil*, Suplemento Dominical, August 6, 1960, 3n1.

101. "Brasileiros na II Bienal," *Correio da Manhã*, January 31, 1954, 11.

102. "Arte concretista vai escalar a montanha"; "O Grupo Frente quer levar a arte concreta ao interior," *Tribuna da Imprensa*, March 14, 1956, 5; "Jovens artistas expõem na serra," *Tribuna da Imprensa*, March 17–18, 1956, 1.

103. Gullar, quoted in "Grupo Frente: o que há de mais importante na arte brasileira." Also see "Jovens artistas expõem na serra."

104. This may have included Pape. In an unpublished text by Serpa, held by PLP, Serpa relays his impressions of Pape's new paintings and reliefs during a studio visit in 1955, and the plan to exhibit them at a Grupo Frente exhibition opens the possibility that Pape showed non-prints at the third and/or fourth Grupo Frente exhibitions. To the best of my knowledge, there was no discussion of Pape's paintings and reliefs by the press in the mid-1950s. See Ivan Serpa, "Text for the New Exhibition of Works by Grupo Frente: Lygia Pape and her Production (Reliefs and Paintings)" in *Lygia Pape: Magnetized Space,* ed. Manuel J. Borja-Villel and Teresa Velázquez (London: Serpentine Gallery, 2011), 63.

105. The painting is dated 1953 by the artist on the verso, but the first record I have found of its exhibition is the third Grupo Frente exhibition in 1956, where it was illustrated in the catalogue.

106. Wynne Phelan is the first to note the artist's use of a *tira-linhas.* See Wynne H. Phelan, "To Bestow a Sense of Light: Hélio Oiticica's Experimental Process," in Ramirez, *Hélio Oiticica,* 78.

107. Hélio Oiticica, "The Transition of Color from Painting into Space and the Meaning of Construction" (1962), in Ramírez, *Hélio Oiticica,* 224.

108. Mário Pedrosa, *Lygia Clark 1950–1952: desenhos, guaches, óleos* (Rio: MES, 1952). See discussion in chapter 4.

109. Clark designed the set for the play *13 Degraus para baixo* by Lúcio Fuiza in Rio in 1953; a temporary stand commissioned by MAM Rio in 1954; and a vitrine dedicated to the same museum in the Associação Brasileira de Imprensa (ABI) building in Rio in 1956. It is unclear whether the announced collaboration with Niemeyer, on his Conjunto Kubitschek (now Edifício JK) in Belo Horizonte, or with architect Leopoldo Teixeira Leite, on a school in Itatiaia in state of Rio de Janeiro, were realized. On Clark's vitrine design, see Adele Nelson, "On Gender and Surface in Lygia Clark's Early Abstraction," in *Lygia Clark: Painting as an Experimental Field, 1948–1958,* ed. Geaninne Gutiérrez-Guimarães (Bilbao: Guggenheim Museum Bilbao, 2020), 74–75.

110. The talk was transcribed in print at least twice, in late 1956 and early 1957. The first instance I have found of her dating the organic line to 1954 was mid-1957. See Lygia Clark, "Uma experiência de integração," *Brasil: Arquitetura Contemporânea,* no. 8 (1956): 45; "Pintora mineira (Ligia Clark) descobre novas linhas orgânicas nas artes plásticas," *Diário de Minas,* January 27, 1957, transcription ACLC; Lygia Clark, "Lygia Clark (pintor concretista): 'A arte me disciplina e me educa,'" *Jornal do Brasil,* August 8, 1957, 1.

111. Lygia Clark, "Conference Given in the Belo Horizonte National School of Architecture in 1956" in *Lygia Clark,* ed. Manuel J. Borja-Villel (Barcelona: Fundació Antoni Tàpies, 1997), 72, with slight modification. The source of this transcription is "Pintora mineira (Ligia Clark) descobre novas linhas orgânicas nas artes plásticas."

112. Mário Pedrosa, "Ligia Clark, e o fascínio do espaço," *Jornal do Brasil,* November 26, 1957, 6. Also see Ferreira Gullar, "Lygia Clark: uma experiência radical (1954–1958)" in Ferreira Gullar, *Lygia Clark* (Rio: Imprensa Nacional, 1958); Edelweiss Sarmento, "Lygia Clark e o espaço concreto expressional," *Jornal do Brasil,* February 7, 1959, Suplemento Dominical, 2. Clark deployed the concept well beyond the 1950s, as in her 1968 text for the Paris periodical *Robho* and 1983 artist book *Livro obra* (Book Work). See "Special: Lygia Clark, fusion généralisée," *Robho,* no. 4 (Fall–Winter 1968): 12–13.

113. Ricardo Bausbaum cautions against viewing Clark's and critics' accounts of the organic line as "the objective description of a process" ("Within the Organic Line and After," in *Art after Conceptual Art,* ed. Alexander Alberro and Sabeth Buchman [Cambridge, MA: MIT Press, 2006], 88–89).

114. See, for example, a selection of notebook writings by Clark from 1957 in Cornelia H. Butler and Luis Pérez-Oramas, eds., *Lygia Clark: The Abandonment of Art, 1948–1988* (New York: MoMA, 2014), 55–58.

115. Clark, "Conference Given in the Belo Horizonte National School of Architecture in 1956," 73.

116. Ibid., with modification.

117. McCann, "Carlos Lacerda," 666.

118. "Mulheres de calças compridas prendem artistas ao bairro"; "Mulheres de várias atividades antecipam a sua escolha."

119. Glória Ferreira, "A greve das cores" in Paulo Herkenhoff and Glória Ferreira, eds., *Salão preto e branco: III Salão nacional de arte moderna, 1954, a arte e seus materiais* (Rio: Funarte, 1985); Small, *Hélio Oiticica,* 168; Aleca Le Blanc, "The Agency of Artists at the Salão Preto e Branco," in *Arte concreta e vertentes construtivas: teoria, crítica e história da arte técnica, Jornada ABCA,* ed. Luiz Antônio Cruz Souza (Belo Horizonte, Brazil: Editora ABCA, 2018), 31.

120. For illustration and discussion of Clark's *Quadro objeto,* see Nelson, "On Gender and Surface in Lygia Clark's Early Abstraction," 65–69.

121. With a different emphasis than my argument on Clark's presentation at Venice in 1954, Luis Pérez-Oramas also suggests resonance between her 1953–54 kaleidoscopic paintings and Clark's subsequent work. See Luis Pérez-Oramas, "Lygia Clark: If You Hold A Stone" in Butler and Pérez-Oramas, *Lygia Clark,* 33.

122. Pia Gottschaller, "Making Concrete Art," in *Making Art Concrete: Works from Argentina and Brazil in the Colección Patricia Phelps de Cisneros,* ed. Aleca Le Blanc (Los Angeles: Getty Publications, 2017), 49–50.

123. Clark altered the numbering to be sequential for the accepted works at the third Bienal. See copies of Fichas de identidade do artista, III Bienal do Museu de Arte Moderna de São Paulo, January 25, 1955 and May 22, 1955, ACLC.

124. Clark had Nadal Mora's book open in her studio during an interviewer's visit in 1957, and Serpa held an example in his library. Vicente Nadal Mora, *Técnica gráfica del dibujo geométrico: trazados lineales* (Buenos Aires: Imprenta Mercantali, 1942); "Lígia Clark: Prêmio 'Diário de Notícias' na IV Bienal," *Diário de Notícias,* October 13, 1957, supplement Revista Feminina no. 26, 8. For further analysis of Clark's use of the Nadal Mora book, see Nelson, "On Gender and Surface in Lygia Clark's Early Abstraction," 73–74.

125. Lucy Teixeira, "Una experienza brasiliana," *Commentari: Rivista di Critica e Storia dell'Arte,* no. 8 (1957): Tavv. C, Fig. 2.

126. Mário Pedrosa, "Integration of the Arts," *Brazilian-American Survey,* no. 3 (1955–56): 61.

127. Lygia Clark, "1957" (1957), in Butler and Pérez-Oramas, *Lygia Clark,* 55.

128. Clark, "Lygia Clark (pintor concretista)."

129. The other version of *Superfície modulada n. 20* was shown in a traveling exhibition organized by MAM Rio in 1957. See *Arte moderno en Brasil.*

130. Clark, "Lygia Clark (pintor concretista)."

131. Adele Nelson, "Sensitive and Nondiscursive Things: Lygia Pape and the Reconception of Printmaking," *Art Journal* 71, no. 3 (Fall 2012): 26–45.

132. The print in MoMA's collection, originally titled *Xilogravura* and currently dated 1959, is not signed or dated. The examples of the print in Projeto Lygia Pape's collection are signed and dated by the artist 1956 and 1957. The earlier dates correspond to Gullar's statement that the black ground works preceded the frieze-like works included in the first Neo-Concrete exhibition. Ferreira Gullar, "1a Exposição de arte neoconcreta," *Jornal do Brasil,* March 15, 1959, Suplemento Dominical, 5.

133. Clark, "Lygia Clark (pintor concretista)."

134. Ibid.

135. "Lígia Clark: Prêmio 'Diário de Notícias' na IV Bienal," 9.

CONCLUSION

1. The quotations, respectively, are from Mário Pedrosa, "Paulistas e cariocas" (1957), in *Mário Pedrosa: Primary Documents,* ed. Glória Ferreira and Paulo Herkenhoff (New York: MoMA, 2015), 274; Waldemar Cordeiro, "Teoria e prática do concretismo carioca," *AD: Arquitetura e Decoração* 22 (March–April 1957), in Analívia Cordeiro, ed., *Waldemar Cordeiro: fantasia exata* (São Paulo: Itaú Cultural, 2014), 180. Also see Ferreira Gullar, "Pintura concreta," *Jornal do Brasil,* February 10, 1957, Suplemento Dominical, 9.

2. Waldemar Cordeiro, "Arte industrial," *AD* 27 (February–March 1958), in Cordeiro, *Waldemar Cordeiro,* 185.

3. On Gullar's differentiation of Rio and São Paulo practices, see Ferreira Gullar, "I Exposição de arte concreta: o grupo de São Paulo," *Jornal do Brasil,* February 17, 1957, Suplemento Dominical, 9; Ferreira Gullar, "I Exposição de arte concreta: o grupo do

Rio," *Jornal do Brasil,* February 24, 1957, Suplemento Dominical, 8. For his best known polemic against an overly rationalist approach to Concretism, see Ferreira Gullar et al., "Neo-Concrete Manifesto" (1959), in *Inverted Utopias: Avant-Garde Art in Latin America,* ed. Mari Carmen Ramírez and Héctor Olea (Houston: MFAH, 2004), 497.

4. Ronaldo Brito, *Neoconcretismo: vértice e ruptura do projeto construtivo brasileiro* (Rio: Funarte; Instituto Nacional de Artes Plásticas, 1985; São Paulo: Cosac Naify, 1999).

5. The exhibition in Rio was in the galleries of MEC (not MAM Rio's provisional site at MEC); its installation is only sparsely recorded in press accounts.

6. Mammì, Bandeira, and Stolarski also identified the authors of the majority of the works and poems visible—identifications with which I agree and to which I have adhered in my discussion—and created composite photographs to convey the space at MAM-SP. Lorenzo Mammì, João Bandeira, and André Stolarski, *Concreta '56: a raiz da forma/Concret '56: The Root of Form* (São Paulo: MAM-SP, 2006).

7. On the Leirner prize, see Regina Teixeira de Barros, "A Galeria das Artes de Folhas e Prêmio Leirner de Arte Contemporânea: arte e meio artístico em São Paulo, 1958–1962" (PhD diss, Universidade de São Paulo, 2020).

8. The school imagined by Maldonado was modeled on the Hochschule für Gestaltung (HfG), where Maldonado was rector. On the proposal and its ultimate realization as the Escola Superior de Desenho Industrial in 1963, see Silvia Fernández, "The Origins of Design Education in Latin America: From the hfg in Ulm to Globalization," *Design Issues* 22, no. 1 (Winter 2006): 3–19; Aleca Le Blanc, "The Material of Form: How Concrete Artists Responded to the Second Industrial Revolution in Latin America," in *Making Art Concrete: Works from Argentina and Brazil in the Colección Patricia Phelps de Cisneros,* ed. Aleca Le Blanc (Los Angeles: Getty Publications, 2017), 1, 5–6.

9. Lina Bo Bardi and P.M. Bardi, "Declaração," *Habitat: Revista das Artes no Brasil* 15 (March–April 1954): 1. With the Bardis absent, the acerbic chronicles at the back of the magazine, skewering creators, patrons, and politicians alike, morphed into a more conventional rundown of recent exhibitions, and art critic José Geraldo Vieira took a more positive tone both under his own byline and that of his pseudonym, Manuel Germano.

10. For insightful discussions of the Sunday supplement of the *Jornal do Brasil,* see Irene V. Small, *Hélio Oiticica: Folding the Frame* (Chicago: University of Chicago Press, 2016), 43–49; Sergio Delgado Moya, *Delirious Consumption: Aesthetics and Consumer Capitalism in Mexico and Brazil* (Austin: University of Texas Press, 2017), 92–95.

11. Waldemar Cordeiro, "Arquitetura e arte," *AD* 22 (March–April 1957).

12. Ibid. This was a recurring subject in *AD.* See Eduardo Corona, "Arquitetos premiados em pintura e desenho," *AD* 19 (July–August 1956); Waldemar Cordeiro, "Arte, arquitetura e vida," *AD* 26 (December 1957).

13. Mário Pedrosa, "Architecture and Art Criticism I" (1957), in Ferreira and Herkenhoff, *Mário Pedrosa,* 356. Pedrosa's series of texts on architecture immediately followed his

articles dedicated to the Exposição nacional de arte concreta in *Jornal do Brasil*. Also see Mário Pedrosa, "Architecture as Work of Art," in Ferreira and Herkenhoff, *Mário Pedrosa*, 357–58.

14. See reprinted letters from Augusto de Campos to Décio Pignatari of May and July 1956 in João Bandeira, *Arte concreta paulista: documentos* (São Paulo: Cosac Naify, 2002), 71.

15. Among those documented installing the exhibition were Ronaldo Azeredo, Lothar Charoux, the Campos brothers, Hermelindo Fiaminghi, Judith Lauand, Maurício Nogueira Lima, and Décio Pignatari. See Audálio Dantas, "Pintura, desenho, escultura e poesia na exposição nacional de arte concreta," *Folha da Noite*, December 3, 1956, 5, in Bandeira, *Arte concreta paulista*, 72; "Concretos," *Jornal do Brasil*, December 9, 1956, Suplemento Dominical, 5.

16. Ferreira Gullar retrospectively stated that the Rio participants were contacted individually and asked to select and send their works. See Ferreira Gullar and Ariel Jiménez, *Ferreira Gullar in Conversation with Ariel Jiménez* (New York: Fundación Cisneros/ Colección Patricia Phelps de Cisneros, 2012), 34–35.

17. "Arte concrete e poesia," *Jornal do Brasil*, November 11, 1956, Suplemento Dominical, 5. To the best of my knowledge, the first mentions in the São Paulo press were short notices on November 29 and November 30, 1956 in *Folha da Manhã* and *Diário da Noite*.

18. Ferreira Gullar and Oliveira Bastos, "Figuras: palavra," *Jornal do Brasil*, February 24, 1957, Suplemento Dominical, 8. The involvement of Gullar and Bastos would provide an explanation for the announced (but ultimately unrealized) inclusion of the sculptor and graphic designer Amilcar de Castro, who was hired, in early 1957, as the graphic designer of the Sunday supplement and the larger *Jornal do Brasil*.

19. Delgado Moya, *Delirious Consumption*, 90.

20. Sixty-five works are visible in known installation views, which exclude works by at least four participants. One review put the total number as close to eighty ("Exposição nacional de arte concreta," *Folha da Manhã*, December 5, 1956, 3).

21. Waldemar Cordeiro "O objeto," *AD* 20 (December 1956); Décio Pignatari, "Arte concreta: objeto e objetivo," *AD* 20 (December 1956). Pignatari's text was the lead editorial and Cordeiro's essay, accompanied by those of the Campos brothers, Pignatari, and Gullar, appeared in the section dedicated to the exhibition.

22. Pignatari, "Arte concreta: objeto e objetivo."

23. Cordeiro, "O objeto," in Cordeiro, *Waldemar Cordeiro*, 175.

24. Cordeiro, "O objeto," trans. in Aracy A. Amaral, "Abstract Constructivist Trends in Argentina, Brazil, Venezuela, and Colombia," in *Latin American Artists of the Twentieth Century*, ed. Waldo Rasmussen (New York: MoMA, 1993), 91, with slight modification.

25. Sérgio B. Martins, *Constructing an Avant-Garde: Art in Brazil, 1949–1979* (Cambridge, MA: MIT Press, 2013), 26. Also see Givaldo Medeiros, "Dialética concretista : o percurso de

Waldemar Cordeiro," *Revista do IEB* 45 (September 2007): 73–76. On Gramsci and Cordeiro's art of the 1960s, see Adrian Anagnost. "Internationalism, Brosilidade, and Politics: Waldemar Cordeiro and the Search for a Universal Language," *Hemisphere: Visual Cultures of the Americas* 3, no. 1 (2010) : 29–34; Rachel Price, "Early Brazilian Digital Culture; or, The Woman Who Was Not B.B.," *Grey Room* 47 (Spring 2012): 60–79.

26. Cordeiro, "O objeto," in Cordeiro, *Waldemar Cordeiro,* 176. Emphasis in the original.

27. Martins, *Constructing an Avant-Garde,* 27.

28. Ibid., 26.

29. There are discrepancies between the 1948 floor plan of the museum and the built space documented in photography since Tarsila do Amaral's retrospective opened in December 1950. It is possible to conclude the large gallery was substantially renovated at least once in 1950, with a floor-to-ceiling wall constructed to enclose three columns that subdivided the space, block off a large windowed wall, and create a target wall. My understanding of the space differs from that proposed previously. Marlene Yurgel, ed., *Vilanova Artigas: projetos digitalizados,* vol. 19 (São Paulo: Faculdade de Arquitetura e Urbanismo da Universidade de São Paulo, 2010), 3373–78; Mammì, Bandeira, and Stolarski, *Concreta '56,* 14–15.

30. Franz Weissmann stated he submitted *Cubo vazado* to the first Bienal and that it was rejected, a proposal disputed by the records at the AHWS, which record him submitting three figurative sculptures made of clay and gesso. He submitted five metal sculptures to the second Bienal, one of which was selected. To the best of my knowledge, the first instance in which he exhibited a work with the title *Cubo vazado* was in 1954 at the III Salão paulista de arte moderna, where it was praised by reviewers. It is possible the work displayed at MAM-SP in 1956 was a larger version of the work shown in 1954. See Stephen Feeke and Penelope Curtis, eds., *Espaço aberto/Espaço fechado: Sites for Sculpture in Modern Brazil* (Leeds: Henry Moore Institute, 2006), 29; Franz Weissmann, Ficha de identidade do artista, box 1/18, 01 Bienal de São Paulo, MAM, AHWS; Franz Weissmann, Ficha de identidade do artista, April 26, 1953, box 02/17, folder 8, 02 Bienal de São Paulo, MAM, AHWS.

31. Manuel Germano [José Geraldo Vieira], "Exposição nacional de arte concreta," *Folha da Manhã,* December 16, 1956, 7.

32. Based on photographs located by Mammì (in addition to Fiaminghi's), it appears that at least three paintings by Barros were displayed. See Mammì, Bandeira, and Stolarski, *Concreta '56,* 35, 41. It is likely the works by César and Hélio Oiticica, Pape, and Alexandre Wollner were displayed in the hallway or an auxiliary space off the large gallery; they do not appear in Fiaminghi's photographs and are unmentioned in exhibition reviews detailing the works displayed in the large gallery and small room.

33. Germano, "Exposição nacional de arte concreta"; Sérgio Milliet, "A propósito da exposição concretista," *O Estado de São Paulo,* December 21, 1956, 6.

34. See, for example, a series of negative reviews of the exhibition written anonymously by critic Geraldo Ferraz, which were singled out for rebuttal by Augusto de Campos:

[Geraldo Ferraz], "Exposição de pintura concreta no MAM," *O Estado de São Paulo,* December 13, 1956, 8; [Geraldo Ferraz], "Os concretos no museu," *O Estado de São Paulo,* December 15, 1956, 6; [Geraldo Ferraz], "Os concretos da sala grande," *O Estado de São Paulo,* December 18, 1956, 12; Augusto de Campos, "Concretos e anônimos," *Jornal do Brasil,* December 30, 1956, Suplemento Dominical, 5.

35. This interpretation of the poem draws on Décio Pignatari and Jon M. Tolman, "Concrete Poetry: A Brief Structural-Historical Guideline," *Poetics Today* 3, no. 3 (Summer 1982): 191.

36. On Lauand's incorporation into the São Paulo Concrete art group, see Aliza Edelman, *Judith Lauand: Brazilian Concrete Abstractions* (New York: Driscoll Babcock Galleries, 2017), 7–8.

37. Haar passed away in 1954. Wladyslaw continued to actively exhibit but was no longer considered a Concrete artist.

38. Pignatari, for example, in his correspondence with Augusto de Campos, assumed that Serpa would be among the participating artists from Rio. See Bandeira, *Arte concreta paulista,* 71.

39. "Deixa o magistério," *Jornal do Brasil,* January 1, 1957, Suplemento Dominical, 9. The Rio newspaper *Correio da Manhã,* which lavished coverage on Serpa throughout the 1950s, did not note Serpa's absence from the exhibition in São Paulo.

40. Ferreira Gullar, "Ivan Serpa se define 'sou pintor concreto,'" *Jornal do Brasil,* March 3, 1957, Suplemento Dominical, 9. It is possible that an interview Serpa gave to *Tribuna da Imprensa,* in which he criticized the Exposição nacional de arte concreta, may have been a source of the rumors ("Ivan Serpa define o que é arte concreta," *Tribuna da Imprensa,* February 8, 1957, 7).

41. Gullar, "Ivan Serpa se define 'sou pintor concreto.'" In addition to working at MAM Rio, the Biblioteca Nacional, and at the museum of children's art he started in Copacabana in 1956, he also taught art classes at his home.

42. Gullar, "Ivan Serpa se define 'sou pintor concreto.'"

43. "Exposição nacional de arte concreta, m.a.m. s. paulo, dezembro 1956," *AD* 22 (March–April 1957).

44. With collaborators, Barros established the furniture design company Unilabor in 1954, an industrial design and communication firm, Forminform, in 1957, and another furniture design company, Hobjeto Móveis Ltda., in 1964. See Giovanna Bragaglia, "Cronologia: Geraldo de Barros (1923–1998)," in Heloisa Espada, ed., *Geraldo de Barros e a fotografia* (São Paulo: IMS; Edições SESC, 2014), 287–89.

: 200 ml. p.g.
6 x 23 . e.

FRANÇA : 220 ml. p.g.
6 x 23 . e.
5 x 11 . e.

ALEMANHA.
58 ml. p.g.
4x6 . e.

SUIÇA.
58 ml. p.g.
4x6 . e.

BELGICA : 116 ml. p.g.
4 x 12 . e.

ENAL DO MUSEU DE ARTE MODERNA DE SÃO PAULO.

IIÇÃO DOS PAINEIS : EUROPA · AMERICA DO SUL· ESCALA 1:100.

Selected Bibliography

Alambert, Francisco, and Polyana Canhête. *As Bienais de São Paulo: da era do museu à era dos curadores (1951–2001)*. São Paulo: Boitempo, 2004.

Alberro, Alexander. *Abstraction in Reverse: The Reconfigured Spectator in Mid-Twentieth-Century Latin American Art*. Chicago: University of Chicago Press, 2017.

Amaral, Aracy A, ed. *Arte construtiva no Brasil: coleção Adolpho Leirner/Constructive Art in Brazil: Adolpho Leirner Collection*. São Paulo: DBA Artes Gráficas, 1998.

———. *Arte para quê? A preocupação social na arte brasileira, 1930–1970*. 1984. 3rd ed. São Paulo: Studio Nobel, 2003.

———, ed. *Perfil de um acervo: Museu de Arte Contemporânea da Universidade de São Paulo*. São Paulo: Techint, 1988.

———, ed. *Projeto construtivo brasileiro na arte (1950–1962)*. Rio de Janeiro: Museu de Arte Moderna do Rio de Janeiro; São Paulo: Pinacoteca do Estado de São Paulo, 1977.

Amarante, Leonor. *As Bienais de São Paulo, 1951 a 1987*. São Paulo: Projeto, 1989.

Amor, Mónica. *Theories of the Nonobject: Argentina, Brazil, Venezuela, 1944–1969*. Oakland: University of California Press, 2016.

Anagnost, Adrian. "Limitless Museum: P.M. Bardi's Aesthetic Reeducation." *Modernism/Modernity* 26, no. 4 (November 2019): 687–725.

Arantes, Otília. *Mário Pedrosa: itinerário crítico*. 1991. 2nd ed. São Paulo: Cosac Naify, 2004.

Arruda, Maria Arminda do Nascimento. *Metrópole e cultura: São Paulo no meio século XX*. Bauru: EDUSC, 2001.

Bandeira, João, ed. *Arte concreta paulista: documentos*. São Paulo: Cosac Naify, 2002.

Barcinski, Fabiana Werneck, Vera Beatriz Siqueira, and Hélio Márcio Dias Ferreira, eds. *Ivan Serpa.* Rio de Janeiro: Silvia Roesler; Instituto Cultural The Axis, 2003.

Barros, Fabiana de, ed. *Geraldo de Barros: isso.* São Paulo: Edições SESC, 2013.

Barros, Regina Teixeira de, ed. *Arte construtiva na Pinacoteca do Estado de São Paulo.* São Paulo: Pinacoteca do Estado de São Paulo, 2014.

Belluzzo, Ana Maria, ed. *Waldemar Cordeiro: uma aventura da razão.* São Paulo: Museu de Arte Contemporânea da Universidade de São Paulo, 1986.

Bethell, Leslie, and Ian Roxborough, eds. *Latin America Between the Second World War and the Cold War: Crisis and Containment, 1944–1948.* Cambridge, UK: Cambridge University Press, 1993.

Borja-Villel, Manuel J., and Teresa Velázquez, eds. *Lygia Pape: Magnetized Space.* London: Serpentine Gallery, 2011.

Brito, Ronaldo. *Neoconcretismo: vértice e ruptura do projeto construtivo brasileiro.* Rio de Janeiro: Funarte; Instituto Nacional de Artes Plásticas, 1985; São Paulo: Cosac Naify, 1999.

Butler, Cornelia H., and Luis Pérez-Oramas, eds. *Lygia Clark: The Abandonment of Art, 1948–1988.* New York: Museum of Modern Art, 2014.

Cabañas, Kaira M. *Learning from Madness: Brazilian Modernism and Global Contemporary Art.* Chicago: University of Chicago Press, 2018.

Candela, Iria, ed. *Lygia Pape: A Multitude of Forms.* New York: Metropolitan Museum of Art, 2017.

Chiarelli, Tadeu. "Art in São Paulo and the Modernist Segment of the Collection." In *Coleção Nemirovsky,* edited by Maria Alice Milliet, 81–90. São Paulo: Museu de Arte Moderna de São Paulo, 2003.

Cintrão, Rejane, and Ana Paula Nascimento. *Grupo Ruptura.* São Paulo: Cosac Naify, 2002.

Cocchiarale, Fernando, and Anna Bella Geiger, eds. *Abstracionismo geométrico e informal: a vanguarda brasileira nos anos cinquenta.* Rio de Janeiro: Funarte; Instituto Nacional de Artes Plásticas, 1987.

Cordeiro, Analívia, ed. *Waldemar Cordeiro: fantasia exata.* São Paulo: Itaú Cultural, 2014.

Costa, Helouise, and Renato Rodrigues da Silva. *A fotografia moderna no Brasil.* São Paulo: Cosac Naify, 2004.

Delgado Moya, Sergio. *Delirious Consumption: Aesthetics and Consumer Capitalism in Mexico and Brazil.* Austin: University of Texas Press, 2017.

Espada, Heloisa. *Geraldo de Barros e a fotografia.* São Paulo: Instituto Moreira Salles; Edições SESC, 2014.

Fabris, Annateresa. *O desafio do olhar: fotografia e artes visuais no período das vanguardas históricas.* 2 vols. São Paulo: WMF Martins Fontes, 2011–13.

———, and Luiz Camillo Osorio, eds. *MAM 60.* São Paulo: Museu de Arte Moderna de São Paulo, 2008.

Feeke, Stephen, and Penelope Curtis, eds. *Espaço aberto/espaço fechado: Sites for Sculpture in Modern Brazil.* Leeds: Henry Moore Institute, 2006.

Ferreira, Glória, and Paulo Herkenhoff, eds. *Mário Pedrosa: Primary Documents.* New York: Museum of Modern Art, 2015.

Fischer, Brodwyn. *A Poverty of Rights: Citizenship and Inequality in Twentieth-Century Rio de Janeiro.* Palo Alto, CA: Stanford University Press, 2008.

Fox, Claire F. *Making Art Panamerican: Cultural Policy and the Cold War.* Minneapolis: University of Minnesota Press, 2013.

García, María Amalia. *Abstract Crossings: Cultural Exchange Between Argentina and Brazil.* Oakland: University of California Press, 2019.

Giunta, Andrea. *Avant-Garde, Internationalism, and Politics: Argentine Art in the Sixties.* Durham, NC: Duke University Press, 2007.

Greet, Michele, and Gina McDaniel Tarver, eds. *Art Museums of Latin America: Structuring Representation.* New York: Routledge, 2018.

Guilbaut, Serge. "*Ménage à trois:* Paris, New York, São Paulo, and the Love of Modern Art." In *Internationalizing the History of American Art: Views,* edited by Barbara Groseclose and Jochen Wierich, 159–77. University Park: Pennsylvania State University Press, 2009.

Gutiérrez-Guimarães, Geaninne, ed. *Lygia Clark: Painting as an Experimental Field, 1948–1958.* Bilbao: Guggenheim Museum Bilbao, 2020.

Herbst, Hélio. *Pelos salões das Bienais, a arquitetura ausente dos manuais: contribuições para a historiografia brasileira (1951–1959).* São Paulo: Annablume; Fapesp, 2011.

Herkenhoff, Paulo. "Eliseu Visconti: moderno antes do modernismo." *5 Visões do Rio na Coleção Fadel.* Rio de Janeiro: Edições Fadel, 2009.

Holston, James. *Insurgent Citizenship: Disjunctions of Democracy and Modernity in Brazil.* Princeton, NJ: Princeton University Press, 2008.

Jones, Caroline A. *The Global Work of Art: World's Fairs, Biennials, and the Aesthetics of Experience.* Chicago: University of Chicago Press, 2016.

Le Blanc, Aleca, Pia Gottschaller, Zanna Gilbert, Tom Learner, and Andrew Perchuk, eds. *Making Art Concrete: Works from Argentina and Brazil in the Colección Patricia Phelps de Cisneros.* Los Angeles: Getty Publications, 2017.

Leon, Ethel. *IAC: primeira escola de design do Brasil.* São Paulo: Blücher, 2014.

Lesser, Jeffrey. *Negotiating National Identity: Immigrants, Minorities, and the Struggle for Ethnicity in Brazil.* Durham, NC: Duke University Press, 1999.

Lima, Zeuler R.M.A. *Lina Bo Bardi.* New Haven, CT: Yale University Press, 2013.

Magalhães, Ana Gonçalves, ed. *Classicismo, realismo, vanguarda: pintura italiana no entreguerras.* São Paulo: Museu de Arte Contemporânea da Universidade de São Paulo, 2013.

Mammì, Lorenzo, João Bandeira, and André Stolarski. *Concreta '56: a raiz da forma/Concret '56: The Root of Form.* São Paulo: Museu de Arte Moderna de São Paulo, 2006.

Martins, Sérgio B. *Constructing an Avant-Garde: Art in Brazil, 1949–1979.* Cambridge, MA: MIT Press, 2013.

McCann, Bryan. "Carlos Lacerda: Rise and Fall of a Middle-Class Populist in 1950s Brazil." *Hispanic American Historical Review* 83, no. 4 (November 2003): 661–96.

Nelson, Adele. "The Bauhaus in Brazil: Pedagogy and Practice." *ARTMargins* 5, no. 2 (June 2016): 27–49.

———. "Far from Good Design: Social Responsibility and Waldemar Cordeiro's Early Theory of Form." *Artelogie: Recherche sur les Arts, le Patrimoine et la Littérature de l'Amérique Latine,* no. 15 (2020). www.journals.openedition.org/artelogie/4374.

———. "Sensitive and Nondiscursive Things: Lygia Pape and the Reconception of Printmaking." *Art Journal* 71, no. 3 (Fall 2012): 26–45.

O'Hare, Mary Kate, ed. *Constructive Spirit: Abstract Art in South and North America, 1920s–50s.* Petaluma, CA: Pomegranate, 2010.

Olea, Héctor, and Mari Carmen Ramírez, eds. *Building on a Construct: The Adolpho Leirner Collection of Brazilian Constructive Art at the Museum of Fine Arts, Houston.* Houston: Museum of Fine Arts, Houston, 2009.

Oliveira, Rita Alves. "Bienal de São Paulo: impacto na cultura brasileira." *São Paulo em Perspectiva* 15, no. 3 (2001): 18–28.

Osorio, Luiz Camillo, ed. *Abraham Palatnik.* São Paulo: Cosac Naify, 2004.

Pedrosa, Mário. *Panorama da pintura moderna.* Rio de Janeiro: Ministério da Educação e Saúde, 1952.

———. *Textos escolhidos.* Edited by Otília Arantes. 4 vols. São Paulo: Edusp, 1995–2000.

Pérez-Barreiro, Gabriel, ed. *The Geometry of Hope: Latin American Abstract Art from the Patricia Phelps de Cisneros Collection.* Austin: Blanton Museum of Art, University of Texas at Austin, 2007.

———, and Michelle Sommer, eds. *Mário Pedrosa: de la naturaleza afectiva de la forma.* Madrid: Museo Nacional Centro de Arte Reina Sofía, 2017.

Ramírez, Mari Carmen, ed. *Hélio Oiticica: The Body of Color.* Houston: Museum of Fine Arts, Houston; London: Tate Modern, 2007.

———, and Héctor Olea, eds. *Inverted Utopias: Avant-Garde Art in Latin America.* Houston: Museum of Fine Arts, Houston, 2004.

Sant'Anna, Sabrina Parracho. *Construindo a memória do futuro: uma análise da fundação do Museu de Arte Moderna do Rio de Janeiro.* Rio de Janeiro: FGV, 2011.

Silva, Denise Ferreira da. *Toward a Global Idea of Race.* Minneapolis: University of Minnesota Press, 2007.

Skidmore, Thomas. *Politics in Brazil, 1930–1964: An Experiment in Democracy.* 1967. 2nd ed. Oxford: Oxford University Press, 2007.

Small, Irene V. *Hélio Oiticica: Folding the Frame.* Chicago: University of Chicago Press, 2016.

Weinstein, Barbara. *The Color of Modernity: São Paulo and the Making of Race and Nation in Brazil.* Durham, NC: Duke University Press, 2015.

Whitelegg, Isobel. "The Bienal Internacional de São Paulo: A Concise History, 1951–2014." *Perspective,* no. 2 (2013): 380–86.

Zelevansky, Lynn, Elisabeth Sussman, James Rondeau, and Donna De Salvo, eds. *Hélio Oiticica: To Organize Delirium.* Pittsburgh, PA: Carnegie Museum of Art, 2016.

Illustrations

Index

Barros's photography (*continued*)

291 (n. 97); *Fotoforma: Geraldo de Barros* exhibition (MASP, 1951), 56, *57*, 59, 71; *Fotoforma* (punch card series, 1952–53), 72, 75–76, *75*, 87, 291 (n. 99); heterodoxy and, 59; internegatives and, 76, 291 (n. 99); Pedrosa on, 56; photograms, 71, 72, *74*, 75–76, *75*, 86–87; Salão internacional de arte fotográfica de São Paulo and, 72, *73*; Second São Paulo Bienal photography exhibition and, 72, 204

Baruch, Eric, 219, 319 (nn. 2,9)

Bastos, Oliveira, 259, 331 (n. 18)

Bauhaus: Bill and, 220–21; Grupo Frente and, 231, 232–33; Grupo Ruptura and, 143; Hochschule für Gestaltung and, 104, 220, 221, 298 (n. 57), 323 (n. 48); Instituto de Arte Contemporânea and, 104–5, 219, 299 (n. 61); Maluf and, 108; as model, 7; Nazi closure of, 180; Serpa's pedagogy and, 219, 220

Bazaine, Jean, 37

"Beauty from Function and as Function" (Bill), 56

Belluzzo, Ana Maria, 134

Bennett, Tony, 6

Bento, Antonio, 96, 98–99, 116, 197

Biblioteca Municipal, São Paulo, 19–21, 23

Bienal Hispanoamericana de Arte (Hispanic-American Art Biennial) (Madrid), 101

Bill, Max: Barros and, 70, 71–72, 75, 77, 79, 81, 290 (n. 87); Bauhaus and, 220–21; "Beauty from Function and as Function," 56; Brazil visits (1953), 220, 221, 323; Brazilian modernity and, 118, 120; Concretism term and, 8; Cordeiro and, 123–24; First São Paulo Bienal installation and, 122, 123, 126, 130, 302 (n. 104); First São Paulo Bienal prizes and, 91, 121, 125; First São Paulo Bienal Swiss representation and, 122, 302 (n. 105); on form, 48, 52, 55–56; *Form: A Balance Sheet of Mid-Twentieth Century Trends in Design*, 48; *Habitat: Revista das Artes no Brasil* and, 96; Hochschule für Gestaltung and, 104, 220, 221, 298 (n. 57), 323 (n. 48); Instituto de Arte Contemporânea and, 298 (n.

57); international legitimization and, 126; MAM Rio and, 221; MAM-SP acquisitions, 126, 302 (n. 101); MASP retrospective (1951), 118, 124; Niemeyer and, 191; Pedrosa on, 179; poster for *Josef Albers, Hans Arp, Max Bill* exhibition, 299 (n. 62); Second São Paulo Bienal and, 197, 317 (n. 55), 318 (n. 78); *Tripartite Unity*, 118, *119*, 120, 122, 221

Bittencourt, Paulo, 136, 217

Black Accompaniment (Kandinsky), 35

Black and White Salon (1954), 243–44

Black Mountain College, 298 (n. 56)

Blaszko, Martín, 187

Bloem, Ruy, 176

Bo Bardi, Lina: Brazilian national authenticity and, 97, 100; on First São Paulo Bienal, 126, 129; *Habitat* resignation of, 257, 330 (n. 9); Instituto de Arte Contemporânea and, 297 (n. 48); MASP and, 95, 136; Venice Biennale protests and, 95, 97, 100, 295 (n. 20)

Boccioni, Umberto, *Unique Forms of Continuity in Space*, 175

Boi Preto (Black Ox) (Martins da Silveira), 326 (n. 95)

Boletim Foto-Cine, 204

Bonadei, Aldo, 95, 127

Bonnard, Pierre, 54

Braque, Georges, 28

Brasília, 256

Bratke, Oswaldo, 292 (n. 103)

Brazilian abstraction: artwork titles and, 124–25; Atelier Abstração and, 145, 188, 197–98, *199*, 227; Barros and, 66, 67–68, 69, 71; collegiality and, 134–35, 143, 206, 306 (n. 24); commercialization of, 128–29, *129*; critical reception of, 126–27; elite associations with, 161, 170; Estado Novo marginalization of, 2, 17; Eurocentric scholarship on, 9; Exposição nacional de arte abstrata and, 161, *162*; First São Paulo Bienal and, 90, 91–92, 118, 120–22, 126–27, 188; increased acceptance of, 136; intermediality and, 168; international

release of, 138, 149, 307 (n. 37); on social responsibility, 134; theoretical content of, 146–47

Grupo Santa Helena, 94, 95, 127

Grupo Seibi, 127

Guernica (Picasso), 2, 175, 178, *180*, 193, 194, 197, 202–3

Guignard, Alberto da Veiga, 120, 300 (n. 72)

Guilbaut, Serge, 23, 29, 30, 31

Guitar (Picasso), 178

Gullar, Ferreira: abstraction-realism debates and, 50; on Clark, 242; Exposição nacional de arte concreta and, 259, 265–66, 331 (nn. 16,18); geographical fracture of Brazilian Concretism and, 255, 256; Grupo Frente and, 210, 225–26, 239; MAM Rio art school and, 221; Martins da Silveira and, 238; Rio abstract art community and, 168

Die Gute Form (Good Design) exhibition (1949), 48

Haar, Leopold: death of, 333 (n. 37); *Exposição do Grupo Ruptura* and, 136, 138, 139, 305 (n. 11); Exposição nacional de arte concreta and, 264; Grupo Ruptura manifesto and, *150*

Habitat: Revista das Artes no Brasil (Habitat: Brazilian Arts Magazine), *98–99*; Bardi and Bo Bardi resignations from, 257, 330 (n. 9); on Brazilian abstraction, 127–28; on Brazilian national authenticity and, 96–97; on Clark, 157–58; Diários Associados building and, 295 (n. 19); on international influences, 128–29, *129*; MASP and, 95, 96–97, 136; review of First São Paulo Bienal, 126, 128–30, 303 (n. 112); on Second São Paulo Bienal, 197, 316 (n. 54); Tavares on, 296 (n. 27); Venice Biennale protests and, 95–96

Hanfstaengl, Eberhard, 317 (n. 55)

Hartung, Hans, 35, 37

Head (González), 37

Hélion, Jean, 31

hemispheric identity, 176, 182, 185, 187, 193

Herkenhoff, Paulo, 222, 314 (n. 30)

Hlito, Alfredo, Second São Paulo Bienal and, 187, 194

Hochschule für Gestaltung (Institute of Design) (HfG), 104, 220, 221, 298 (n. 57), 323 (n. 48), 330 (n. 8)

Hodler, Ferdinand, 177

Hoje, 101, 294 (n. 8)

Holston, James, 3–4

Homage to the Square series (Albers), 299 (n. 62)

Homer, Winslow, 185, 186

Hotel Quitandinha (Petrópolis), 160–61

Hovering (Klee), 223

Husserl, Edmund, 313 (n. 18)

IAC (Institute of Contemporary Art). *See* Instituto de Arte Contemporânea

Ibberson, Vincent, 219, 319 (nn. 2,9)

Iber, Patrick, 147

IBEU (Brazil-United States Institute). *See* Instituto Brasil-Estados Unidos

Ideia visível (Visible Idea) (Cordeiro), 264

illusionism, 49, 50, 55, 152, 162

immigrants: Brazilian national authenticity and, 97–98, 99–100; *Exposição do Grupo Ruptura* and, 136; First São Paulo Bienal and, 116

Impressionism, 31, 50, 153, 184

Índio e a suassuapara (Indian and the Fallow Deer) (Brecheret), 111, *112*

Individualized Altimetry of Layers (Klee), *181*

industrial materials: Clark's use of, 246, 251, *251*; Exposição nacional de arte abstrata and, 167; gender and, 251–52; Grupo Frente and, 239–40, 252; Grupo Ruptura and, 138, *139*, 140, *141*, 143; Rio abstract art community and, 168; Serpa's use of, 83, *84*, 86, 134

Institute of Design (Chicago), 104, 105. *See also* Bauhaus

Nierendorf, Karl, 26, 30, 31–32, 33

Nogueira Lima, Maurício: *Composição n. 2* (Composition no. 2), 143, *144*; Cordeiro and, 306 (n. 21), 308 (n. 50); Exposição nacional de arte concreta and, 264, 265, 331 (n. 15); Second São Paulo Bienal and, 198; II Salão paulista de arte moderna and, 140, 143, *144*

Noigandres, 258

non-artists: Grupo Frente and, 228, 230, 241; Pedrosa on, 49, 51, 56, 216, 220, 221

non-white artists, 96–97, 127, 296 (n. 27). *See also* Afro-Brazilians; *specific artists*

nonobjective abstraction: aesthetic orthodoxy and, 50, 179–80; artwork titles and, 125; Cordeiro on, 55, 70; critical reception of, 126–27; Degand on, 40; in *Exposição do Grupo Ruptura*, 59, 138–39, *139*; First São Paulo Bienal and, 90, 122, *122*, 125, 126–27; Grupo Frente and, 230, 231; MAM Rio art school and, 218, 222; nationalism and, 256; Pedrosa on, 180; Picasso retrospective and, 178; Second São Paulo Bienal and, 197, 198; II Salão paulista de arte moderna and, 143; Serpa and, 82, 125. *See also* Brazilian Concretism

Nude in an Armchair (Picasso), 178

O Cangaceiro (Barreto), 114

O Colar (*Retrato de Yvonne Visconti*) (Visconti), *184*

O Estado de São Paulo, 21, 152, 304 (n. 119), 306 (n. 17)

"O objeto" (The Object) (Cordeiro), 260–61, 331 (n. 23)

object-form, 48, 146

Objeto-forma (*Desenvolvimento de um quadrado*) (Object-Form [Development of a Square]) (Barros). *See Função diagonal*

Office of Inter-American Affairs (OIAA), 21, 22

Oiticica, César: children's art and, 228, 230; Exposição nacional de arte concreta and, 332 (n. 32); Grupo Frente and, 231, 319 (nn. 2,9); MAM Rio art school and, 219, 221, 222

Oiticica, Hélio: art education of, 219, 221–23, 323 (n. 57), 324 (n. 59); children's art and, 228, 230; Exposição nacional de arte concreta and, 332 (n. 32); *Grupo Frente*, *225*; Grupo Frente and, 210, 231, *232*, 240–41, 319 (nn. 2,9); influences on, 223–25, *224*, 324 (nn. 59–60,62); *Sem título*, *232*; surface reconstruction and, 252; *Três tempos* (*quadro 1*) (Three Times [Painting 1]), *240*, 241

O'Keeffe, Georgia, 35

Oliveira, Rita Alves, 101, 102

organic line (*linha orgânica*), 242–43, *244*, 246

Organization of American States (OAS). *See* Pan American Union

Orozco, José Clemente, 95, 186, 187

Osorio, Luiz Camillo, 8, 87, 168

Ostrower, Fayga, 162, 219, 319–20 (n. 9)

ovo novelo (ovum skein) (Campos), 264, *265*

Palácio Gustavo Capanema murals (Portinari), 17

Palatnik, Abraham: artwork titles and, 125; Brazilian Concretism and, 87; Exposição nacional de arte abstrata and, 166–68; Exposição nacional de arte concreta and, 259; First São Paulo Bienal and, 91, 120, 121, 125; form and, 242; Gestalt theory and, 58; Grupo Frente and, 210, 231, 319 (n. 2); Mavignier on, 50; nonobjective abstraction and, 125; *Paralelas amarelo-laranja* (Yellow-Orange Parallels), 167; *Paralelas em azul e laranja numa sequência horizontal* (Parallels in Blue and Orange in Horizontal Sequence), 166–67; *Paralelas n. 3* (Parallels no. 3), 167; Rio abstract art community and, 168, 169; Second São Paulo Bienal and, 188; *Sequência com intervalos*, 167, *167*; *Sequência vertical* (Vertical Sequence), 167

Pallucchini, Rodolfo, 177, 317 (n. 55)

Pan American Union (PAU), 82, 183, 228

Pan-Americanism, 176, 193. *See also* hemispheric identity

Pancetti, José, 120, 300 (n. 72)

Willumsen, Jens Ferdinand, 177

Wladyslaw, Anatol: *Composição*, 140, *142*;
Cubism and, 125; *Exposição do Grupo Ruptura*
and, 137, 138, 139, 140, 157; Exposição nacional
de arte concreta and, 264; Grupo Ruptura
manifesto and, *150*; Second São Paulo Bienal
and, 188; II Salão paulista de arte moderna
and, 140, 143; Venice Biennale protests
and, 95

Wölfflin, Heinrich, 49–50

Wollner, Alexandre, 140, 194, 259, 306 (n. 21), 332
(n. 32)

women. *See* gender; sexism

World War II, 15, 18, 19, 22, 92, 177, 183

Wörringer, Wilhelm, 323 (n. 57)

Xul Solar, Alejandro, 125

Yalenti, José V. E., 319 (n. 82)

Zanini, Mario, 127

Zanini, Walter, 71, 77

Zervos, Christian, 29

Zweig, Stefan, 7

Founded in 1893,
UNIVERSITY OF CALIFORNIA PRESS
publishes bold, progressive books and journals
on topics in the arts, humanities, social sciences,
and natural sciences—with a focus on social
justice issues—that inspire thought and action
among readers worldwide.

The UC PRESS FOUNDATION
raises funds to uphold the press's vital role
as an independent, nonprofit publisher, and
receives philanthropic support from a wide
range of individuals and institutions—and from
committed readers like you. To learn more, visit
ucpress.edu/supportus.